# BEYOND THE FACE
## NEW PERSPECTIVES ON PORTRAITURE

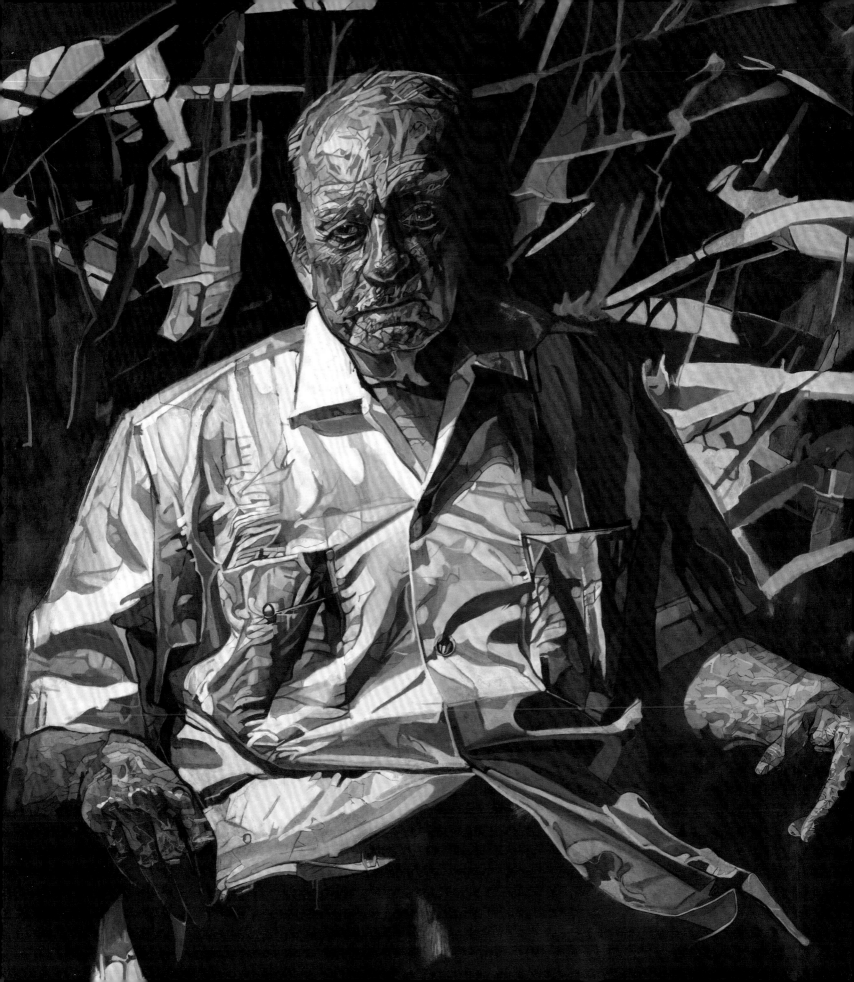

# BEYOND THE FACE
## NEW PERSPECTIVES ON PORTRAITURE

Edited by Wendy Wick Reaves

National Portrait Gallery, Smithsonian Institution, Washington, DC
in association with
D Giles Limited, London

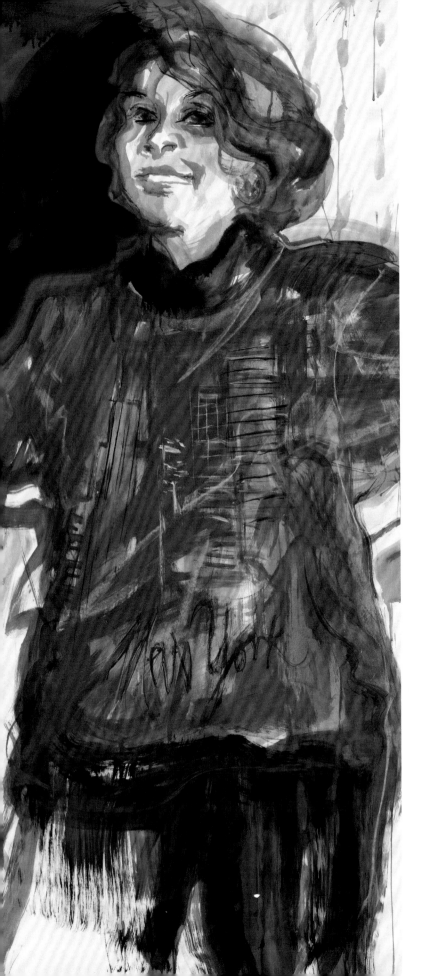

# CONTENTS

BEYOND THE FACE: NEW PERSPECTIVES ON PORTRAITURE
was made possible through the generous support of these individuals:

Sally Chubb

Jacquelyn and William Sheehan

Gay and Tony Barclay

Alan and Lois Fern

Daniel Okrent

Cathy and Michael Podell

# DIRECTOR'S FOREWORD

Kim Sajet

Scholarship and research are at the core of the Smithsonian Institution's mission to foster the "increase and diffusion" of knowledge. At the National Portrait Gallery—where biography, portraiture, and history intersect—we are proud of the legacy of serious research undergirding all of our exhibitions and publications. With generous funding from Robert L. McNeil Jr. and the Barra Foundation, the museum has for many years been able to hold a scholarly symposium honoring American art scholar Edgar P. Richardson and focusing on subjects as varied as the portraits by Gilbert Stuart, trends in contemporary portraiture, images of Elvis Presley, portraits of Marcel Duchamp, and racial masquerade. To further our commitment to fostering new scholarship, in 2018 the Portrait Gallery is launching a center for scholarly inquiry to support continued research on portraiture and biography. The initiative will encompass future Richardson symposia, study days in the galleries, collegial reviews of manuscripts in progress, and a new essay prize, all contained within a new resource, "PORTAL: Insights into Portraiture."

*Beyond the Face: New Perspectives on Portraiture* celebrates the inauguration of PORTAL. Written by some of today's very best scholars in the field, the sixteen groundbreaking essays in this volume range from an exploration of iconoclasm in the eighteenth century to an analysis of contemporary artist María Magdalena Campos-Pons's emotional and affecting performance pieces. We expect the book to engage both general and scholarly audiences who are interested in gaining a better understanding of the ever-changing and challenging genre of portraiture.

I am most grateful to Wendy Wick Reaves, Curator Emerita of Prints, Drawings, and Media Arts, for taking the lead in soliciting and selecting proposals, editing the essays, compiling the bibliography, and writing a thought-provoking introduction. The museum's curatorial staff, particularly Chief Curator Brandon Brame Fortune, provided assistance and insights throughout the book's development. I also thank Rhys Conlon, Head of Publications, for her hard work on this project.

This publication would not have been possible without the support of Sally Chubb, Jacquelyn and William Sheehan, Gay and Tony Barclay, Alan and Lois Fern, Daniel Okrent, Cathy and Michael Podell, and Mary Challinor. *Beyond the Face* is the first in an expected series of volumes on portraiture, a topic of unending fascination for artists, scholars, and the public at large.

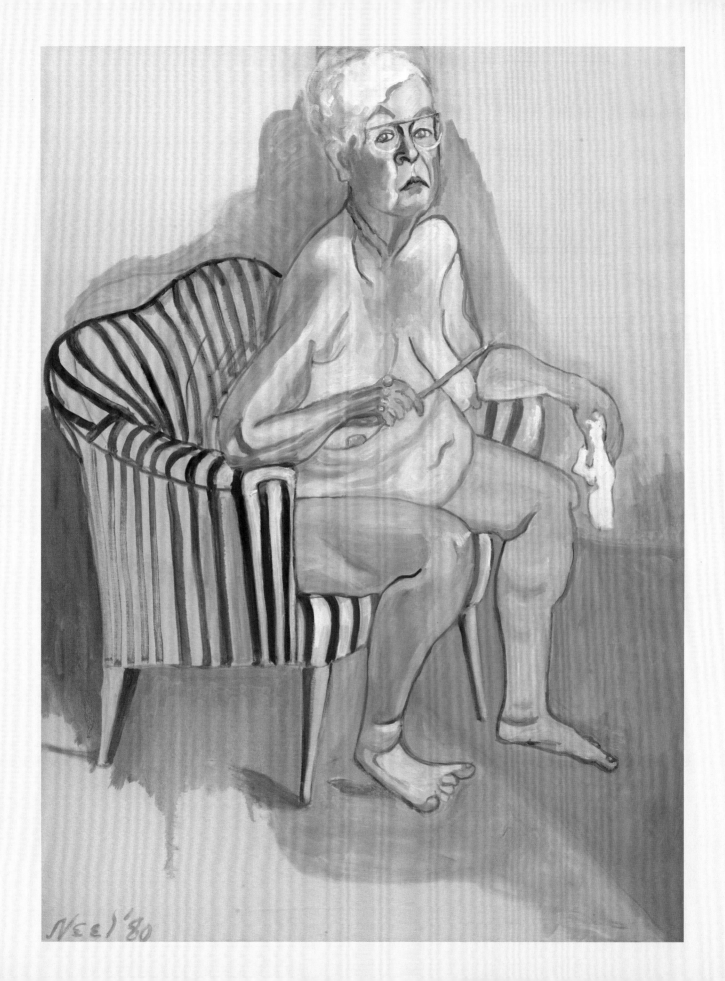

# INTRODUCTION

Wendy Wick Reaves

Alice Neel, who completed her idiosyncratic self-portrait in 1980, at the age of eighty, spent much of her career in obscurity, painting unsaleable portraits of nude pregnant women, acquaintances in her Spanish Harlem neighborhood, lovers, and friends. She had persisted in figurative work even when the mid-twentieth-century art world, with its focus on abstraction, Minimalism, and Pop art, dismissed it definitively. Not until late in her career did she finally gain acclaim for her compelling, groundbreaking portraiture. In her self-portrait, she reveled in the depiction of cellulite, sagging flesh, and drooping shoulders, defying conventions about ideal beauty, sexualized female nudity, and dignified views of aging. Using humor, faux-naif distortion, bold contours, dancing stripes, and exuberant colors, she turned elderly imperfections and resignation into an emphatic celebration of life and art. Neel's self-portrait reminds us of how easily portraiture and its conventions can be upended by artistic originality.

Over the centuries, the status of portraiture as an artistic genre has experienced glorious highs followed, often precipitously, by new lows. The portraitist, admired at one time for portraying exemplars of character and rectitude for the public to emulate, could, in the next era, appear a meretricious flatterer selling his or her skills with little regard for truth or art. Sometimes this fragile respect was due to perceptions of effortlessness: portraiture's tie to objective representation, its dependence on the mimetic depiction of face and figure, and its formulaic conventions of posing and com-posing. Over the years, it has been considered more craft than art, more artisanal than intellectual, or more stolidly conservative than stylistically progressive. This periodic sinking in status has often spurred reinvention by the next generation, annoyed into inspiration by the proscriptions of the old. "The dumbest, most moribund, out-of-date, and shopworn of possible things you could do was to make a portrait," Chuck Close remembered about the moment when he stubbornly launched his brilliant career depicting faces.[1]

Portraiture persists, whatever its status. Furthermore, as the essays in this volume make clear, it is seldom as straightforward as it seems. When the Smithsonian's National Portrait Gallery opened its doors in 1968, methodologies for understanding the nuances of portraiture were limited. Scholarship had benefitted from the taxonomic work of cataloguing and attributing painting and sculpture, but the broader view of portrayal throughout the visual culture lagged behind. The museum's fiftieth anniversary in 2018 gives us an opportunity to assess the study of portraiture. The last few decades have revived interest in analyzing a genre clearly distinct in many ways from other forms of art making, and the authors in this volume demonstrate stimulating new endeavors in that direction.

*Self-Portrait* by Alice Neel, 1980
Oil on canvas, 135.3 × 101 cm (53¼ × 39¾ in.)
National Portrait Gallery, Smithsonian Institution

Modes of figural depiction, far from being solidified, evolve constantly, and our analysis of them needs frequent updating. As images, portraits reflect codes of deportment, social and political environments, and the visual rhetoric of their day. As indexical representations of the individual, they reference issues of identity and subjectivity consistent with contemporary understanding, while subtleties of normative and non-normative affiliation hover just beneath their surfaces. As material objects, portraits are subject to the vagaries of time and place; physical change, translocation, and new modes of interpretation and exhibition can alter their meanings.[2] The role of the viewer must also be considered. Who is the audience? How does the viewer receive and interact with the image at the time of production or generations later? Often the answers to those questions involve the dissemination of the picture and how it spreads into the culture through display, replication, or reproduction.

Far from being self-evident, as critics sometimes imply, portraiture requires an arsenal of tools and lenses with which to understand nuance and context. This volume provides a general introduction to the genre and its triangulation of artist, subject, and viewer. But the authors of these essays also offer fresh analytical approaches to expand our perceptions. Recent scholarship probes the business of portraiture, the manipulation or evolution of the physical object, the dissemination of the image, symbolic evocations of personality, theatricality and self-presentation, the power dynamics between sitter and artist, and political and economic implications.

Authors Lauren Lessing, Nina Roth-Wells, and Terri Sabatos start off this volume by grounding our consciousness in the portrait as a physical object. Their essay "Body Politics: Copley's Portraits as Political Effigies during the American Revolution" examines acts of iconoclasm by both patriots and loyalists who defaced canvases by John Singleton Copley as symbolic mutilation directed toward the subject depicted. Careful analysis by conservators and curators reconstructs the damages wrought to these works and their subsequent treatment. Copley's desecrated portraits were sometimes repaired as if to hide the disrespect they suffered; in other cases, family members considered the defacement a proud statement of an ancestor's brave if unpopular stance.

This emphasis on the materiality of the object undergirds Juanita Solano Roa's study, "The Other's Other: Portrait Photography in Latin America, 1890–1930." She considers the initial process of photographic composition including touched-up negatives along with highly artificial posing. Exploring the compositional manipulations of four Latin American photographic studios, Solano Roa illuminates the social, political, and religious agendas underlying their portraits. The artifice of these studios, she

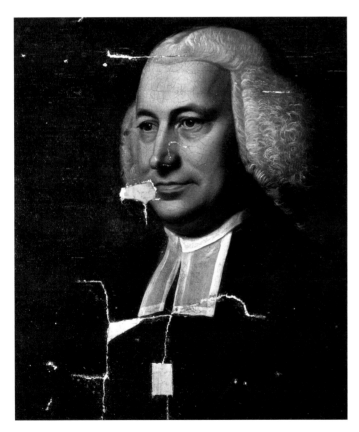

*Portrait of Rev. Samuel Cooper (1725–1783), Pastor of Brattle Square Church, Boston* (during conservation treatment in 1957; detail), ca. 1769–71, see page 33

explains, reinforces national or indigenous identities or local rituals surrounding death. A focus on materiality also implies the transformation of objects over time and their re-presentation and interpretation in different settings. Taína Caragol, in "Meaningful (Dis)placements: The Portrait of Luis Muñoz Marín by Francisco Rodón at the National Portrait Gallery," discusses the impact that the long-term loan of a single painting has on an institution whose goal is to diversify and expand the understanding of the American experience. In this setting, the monumental portrait has acquired a heightened significance and a new role for this pivotal figure in Puerto Rican history. Caragol's study reminds us of the importance of the viewer's engagement with portraiture, the mutability of meaning over time, and the role of display in influencing interpretation.

Jennifer Van Horn, in "Prince Demah and the Profession of Portrait Painting," focuses our attention on the business of portraiture in the eighteenth century and the power relationship between the artist and the sitter. She discusses the impropriety of a slave concentrating his gaze on a gentleman, which complicated a portrait sitting and was made more problematic if the subject was female. Demah's challenges with securing commissions, engaging with patrons, and developing a reputation clarify the difficulties an enslaved person—and by extension, a female artist—had negotiating such a career. Van Horn grounds Demah's situation in contemporary debates on visuality and the power of the gaze.

Ross Barrett employs an economic lens in his analysis of two portraits of George Washington, both referencing Pierre Charles L'Enfant's plan of the proposed capital city on the Potomac River. He argues that these formal, dignified images of Washington buttressed liberal economic ideals and "the speculative ethos of market capitalism." The controversial new federal city plan worried fiscal conservatives, who considered speculation, based on unsubstantiated forms of value, a risky gamble on the future. Barrett relates the former president's

*Caucus Curs in Full Yell, or a War Whoop to Saddle on the People, a Pappoose President* by James Akin (detail), 1824, see page 87

deep involvement in L'Enfant's plan and the promotional campaigns surrounding it. George Washington's reputation as deliberate and rational lent credence to the viability of the project and the security of speculative enterprise in the newly forming economy of the young republic. While the financial ramifications of market forces, patronage, advertising, and itinerancy influence artistic production, Barrett's essay suggests that broader economic trends may also be implicit in portrait images.

Several of these studies touch on political agendas and depictions of public figures. Allison M. Stagg, for example, focuses on satire against political notables in her essay "Caricature Portraits and Early American Identity." Reviewing caricature prints from the late eighteenth and early nineteenth centuries, some of which are known today only through newspaper descriptions, she illuminates

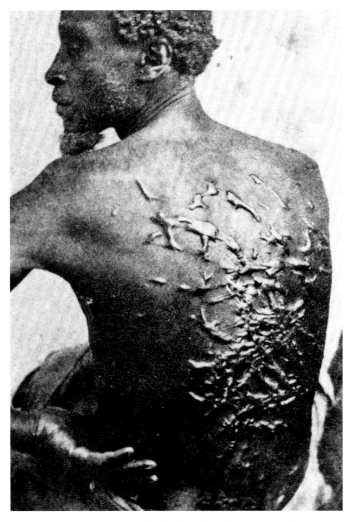

*Gordon* by the Mathew Brady Studio (detail), 1863, see page 99

the impact these satiric images had on prominent figures and their public. Stagg also probes a crucial aspect of portraiture: how an image is disseminated and encountered by viewers. Citing letters from the subjects themselves, she uncovers evidence for caricature displays on barbershop and post office walls, on fences, and in print shop windows.

Dissemination of the image and its consequent effect emerges as a theme in several of these essays. Kate Clarke Lemay, in "Reconstruction Reconsidered: The Gordon Collection of the National Portrait Gallery," traces the photograph of a former slave's scarred back, horrific evidence of whipping and maltreatment, as it seeps into

public consciousness through inexpensive cartes de visite and promotion by abolitionists. Greatly influential at the time, the highly charged image has also been appropriated by contemporary artists, as Lemay relates, serving modern generations as a symbol of the collective trauma of slavery in today's culture. Erin Pauwels, in her essay "'Let Me Take Your Head': Photographic Portraiture and the Gilded Age Celebrity Image," discusses the dissemination of portrait imagery in a later generation and its intersection with fame. Pauwels examines how such objects as Napoleon Sarony's photograph of Mark Twain, replicated in cartes de visite, cabinet cards, illustrations, and advertisements, ultimately became a struggle for the control of likeness in the celebrity culture of the Gilded Age.

Christopher Allison in "Cloud of Witnesses: Painting History through Combinative Portraiture" looks at the religious underpinnings of assembling diverse individuals into single pictures for the purpose of historical commemoration. He takes the concept of "witnesses to history" back to Hebraic and Christian biblical sources and onward through debates about history painting and portraiture in the eighteenth century. Theodosia and Charles Chaucer Goss produced their ambitious "combination picture," a print entitled *The Founders and Pioneers of Methodism*, in 1873, drawing upon new technologies and a dogged religious fervor. Allison describes how Charles Goss solicited likenesses from descendants and how Theodosia photographed those various portrait forms, made solar enlargements (or reductions) of each, and then enhanced them with India ink and reformatted them into similar poses. Theodosia Goss's technique and this laborious project of combining 255 heads into a single print suggests an unexpected market for both reconstituted portraiture and images of religious leaders serving the role of historical remembrance.

In a pre-photographic age, Joshua Reynolds had suggested that painters focus on the "general idea" in portraiture, downplaying the specificity of costume and

peripheral features. The advent of the daguerreotype, however, offered a level of minute detail that appeared to commentators of the 1840s to reveal the truth and the very "soul" of the sitter. Akela Reason, in "Soul-Searching: The Portrait in Gilded Age America," examines how discourse concerning the soul developed a few decades later, after new psychological and sociological probing into the nature of personal identity. As she relates, portraying the soul, a desired goal for artists in that era, typically meant focusing on those unique inner traits of the individual distinctive from all others. Reason's study traces the prevalence of this interiority from fine art to popular media but also its evidence in literature, biographies, memoirs, and journalism.

Humor can be a powerful tool in the hands of a portraitist. It is a cultural product, however, often quickly eclipsed by shifting moods or new forms, making its subtleties difficult to parse for later generations. ShiPu Wang, in his study "Playing Against Type: Frank Matsura's Photographic Performances," recovers the techniques that enabled this innovative Japanese American photographer to create a respected role for himself in his frontier town while producing seemingly transgressive photos that blurred conventional boundaries. Early twentieth-century images depicting cross-dressing, same-sex couples, the defiance of gender decorum, and the intimate pairing of Native Americans with homesteaders and immigrants, including himself, appear remarkable for their time and place. But, Wang explains, it was Matsura's use of a mode of light-hearted playfulness that facilitated a great deal of freedom to break social, ethnic, sexual, and gender barriers. Matsura's diverse community accepted his playfulness as harmless entertainment and the mark of an endearing, fun personality.

Play, of course, also references the performativity of all portraiture by the subject or the artist or both, and is a theme explored by many of the essayists in this collection. Matsura encouraged his sitters to experiment with pose, costume, and setting; no doubt this agency established

*Portrait of Mauvolyene Carpenter* by Woodard's Studio (detail), ca. 1930, see page 220

trust and comradery. Pauwels discusses Napoleon Sarony's dramatic crafting of his portrait images as a basis for copyright and a groundbreaking Supreme Court victory in the definition of photography as art. Amy Mooney, in "Photos of Style and Dignity: Woodard's Studios and the Delivery of Black Modern Subjectivity," explains how the studios of the Woodard photographic empire shaped black subjectivity in Chicago, Cleveland, Kansas City, and New York City through tastefully constructed images meant to elevate their African American subjects to a desired level of class and dignity.

*Poster Portrait: Duncan*
by Charles Demuth, 1925,
see page 232

Performance and all types of game playing infuse the work of Marcel Duchamp. Throughout his career, he delighted in word play, theatrical role-playing, humorous defiance of convention, and unbalancing expectations. As Anne Collins Goodyear analyzes in "Call It a Little Game Between 'I' and 'Me': Mar/Cel Duchamp in the Wilson-Lincoln System," Duchamp, just as transgressive as Matsura, "plays" with perspective in a subversive way. His fascination with what he called the "Wilson-Lincoln" system, in which two or more likenesses are visible from different angles within a single structure, was based upon folded and pleated lithographic images of the nineteenth century as well as modern lenticular models. Goodyear explores how Duchamp applied perspectival games throughout his career, toggling between persona, genders, or dimensions, to represent the shifting, multivalent nature of personal identity.

Nikki A. Greene investigates performance art as a form of portraiture, a natural extension of this element of theatrical presentation. In "*Habla LAMADRE*: María Magdalena Campos-Pons, Carrie Mae Weems, and Black Feminist Performance," Greene focuses on a work by Campos-Pons at the Guggenheim in 2014 in honor of Carrie Mae Weems, the first woman of African descent to have a solo exhibition at the museum. Costume played a critical role in the event, with Campos-Pons dressed in a tiered white dress echoing the famous spiral of the museum's Frank Lloyd Wright building. Campos-Pons also accessed the religious traditions of her roots in her performance, invoking a Yoruba-based goddess she encountered in Afro-Cuban culture. Greene explores how Campos-Pons used her own body as a site of the African diaspora, a black, feminist intervention, invading, and in dissonance with, the museum's white space. Along with a number of other authors in this collection, she provides a fresh perspective on issues of race, ethnicity, and gender in the study of portraiture.

Adventurous artists of the early twentieth century, as Jonathan Frederick Walz relates, mounted a deliberate challenge to portraiture's dependence on representation.

In "Side Eye: Early-Twentieth-Century American Portraiture on the Periphery," Walz first identifies the long history of portraiture as encompassing indexical evidence, commemoration, biography, and politics. Those traditional functions remained, Walz asserts, even while modernist artists—along with composers, writers, and filmmakers—eschewed directly observed likenesses. By evoking identity through such visual equivalents as shapes, mathematical equations, military or theatrical symbols, and accessory objects related to the sitter, these "peripheral" portraits synthesized elements of identity, obviating, in his view, deeply ingrained distinctions of race, class, gender, and sexual orientation.

In his study "Making Sense of Our Selfie Nation," Richard H. Saunders draws upon the history of self-portraiture to heighten our understanding of this contemporary digital phenomenon. While the selfie relates to long-standing traditions of recording and witnessing events, idealizing the body, placing the self in community, and observing change over time, it can also be more crafted than ever, more manipulated, artificial, and extreme than traditional posing. As he explicates the interconnectivity of this global social media self-presentation, Saunders includes the cautionary reminder of the temporal nature of today's forms, which constantly adapt to new technologies and platforms, morphing into fresh expression.

An element of unpredictability can enliven portraiture in every era. For his portrait of Willem de Kooning, entitled *De Kooning Breaks Through*, Red Grooms used some of the same tools as Alice Neel to entertain, surprise, and defy convention (see p. 22). His 1987 image is an eight-inch-deep, three-dimensional color lithograph depicting the renowned painter on a bike, the front wheel of which tears through his "painted" picture *Woman and Bicycle*. Captured on the handlebars is a ferocious female, one of an infamous series of nudes that de Kooning painted in the 1950s. An acknowledged master of Abstract Expressionism, de Kooning outraged purists with his return to figuration. Furthermore, his frightening females seemed to exist somewhere between the popular art of pin-up girls and advertising and the fine art conflation of abstraction and figuration. The punning title refers to de Kooning breaking through artistic conventions, as well as to the actual penetration of the sheet of paper and the explosive

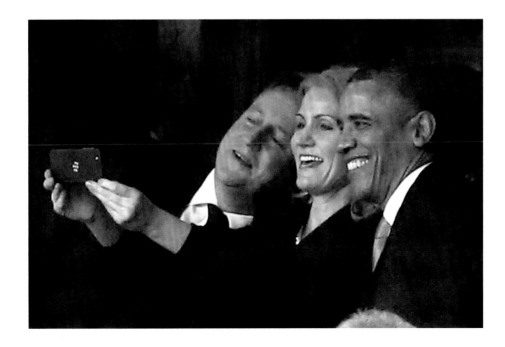

President Barack Obama, Danish Prime Minister Helle Thorning-Schmidt, and British Prime Minister David Cameron at Nelson Mandela's memorial service, December 10, 2013, see page 269

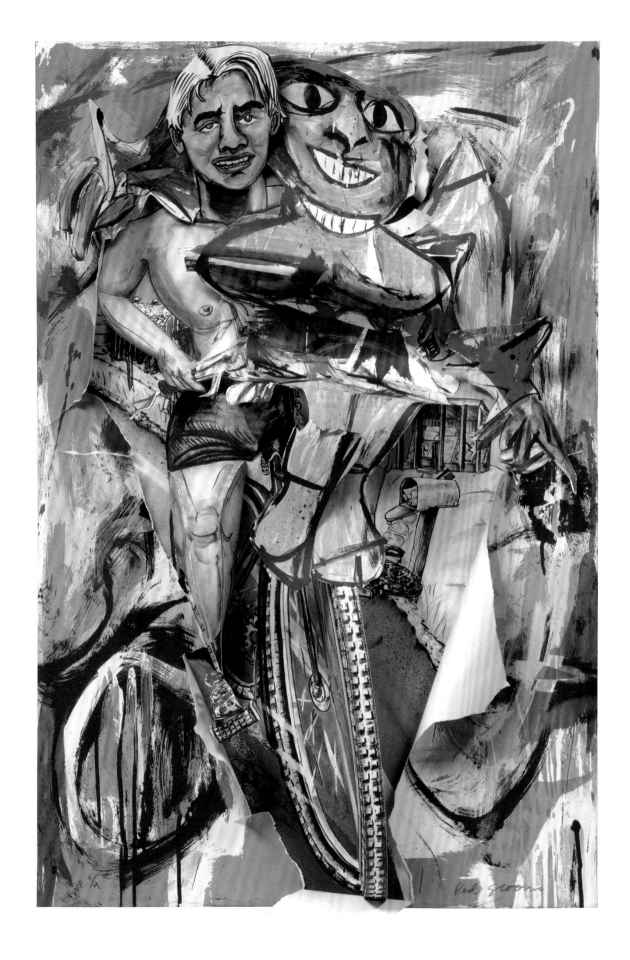

movement from two dimensions into three. Sexual, comic, aesthetic, and biographical implications abound. Grooms had been transgressing boundaries himself throughout his career with a zany, unorthodox take on representation. Mixing high art and low, humor and implied violence, he suggests the caricatural distortion of comic books and the implied energy and aggressive destruction of animated cartooning.

The concept of breaking through can also be applied to the study of portraiture in the sense of penetrating the outward surface of a recognizable likeness. As these essays illustrate, portrait artists over the centuries, while sharing the impulse to evoke the individual and assert identity within a cultural moment, have deployed a variety of aesthetic references and choices, definitions of truth, political and social motivations, religious and economic implications, conceptual tools, and modes of disseminating their imagery. While not all portraiture was, or is, revolutionary or experimental, the portrayal of the individual demands a consideration of the nature of selfhood. Artists have acquired new strategies over time to address changing notions of identity, particularly with regard to its multiplicity and inconstancy. Furthermore, the subjects of their portraits have their own agency, artifice, and needs, and the viewer's role might influence meaning as pictures are exposed to physical change and reinterpretation. Objects, in Margaretta Lovell's words, can be "both self-evident and deeply coded," and portraiture, arguably more than other visual art forms, reflects that truth.[3] Understanding portraiture requires extended, concentrated looking as well as flexible thinking, and these studies equip us with innovative approaches to see *beyond the face*.

*De Kooning Breaks Through* by Red Grooms, 1987
Color lithograph and sculpted paper, plexiglass case
119.4 × 83.8 × 22.2 cm (47 × 33 × 8¾ in.)
National Portrait Gallery, Smithsonian Institution; this acquisition was made possible by a generous contribution from the James Smithson Society

Notes

National Portrait Gallery Director Kim Sajet first conceived of this book of essays and made it possible. I am most grateful to her, to Chief Curator Brandon Brame Fortune, and to all our essayists who set aside other projects to contribute their insightful studies on portraiture.

National Portrait Gallery curators and Laura Manaker advised and assisted in various ways. I also wish to thank Rhys Conlon, the museum's head of publications, along with Dan Giles, Pat Barylski, and Sarah McLaughlin of Giles Ltd. The elegant design was conceived by Caroline and Roger Hillier, The Old Chapel Graphic Design.

I am especially indebted to our generous donors for both their support and their faith in this project, including Sally Chubb, Lynn and Bishop Sheehan, Gay and Tony Barclay, Alan and Lois Fern, Daniel Okrent, Cathy and Michael Podell, Mary Challinor, Eleanor Adams, and Jeannine Smith Clark.

1   Siri Engberg, "The Paper Mirror: Chuck Close's Self-Reflection in Drawings and Prints," in *Chuck Close: Self-Portraits, 1967–2005*, by Siri Engberg, Madeleine Grynsztejn, and Douglas R. Nickel (San Francisco: San Francisco Museum of Modern Art; Minneapolis, MN: Walker Art Center, 2005), 137.

2   Marcia Pointon, *Portrayal and the Search for Identity* (London: Reaktion Books, 2013), 45.

3   Margaretta M. Lovell, *Art in a Season of Revolution: Painters, Artisans, and Patrons in Early America* (Philadelphia: University of Pennsylvania Press, 2005), viii.

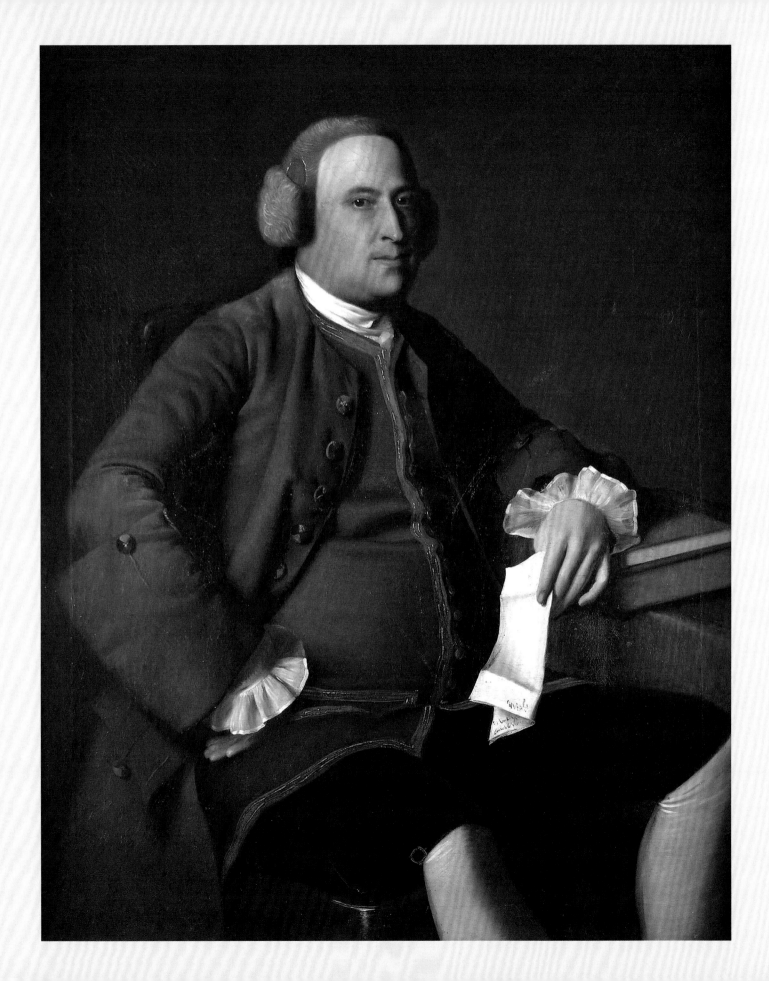

# BODY POLITICS

## COPLEY'S PORTRAITS AS POLITICAL EFFIGIES DURING THE AMERICAN REVOLUTION

Lauren Lessing
Nina Roth-Wells
Terri Sabatos

On a dry, sweltering day in late August 1774, a crowd of more than a thousand dust-covered men converged outside the Rutland, Massachusetts, home of Colonel John Murray, a prosperous merchant and former army officer and government official. Carrying sticks, farm implements, or whatever weapons they possessed, these angry intruders were undoubtedly an intimidating sight. In anticipation of their arrival, Murray had fled to Boston two days earlier.

The fifty-four-year-old loyalist had served as an elected representative to the Massachusetts Assembly for more than a decade, but his popularity had recently plummeted after the military governor Thomas Gage appointed him to the thirty-six-man "mandamus council," which replaced that democratic body. Now, a crowd of outraged Whigs gathered at his door to demand that he publicly resign.

Upon learning of Murray's absence, the men forced their way into the house, terrifying his family and wreaking havoc. Before leaving the front parlor, someone—probably a local Whig leader named Willard Moore—thrust a bayonet through John Singleton Copley's portrait of Murray, piercing the portion of the canvas that featured the colonel's head (fig.1.1). A few days later, a letter written by Moore appeared in Boston newspapers, buttressing the threatening defacement of Murray's portrait with equally ominous words. Declaring the colonel "an enemy to this Province," Moore warned that unless he stepped down from his council seat immediately, the "People of this Country" would soon pay him another visit.[1]

Murray had commissioned Copley to paint his portrait and that of his wife after his retirement from military service, at the outset of his political career. The portrait of Murray presents a prosperous gentleman in civilian attire seated at a writing desk, while that of Lucretia Chandler Murray shows an elegantly dressed lady posed before a large, decorative urn.

Copley's preeminence as a portrait painter in colonial Massachusetts rested on his skillful rendering of realistic likenesses and on his ability to surround his subjects with the seemingly tangible trappings of material wealth. Overflowing with rich fabrics and other expensive commodities, his portraits of the Murrays and other

**Fig. 1.1**
*Colonel John Murray* by John Singleton Copley, ca. 1763
Oil on canvas, 124.5 × 99.1 cm (49 × 39 in.)
New Brunswick Museum–Musée du Nouveau-Brunswick;
Sir J. Douglas Hazen Bequest

prosperous colonists both conveyed and contributed to their elevated social status. Recently, art historian Jennifer Roberts has drawn a link between Copley's deftly painted illusions and the materiality of his paintings themselves, revealing how they, like the luxury goods they depict, could become cargo moving precariously around the eighteenth-century Atlantic world.[2]

Most of Copley's American patrons were merchants or officials involved in trade. As such, they must have been keenly aware that painted portraits were not only physical objects but also commercial goods that could be bought, sold, transported, and exchanged. Additionally, as the case of John Murray shows, these men and women were actors on a political stage. In this charged moment, the vulnerable physicality of Copley's paintings was reinforced through public and transformative acts of iconoclasm.

During the years leading up to and encompassing the Revolutionary War (1775–83), both American colonists and British soldiers attacked portraits of their opponents, leaving in their wake painted bodies that were slashed, punctured, and publicly dishonored. Although scholars have considered several of these incidents in isolation, none have explored eighteenth-century portrait mutilation as a sustained cultural practice or a widespread form of political speech. To be properly understood, such damaged canvases must first be discovered, then analyzed using conservation science, and the symbolic performances of bodily harm examined within the context of the intertwined theatrical, material, and visual cultures of political violence that pervaded the Revolutionary era. Though they were hardly alone in being targeted, paintings by Copley are ideal subjects for such consideration. Because prominent colonists on both sides of the political divide commissioned portraits by him, studying intentional damage to these objects allows us to compare and contrast British and Revolutionary approaches to portrait iconoclasm.

When Copley left the American colonies for good in June 1774, he knew that patriots had attacked several of his paintings of prominent loyalists, including his well-known three-quarter-length portrait (now lost) of Massachusetts Governor Francis Bernard. As historian and Copley biographer Jane Kamensky has noted, the Bernard portrait, one of three portraits that he had executed for the newly rebuilt Harvard Hall in 1766, was the most important commission of Copley's early career. The artist was likely distraught when it was vandalized in October 1768 to protest Bernard's support of the British occupation of Boston. The portrait's unknown attackers entered the hall in the dark of night and carefully cut a heart-shaped piece of canvas from the portion of the painting depicting Bernard's torso. The Whig newspaper *Journal of the Times*, one of several sources to report on the event, explained, "From Cambridge we learn, that last evening, the picture of—, hanging in the college-hall, had a piece cut out of the breast exactly describing a heart, and a note,—that it was a most charitable attempt to deprive him of that part, which a retrospect upon his administration must have rendered exquisitely painful."

The President and Fellows of Harvard College responded by paying Copley to repair the painting and then having it reframed and moved to a more secure location. The *Journal of the Times* again took critical note: "Our American limner, Mr. Copley, by the surprising art of his pencil, has actually restored *as good a heart* as had been taken from it, tho' upon a near and accurate inspection, it will be found to be no other than a *false one*."[3] This reference to Bernard's supposed false dealing with the people of Boston suggests that Copley's repairs did not undo the reputational damage the iconoclasts had inflicted.

The painting of Bernard was not the first work by Copley to be mutilated for political reasons. In September 1765, the artist wrote to inform his friend Captain R. G. Bruce that he was sending a portrait of his younger half brother, Henry Pelham, to Bruce's care in London, where it was to be exhibited at the Royal Academy. Explaining that he was sending the portrait—now known as *A Boy with*

a *Flying Squirrel* (1765, Museum of Fine Arts, Boston)—earlier than originally planned, Copley expressed concern not only for its safe passage across the Atlantic Ocean, but also—more obliquely—for the safety of his portraits remaining in Boston. Two weeks earlier, he informed Bruce, enraged citizens protesting the soon-to-be imposed Stamp Act had stormed through the town, executing customs officials in effigy and damaging their houses and property. "Capt. Jacobson is just arrived with the stamps which has caused so much noise and confusion among us Americans," wrote Copley, ". . . in Boston we demolished the Lieut. Gouverner's house, the Stamp Office, Mr. Story's, and greatly damaged Capt. Hallowell's and the secretary's house, since which there is a strong military watch kept every night which keeps the town in quietness."[4] Although he claimed to be shipping *A Boy with a Flying Squirrel* early in order to ensure sufficient time for it to be vetted before the exhibition, an equally pressing motive was likely Copley's desire to get this work, of which he was particularly proud, safely out of the colonies as soon as possible. As the artist was no doubt aware, his portrait of Benjamin Hallowell Jr. had been badly damaged during one of the incidents he listed in his letter to Bruce.

Copley probably painted Hallowell's portrait in 1764, when Hallowell accepted the post of comptroller of customs (fig. 1.2). In this office, he was responsible for recording and appraising the cargo of all ships entering and leaving the port of Boston in order to levy taxes on them. Revolution was in the air, and Hallowell—a High Tory official appointed by the Crown—was not a popular man. He was certainly powerful, though, and Copley conveyed this power masterfully. Though Hallowell is seated in the portrait, his downward gaze makes it seem as though he is above his audience. His surroundings are dark, but he is as brightly illuminated as a saint in a Baroque altarpiece. As in other portraits by Copley, painted props, including Hallowell's suit of fine gray wool, red velvet drapery, a pewter inkstand, and his tax ledger (which he holds in his lap like a phallus) signify

his wealth and status. Careful analysis of photographs taken before the painting was conserved reveals a pattern of punctures that seem to have been inflicted by a single, right-handed assailant who stabbed the painting multiple times in the subject's forehead, left eye, face, upper chest, left arm, and near his legs, working diagonally downward from the upper left to lower right corners of the canvas (fig. 1.3).[5] By piercing the portrait in this manner, the attacker may have sought to obliterate the painted signs of Hallowell's power—including the subject's seeming ability to return the gaze of viewers.

Eighteenth-century loyalist and British sources portray the Boston Stamp Act protestors as little more than an enraged, inebriated mob, bent on riot and destruction. For instance, the *Scots Magazine* described the men who vandalized Hallowell's Hanover Street mansion as "a great number of disguised ruffians, armed with clubs, staves, etc."

> Boisterous and intrepid . . . they rushed onward, increasing still in numbers and fury, to the new and elegantly finished building of Benjamin Hallowell, Jr. Esq., where, after tearing down the fences, breaking the windows, etc., they at length entered the house, and, in the most savage and destructive manner, broke and abused his furniture, chairs, tables, desk, glasses, china, and, in short, everything they could lay their hands on.[6]

Following pages:

**Fig. 1.2**
*Benjamin Hallowell Jr.* by John Singleton Copley, ca. 1764
Oil on canvas, 127 × 101.6 cm (50 × 40 in.)
Colby College Museum of Art; gift of the Vaughan Family of Maine, funding of painting's conservation by Louisa Vaughan Conrad

**Fig. 1.3**
*Benjamin Hallowell Jr.* (black-and-white photograph of the painting prior to conservation treatment in 1988), ca. 1764 (see fig. 1.2)

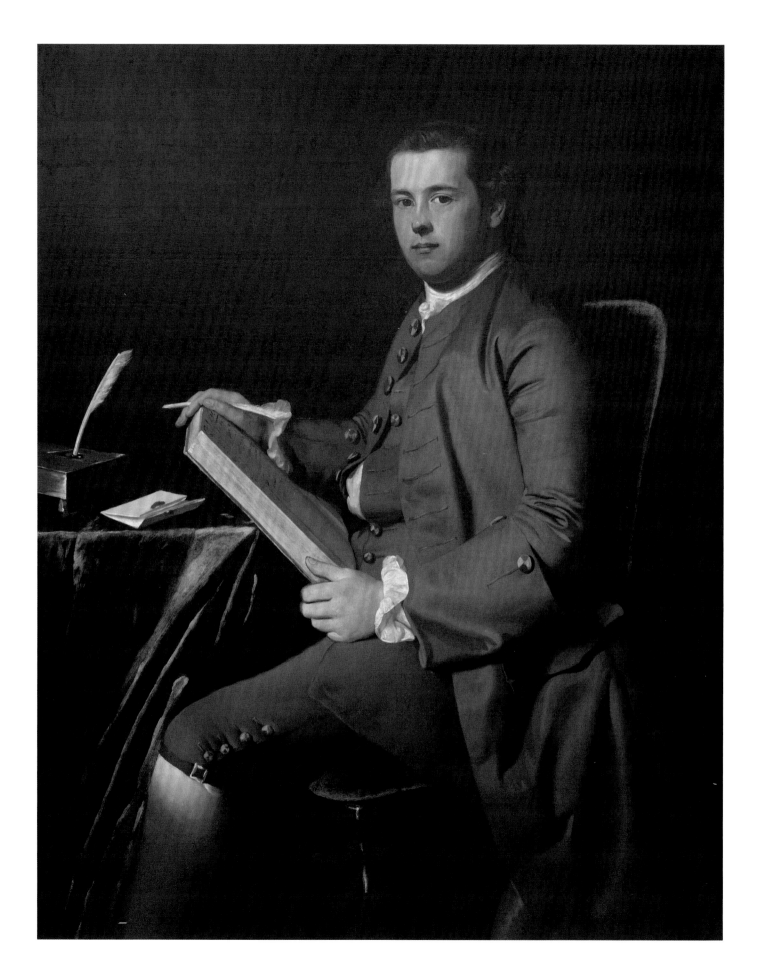

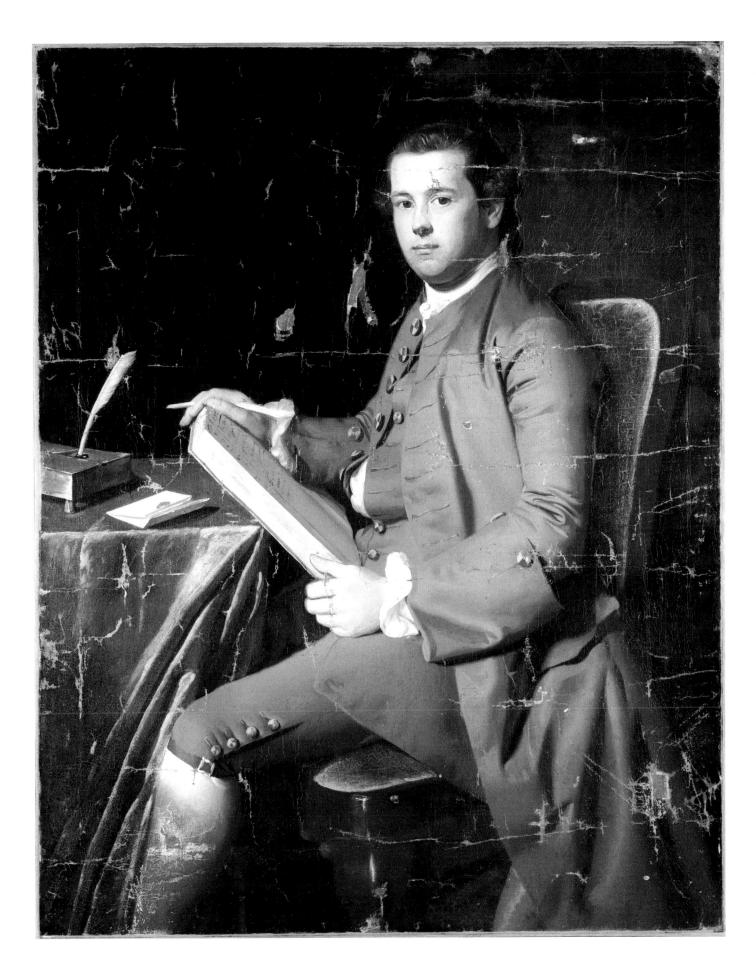

Kamensky has echoed this account, imagining that the working-class rioters, drunk and enraged by the evidence of Hallowell's ill-gotten wealth, "fell upon [Copley's] portrait, stabbing and slashing the painted figure, especially the face." Contrasting this seemingly extemporized act of mutilation with the almost surgical maiming of Governor Bernard's portrait, she surmises the latter was perpetrated by Harvard students who were motivated by a philosophical commitment to democracy and home rule rather than by liquor or envy.[7] Physical evidence, however, suggests that the maiming of Hallowell's portrait—though not as careful as the damage done to Bernard's—was nonetheless calculated and carried out by a single hand. Furthermore, both acts of portrait mutilation conform to a long tradition of highly theatrical political performance that dates back to the sixteenth-century Protestant Reformation in Europe. The well-established practice of punishing despised persons in effigy was a central element of that tradition, which was carried out by men and women of all classes.

Distinguishing iconoclasm from mere acts of vandalism in which destruction is an end in itself, historians Anne McClanan and Jeffrey Johnson have defined this practice as "a principled attack on specific objects aimed primarily at the objects' referents or their connection to the power they represent." Iconoclastic acts entail the intent not only to destroy objects, but also to attack their referents, who are physically beyond the iconoclasts' reach.[8] During the Protestant Reformation in Britain, effigies of the pope and other Catholic religious authorities were frequently destroyed in public demonstrations of faith, and these ritual performances of protest were translated and adapted to address the circumstances of colonial America. For instance, during the Stamp Act riots, protesters modified the well-known characters of a November Pope Day pageant, replacing the despised figure of the pope with a representation of Andrew Oliver, lieutenant governor of Massachusetts Bay and administrator of the Stamp Act. Oliver's effigy was hung from an elm known as the Liberty

Tree, situated near Boston Common along the main road that stretched from Roxbury to Boston, taken down in the evening, beheaded in front of Oliver's house, and eventually burned in a bonfire. While the angry colonists probably did not believe Oliver himself would suffer the same injuries they meted out to his effigy, their actions allowed them to symbolically deliver the punishment they felt the real Oliver deserved.[9]

If a quickly fashioned dummy could represent a specific person, portraiture, with its emphasis on replicating the physiognomy of an individual, highlighting social standing, and demonstrating material wealth, created an even stronger connection to the referent. In her discussion of the use of images in early modern drama, Margaret Tassi has argued that portraits especially possess "an aura of real presence." Early modern dramas such as *Arden of Faversham* (anonymous author, 1580s) and *The Noble Spanish Souldier* by Samuel Rowley (1610) have plots that conflate a character's portrait with their physical body, so that damage inflicted on a portrait was believed to also harm its subject.[10] Confirming that the iconoclasm enacted in these dramas reflects actual social practices, Roy Strong has related several instances where portraits of Elizabeth I were stabbed, cut to pieces, and burnt in an attempt to harm not only the queen's reputation, but also her physical person.[11] More recently, historian David Cressy has traced the ritual defacement of painted portraits forward to the mid-seventeenth century in England, relating numerous incidents in which portraits of James I, Charles I, and prominent Puritans like William Prynne were stabbed, burnt, or otherwise mutilated for political ends. Such performances of symbolic violence, Cressy contends, constituted a valid form of political language in a world where "everyone knew that loyalties and animosities could be articulated through spectacle and action as well as through speech or text."[12] The practice of damaging painted portraits for iconoclastic purposes spread to British North America and continued for the next century. In fact, by the late eighteenth century, the

word "effigy" could denote either a crude dummy figure or a professionally sculpted or painted portrait.[13] American colonists attacked both kinds of effigies, often in tandem, during public protests. For instance, the same rowdy mob of Whigs who hung, beheaded, and burned the dummy representing Oliver during the Stamp Act protests also attacked oil portraits of Hallowell and of the lieutenant governor of Massachusetts, Thomas Hutchinson, along with portraits of Hutchinson's relatives.[14]

Damage to effigies of all sorts resonated with Revolutionary War–era political prints, in which images of wounded and dismembered bodies frequently served as metaphorical references to the fragmentation of the body politic and the ill health of the nation. For instance, Benjamin Franklin's well-known engraving *The Colonies Reduc'd*, published in 1767 in response to the Stamp Act, depicts Britannia as a brutalized woman whose severed appendages, representing the rebellious North American colonies, lie strewn about her head and torso.[15] Such symbolic representations of violence were produced and consumed in a culture where the whipping, pillorying, and hanging of criminals, and the beating, tarring, and feathering of political opponents, were common forms of public entertainment. Throughout the eighteenth century, harm inflicted publicly upon bodies—whether real or represented—heaped "damage, scandal, infamy, contempt, ridicule, and disgrace" (in the recorded words of one colonial American libel case) upon their owners, stripping them of both honor and dignity.[16]

While American patriots attacked images of their loyalist foes, government officials, and, eventually, King George III and Queen Charlotte themselves, loyalists and British soldiers damaged portraits of prominent patriots and others whom they perceived to be in rebellion against the crown.[17] To cite one of many examples, on September 9, 1781, a group of loyalists entered the State House in Philadelphia and slashed Charles Willson Peale's 1779 portrait of George Washington at the Battle of Princeton

(Yale University Art Gallery), prompting a local patriot newspaper to decry the act:

> It is a matter of grief and sorrowful reflection that any of the human race can be so abandoned, as to offer such an insult to men who are and have been an honor to human nature, who venture and have ventured their lives for the liberties of their fellow-men. A being who carries such malice in his breast must be miserable beyond conception. We need wish him no other punishment than his own feelings.[18]

Of this incident, art historian Paul Staiti has recently written, "The slashing of Washington's portrait tells us that works of art carried extra weight in a time of Revolution . . . A symbolic death even had some advantages over the real thing in that it was possible not only to destroy Washington's image, but also to insult the values present in that image."[19] The fact that Peale's portrait depicts a national leader surrounded by patriotic symbols representing heroic sacrifice, victory, and independence made it a logical target for loyalist iconoclasts, yet portraits of far less illustrious patriots, including several by Copley that were abandoned by families fleeing the siege of Boston in April 1775, suffered similar fates.

In 1957, as he cleaned Copley's portrait of the Reverend Samuel Cooper, conservator Alfred Jakstas discovered very old fabric patches on the back of the unlined canvas that alerted him to the fact that the painting had suffered harm fairly early in its existence (figs. 1.4 and 1.5). As he worked, he was probably surprised by the full extent of the damage exposed by his cleaning. In his notes and photographs, Jakstas carefully recorded three large, square holes in the subject's face, breast, and right arm, and half a dozen complex tears in the canvas, many spreading across the subject's head and body. The square holes were likely the result of punctures that were trimmed in order

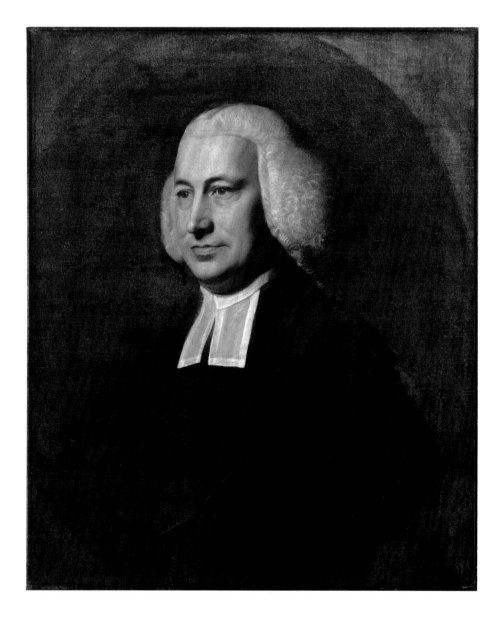

**Fig. 1.4**
*Portrait of Rev. Samuel Cooper
(1725–1783), Pastor of Brattle
Square Church, Boston* by John
Singleton Copley, ca. 1769–71
Oil on canvas
76.5 × 63.5 cm (30⅛ × 25 in.)
Williams College Museum of Art;
bequest of Charles M. Davenport,
class of 1901

**Fig. 1.5**
*Portrait of Rev. Samuel Cooper
(1725–1783), Pastor of Brattle
Square Church, Boston* (black-
and-white photograph of the
painting during conservation
treatment in 1957), ca. 1769–71
(see fig. 1.4)

to facilitate patching. Based on the shape and pattern of the tears, they too likely resulted from thrusts through the canvas that were forceful enough to cause rips to radiate from the points of impact.[20] The pattern that emerges once again indicates a single, right-handed assailant working downward from the upper left corner to the lower right corner of the canvas.

The events that Cooper recorded in his diary during 1775 and 1776 offer a likely explanation of his portrait's defacement. He was the pastor of the fashionable Brattle Street Church in Boston, where some of the city's wealthiest denizens worshipped. These included Copley's loyalist father-in-law Richard Clarke and Son of Liberty Samuel Adams. Cooper—a moderate Whig—preached what his biographer has described as a "soothing gospel of reassurance" that pleased both sides, so he was surprised to find himself denounced by the Crown for "prostituting his religion" and fomenting revolution in March 1775. He was staying with friends in the country at the time. Fearing for his life if he returned to occupied Boston, he wrote

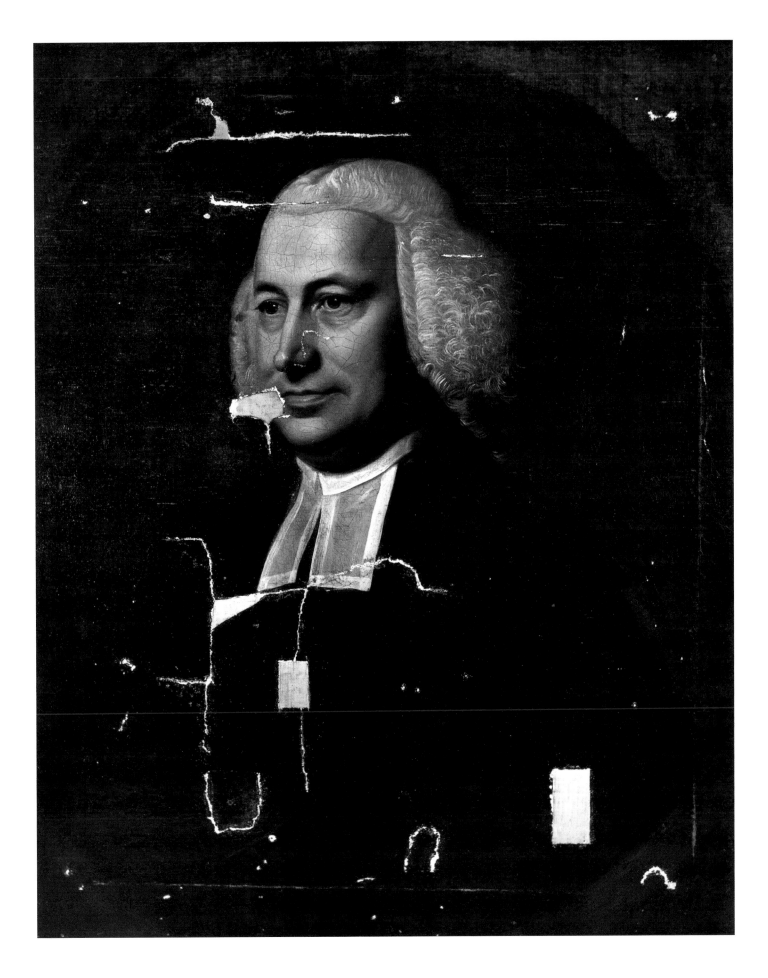

dejectedly that he must abandon "all my plate, books, furniture, and so forth." After the siege ended the following year, the Cooper family returned home to find Boston a "melancholy scene. Many houses pulled down by the British soldiery, the shops all shut. Marks of rapine and plunder everywhere." Indeed, the Brattle Street Church had been used as a barracks for British soldiers and Cooper found it in "a filthy and defaced condition." The parsonage, he noted dolefully, was equally wrecked and "robb'd of a great part of my furniture."[21] It was almost certainly one of the British officers billeted in the parsonage or one of the soldiers under their command that stabbed Cooper's portrait through the face, chest, and arm.

Like Cooper, the two pastors of the Old South Church fled Boston with their families shortly before the siege began, leaving their possessions behind. According to descendants of the junior pastor, John Bacon, a British officer stabbed Copley's portrait of his wife, Elizabeth Goldthwaite Bacon, with a bayonet. Physical evidence bears this out. There are two repaired, jagged holes above the subject's head (one of which grazes her scalp), another slicing her neck between her chin and pearl choker, and a fourth puncture through the left side of her torso (figs. 1.6 and 1.7).[22] The painting hung in the newer of the two parsonages owned by the church—a three-story frame house across Milk Street from the Bowdoin Mansion, where British General John Burgoyne resided during the siege; it housed officers serving directly under the general. One of these officers probably damaged the portrait. Ironically, Elizabeth Goldthwaite Bacon was the daughter of one of Boston's most prominent loyalists, Ezekiel Goldthwaite, and her husband had lost his pulpit just weeks prior to the siege for his suspected affinities with British authorities—charges that had dogged him since his marriage in 1771.

It was uncommon for American colonists to intentionally damage portraits of women. The Stamp Act rioters, for instance, left Copley's portrait of Benjamin Hallowell's wife untouched even as they ransacked the other possessions in his house.[23] It is possible that chivalry stayed their hands, or these iconoclasts may simply have viewed women (who were not political actors on a public stage in the same ways that their husbands, brothers, and sons were) as beneath their notice. In any case, the British forces occupying Boston did not share the colonists' qualms about damaging portraits of ladies. It is worth considering some of the possible reasons for this different outlook, which made the stabbing of Mrs. Bacon's portrait possible. One explanation lies in the British attitude toward Congregational churches and clergy. Because Congregationalism originated in a rebellion against the Church of England, and because (unlike their Anglican sisters) Congregational churches were independent of the state, British military authorities viewed them as symbols of the American rebellion. Furthermore, the language used to condemn Congregationalist ministers—that they were "prostituting" Christianity in the service of revolution—feminized, de-classed, and desacralized them by conflating them with low, un-virtuous women. The British officers occupying Boston made this rhetoric manifest by converting Congregational churches into places frequented by actual prostitutes.[24] Burgoyne, for instance, converted the Old South Church into a riding school for a regiment of dragoons, ordering laborers to strip the church's interior, burn its books and woodwork, convert its pews into pig sties, dump hundreds of loads of dirt and gravel on its floor, and replace its south entrance with a bar over which horses could leap. Only the east galleries were left in place—the top one providing seating for "those who came to witness feats of horsemanship" and the bottom one serving a tavern.[25] This transformation of the sacred into the profane may well have extended to the church's rectory,

Fig. 1.6
*Mrs. Alexander Cumming, née Elizabeth Goldthwaite, later Mrs. John Bacon* by John Singleton Copley, 1770
Oil on canvas, 75.7 × 62.7 cm (29$^{13}$/$_{16}$ × 24$^{11}$/$_{16}$ in.)
Brooklyn Museum; gift of Walter H. Crittenden

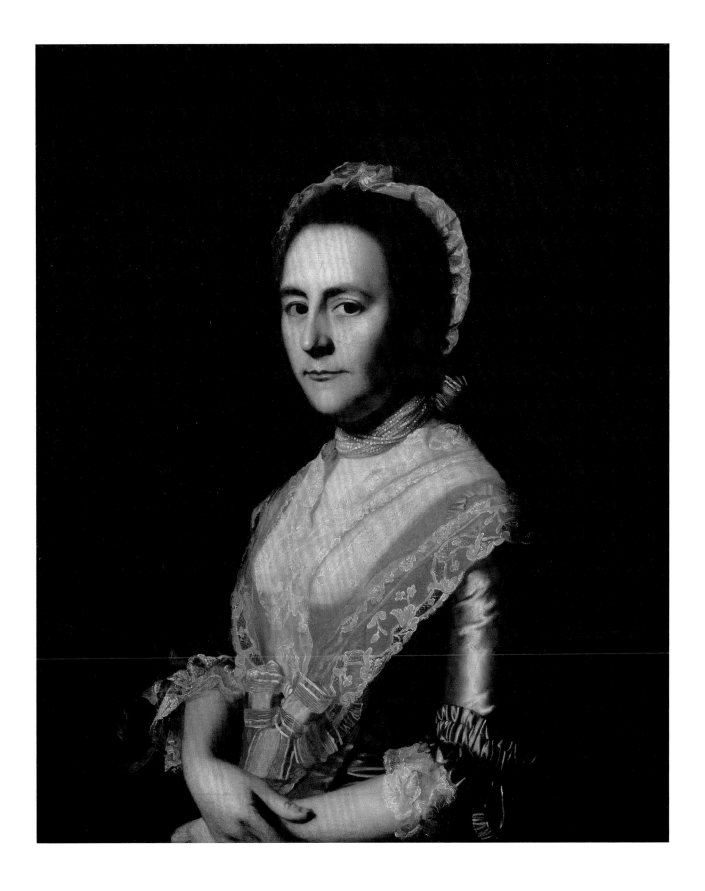

stripping Mrs. Bacon of her status as a Christian lady and leaving her painted body open to abuse.

Iconoclasm, according to medieval literature scholar James Simpson, is a form of historiography. By destroying images, iconoclasts create historical narratives in which the present moment is separated from all that has occurred before and defined as the beginning of a new era.[26] Such radical history making has obvious appeal during a political revolution. The purpose of Revolutionary-era portrait maiming was not, however, to entirely destroy or erase the subjects depicted. Instead, it was to appropriate their images and transform them through violent, disruptive acts that mirrored bodily harm. Like public beatings, executions, and duels, portrait damage was a performance related to eighteenth-century codes of masculine honor. The colonists who cut into the portraits of Benjamin Hallowell, Francis Bernard, and John Murray sought to shame those men before their compatriots and a broader, newspaper-reading public. The British officers who stabbed the portraits of Samuel Cooper and Elizabeth Goldthwaite Bacon were (like the dragoons who jumped their horses into the desecrated sanctuary of the Old South Church) publicly asserting their dominance over their defeated enemies by defiling their possessions.

The owners of Copley's damaged portraits carried on the process of history making through their subsequent actions, which determined whether these paintings continued to serve the narrative purposes of the iconoclasts or could be reclaimed. Benjamin Hallowell rolled up his defaced portrait and left it with his sister in Maine as he fled the colonies for Britain. He never retrieved it—a reaction that suggests this former source of pride had become for him an object of shame and trauma. John Murray, however, publicly reinterpreted the damage to his portrait as visible proof of his loyalty to Britain by proudly displaying it with the bayonet hole left visible—a practice that his descendants continued and that the New Brunswick Museum continues to this day. Elizabeth Goldthwaite Bacon's family did the

same, leaving the gashes in her portrait evident until the Brooklyn Museum concealed them in 1933.[27] Further fetishizing the damage, Bacon's descendants wrote poetry in honor of her bravery (as if she herself had faced the bayonets of the British officers occupying her home) and pasted these onto the back of the damaged canvas. Although the museum did not preserve the Bacon family's poems and their exact wording is unknown, this case was not unique. Swept up by the fascination with the American Revolution that preceded the centennial, Oliver Wendell Holmes wrote and published a poem honoring his ancestor Dorothy Quincy, whose portrait by an unknown colonial painter was similarly damaged during the siege of Boston:

Hold up the canvas full in view,—
Look! there's a rent the light shines through,
Dark with a century's fringe of dust,—
That was a Red-Coat's rapier-thrust!
Such is the tale the lady old,
Dorothy's daughter's daughter, told.[28]

By considering Copley's portraits as evolving entities whose "lives" following their creation are equally worthy of study, eighteenth-century portraiture can be understood as a process of negotiation and redefinition, with meanings that continually changed as they were moved, damaged, conserved, displayed, stored, reframed, and reinterpreted over time. Art museums have obscured these complex histories. Within the art historical narrative of the museum, a portrait is first and foremost a set of perceptions and ideas given form by an artist, and only secondarily an object. Copley himself was an admirer of the enlightenment ideals that gave rise to this outlook. In a 1767 letter to his mentor Benjamin West, he famously lamented that his fellow

Fig. 1.7
*Mrs. Alexander Cumming, née Elizabeth Goldthwaite, later Mrs. John Bacon* (X-ray showing tears), 1770 (see. fig. 1.6)

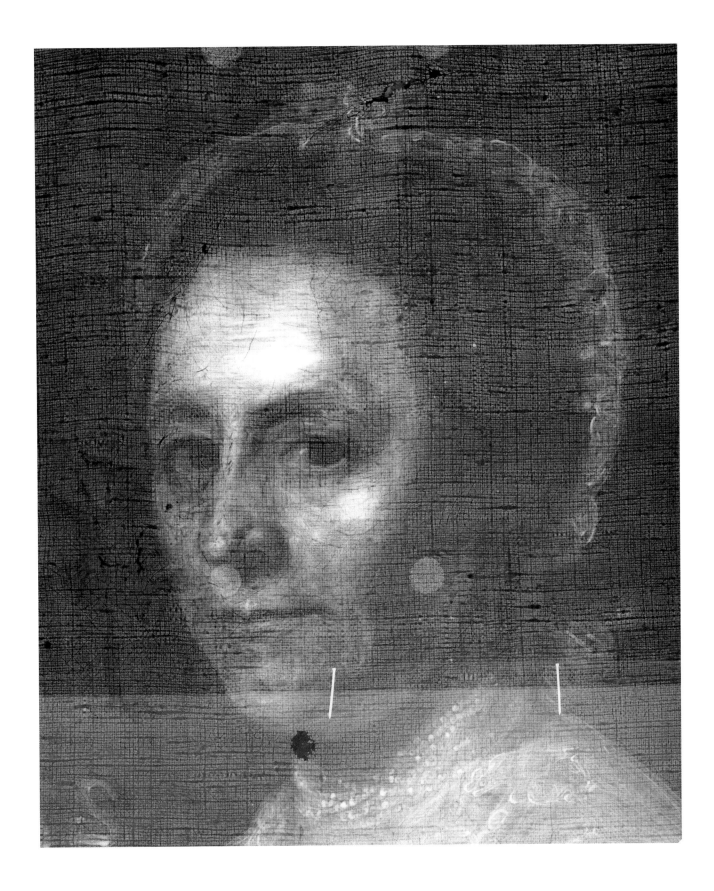

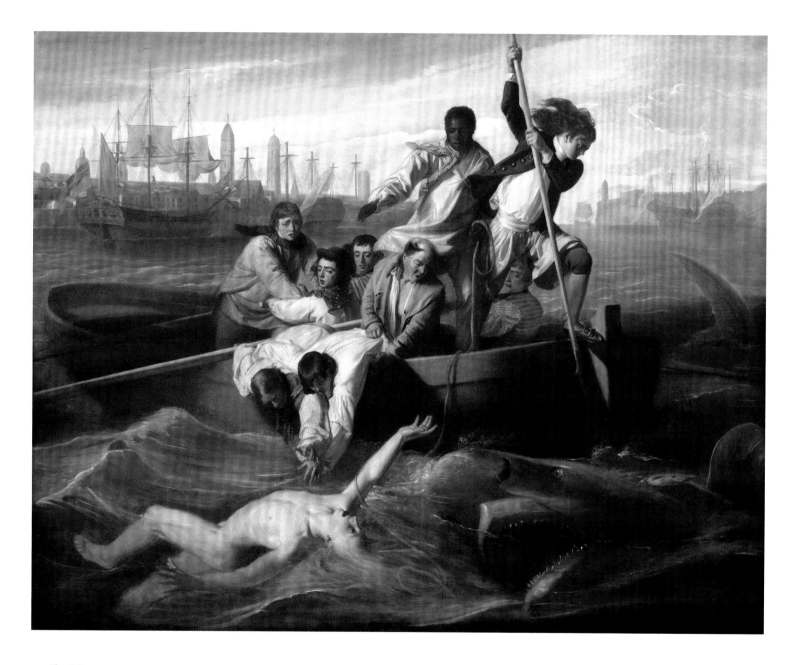

**Fig. 1.8**
*Watson and the Shark* by John Singleton Copley, 1778
Oil on canvas, 182.1 × 229.7 cm (71¹¹⁄₁₆ × 90⁷⁄₁₆ in.)
National Gallery of Art, Washington, DC; Ferdinand Lammot Belin Fund

Americans tended to view paintings as objects rather than art: "The people [in Boston] generally regard [painting] no more than any other usefull [*sic*] trade, as they sometimes term it, like that of a Carpenter tailor or shew maker, not as one of the most noble Arts in the World. Which is not a little Mortifying to me."[29]

Copley's feelings about the repeated maiming of his American portraits, of which he was surely aware, are not recorded. They are, however, suggested by a dramatic scene that he painted three years after reestablishing his career in London. Originally titled *A Young Man Attacked by a Shark*, Copley's 1778 narrative painting *Watson and the Shark* depicts his friend, the British merchant Brook Watson, as a nude fourteen-year-old boy swimming in Havana Harbor, just moments before a shark severed the lower portion of his right leg (fig. 1.8). Although it presents an actual event in Watson's young life, scholars have linked the sublime imagery of this painting to the ongoing brutality of the American Revolution and the violent iconography of contemporary political prints. In a recent publication, Jennifer Roberts considers the way Watson's pale, vulnerable body sinks elusively away from his rescuers' grasping hands, perceiving a veiled allusion to the tea that patriots had thrown into Boston Harbor five years earlier. In this way, she argues, the painting allegorically illustrates the danger of transporting goods of all sorts—including paintings—across the Atlantic Ocean.[30] Though the perils of the sea are certainly an important theme in *Watson and the Shark*, Copley also confronted other, equally dire threats to the longevity and integrity of his paintings in the scene. By so dramatically showing the impending dismemberment of the portrait subject's body, the artist subtly invited viewers to share his horror at the mutilation of other painted bodies—specifically those in some of his own early portraits—which were now beyond his reach in the treacherous political waters of the American colonies.

Notes

1 Jonas Reed, *A History of Rutland: Worcester County, Massachusetts, from Its Earliest Settlement* (Worcester, MA: Mirick & Bartlett, 1836), 61; Ray Raphael and Mary Raphael, *The Spirit of '74: How the American Revolution Began* (New York: The New Press, 2015), 84–86; George Chandler, *The Chandler Family: The Descendants of William and Annis Chandler who Settled in Roxbury, Massachusetts* (Worcester, MA: Charles Hamilton, 1883), 247–48.

2 Jennifer Roberts, "Copley's Cargo: *Boy with a Squirrel* and the Dilemma of Transit," *American Art* 21, no. 2 (Summer 2007): 21–41; Jennifer L. Roberts, *Transporting Visions: The Movement of Images in Early America* (Oakland: University of California Press, 2014), 163.

3 *Journal of the Times*, October 6, 1768, and March 14, 1769, quoted in Jane Kamensky, *A Revolution in Color: The World of John Singleton Copley* (New York: W. W. Norton, 2017), 144–45. We are grateful to Ethan Lasser, the Margaret S. Winthrop Associate Curator of American Art at the Harvard Art Museums, who graciously shared his research on this incident with us. See also Margaretta M. Lovell, *Art in a Season of Revolution: Painters, Artisans, and Patrons in Early America* (Philadelphia: University of Pennsylvania Press, 2005), 58.

4 J. S. Copley to Captain R. G. Bruce, Boston, September 10, 1765, in *Letters and Papers of John Singleton Copley and Henry Pelham, 1739–1776* (Boston: Massachusetts Historical Society, 1914), 35–36.

5 Wendy Watson was the first scholar to connect this damage, identified by conservators at the Williamstown Art Conservation Center in 1988, to the Stamp Act riots. See Watson, *Altered States: Conservation, Analysis, and Interpretation of Works of Art* (South Hadley, MA: Mount Holyoke Museum of Art, 1994), 56–59. Recently, paintings conservator Nina Roth-Wells has analyzed and reinterpreted the damage, attributing it to a single, right-handed assailant who repeatedly punctured the canvas with a sharp object.

6 "Affairs in North America," *Scots Magazine* 26 (October 1765): 549.

7 Kamensky, *A Revolution in Color*, 106.

8 A. McClanan and J. Johnson, eds., *Negating the Image: Case Studies in Iconoclasm* (Aldershot, UK: Ashgate, 2005), 3.

9 Susan Juster, "Iconoclasm without Icons: The Destruction of Sacred Objects in Colonial North America," in *Empire of Gods: Religious Encounters in the Early Modern Atlantic*, ed. Juster and Linder Gregerson (Philadelphia: University of Pennsylvania Press, 2011), 222–23; Robert Blair St. George, *Conversing by Signs* (Chapel Hill: University of North Carolina Press, 1998), 250–62. For a detailed discussion of the Stamp Act riots and the themes and symbolism borrowed from the Pope Day celebration, see Peter Messer, "Stamps and Popes: Rethinking the Role of Violence in the Coming of the American Revolution," in *Between Sovereignty and Anarchy: The Politics of Violence in the American Revolutionary Era*, ed. Patrick Griffith (Richmond: University of Virginia Press, 2015), 114–28.

10 Margaret Tassi, *A Scandal of Images* (Susquehanna University Press, 2005), particularly 140–41.

11 Roy Strong, *Portraits of QE I* (Oxford, 1963), 39; Tassi, *A Scandal of Images*, 141.

12 David Cressy, "Different Kinds of Speaking: Symbolic Violence and Secular Iconoclasm in Early Modern England," in *Protestant Identities: Religion, Society, and Self-Fashioning in Post-Reformation England*, ed. Muriel C. McClendon, Joseph P. Ward and Michael MacDonald (Stanford, CA: Stanford University Press, 1999), 19–42.

13 See the entry for "effigy" in Samuel Johnson, *A Dictionary of the English Language,* 11th edition. (Edinburgh: Tho. Brown, R. Ross, and J. Symington, 1797), n.p.

14 Letter from Lt. Governor Thomas Hutchinson to Richard Jackson, Boston, August 30, 1765, in Richard Jackson, *Prologue to Revolution: Sources and Documents on the Stamp Act Crisis, 1764–66* (Chapel Hill: University of North Carolina Press, 1959), 108. After the attack on his Boston residence, Hutchinson moved his family and surviving possessions to his country house in Milton, Massachusetts, where, after the publication of damning letters by Hutchinson in 1772, a Whig mob again attacked an oil portrait of him (the 1741 work by Edward Truman, now in the Massachusetts Historical Society collection). The Whig mob stabbed the painting repeatedly with a bayonet and tore out one eye—almost mirroring the earlier attack on Hallowell's other portrait. See Bernard Bailyn, *The Ordeal of Thomas Hutchinson* (Cambridge, MA: Harvard University Press, 1974), 4.

15 Franklin's design was based on two of his earlier prints: *Magna Britannia: Her Colonies Reduc'd*, 1749, and *The English Lion Dismember'd,* 1756; see http://founders.archives.gov/documents/Franklin/01-13-02-0023.

16 Eighteenth-century libel suit against three persons for "erecting a gallows and hanging from it an effigy" of "W. M., a good, peaceable, and well disposed subject of our lord the king..." cited in J. C. Perkins, Esq., *A Practical Treatise on Criminal Law with Comprehensive Notes*, vol. 3 (Springfield, MA: G. & C. Marriam, 1841), 908–9.

17 For information on the defacement of portraits depicting King George III and Queen Charlotte, see Brendan McConville, *The King's Three Faces: The Rise and Fall of Royal America* (Chapel Hill: University of North Carolina Press, 2006), 135–36.

18 *Bailey's Freeman's Journal* (Philadelphia), September 12, 1781.

19 Pauli Staiti, *Of Arms and Artists: The American Revolution through Painters' Eyes* (New York: Bloomsbury, 2016), 4–5.

20 Undated examination report for John Singleton Copley's portrait of Samuel Cooper, ts, curatorial object file, Williams College Museum of Art.

21 Nancy Mowll Mathews, ed., *American Dreams: American Art to 1950 in the Williams College Museum of Art* (Williamstown, MA: Williams College Museum of Art, 2001), 27–29; Charles W. Akers, "Religion and the American Revolution: Samuel Cooper and the Brattle Street Church," *William and Mary Quarterly* 35, no. 3 (July 1978): 492; Samuel Cooper, "Diary of Samuel Cooper, 1775–1776," *American Historical Review* 6, no. 2 (January 1901): 301–41.

22 Undated X-ray and 1961 conservation report for John Singleton Copley's portrait of Mrs. Alexander Cummings (Mrs. John Bacon; Elizabeth Goldthwaite), curatorial object files, Department of American Art, Brooklyn Museum.

23 Copley's portrait of Mary Boylston Hallowell is in the collection of the Detroit Institute of Arts and bears no signs of physical damage. In his catalogue raisonné of Copley's work, Jules Prown gives this portrait a date of ca. 1767–68, slightly later than that of the portrait of Benjamin Hallowell; however, given the precarious position of the Hallowell family after the Stamp Act riots and the ruined state of Benjamin Hallowell's portrait at that time, this date seems improbable. It is far more likely that the two portraits were both painted ca. 1764, as ornaments for the Hallowells' new Boston mansion. Jules David Prown, *John Singleton Copley in America* (Washington, DC: National Gallery of Art, 1966), 217.

24 Akers, "Religion and the American Revolution," 492; J. Patrick Mullins, "'A Kind of War, Tho' Hitherto an Un-Bloody One': Jonathan Mayhew, Francis Bernard, and the Indian Affair," *Massachusetts Historical Review*, 11 (2009): 27–56.

25 Benjamin Blydenburg Wisener, *The History of the Old South Church in Boston* (Boston: Crocker & Brewster, 1830), 33–35; Hamilton Andrews Hill, *History of the Old South Church (Third Church), 1699–1884* (New York: Houghton Mifflin, 1889), 118, 177–79.

26 James Simpson, *Under the Hammer: Iconoclasm in the Anglo-American Tradition* (New York: Oxford University Press, 2010), 16.

27 Curatorial object files, Department of American Art, Brooklyn Museum.

28 Oliver Wendell Holmes, "Dorothy Q.: A Family Portrait," *Atlantic Monthly* 27 (1871): 121.

29 *Letters and Papers of John Singleton Copley and Henry Pelham, 1739–1776*, 65.

30 Ann Uhry Abrams, "Politics, Prints and John Singleton Copley's *Watson and the Shark*," *Art Bulletin* 61, no. 2 (June 1979): 265–76; Roberts, *Transporting Visions*, 163.

# PRINCE DEMAH AND THE PROFESSION OF PORTRAIT PAINTING

Jennifer Van Horn

In February 1773, Boston merchant William Duguid sat for his portrait, and the likeness that came from the session is, in many ways, quite predictable (fig. 2.1). Seated in a wooden chair, Duguid wears a fashionable chintz banyan or dressing gown, and he appears to be in his study; a bookcase is visible behind him to his right, with leather-bound tomes resting on its shelves. Duguid, a Scottish immigrant who specialized in textiles, is presented as many other successful merchants were in early America, and his portrait, though smaller and more modest, bears comparison with a painting of the wealthy merchant Nicholas Boylston that had been painted six years earlier by the most sought-after portraitist in Boston, John Singleton Copley (fig. 2.2). Like Duguid, Boylston is shown sitting in a wooden chair and wearing a banyan, his a shimmering blue-green silk damask. Boylston's tremendous mercantile success is suggested by the sumptuous fabrics that drape the table and billow behind him, as well as by the ship plying the Atlantic in the background. Despite its luxuriousness, Boylston's portrait shares a common format with Duguid's, suggesting that both adhered to local taste. What is unusual about Duguid's portrait is not, in fact, the work itself, but rather the story of the artist who painted

it: Prince Demah Barnes, an enslaved African American portraitist owned by another Massachusetts merchant and his wife, Henry and Christian Barnes.[1]

Prince Demah's recently recovered story is remarkable. A one-time sailor, he was purchased in his twenties by the Barneses (who already owned his mother, Daphney). Impressed by his artistic talent, Henry Barnes took Demah to London to train briefly with painter Robert Edge Pine. Demah then returned to Massachusetts where the Barneses helped him begin to establish himself as a portraitist. An advertisement they placed in the *Boston News-Letter* between January and November 1773 alerted residents: "At Mr. *M'Lean's*, Watch-Maker, near the Town-House, is a Negro Man whose extraordinary Genius has been assisted by one of the best Masters in *London*; he takes Faces at the lowest Rates. Specimens of his Performances may be seen at said Place." Although we don't know how many patrons the advertisement ultimately attracted, it evidently quickly caught Duguid's attention because one month after the ad

Fig. 2.1
*Portrait of William Duguid* by Prince Demah Barnes, 1773
Oil on canvas, 52.7 × 40 cm (20¾ × 15¾ in.)
Metropolitan Museum of Art; Friends of the American Wing Fund

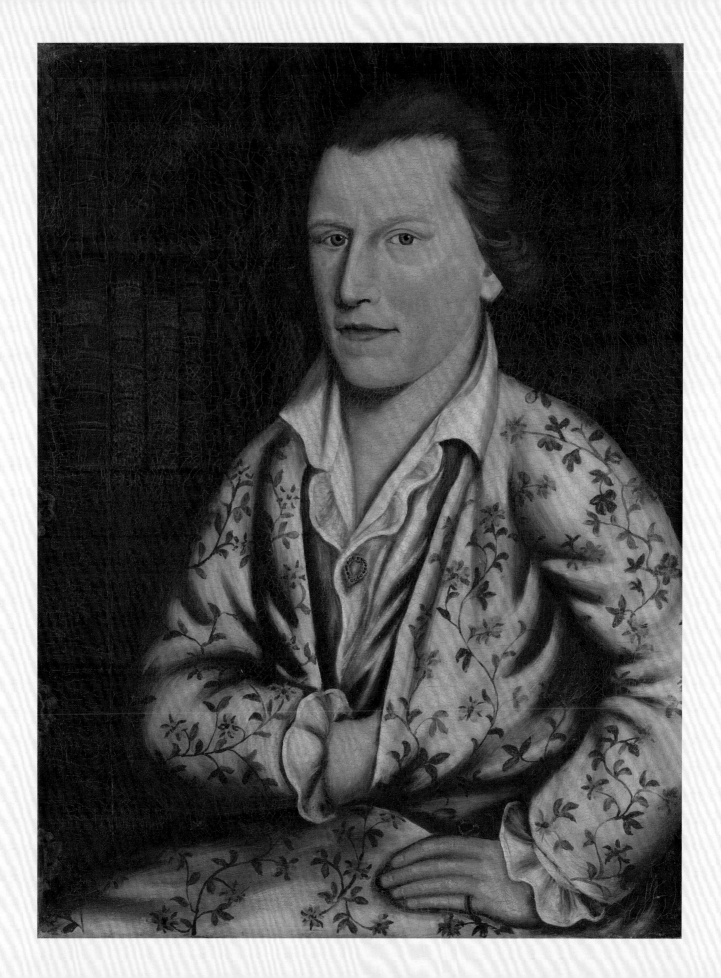

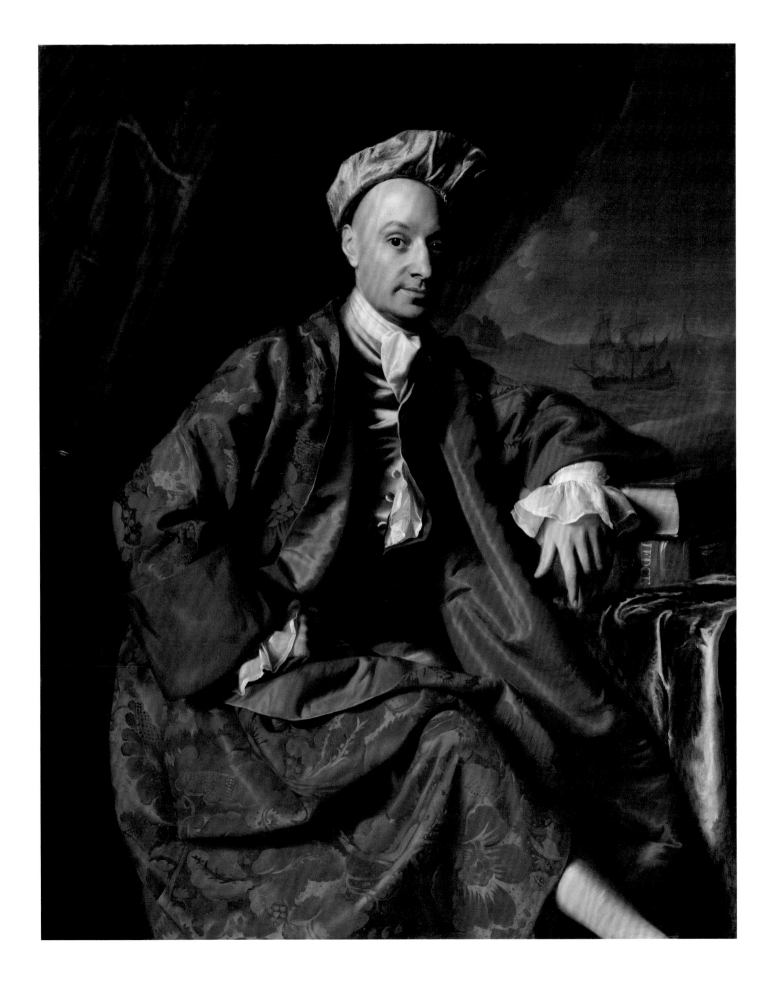

first appeared, Prince Demah signed a finished portrait of the merchant. He inscribed several phrases in Latin on the back stretcher that can be loosely translated as, "W[illiam] D[uguid] aged 26 in 1773 / Prince Demah Barnes painted this February 1773." Demah's artistic career was a brief one. By late 1775 the Barneses, who were loyalists, had fled for England, and in April 1777, Demah had enlisted in the colonial Massachusetts militia. He died in late March 1778, probably as a victim of one of the many infectious diseases that swept through Revolutionary War encampments.[2]

Amazingly, at least three paintings by Prince Demah survived. Aside from the painting of Duguid, the other two, portraits of Demah's master, Henry Barnes (fig. 2.3), and mistress, Christian Barnes (fig. 2.4), are likely copies after John Singleton Copley's portraits, now lost.[3] Between 1769 and 1773 Demah primarily made copies after existing works, but he also painted several sitters "from life." In March 1772, Christian Barnes noted in one of her copious letters, written to her friend Elizabeth Smith, that Demah had "taken five pictures from life since his return [from London] three of them as good likenesses as ever Mr. Copling [Copley] took." To Christian Barnes, at least, Demah's portrait of Duguid and Copley's of Boylston were comparable. The identities of the five sitters whom she references are unknown, and those canvases are unfortunately unlocated. Demah's portrait of Duguid is therefore the only known surviving portrait by Demah to have been made from a face-to-face sitting.[4] As such, the painting provides a rare opportunity to consider the complicated range of attitudes, expectations, and preconceptions that shaped the meeting of an enslaved African American portraitist and a white patron in early America.

As art historian Angela Rosenthal has argued, a portrait is not simply the result of an artist applying paint to canvas but is rather the product of a social encounter, a public meeting between a sitter and an artist in which cultural expectations shape the event. The eighteenth-century portrait studio was a site of negotiation over the role of the artist and the qualities that the artist was supposed to embody (issues that were highly contested across the British Atlantic), as well as debates over visuality. Who had the right to look at whom? What power did his or her gaze carry with it? In cases where the artist deviated from the normative type of a white male portrait painter, sittings mobilized anxiety with regard to race and gender. For the female artists whom Rosenthal studied, the portrait sittings raised questions about women's roles, whereas for Prince Demah and William Duguid, this encounter was intensely racialized. After Demah sat down to paint a portrait of a white merchant, he necessarily engaged in an act of close looking, staring openly at Duguid's face.[5] This scrutiny reversed the conventional power dynamic between a slave and a white man. Enslaved people were expected to exhibit subservience and not to brazenly look at whites. How did Demah overcome this challenge to successfully complete his painting? More broadly, how did Prince Demah, and his masters, present and promote him so as to make his racial transgression as a portraitist not only possible, but palatable for white sitters? The finished portrait of Duguid testifies to Prince Demah's rare achievement in becoming an African American portrait

Following pages:

**Fig. 2.3**
*Portrait of Henry Barnes* by Prince Demah Barnes, ca. 1771–73
Oil on canvas, 85.7 × 74.9 cm (33¾ × 29½ in.)
Hingham Historical Society

**Fig. 2.4**
*Portrait of Christian Barnes* by Prince Demah Barnes, ca. 1771–73
Oil on canvas, 85.7 × 74.9 cm (33¾ × 29½ in.)
Hingham Historical Society

**Fig. 2.2**
*Nicholas Boylston* by John Singleton Copley, 1767
Oil on canvas, 127.3 × 101.1 cm (50⅛ × 30¹³⁄₁₆ in.)
Harvard University Portrait Collection; bequest of Ward Nicholas Boylston to Harvard College, 1828

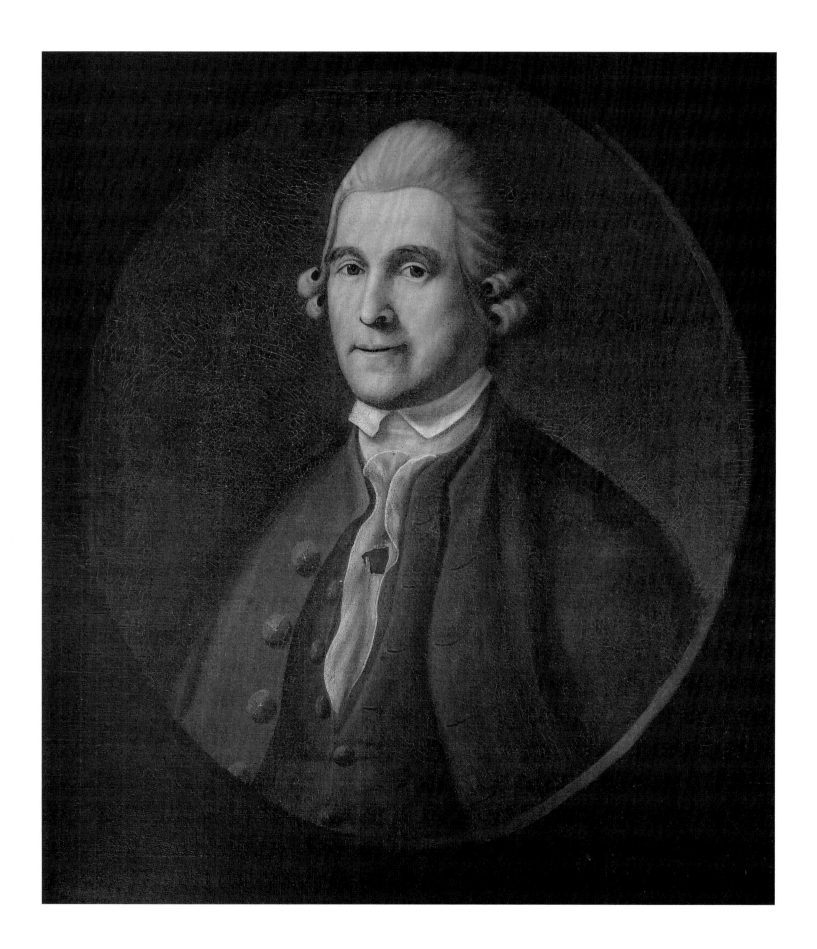

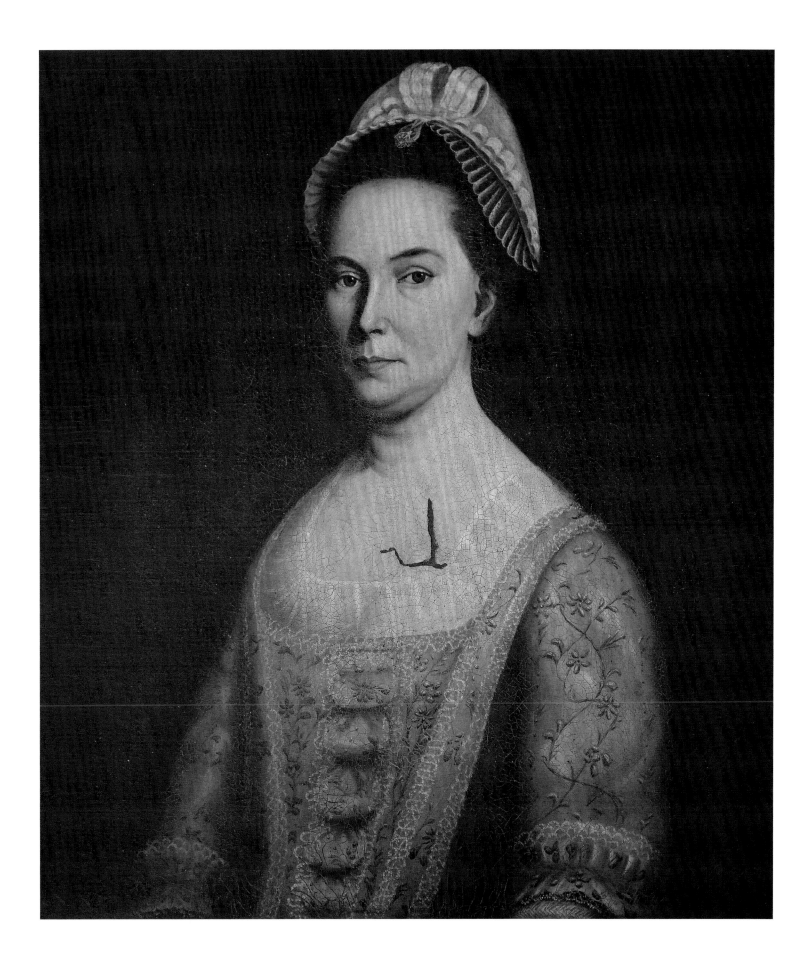

painter in colonial America but also reveals the limitations that circumscribed his short career.

In the nineteenth century, several free blacks offered their services as portraitists, most famously Joshua Johnston in Baltimore.[6] Certainly, Prince Demah was not the only African American involved in portrait production. In colonial America, other enslaved men worked for artists as body servants, messengers, couriers of finished portraits, and even studio assistants. Earlier in the eighteenth century, Boston portraitist John Smibert enslaved a man named Cuffee who likely helped him process the pigments that he used in his paintings. Cuffee's "Leather Breeches," which are described in an advertisement that Smibert placed in the hope of apprehending him, testify to Cuffee's participation in his master's craft; the pants were "stain'd with divers sorts of paints," likely the result of his physical labor of breaking down pigments with a mortar and pestle, a messy and time-consuming process.[7] Yet, these colonial slaves were not painters themselves. Their labors were categorized as "servile" or "manual" and thus fit within the range of work that artists and craftsmen deemed to be acceptable for slaves. The Spanish artist Diego Velázquez owned an Afro-Hispanic slave named Juan de Pareja (ca. 1606–1670) who likely performed similar tasks to Cuffee. According to an early biographer, Velázquez asked Pareja "to grind his Colours and prepare the Canvas, and other servile Offices belonging to the Art and about the House." However, "for the honor of the art," Velázquez "would never suffer him [Pareja] to meddle with Painting or Drawing." Slaves in early America were not permitted to touch brush to canvas as that was restricted to the white artist or his white apprentices.[8]

Prince Demah's exceptionality as a painter stemmed, in part, from his atypical situation. Most slave assistants were owned by an artist, but Demah's master was a merchant. After learning about Demah's talent from his mother, Daphney, who was also their slave, Henry Barnes and his wife asked Demah to copy a portrait. They were so impressed by "the force of [Demah's] natural Genius" that they purchased him in 1769 and helped him obtain an education in portrait painting. Christian Barnes, in particular, viewed Demah's career as *her* project, writing to a friend that the purchase of him was "intirely [*sic*] my own [Scheme], and as it is the only one I ever ingaged [*sic*] in I shall be greatly disappointed if it does not succeed." Demah's training got off to a difficult start. The Barneses, who were not artists themselves, were "at a great loss for proper materials." Even after buying some pastel crayons, Christian lamented that she was "so ignorant as not to know what they are to be laid on." Nonetheless, the couple persevered. They were confident enough in Demah's ability to make a significant financial investment to send him to London in 1770–71 so that he could train with a well-known artist. (He was accompanied by his master who feared Demah might grasp this chance for freedom.)[9]

It was in the London studio of Robert Edge Pine, a portraitist and history painter, that Demah received instruction on how to prepare oil paints and ready a canvas, as well as on how to paint a likeness. Though Pine eschewed the Royal Academy, he was one of the most successful portraitists in London in the 1760s and early 1770s, depicting such well-known personages as historian and activist Catharine Macaulay, whom he painted around 1775 in a neoclassical style, dressed as a Roman matron to reflect her commitment to democratic political ideals (fig. 2.5). It was likely from Pine that Demah acquired his ideas of how a professional artist should conduct himself and interact with sitters when painting portraits from life.[10]

While Demah's artistic training was unusual for an enslaved person, Christian Barnes's interest in developing his skills can be compared with a similar project undertaken in Boston around the same time. The enslaved poet Phillis Wheatley was also educated by her owners, John and Susannah Wheatley, with their daughter Mary serving as Phillis's tutor. Like Henry Barnes, who was not only a merchant but also a distiller and investor in manufacturing,

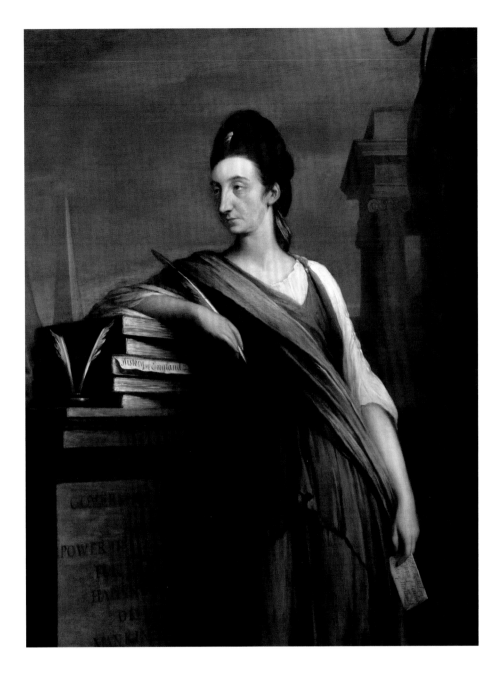

**Fig. 2.5**
*Catharine Macaulay (née Sawbridge)* by Robert Edge Pine, ca. 1775
Oil on canvas, 137.2 × 104.8 cm (54 × 41¼ in.)
National Portrait Gallery, London; purchased 1985

John Wheatley was a successful tradesman (a tailor), as well as a ship owner. Like the Barneses, the Wheatleys used Boston newspapers to alert readers to their slave's ability, publishing several of her poems in the late 1760s and early 1770s. Finally, like Demah, Phillis Wheatley traveled to London where she had a volume of her poetry published and was hailed for her poems across the British Atlantic.[11] Christian Barnes believed that Prince Demah could achieve renown as Wheatley had. Predicting he "will do Honour to the profession" of a portraitist, Christian called Demah by the nickname "Hogarth" after the most famous British painter of the eighteenth century. She gushed in letters to her friend Elizabeth Smith about her "Black Limner," claiming "he could coppy [*sic*] a Picture as well as any Body in this Country."[12]

Barnes wanted Prince Demah to be a practicing portraitist, an artist in his own right, but this ran counter to most eighteenth-century artists' desire to restrict and to uplift their profession. British painters' quest to distinguish their craft from artisanal trades weighed heavily on early

American artists' minds at mid-century. London's aesthetic theorists preached that artists should not be tradesmen but rather gentlemen who were valued for their intellectual accomplishments and polite behaviors. Accordingly, colonial artists sought to heighten their social status and to reframe viewers' perceptions of their work as intellectual rather than mechanical. Boston's resident portrait painter John Singleton Copley strongly registered this desire. Around 1767 Copley lamented to a correspondent, "The people generally regard it [painting] no more than any other usefull [sic] trade, as they sometimes term it, like that of a Carpenter tailor or shew maker, not as one of the most noble Arts in the World." Copley despaired that Bostonians lumped him together with artisans rather than perceiving him as the gentleman that a true artist should be.[13]

Copley's desire to promote the exclusivity of his profession might explain his marked disinterest in Prince Demah. The Barneses were forced to take Demah all the way to London because, as Christian noted, "People in general think Mr. Copling [Copley] will not be willing to give him any instruction and you know there is nobody else in Boston that does any thing in the Business." The renowned artist, who had more patrons than he could satisfy, simply might not have had the time to devote to training an uneducated student. Perhaps, too, Copley's interest in shoring up the status of his craft led him to deem Demah's career an unwelcome racial incursion; Demah undermined and potentially subverted the profession as Copley practiced it.[14] Copley's perceived dismissiveness highlights Robert Edge Pine's willingness to break convention by taking on a black pupil. Scholars have speculated that Pine might have been encouraged to do so because of his own possible mixed-race status; his father was rumored to have been part African. An attitude of racial tolerance would fit well with Pine's politically progressive views. So entranced was he by the American Revolution that Pine immigrated to the United States to paint American worthies in the hopes of commemorating the Revolution through history painting.[15]

We cannot know whether Copley deliberately rejected Demah for his race, but given the Bostonian's irritation at being perceived as an artisan, it is highly likely that he was angered by the advertisements the Barneses placed in the Boston News-Letter. Far from distancing himself from artisans, Demah set up his studio in a watchmaker's shop. He advertised in a newspaper like a merchant, artisan, or tradesman, rather than relying upon letters of introduction or word of mouth to spread his reputation as other artists did. Furthermore, the advertisement alerted customers that "he takes Faces at the lowest Rates," equating his painting of portraits to inexpensive craft production.[16] Perhaps Copley perceived the danger Demah posed as all the more threatening because the slave had trained by copying Copley's portraits and in the process mastered Copley's basic bust or waist-length portrait formula, visible in Demah's depictions of Henry and Christian Barnes (see figs. 2.3 and 2.4). Demah could not rival Copley's technical prowess (no matter what Christian Barnes claimed), but he was a black artist/artisan who offered Copley-style depictions, and copies after Copley paintings, at a lower rate. Demah thereby simultaneously destabilized both Copley's claims to gentlemanly status and the exclusiveness of the fantasies he offered his patrons.

Prince Demah had one more qualification that might have alarmed Copley: training from "one of the best Masters in London," as the Barneses' advertisement touted, an attribute that the more prestigious painter lacked. Copley spent much of his time in the late 1760s and early 1770s lamenting his separation from London's art world, sending works for exhibition at the Society of Artists and anxiously awaiting the judgments of London-based painters Benjamin West and Joshua Reynolds. Even as he received Reynolds's warning that he should leave the colonies before his "Manner and Taste [were] corrupted and fixed by working [in his] little way at Boston," Copley was faced with an enslaved painter who had been the beneficiary of London training.[17] In fact, Demah could claim

greater first-hand knowledge of London's painters' studios and art world than Copley could, a fact that the Bostonian must have found galling. Demah's status as an enslaved portraitist who had trained in the art capital of the British Empire lent him, in this way, greater legitimacy than Copley himself. The Barneses might have circulated the words of praise bestowed upon Demah by Patience Wright, the famous American wax sculptress then living in London, who told Henry Barnes that he "carr[ied] . . . a Treasure to America" in Demah.[18] Perhaps, as William Duguid sat for Prince Demah, he felt himself to be a thrifty consumer. He was having his likeness taken by a painter with the closest connections to London in all of Boston, and Demah's enslaved status afforded Duguid this opportunity at a low price that the twenty-six-year-old could afford.

Yet as much as Demah's connection to London and his training might have infuriated Copley, the Bostonian must have known Demah could never pose a real threat for the simple fact that he was enslaved. Gossiping about Christian's "scheme" to a mutual acquaintance, one of the Barneses' friends summarized most early Americans' attitude: "who in Boston would prefer a Negro to Copley[?]" Her query indicates the significant barrier that Prince Demah faced due to his race and enslaved status. On the one hand, Demah's public act of portrait painting enabled him to showcase his hard-won skills garnered from a master in London. On the other hand, the color of his skin and the public nature of his painting recalled the other venues in early America where African bodies were put on view as objects for sale or as natural history specimens.

Though Christian Barnes supported Demah's pursuit of art, in her letters she referred to his career as a moneymaking venture, declaring her intention to "Exhibit him to the Publick" and to "reap . . . some advantages from his performances." Demah was a portraitist, but the Barneses expected to profit from his labor.[19] When seen in this way, Demah's creation of portraits in an artisan's shop can be equated to public performances of curiosities or "freaks" that took place in similar rooms in shops and taverns across early America. These performers included several African Americans such as the "WHITE Negro Girl, of Negro Parents . . . as white as any European" who had "a lively Blush in her Countenance . . . and Hair frilled as the Wool of a white Lamb," shown in Charleston, South Carolina, in May 1743 at the cost of "Five Shillings for each Person." Or he could be likened to the famous Martha Ann Honeywell, a white woman who was born without full legs, arms, hands, or fingers, and who used the three toes on her right foot to cut silhouettes for paying customers during her many performances in America and Europe. Indeed, the Barneses' language in their newspaper advertisement, which promised that patrons could view "Specimens of his Performances," highlights both the anthropological or scientific nature of the exhibition that patrons expected to see as well as the fact that watching Demah create their portrait was a critical part of the experience. This might also help explain the lengthy inscription included on the back rail of Duguid's portrait that recorded the details of the sitting and testified to the unusual education of an enslaved artist who learned not only to paint in London but to pen Latin phrases. As Duguid sat for Prince Demah, the artist himself was placed on display. Like the albino slave girl in Charleston or the disabled Honeywell, Demah was exhibited for clients as an oddity or rarity.[20]

What was the nature of the spectacle that Duguid and others paid to see? It was not that Demah's body itself was grotesque; rather, it was the uniqueness of his artistic talent. Christian Barnes found Demah to be so praiseworthy because he defied expectations of Africans' supposedly inherent artistic inability. Thomas Jefferson spelled out this view in his *Notes on the State of Virginia* (1781–83). The politician, slave owner, and natural historian claimed that he had "never see[n] even an elementary trace of painting or sculpture" in African Americans, concluding, "In general, their existence appears to participate more of sensation than reflection." In other words, slaves could

respond to stimuli aimed at their lower emotions, such as lust or rhythm, but lacked the logical and sustained thought required to produce art.[21]

As scientific understandings of aesthetics and vision developed over the eighteenth and nineteenth centuries, scientists explained African Americans' supposed lack of talent by "proving" that African Americans were physiologically incapable of close looking. By 1851 the New Orleans physician Samuel Cartwright claimed that "the inner canthus of the negro's eye is anatomically constructed like that of the orang-outang, and not like that of the white man," explaining why African Americans' "aesthetic faculties are still in a child-like, or infantile condition." Demah's race consistently shaped the Barneses' perceptions of the quality and value of his works. Christian presented the slave's productions to her friends as worthy of "esteem as a Curiosity at least." She and her husband similarly marketed Demah in the newspaper, not as an artist worthy of patronage in his own right, but as a "Curiosity" and wonder, a "Negro Man" with "extraordinary Genius."[22]

An engraving produced in London in 1834 satirizes the perceived inherent ridiculousness of an African being able to create portraits (fig. 2.6). In the print, entitled *The Portrait*, we see a black painter seated before an easel at work on a likeness. He is dressed like a gentleman and his subject, a heavily stereotyped black woman who reclines on a couch before him, is also dressed fashionably. In her case, she is clad so modishly as to appear clownish. Indeed, the lavishness of the black figures' appearance is deliberately discordant with the awkward disposition of their bodies, alerting us to the artist's intention to show a world that is disjointed and disorderly. Afro-Britons sitting for and painting portraits is not part of the normal order of things, the print assures us. As with many similar American and British satirical engravings that criticized blacks' assumption of polite behaviors, these figures' dialect-ridden words highlight the presumed ridiculousness of their actions. The female sitter beseeches, "I look bery Pale dis morning . . .

so just be kind enuf to Paint me wid a little Colour." The eager artist replies, "Belebe me Madamoiselle it is beyond de power ob my Abilitites to ribal de Glowing Bermilion ob dose Beauteous Cheeks." Black skin is presented here as marking the antithesis of beauty and of artistic production: a sitter should not have dark skin, just as an artist should not be black himself. Portraiture and the space of the artist's studio should be reserved for whites. The presence of an African American, the print argues, renders portraiture farce.[23]

The satirical engraving lampoons blacks' pretentions of gentility as they tried to be artists or have their portraits made. However, it does not tackle an interracial portrait sitting, presumably something so subversive as to be unhumorous. The largest problem with an African American artist painting likenesses of whites was the gaze: the power to look directly at a person's face for as long as one desired. In early America, whites reserved the right to wield the gaze for themselves, unleashing their power of discernment at auctions, where they appraised a slave's body to determine his or her market value while simultaneously restricting slaves' vision.[24] An African American artist turning the gaze on a white sitter, as required to make a portrait, disrupted the social order.

Despite the decline of the institution in Massachusetts beginning in the 1760s, slavery was endemic, and many Bostonians, from artisans to merchants to shopkeepers, owned slaves.[25] It is not known whether William Duguid held any, but he was fully immersed in Boston's racialized society. The city's enslaved men, women, and children learned early and well to keep their eyes down. They were taught to show their subservience and humility, and to never stare openly at whites. If he had not discovered the visual operations of slavery as a sailor, Prince Demah would have been introduced to them in the Barnes household, where he balanced painting with his duties as a "valet de chamber," or manservant, to Henry Barnes. Christian was pleased with Demah's deference, remarking he "has every

**Fig. 2.6**
*The Portrait*, from *Black Jokes, Being a Series of Laughable Caricatures on the March of Manners Amongst Blacks*, Charles Hunt after W. Summers, 1834
Hand-colored aquatint
Yale Center for British Art; Paul Mellon Collection

qualification to render him a good Servant, Sober, diligent, and Faithfull." She was reassured that "supposing he is not qualified for a Painter he may be otherwise made a very successful Servant."[26]

Whereas a good manservant kept his eyes downcast in the presence of whites, a portraitist had to master the art of looking with great precision at a white sitter's face. Painting a portrait required the artist and the sitter to spend several hours in close proximity to one another. The *Universal Magazine of Knowledge and Pleasure*, a London periodical, described how the sittings should proceed. In the first sitting the portraitist concentrated on establishing rough outlines and background color, but the second and third sittings, which typically lasted "four or five hours" apiece, required rigorous scrutiny. "[Y]ou must most exactly observe," the author enjoined artists. The portraitist should "go over the face very curiously, observing whatever may conduce either to likeness, or judicious colouring; also taking notice of the . . . graces, beauties, or deformities, as they appear in nature," including "scars, moles, & c., glances of the eyes, descending and circumflexions of the mouth" as well as "any particularities as to the set or motion of the head, eyes, or mouth (supposing it not be unbecoming), . . . the deepness of the eye-brows and those more perspicuous notes and marks in the face."[27]

Prince Demah spent approximately ten hours staring at Duguid's face, attentive to every shadow, twitch of the eye, and patch of redness.[28] He lavished equal attention on the gentleman's clothes and accessories, and thanks to the survival of Duguid's brooch (fig. 2.7), we can see in the painting that Demah exactingly reproduced the silver and garnet piece of jewelry that nestles amidst the ruffles on the merchant's chest. Like other artists, he might have asked Duguid to leave the brooch behind so he could paint it, as well as his calico banyan, whose floral pattern the portraitist also probably replicated. If Demah painted either of these items from life, however, it added still more time to his sitter's lengthy commitment.

Fig. 2.7
Brooch worn by William Duguid, ca. 1770
Silver and garnet, 2.9 × 3.2 cm (1⅛ × 1¼ in.), with pin
Metropolitan Museum of Art; Friends of the American Wing Fund, 2010

The act of sitting for a portrait was physically and oftentimes emotionally grueling for both artist and sitter as they jockeyed to assert their social position—the artist as a skilled practitioner and gentleman, the male sitter as someone with wealth, power, and prestige. For Demah and Duguid, however, the portrait sitting was especially fraught as a white merchant faced the unusual prospect of giving an enslaved man unlimited visual power over his body. For this short period of time, Demah was able to return the gaze. Instead of having the white viewer's eyes fixed on him, it was he who looked critically at the sitter. Moreover, he was able to pose the sitter as he desired, to request that Duguid not fidget, to ask him to shift slightly, and to tell him when the sitting was over for the day. Demah wielded incredible power within the painting room, a power that was all the more marked because of his lack of control as an enslaved man in all other aspects of his life. If Henry and Christian Barnes had the authority to command Demah's labor, to script his actions, and to decide what he should do and when, then for a brief moment of carnivalesque inversion Demah commanded a white body. That the enslaved man enjoyed this freedom is not hard to imagine. Several clues from his life history and the Barneses' accounts of his behavior indicate the level of supervision that Demah endured while enslaved and highlight the fact that he did not have the freedom to express himself. While in London with Demah, Henry Barnes wrote to his wife's friend Elizabeth Smith. Expressing fear that Demah might "attempt his freedom," he admitted, "I do not let him converse

with any of his own colour here." Barnes noted "his life & situation are so precarious if he should even attempt his Freedom it would give me such a disgust to him I should not overlook it." Henry Barnes realized that his financial investment in Demah would be all for naught if he decided to slip away among London's free blacks. Perhaps, Barnes recognized that training in the craft of portrait painting opened an avenue for financial independence to his slave. Whereas Henry Barnes seems to have viewed Demah with suspicion, his wife was willing to take her slave's silence as acquiescence. She informed Elizabeth, "I believe as he was Born in our family he is of Tory Principles but of that I am not quite so certain as he has not yet declar'd himself [a loyalist]." In fact, Demah did not support the British as his master and mistress did, but he wisely kept his political opinions to himself and only openly joined the patriots' cause after his owners fled.[29]

If portrait painting offered Demah an opportunity to exert his own critical gaze and to enjoy an independence of thought and expression, he nevertheless did not experience the same career opportunities that white portraitists did. Demah could not negotiate his own fees, recruit for patrons among his social peers, decline prospective patrons, or even keep the money paid for his services. Painting did not provide him a path to freedom since the Barneses appear to have kept the fees paid by Demah's patrons, just as many slave holders accepted the wages paid to the slaves they rented out to other masters. Demah might have been allowed to keep some percentage of those wages for himself, as did some skilled rented slaves (e.g., cabinetmakers and silversmiths), but he also might not have received anything.

Since the Barneses were looking for a way to recoup the money they outlaid for Demah's training, it seems unlikely that they parted with any of the funds he earned. Prince Demah's enslaved status also meant that he was less capable of asserting his artistic agency and had to accede to others' suggestions about his paintings. Demah

encountered the same set of problems that other portrait painters in early America faced: how to satisfy sitters with a likeness that at once flattered but did not fall so far afield as to be humorous. But he did so at a distinct disadvantage. Despite his training, his taste was considered to be inferior to that of his patrons or his masters, and so he had to alter his paintings to accommodate their desires. Christian Barnes evoked the kind of docility she expected Demah to exhibit when instructing a friend, "Please . . . give him [Demah] any directions you think proper as to the Dress of the Head." As a slave who painted at his master's and mistress's whim, he had extra incentive to make sure that his patrons were pleased with his representations. The Barneses chose to purchase Demah because of his specialized skills, and if they found him lacking or if they tired of their experiment, they could easily sell him away from his mother again. All decisions about Demah's career ultimately rested on the Barneses' shoulders, so as Demah painted, he sought to please not just his sitter but also his masters.[30]

The limitations of Prince Demah's ability to be the kind of autonomous portrait painter he desired come across in his interactions with Elizabeth Smith. As a favor to Christian Barnes, her friend and long-time correspondent agreed to let Demah copy Smith's picture (likely by Copley). Either Smith, the Barneses, or perhaps Demah himself were evidently dissatisfied with the final product, because the next year Christian beseeched Elizabeth, "if you have an hour to spare at any time when you are in Boston you will allow Prince to make some alteration in the Coppy [sic] he has taken from your Picture which he says he cannot do but from life." In arguing that he needed a life sitting to alter his depiction, Demah followed the practice of England's most fashionable portraitists. Thomas Gainsborough, for instance, in a letter to his patron the Earl of Dartmouth, maintained that he needed a sitting to make any changes to a painting, writing, "I cannot (without taking away from the likeness) touch it unless from the Life."[31] We do not know if Smith ever sat for Demah, but Christian's beseeching

tone in her request suggests her friend's reluctance. The reason might have been Smith's distrust of Demah. She had previously been offended by Demah's lack of decorum after he supposedly slept the night at her house while on his way from Boston to Marlborough, where the Barnes family lived, and he neglected to make himself known or to offer his thanks to Smith. In Demah's defense Christian reported, "he told me you were abroad when he arrived and . . . he was obliged to go off before you was up. You know he is a very Simple Fellow and greatly deficient in Point of breeding, or he certainly would have stid [sic] to have paid his compliments to you."[32] Having already deemed Demah to be insufficiently tutored in polite address, it is improbable that Elizabeth Smith would have agreed to sit before him and place him in a position of power over herself, even temporarily.

If Elizabeth Smith knew Demah and perhaps refused to sit before him, it is still more unlikely that an elite woman who did not know the enslaved man would have voluntarily had her portrait painted by him. Portrait painting could be seen as a highly sexualized event, one in which the male artist dwelt upon the female sitter's charms and occasionally found himself besotted. When Charles Willson Peale painted the twenty-year-old Susannah Caldwell, whom he found to be quite attractive, he related, "The portrait painter cannot but be sensible of the attractions of a lovely sitter . . . and if he cannot fall in love with his copy, yet he is in danger from the original, whose native charms he endeavors to develop."[33] Given racist notions that African Americans were dominated by their base passions and thus unable to restrain their lustful desires (Jefferson noted, "They are more ardent after their female"), white sitters anticipated such stimuli would drive a black artist to action. For a black man to gaze openly (and perhaps lustfully) upon a white woman conjured whites' dread of racial mixing or miscegenation. This was such a strong fear for many white Americans that into the twentieth century, southern states prosecuted black men for "eyeballing," a crime that consisted of a black man being perceived as publicly ogling a white woman.[34]

Female sitters might have had all the more reason to steer clear of a black artist due to the semi-erotic nature of the portraits that gained popularity for elite women in the 1760s and 1770s. John Singleton Copley's portrait of Margaret Gage (Mrs. Thomas Gage) provides a prime example of this type (fig. 2.8). Gage appears in dishabille (without stays), wearing exotic Turkish costume and lounging on a sofa. The sensuality that Copley conjured through Gage's Eastern-inspired dress, including a turban and beaded sash, titillated viewers just playfully enough to render her appealing but not impolite.[35] It was quite simply unacceptable in early America for Prince Demah to paint a portrait of a white female sitter with such sexual undertones. The African American female sitter in the satirical print *The Portrait* (see fig. 2.6) indicates the ways that such hints of sexuality were imagined to become uncontrollable passions when they intersected with black performance. Like Margaret Gage, this woman, too, reclines on a couch, but her abundantly evident physical charms render her grotesque rather than erotic. The avid expression on the painter's face as he surveys her form suggests that he has been aroused by her seductive appearance, as does the knowing smile on the servant's face as he appears at the door with a tray of libations. Perhaps, the artist suggests, this portrait session is about to devolve into more intimate contact. Prince Demah might insist upon his need to paint a female sitter from life, but Boston's elite women did not want to put themselves in this position. Thus, it seems fitting that the one portrait from a paying sitter that survives is that of a man. As William Duguid posed, he did not have to worry about these entanglements of race and gender.

Often when art historians consider early American portraits, we look at the stories of their makers or their patrons. We consider the social uses to which people put their portraits when they brought them home and displayed them on their walls.[36] Yet it was when Prince Demah and

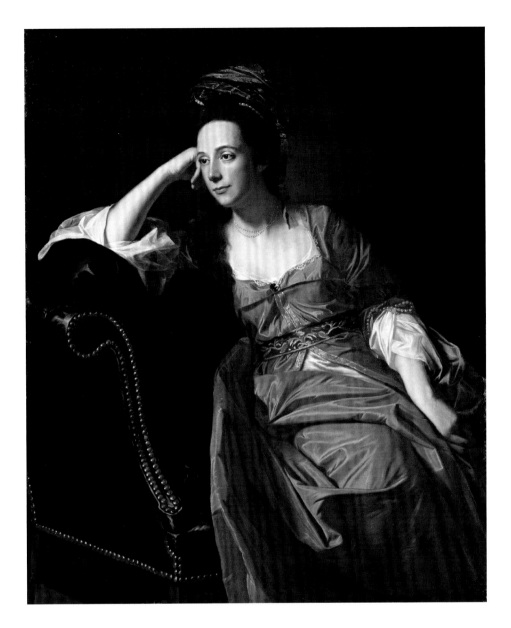

**Fig. 2.8**
*Mrs. Thomas Gage* by
John Singleton Copley, 1771
Oil on canvas
127 × 101.6 cm (50 × 40 in.)
Timken Museum of Art;
Putnam Foundation

William Duguid came together in a watchmaker's shop, as artist and sitter, that the complicated strands of racial discourse that rendered an "imbalanced visual economy" became most visible. It was in the moment when Demah acted most compellingly as a professional painter that he, ironically, was revealed as never being able to fully become one. Prince Demah's career offers a double-edged tale of accomplishment and constraint, resistance and compliance. It is telling that when the Barneses fled Massachusetts in late 1775, Demah's career appears to have gone with them. Ironically, this was his chance to finally capture some of Copley's business as the loyalist-leaning artist also left Boston in 1774 for Europe, and eventually London.[37] Without his interlocutors advertising for him in the newspaper, and simultaneously selling his blackness, however, Demah was unable to penetrate an increasingly unsteady market for likenesses. More important, he chose the patriot cause over his artistic career by joining the Massachusetts militia. The Barneses might have granted Demah his freedom before their departure, or he might have seized it for himself, as did many other African Americans who joined the army. On March 11, 1778, when Demah wrote his will, he identified himself, one imagines proudly, as both "Prince Demah, limner" and a "free Negro."[38]

## Notes

1 "Prince Demah Barnes—*Portrait of William Duguid*," online collection record, Metropolitan Museum of Art, New York, http://www.metmuseum.org/art/collection/search/20517. Carrie Rebora Barratt et al., *John Singleton Copley in America* (New York: Metropolitan Museum of Art, 1995), 224–29.

2 Amelia Peck and Paula M. Bagger, "Prince Demah Barnes: Portraitist and Slave in Colonial Boston," *Magazine Antiques* 182, no. 1 (January/February 2015): 154–58, http://www.themagazineantiques.com/articles/prince-demah-barnes-1/. *Boston News-Letter*, January 7, 14, 21; February 4, 11; March 11, 25; October 28; and November 4, 26, 1773. I will use the name Prince Demah in this essay as it is the name the artist employed in his will. He signed the Duguid portrait "Prince Demah Barnes," but seemingly dropped Barnes from his name once he had the opportunity. This naming convention honors his decision.

3 Peck and Bagger, "Prince Demah Barnes," 157, 159.

4 Christian Barnes to Elizabeth Smith, March 9, 1772, Christian Barnes Papers, 1768–1784, Library of Congress. Since there is no document to suggest that the Barneses freed Demah, or a reference to their having done so in Christian's otherwise encyclopedic correspondence from the period, I assume that Demah continued to work as an enslaved portraitist until the loyalist Barnes family fled Boston in 1775.

5 Angela Rosenthal, "She's Got the Look! Eighteenth-Century Female Portrait Painters and the Psychology of a Potentially 'Dangerous Employment,'" in *Portraiture: Facing the Subject*, ed. Joanna Woodall (Manchester: Manchester University Press, 1997), 147–66, esp. 147–51.

6 Carolyn Weekley, *Joshua Johnston: Freeman and Early American Portrait Painter* (Baltimore: Maryland Historical Society, 1987). Lisa A. Farrington, "Black or White? Racial Identity in Nineteenth-Century African American Art," *Notes in the History of Art* 31, no. 3 (Spring 2012): 5–12.

7 *New England Weekly Journal*, October 18, 1737; Linda Baumgarten, "'Clothes for the People'—Slave Clothing in Early Virginia," *Journal of Early Southern Decorative Arts* 14, no. 2 (November 1988): 27–61, esp. 53; Richard H. Saunders, *John Smibert: Colonial America's First Portrait Painter* (New Haven, CT: Yale University Press, 1995), 103–4; James Ayers, *The Artist's Craft: A History of Tools, Techniques, and Materials* (Oxford: Phaidon Press, 1985), 87–94.

8 Carmen Fracchia, "Metamorphoses of the Self in Early-Modern Spain: Slave Portraiture and the Case of Juan De Pareja," in *Slave Portraiture in the Atlantic World*, ed. Agnes Lugo-Ortiz and Angela Rosenthal (Cambridge: Cambridge University Press, 2013), 147–69; esp. 150–51. Quotations in Antonio Palomino de Castro y Velasco, *An Account of the Lives and Works of the Most Eminent Spanish Painters, Sculptors and Architects . . .* (London, 1739), 73–75; John Smith, *The Art of Painting in Oil* (London, 1738), 21, 26.

9 Christian Barnes to Elizabeth Smith, November 20, 1769; December 23, 1769; March 20, 1770, Christian Barnes Papers. Janette Barclay to Elizabeth Smith, undated [Summer 1770], Murray-Robbins Family Papers, Massachusetts Historical Society, quoted in Peck and Bagger, "Prince Demah Barnes," 157. Henry Barnes to Elizabeth Smith, February 12, 1771,

Ms.N-1157, box 1, folder 2, Murray-Robbins Family Papers, Massachusetts Historical Society.

10 Robert G. Stewart, *Robert Edge Pine: A British Portrait Painter in America 1784–1788* (Washington, DC: Smithsonian Institution Press, 1979); Matthew Hargraves, *"Candidates for Fame": The Society of Artists of Great Britain 1760–1791* (London: Yale University Press for the Paul Mellon Centre for Studies in British Art, 2005), 170–171.

11 Gwendolyn DuBois Shaw, *Portraits of a People: Picturing African Americans in the Nineteenth Century* (Seattle: University Press of Washington for the Addison Gallery of American Art, Phillips Academy, 2006), 30–32; Eric Slauter, "Looking for Scipio Moorhead: An 'African Painter' in Revolutionary North America," in Lugo-Ortiz and Rosenthal, *Slave Portraiture in the Atlantic World*, 89–118.

12 Christian Barnes to Elizabeth Smith, March 20, 1770; undated letter after November 24 and before December 17, 1770; March 9, 1772, Christian Barnes Papers.

13 Jane Kamensky, *A Revolution in Color: The World of John Singleton Copley* (New York: W. W. Norton and Company, 2016), 166–68. Copley to [West or Captain R. G. Bruce?], [1767?], in *Letters and Papers of John Singleton Copley and Henry Pelham, 1739–1776* (Boston: Massachusetts Historical Society, 1914), 31, 65–66. Susan Rather, "Carpenter, Tailor, Shoemaker, Artist: Copley and Portrait Painting around 1770," *Art Bulletin*, 79 (1997), 269–90. Christian Barnes to Elizabeth Smith, March 20, 1770, Christian Barnes Papers.

14 Christian Barnes to Elizabeth Smith, March 20, 1770, Christian Barnes Papers. For a similar assessment of the lack of training opportunities in Boston, see John Trumbull, *Autobiography, Reminiscences, and Letters of John Trumbull, from 1756 to 1841* (New Haven: B. L. Hamlen, 1841), 49. Kamensky, *Revolution in Color*, 167.

15 Andrew Prescott, "John Pine: A Sociable Craftsman," *Masonic Quarterly* 10 (July 2004), http://mqmagazine.co.uk/issue-10/p-07.php. Peck and Bagger, "Prince Demah Barnes," 157.

16 Advertisement, *Boston News-Letter*, January 7, 1773.

17 Advertisement, *Boston News-Letter*, January 7, 1773. R. G. Bruce relayed Joshua Reynolds's appraisal to John Singleton Copley (August 4, 1776); *Letters and Papers of John Singleton Copley and Henry Pelham*, 41.

18 Henry Barnes to Elizabeth Smith, February 21, 1771, box 1, folder 2, Murray-Robbins Family Papers, Massachusetts Historical Society.

19 Christian Barnes to Elizabeth Murray Smith, March 20, 1770, Christian Barnes Papers.

20 Advertisement, *South Carolina Gazette*, May 30, 1743; Kariann A. Yakota, "Not Written in Black and White: American National Identity and the Curious Color Transformation of Henry Moss," *Common-place* 4, no. 2 (January 2004), http://www.common-place-archives.org/vol-04/no-02/yokota/; Laurel Daen, "Martha Ann Honeywell: Art, Performance, and Disability in the Early Republic," *Journal of the Early Republic* 37, no. 2 (Summer 2017): 225–50. Advertisement, *Boston News-Letter*, January 7, 1773. For the inscriptions, see: Peck and Bagger, "Prince Demah Barnes," 155.

21 Jasmine Nichole Cobb, *Picture Freedom: Remaking Black Visuality in the Early Nineteenth-Century* (New York: New York University Press, 2015), 35–37. Thomas Jefferson, *Notes on the State of Virginia*, in *The Portable Thomas Jefferson*, ed. Merrill D. Peterson (New York: Penguin Books, 1975), 188–89. Simon Gikandi, *Slavery and the Culture of Taste* (Princeton, NJ: Princeton University Press, 2011), 102–4.

22 Samuel A. Cartwright, "Diseases and Peculiarities of the Negro Race," *De Bow's Review* 11 (July 1851): 66, 67, and 69. Mark M. Smith, *How Race Is Made: Slavery, Segregation and the Senses* (Chapel Hill: University of North Carolina Press, 2006), 43–44. Christian Barnes to Elizabeth Smith, February 9, 1770, Christian Barnes Papers. Advertisement, *Boston News-Letter*, January 7, 1773.

23 Gillian Forrester, "Mapping a New Kingdom: Belisario's Sketches of Character," in *Art and Emancipation in Jamaica: Isaac Mendes Belisario and His Worlds*, by T. J. Barringer, Gillian Forrester, and Barbaro Martinez-Ruiz (New Haven, CT: Yale University Press for the Yale Center for British Art, 2007), 66–87, esp. 78–79.

24 Jonathan Prude, "'To Look Upon the 'Lower Sort': Runaway Ads and the Appearance of Unfree Laborers in America, 1750–1800," *Journal of American History* 78, no. 1 (June 1992): 124–59, esp. 141. Solomon Northrup, *Twelve Years a Slave . . .* (Auburn, NY, 1853), 183.

25 Robert Desroches Jr., "Slave-for-Sale Advertisements and Slavery in Massachusetts, 1704–81," *William and Mary Quarterly* 59 (July 2002): 623–64; Jared Ross Hardesty, *Unfreedom: Slavery and Dependence in Eighteenth-Century Boston* (New York: New York University Press, 2016).

26 Christian Barnes to Elizabeth Smith, undated letter after November 24 and before December 17, 1770; March 20, 1770; May 11, 1770, Christian Barnes Papers.

27 "The Art of Painting, Limning &c. with a Curious Copper—Plate," *Universal Magazine of Knowledge and Pleasure* (London), November 1748, 225–33, quotations 231–32. Margaretta M. Lovell, *Art in a Season of Revolution: Painters, Artisans, and Patrons in Early America* (Philadelphia: University of Pennsylvania Press, 2005), 56–58.

28 Ten hours is an approximation based on the guidelines provided in "The Art of Painting, Limning &c. with a Curious Copper—Plate," 231–32.

29 Henry Barnes to Elizabeth Smith, February 21, 1771, Murray-Robbins Family Papers. Christian Barnes to Elizabeth Smith, March 20, 1770, Christian Barnes Papers.

30 Sarah S. Hughes, "Slaves for Hire: The Allocation of Black Labor in Elizabeth County, Virginia, 1782 to 1810," *William and Mary Quarterly* 35, no. 2 (1978): 260–86; Wendy Warren, *New England Bound: Slavery and Colonization in Early America* (New York: W. W. Norton, 2016), 143. Christian Barnes to Elizabeth Smith, July 22, 1773, Christian Barnes Papers.

31 Christian Barnes to Elizabeth Smith, July 22, 1773, Christian Barnes Papers. Christian first mentioned having a copy made to Elizabeth in a letter of March 9, 1772, Christian Barnes Papers. Gainsborough quoted in D. Mannings, "At the Portrait Painter's: How the Painters of the Eighteenth Century Conducted their Studios and Sittings," *History Today* 27, no. 5 (1977): 279–87, quotation 287.

32 Christian Barnes to Elizabeth Smith, March 9, 1772, Christian Barnes Papers.

33 Rosenthal, "She's Got the Look!" 150–51. Lillian B. Miller, ed., *The Selected Papers of Charles Willson Peale and His Family*, vol. 5, *The Autobiography of Charles Willson Peale* (New Haven, CT: Yale University Press, 2000), 155.

34 Jefferson, *Notes on the State of Virginia*, 187. Mary Frances Berry, "'Reckless Eyeballing': The Matt Ingram Case and the Denial of African American Sexual Freedom," *Journal of African American History* 93, no. 2 (Spring 2008): 223–34.

35 Isabel Breskin, "'On the Periphery of a Greater World': John Singleton Copley's 'Turquerie' Portraits," *Winterthur Portfolio* 36:2/3 (Summer–Autumn 2001), 97–123; Carrie Rebora Barratt, *John Singleton Copley and Margaret Kemble Gage: Turkish Fashion in Eighteenth-Century America* (San Diego, CA: Putnam Foundation, 1998), 24–33.

36 Marcia Pointon, *Portrayal and the Search for Identity* (London: Reaktion Books, 2013), 9.

37 Peck and Bagger, "Prince Demah Barnes," 157–58. The phrase "imbalanced visual economy" is Rosenthal's; see: "She's Got the Look!" 147.

38 Last Will and Testament of Prince Demah, March 11, 1778, admitted to probate April 2, 1778, docket no. 16505, Suffolk County Probate Records, Massachusetts State Archives, Boston. Peck and Bagger, "Prince Demah Barnes," 158. Gary B. Nash, "The African Americans' Revolution," in *Oxford Handbook of the American Revolution*, ed. Edward G. Gray and Jane Kamensky (Oxford: Oxford University Press, 2012), 250–70; Daniel R. Mandell, "'A Natural & Unalienable Right': New England Revolutionary Petitions and African American Identity," in *Remembering the Revolution: Memory, History, and Nation Making from Independence to the Civil War* (Amherst: University of Massachusetts Press, 2013), 41–57.

# "CAPITAL LIKENESSES"

## GEORGE WASHINGTON, THE FEDERAL CITY, AND ECONOMIC SELFHOOD IN AMERICAN PORTRAITURE

Ross Barrett

At some point during the 1840s, the Mohawk Valley Bank of Mohawk, New York, began to inscribe its notes and checks with a portrait of the nation's first president (fig. 3.1). This was a carefully calculated design choice. George Washington, who is cast as a revolutionary hero, wears his colonial army uniform and models a classicized oratorical pose. The portrait sought to affirm the credibility of the bank by aligning it with patriotic feeling, civic duty, and deep historicity. While encouraging faith in the institution that issued the note, the portrait also bolsters the note holder's commitments to the financial transactions registered and facilitated by the document.

Standing assuredly before an ambiguous background of curving shadows or smoke, Washington conveys an attitude of serene confidence in a climate of uncertainty. His likeness promotes the optimism one needed to participate in the many other risky financial ventures enabled by the notes of the Mohawk Valley Bank: buying goods, speculating on land without hard currency, accepting a

distant bank's promise to pay as a credible remittance for local assets, transferring or accepting debt obligations, and extending or using credit.

Presenting a founding father as an instructive embodiment of intrepidity, the portrait offered inspiration and validation to the prospective buyer, borrower, or investor: even as it urged note holders to conduct their financial business confidently, the modest image cast speculative audacity as a deeply rooted American value.

Whether antebellum investors knew it or not, the engraved likeness that graced Mohawk Valley Bank notes was part of a body of portrait images that aligned George Washington with the priorities of the liberal capitalist economy that took shape in the United States during the long nineteenth century (1789–1914). This body of imagery has received relatively little attention from scholars. While good work has been done to reconstruct how Washington's likeness was harnessed to trumpet the ideals of republicanism, proslavery ideology, and sentimental domesticity, few efforts have been made to understand how eighteenth- and nineteenth-century portraits of the president spoke to, and helped to buttress, liberal economic ideals and the speculative ethos of market capitalism.[1]

**Fig. 3.1**
Mohawk Valley Bank check, 1848
Private collection

To begin to shed light on this visual tradition, one should first consider its roots, and two late-eighteenth-century portraits of Washington—Josef Perovani's *George Washington* (1796; see fig. 3.3) and Edward Savage's *The Washington Family* (1789–96; see fig. 3.5)—provide a means for examining the president's involvement in risky enterprise. Perovani's and Savage's pictures, more specifically, foreground Washington's management of a major speculative venture: the development of the new national capital or "federal city" (as it was known at the time).

While *George Washington* and *The Washington Family* developed within different market conditions and experienced divergent cultural afterlives, Perovani's and Savage's pictures were both completed in the vibrant political environment of early-republican Philadelphia, and both contended with the debates that arose in that city (and elsewhere) around the capital project. The scheme for the federal city was highly controversial in its moment. Federalists embraced it, whereas republicans decried the capital venture as an elaborate swindle, a monument to vanity, and a ridiculous folly. These arguments were fueled by broader disagreements about the place of speculation and financial endeavor in the nation's economy—an issue that took on new importance as the banking system expanded in the 1790s. Conceived and composed in this climate of transformation and conflict, *George Washington* and *The Washington Family* advanced laudatory accounts of Washington's work as a developer, which affirmed the credibility of the federal city project and the rectitude of forward-looking speculative enterprise. In so doing, Perovani's and Savage's portraits used the likeness of the president to outline, and advocate for, new modes of economic selfhood and familial belonging that were suited to the dynamics and quandaries of modern market society.

Casting Washington as a virtuous risk taker and a patriotic projector, *George Washington* and *The Washington Family* contributed to a broader cultural effort, spearheaded by liberal economic thinkers, to celebrate

the emerging market economy and link commercial and financial adventurism with national advancement. At the same time, these canvases greatly expanded the visual lexicon that American portraitists employed to visualize economic aspects of identity. Weaving together traditional and innovative elements, *George Washington* and *The Washington Family* shaped visions of enterprising endeavor that set the terms for future imaginings of the first president and other intrepid speculators, entrepreneurs, promoters, and property owners.

## "A MERE SORT OF CASTLE-BUILDING DREAM": WASHINGTON'S FEDERAL CITY

*George Washington* and *The Washington Family* share a common focal point. Perovani's painting depicts Washington gesturing toward a plan of the new national capital. The document's general format and detailed street diagram recall the large-edition plan that Andrew Ellicott designed and James Thackara and John Vallance engraved in November 1792 (fig. 3.2).[2] Three members of Savage's group portrait touch, grasp, or gesture toward another copy of the Ellicott plan that unfurls across the table at the heart of the scene. By using these documents as compositional foci, *George Washington* and *The Washington Family* highlight the major construction venture undertaken by the president during the last decade of his life while alluding to Washington's contributions to the nation's material development and political maturation. In so doing, they also engage the aspect of Washington's grand undertaking that most alarmed period observers—its intertwining with boosterism and speculation.

Perovani's and Savage's painted plans function, on one level, to evoke and celebrate Washington's management of the federal city project.[3] The president selected the city's site in 1791 and devoted his final years to overseeing the design, financing, marketing, and development of the capital. Perovani's and Savage's portraits invoke an especially significant facet of this work: Washington's role

in the city's creation. After commissioning Pierre Charles L'Enfant to develop a plan in spring 1791, Washington oversaw the completion of the Frenchman's original scheme and its revision in 1792 by surveyor Andrew Ellicott. *George Washington* and *The Washington Family* frame the president as the prime mover behind (if not the author of) the federal city's design by situating recognizable facsimiles of the capital plan at Washington's fingertips. In so doing, Perovani's and Savage's portraits gave visual form to an argument frequently made by supporters of the capital project. Lauding the federal city as "an inconceivable improvement upon all other cities in the world," a 1791 *Maryland Journal* notice emphasized that the capital's design had developed "agreeably to the directions of the President of the United States." In similar fashion, a *Gazette of the United States* article declared, "We need only cast our eyes upon . . . the plan of the city, to recognize in them the comprehensive genius of the President ."[4]

In adopting the engraved plan as a primary pictorial element, Perovani's and Savage's paintings also engaged the capital project's controversial economic dynamics. Washington and his commissioners faced significant budgetary challenges as they set out to build the capital; the city's rustic site required capital-intensive improvements, and the president had little state funding at his disposal. Seeking to make up this shortfall with private capital, Washington and the commissioners worked in various ways to encourage investment in the new city. The president urged associates to buy up capital land, administered three public sales of city lots aimed at investors, approved an ill-conceived lottery offering an in-town hotel as a grand prize, and endorsed a highly leveraged speculation on city parcels by financiers James Greenleaf, Robert Morris, and John Nicholson.[5]

To build public interest in these initiatives, backers promoted the federal city in a variety of cultural venues. Washington and the commissioners made sure that glowing accounts of the city appeared in newspapers, broadsides, and pamphlets.[6] Downplaying its rusticity, these texts projected a golden future for the capital, assuring investors that it would "grow up with a degree of rapidity hitherto unparalleled," become "the most considerable city in America," and garner "the admiration and delight of the world."[7] Supporters used imagery to extend these claims. Washington and his deputies had L'Enfant's original design reproduced in various forms, including standalone engravings, pen-and-ink copies, and magazine illustrations.[8] This stream of promotional images culminated with Ellicott's 1792 large-format plan, a dazzlingly detailed representation that capital backers shipped to land agents on the East Coast, in England, and across Europe. The Ellicott plan paired a revised rendering of L'Enfant's design with a fuller array of information and imaginative embellishments than had appeared in earlier depictions. The plan delineates all 1,146 squares of purchasable property in the capital, records the depths of the Potomac and Anacostia Rivers, includes conjectural renderings of the unbuilt White House and capitol, and incorporates textual descriptions of tributaries, streets, and building locations. Taken together, these bits of data and fancy infused the city with concreteness and promise, refiguring the tenuous venture as an emerging metropolis blessed with favorable environmental conditions, teeming with investment opportunities, and poised on the cusp of a glorious future.

By granting prominent position to the Ellicott plan, then, Perovani's and Savage's portraits drew attention to Washington's management of the marketing and financing of the federal city—aspects of the project that worried many observers. Economic conservatives and democratic republicans were deeply troubled by the speculative dynamics of the capital project and the imaginative projections that sustained it. As various scholars have shown, speculation threatened the customary notions of work and profit that these traditionalists held dear: fiscal conservatives argued that speculators sought to make money by gambling on the future rather than making useful

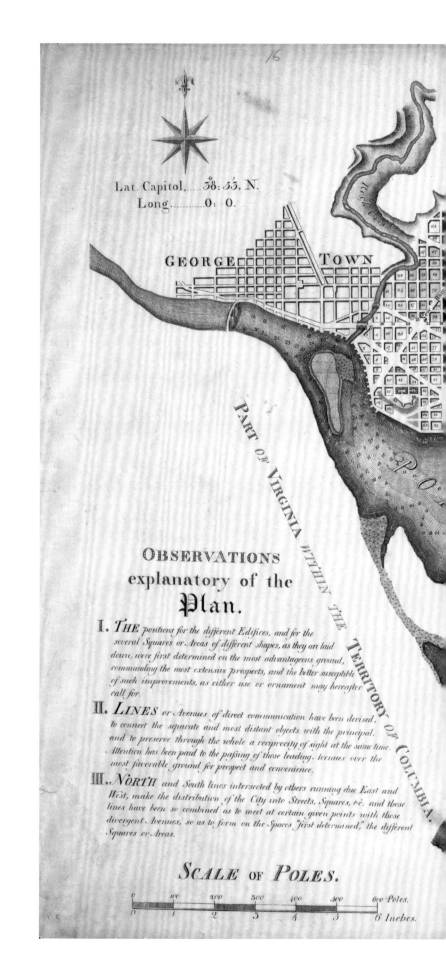

**Fig. 3.2**
*Plan of the City of Washington in the Territory of Columbia* by James Thackara and John Vallance, after Andrew Ellicott and Pierre Charles L'Enfant, 1792
Engraving, 51 × 68 cm (20 × 26 in.)
Library of Congress; Geography and Map Division

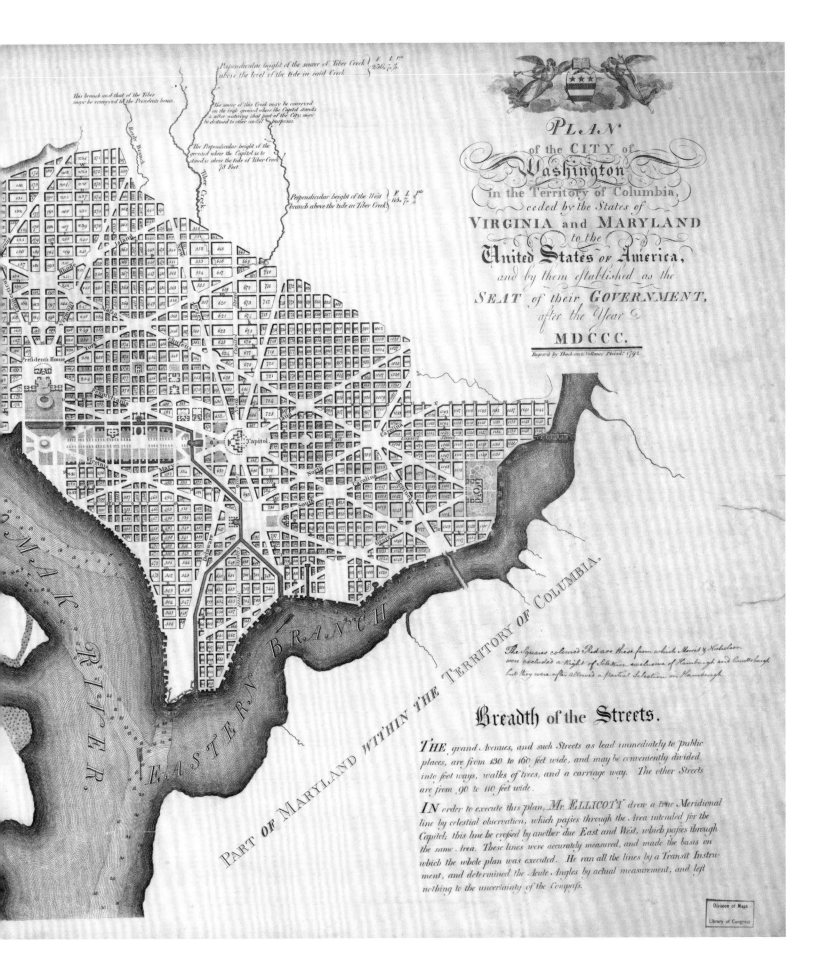

Perpendicular height of the source of Tiber Creek }  F. I.th
above the level of the tide in said Creek.            } 236. 7. ½.

This branch and that of the Tiber
may be conveyed to the Presidents house.

The centre of this Creek may be conveyed
on the high ground where the Capitol stands
& after watering that part of the City may
be destined to other useful purposes.

The Perpendicular height of the
ground where the Capitol is to
stand is above the tide of Tiber Creek
78 Feet.

Perpendicular height of the West  }  F. I.th
branch above the tide in Tiber Creek }  115. 7. ½

Rock Branch.

Tiber Creek

Presidents House.

Capitol

POTOMAK RIVER.

EASTERN BRANCH

PART OF MARYLAND WITHIN THE TERRITORY OF COLUMBIA.

The Squares coloured Red are those from which Morris & Nicholson
were excluded a Right of Selection exclusive of Hamburgh and Carrollsburgh
but they were after allowed a partial Selection in Hamburgh.

## PLAN
of the CITY of
### Washington
in the Territory of Columbia,
ceded by the States of
### VIRGINIA and MARYLAND
to the
### United States of America,
and by them established as the
### SEAT of their GOVERNMENT,
after the Year
### MDCCC.

Engraved by Thackara & Vallance Philad.ª 1792

## Breadth of the Streets.

THE grand Avenues, and such Streets as lead immediately to public
places, are from 130 to 160 feet wide, and may be conveniently divided
into foot ways, walks of trees, and a carriage way. The other Streets
are from 90 to 110 feet wide.

IN order to execute this plan, Mr. ELLICOTT drew a true Meridional
line by celestial observation, which passes through the Area intended for the
Capitol; this line he crossed by another due East and West, which passes through
the same Area. These lines were accurately measured, and made the basis on
which the whole plan was executed. He ran all the lines by a Transit Instru-
ment, and determined the Acute Angles by actual measurement, and left
nothing to the uncertainty of the Compass.

things for the present, trading in weightless fantasies rather than the solid products of factory and farm, and creating strange new forms of value seemingly out of thin air.[9] Working from this perspective, capital opponents critiqued the federal city project as a folly propelled by dreams and delusion. In a 1796 congressional debate, for example, republican representative John Swanwick described the capital as an "airy fiction of speculation, a mere sort of castle-building dream, such as a man oversees when he rises out of bed."[10] Other opponents attacked the creative embellishments of capital publicity. The 1796 pamphlet *Look before You Leap!* thus decried the disingenuousness of pictorial promotions of the city; considering an unspecified plan (possibly the Ellicott print), the pamphlet noted that "The five streets so pompously lain out in the map which we examined" are in fact "avenues cut through the woods, with not a solitary house standing in either of them."[11] These deceptive representations, critics warned, would mislead and bankrupt the novice investor. A 1797 *Charleston City Gazette* editorial accordingly argued, "The pompous descriptions of the flourishing and progressive condition of Washington, have already occasioned the ruin of too many industrious citizens."[12]

Organizing their compositions around a recognizable rendition of the Ellicott plan, *George Washington* and *The Washington Family* present the viewer with a multivalent emblem that speaks to the president's management of the design of the capital and the controversial speculative and promotional campaigns that arose around it. But Perovani's and Savage's portraits do much more than cite these contentious activities. Though they evolved within different conditions of patronage and addressed disparate audiences, *George Washington* and *The Washington Family* outline visions of Washington's land dealings that affirm the credibility of the capital project, tout the virtue of risky enterprise and forward-looking imaginative projection, and counter critiques of the federal city.

## *GEORGE WASHINGTON* AND PRUDENT ENTERPRISE

In 1796, the Philadelphia-based Spanish diplomat Josef de Jáudenes y Nebot commissioned Italian émigré artist Josef Perovani to compose a full-length portrait of George Washington.[13] Jáudenes hoped to obtain a picture of the American president that he could give to Spanish Prime Minister Manuel Godoy y Álvarez de Faria to mark that official's successful negotiation of the 1795 Treaty of San Lorenzo (also known as Pinckney's Treaty), which established an alliance between Spain and the United States. Working to satisfy his patron, Perovani developed a multilayered interpretation of the president that spoke to the diplomatic dynamics of the treaty, celebrated Washington's work as capital developer, and aligned the leader with a new construct of audacious endeavor.

A peripatetic figure, Josef Perovani left relatively few documentary traces behind. After a childhood spent in Brescia, he launched his painterly career in Venice in the 1780s. In July 1795, Perovani resettled in Philadelphia, establishing a studio at 87 Second Street.[14] Then, around 1801, he left the United States for Havana, where he worked until 1804; the artist relocated to Mexico City around that date and remained there until his death, of cholera, in 1835.[15] Perovani's work seems to have eluded critical attention in these various settings. As Isadora Rose-de Viejo has noted, *George Washington* was not in Philadelphia long enough for the local press to respond to it. Jáudenes set sail for Spain with the painting on July 25, 1796, mere weeks after its completion. Displayed initially in Godoy's Madrid palace and then moved in 1813 to the Real Academia de Bellas Artes de San Fernando, where it can be seen today, the portrait inspired no public commentary until 1918, when it was briefly mentioned in a scholarly article about the artist José de Ribera.[16]

Fig. 3.3
*George Washington* by Josef Perovani, 1796
Oil on canvas, 219.7 × 144.8 cm (86⅝ × 57⅛ in.)
Museo de la Real Academia de Bellas Artes de San Fernando, Madrid

Perovani seems to have worked on the margins of the respectable art world during his brief stay in Philadelphia. Surviving evidence suggests that he undertook a range of projects in these years, including portraits, frescoes, and historical subjects.[17] Perovani also participated actively in local political life. In 1796, he painted backdrops and a curtain for a circus performance held in Washington's honor at Ricketts's New Amphitheater, a local venue that regularly hosted pro-administration entertainments.[18] Perovani's curtain featured "the bust of President Washington . . . crowned by Immortality and Liberty," an "eagle supporting the arms of America," and allegorical figures of Minerva and Posterity.[19] The artist produced similar curtains for a 1797 "festival ballet dance" in New York that was likewise given "in honor of the president of the United States."[20]

Perovani seems to have drawn on his knowledge of pro-administration patriotic culture and neoclassical allegory as he composed his monumental portrait of the president (fig. 3.3). Setting to work in the spring of 1796, Perovani apparently modeled the composition of his picture on Gilbert Stuart's contemporaneous full-length portrayal, now known as the "Lansdowne Portrait" after its first owner (fig. 3.4).[21] Like Stuart's canvas, *George Washington* pictures the president in a grand portico with monumental columns and red drapery, standing beside a gilded table, and casting an outstretched arm leftward. Perovani's portrait modifies this format, however, by introducing elements that speak to Washington's work as a diplomat and developer. Two specific documents are on the desk at Washington's side: the capital plan and a folded paper inscribed with the official title of the Treaty of San Lorenzo ("Treaty of Friendship, Limits, and Navigation between Spain and the United States") as well as the signatures of the two officials who negotiated the agreement (Thomas Pinckney and "El Príncipe de la Paz," or Manuel Godoy). The portrait also incorporates a fictive marble sculpture of two allegorical figures in its grand setting. The figure on the left, who bears attributes customarily associated with justice, clutches

a fasces, while the one on the right holds a mirror with a winding snake, alluding to prudence.[22] In the background, the billowing drapery behind Washington lifts to reveal a distant harbor scene on the left edge of the portrait.

Together, these elements glorify Washington's diplomatic engagements with Spain. As treaty negotiations began in the fall of 1795, Spanish and American officials pursued disparate objectives. Godoy and King Charles IV of Spain hoped to forge an alliance that would stabilize Spain's position in Europe, counteract British influence on the United States, and protect Spanish Louisiana against French incursions.[23] Washington's administration aimed to open New Orleans and the Mississippi River to American commerce and to move the nation's southern boundary closer to the Gulf Coast. The final agreement, signed on October 27, 1795, established a "firm and inviolable peace and sincere friendship" between the United States and Spain, a nebulous partnership that involved none of the concrete obligations imposed by other treaties of alliance or commerce.[24] In exchange, Spain agreed to shift the border of its Floridian territory southward and to open New Orleans to American shipping.

The Treaty of San Lorenzo was hailed by the Spanish state as a diplomatic triumph, despite its unequal provisions, and Jáudenes seems to have understood his portrait commission as a means by which he could convey his congratulations to Godoy, and perhaps win the prime minister's favor in the process.[25] Whatever Jáudenes's intentions, *George Washington* presents its sitter and the 1795 treaty in their best light. Various suggestive details speak to the agreement's salutary effects. A discarded pile of armor (cuirass, sword, shield), partially hidden under the table, invokes the new peace established by the

**Fig. 3.4**
*George Washington ("Lansdowne" Portrait)* by Gilbert Stuart, 1796
Oil on canvas, 247.6 × 158.7 cm (97½ × 62½ in.)
National Portrait Gallery, Smithsonian Institution; acquired as a gift to the nation through the generosity of the Donald W. Reynolds Foundation

treaty. And the little harbor view at left offers a glimpse of the improved economic relationship promised by the agreement; picturing a ship flying Spanish merchant marine and American flags in a tranquil harbor, the scene reimagines the contested port of New Orleans as a hub of harmonious international commerce.

*George Washington* similarly extols the political alliance created by the Treaty of San Lorenzo. The portrait works in various ways to cast its sitter as an experienced and virtuous statesman, the sort of leader who would make for an ideal ally. The scene thus includes evocations of the American president's legislative acumen (legal texts at lower right) and patriotic commitment (black cockade at left).[26] At the same time, the sculpted figures of Prudence and Justice serve to affirm the strength of Washington's character. Prudence and justice, along with temperance and fortitude, represent the four cardinal virtues, ideals of ethical conduct that had been central to moral philosophy since the classical past and that played a significant role in eighteenth-century moral commentary.[27] Public tributes to Washington frequently invoked the cardinal virtues when trumpeting his moral ideality. For example, the 1787 inaugural address of his successor, John Adams, praised Washington as a "citizen who by a long course of great actions, regulated by prudence, justice, temperance, and fortitude . . . has merited the gratitude of his fellow-citizens . . . and secured immortal glory."[28] Picturing Washington with allegorical evocations of these ideal characteristics and a host of other suggestive attributes, Perovani's portrait casts the president as an experienced, patriotic, and principled leader. By portraying its sitter as an ideal statesman, *George Washington* implicitly celebrated the treaty that bound its subject to Spain. Perovani's portrait suggests that by entering into an alliance with Washington, Godoy and the Spanish state had secured an ideal international partner.

In its efforts to lionize the American president, *George Washington* engages another aspect of the leader's public endeavors: his involvement in the federal city project.

Because the portrait grants prominent position to the most recognizable pictorial production of that undertaking, it draws suggestive formal connections between the Ellicott plan and the signed text of the Treaty of San Lorenzo. Positioned together on a marble-topped desk, set just beneath an inkpot holding two quills, and rendered in similar tones (both are delineated in gray and tan pigment), the plan and treaty can be read as comparable products of a single process of work and thought. Other nearby elements suggest, in turn, that these documents share certain symbolic functions. Positioned just above the treaty document and linked to it by an arcing quill, the harbor view presents a glowing fantasy of post-treaty New Orleans and offers a peek at the ideal future that the diplomatic agreement aimed to produce. By pairing these elements, Perovani's portrait subtly highlights the treaty's status as a creative projection, an imaginative attempt to conjure up and actualize an as yet unrealized state of being—a work of inventive forecasting, in other words, that resonates with the imaginative city plan underneath it. And by juxtaposing the treaty text and the speculative plan in this way, the painting encourages us to understand the 1795 Spanish-American alliance as something like a wager on the future, an audacious venture undertaken in the face of risk and uncertainty.

Other elements of the portrait speak, in turn, to Washington's capacity to navigate the challenges posed by these perilous endeavors. The allegorical figure of Prudence is crucial in this regard because while the sculpture at once invokes customary understandings of moral virtue, it also ties Washington to a new set of ideal entrepreneurial traits posited by liberal economic thinkers of the period. Working to theorize forms of market endeavor that were remunerative and socially beneficial, liberal intellectuals turned frequently to the construct of prudence. In arguing for the extension of credit to risk-taking entrepreneurs, for example, Jeremy Bentham identified the "prudent and well-grounded projector" as an ideal embodiment of

audacious enterprise.[29] Economist and philosopher Adam Smith likewise cast the "prudent man" as a new paragon of ambitious endeavor, arguing that when this figure

> enters into any new projects or enterprises, they are likely to be well concerted and well prepared. He can never be hurried or drove [sic] into them by any necessity, but has always time and leisure to deliberate soberly and coolly concerning what are likely to be their consequences.[30]

Drawing on prudence's association with practical wisdom—connotations the term had attained over several centuries of everyday usage, apart from moral philosophy—Smith, Bentham, and other thinkers extolled the "prudent man" as a rational, conscientious, and deliberate venturer, an economic actor perfectly equipped to navigate the challenges posed by modern markets and carry off ambitious "projects or enterprises."

Perovani's allegorical sculpture of Prudence quietly invokes a virtue, then, that was central to liberal imaginings of ideal enterprise. Positioned between this suggestive sculpture and the documents on his desk, Washington would seem to perform the persona of the "prudent projector" described by Bentham and Smith. While directing his attention and energies toward the ambitious projects of international diplomacy and speculative city building, the president draws literal and metaphorical support from prudence by draping his arm over the virtue's sculptural personification.

By aligning the president with liberal constructs of prudence and affirming his fitness to realize the audacious objectives of the Treaty of San Lorenzo and federal city scheme, George Washington intensified its lionization of the American leader. Casting Washington as a conscientious projector and the capital venture as a carefully conceived undertaking, the portrait rejected opponents' vision of the city as a work of folly or delusion

and affirmed arguments regularly made by supporters of the project. While acknowledging the venture's speculative audacity, these advocates insisted that Washington and the commissioners were prepared to see the capital project through to completion.[31] In 1796, for example, travel writer Henry Wansey described the capital as a long-contemplated and deliberately planned undertaking. After noting that Washington had been "strongly impressed with . . . the future importance" of the Potomac, Wansey argued that the leader had waited to begin development on the waterway "until time and circumstances should enable him to bring it forward with a prospect of success."[32]

## THE WASHINGTON FAMILY, PROPERTY, AND POSTERITY

Edward Savage's group portrait of the Washingtons makes its own efforts to commend the president's management of the capital project and ratify the prospects of that venture. The Washington Family (fig. 3.5) also strikes out in a new direction, however, harnessing its rendering of the capital plan to advance a vision of kinship that overturns customary familial representations and engages novel understandings of property and posterity that were emerging in the period.

Savage spent several years developing his multivalent likeness of the Washingtons.[33] After composing oil sketches of George and Martha Washington and Martha's grandchildren, George Washington Parke Custis and Eleanor Parke Custis, in 1789 and 1790, Savage worked intermittently over the next six years to develop a full-scale group portrait. In the process, he added a liveried slave to the scene and reworked the likeness of Washington to accord with a standalone portrait of him that he had made in 1793 (fig. 3.6). Savage unveiled the finished canvas in Philadelphia on February 22, 1796 (Washington's sixty-fourth birthday), and made the work a focal point within his Columbian Gallery on Chestnut Street. The portrait was warmly received; critics praised its depictions of George and Martha as "capital likenesses," and delighted in the

**Fig. 3.5**
*The Washington Family* by Edward Savage, 1789–96
Oil on canvas, 213.6 × 284.2 cm (84 1/8 × 111 7/8 in.)
National Gallery of Art, Washington, DC
Andrew W. Mellon Collection

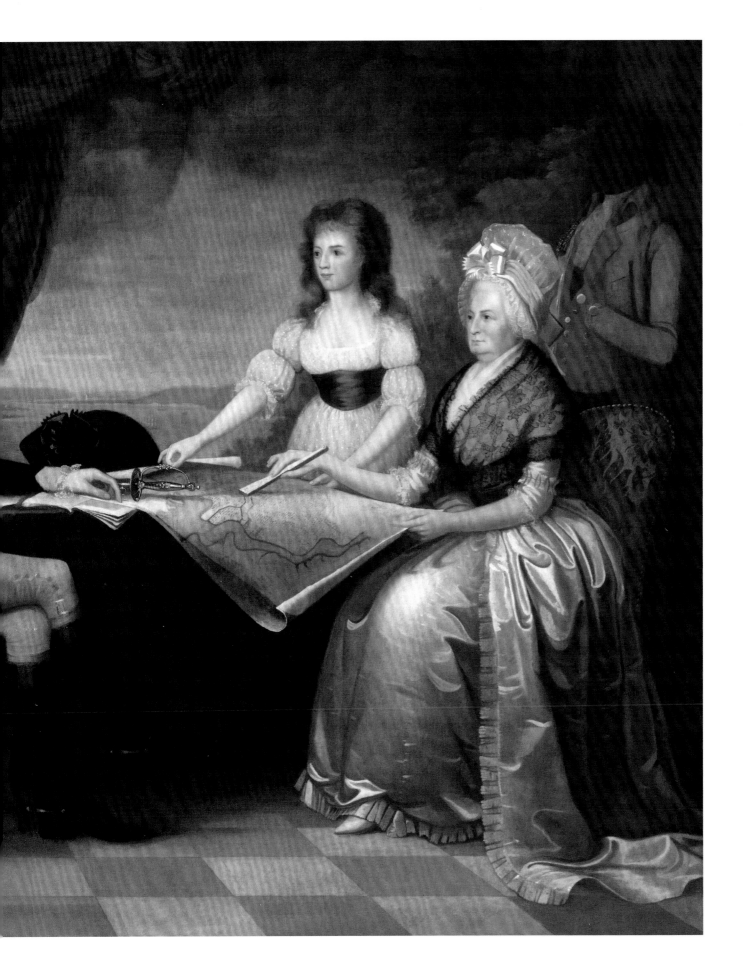

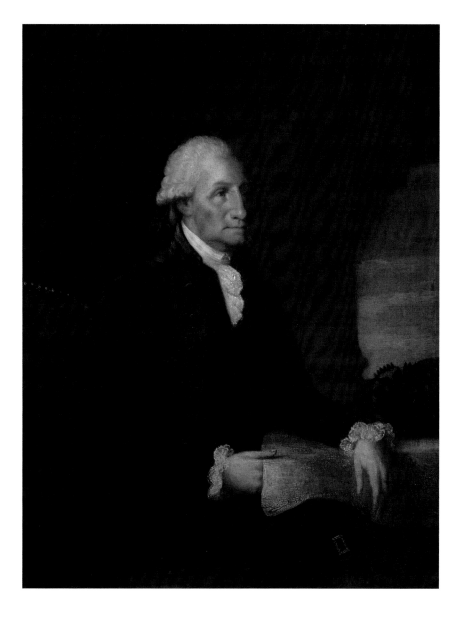

Fig. 3.6
*George Washington*
by Edward Savage, 1793
Oil on mahogany panel
47 × 35.9 cm (18½ × 14⅛ in.)
The Art Institute of Chicago;
gift of Catherine Colvin

picture's rendering of the "plan of the federal city" and the Potomac River valley beyond.[34] Capitalizing on this success, Savage published an engraving of *The Washington Family* in 1798 that was wildly popular and exceptionally lucrative. In a letter to Washington penned that summer, Savage predicted, with quiet glee, that the engraving would garner $10,000 (or nearly $200,000 in today's currency) in subscriptions "in one twelvemonth."[35] Savage's unusually successful print would in turn inspire dozens of copies over the next century.

Part of the appeal of Savage's portrait likely derived from its balanced engagement with vaunted artistic precedents and everyday domestic experience. *The Washington Family* borrows its basic structure—sitters arranged around a table in a classicized portico overlooking a lambent landscape—from John Smibert's *Bermuda Group* (1728, Yale University Art Gallery, New Haven), a group portrait that commemorated the efforts of philosopher and cleric Dean George Berkeley and his followers to establish a utopian settlement in Bermuda. If the similarly

stately setting of *The Washington Family* invited viewers to understand its sitters as another grand gathering of heroic visionaries, the portrait's figural tableau simultaneously rendered the presidential family in terms that are more relatable. Surrounded by domestic furnishings, dressed in relatively understated fashion, and organized in hierarchized gender groupings, the Washingtons appear as a model bourgeois household, a national family that performs the normative social roles of early republican domestic life.[36] The enslaved figure at right imbues the scene with additional connotations. Likely intended as a sign of the Washingtons' propertied status, the slave also functions as a foil that reaffirms the whiteness of the ideal family group at center. As an indistinctly rendered figure that is both part of and excluded from the Washingtons' circle, the servant simultaneously evokes the hazy place of slavery in period imaginings of the national community.[37]

Taken together, then, the setting and figural dynamics of *The Washington Family* cast the presidential clan as a group of forward-looking venturers and a paradigmatic embodiment of white bourgeois kinship. The portrait's engagement with the Washingtons' land dealings extends these symbolic imperatives. Savage's rendering of the president firstly invokes, and quietly recuperates, the projective outlook that Washington adopted as leader of the federal city venture. Taking up a motif first employed by Savage's 1793 likeness of the president, *The Washington Family* pictures Washington sitting in an ornate chair, touching a copy of the capital plan spread out on a table, and gazing into the distance. This depiction resonated with another type of seated portrait that flourished in the moment, a type associated with the evocation of rational reflection and calculative forecasting: the scientific portrait. As art historian Brandon Brame Fortune has shown, eighteenth-century portraits of gentleman scientists often pictured their subjects seated at a table, handling scientific texts or images, and looking into the distance.[38] Charles Willson Peale's *Benjamin Franklin* (1789, Historical Society

of Pennsylvania), for example, depicts its subject leaning on a copy of his writings on electricity and directing his gaze out of the frame. Other portraits paired sitters with scientific diagrams that referenced their theoretical labor. Matthew Pratt's *Cadwallader Colden and His Grandson Warren de Lancey* (ca. 1772, Metropolitan Museum of Art, New York) thus includes a drawing of Colden's gravitational hypotheses.[39] And the comet diagram that appears in Peale's *David Rittenhouse* (1796, National Portrait Gallery, Washington, DC) alludes to the astronomer's efforts to calculate the movements of celestial bodies.[40]

Late-eighteenth-century scientific portraits used the gaze and the graphic image, then, to evoke their sitters' capacity to accurately observe physical reality, formulate credible hypotheses about abstract phenomena, and mathematically predict future events. Savage was intimately familiar with these pictures: the artist composed his own scientific portraits and reproduced other artists' likenesses, including Peale's 1796 painting of Rittenhouse.[41] By applying these portraits' typical format and key iconographic details, *The Washington Family* quietly realigns the president's outlook with the rational, predictive vision of the scientist. In so doing, the portrait invites us to understand Washington's far-reaching projections as credible prognostications grounded in study and reflection.[42] Period viewers seem to have followed these cues. Describing the president's gaze as "the serene commanding aspect of a venerable man, whose presence alone calms the tempest," an approving *New York Morning Chronicle* review thus associated Washington's far-reaching look with sober-minded rationality.[43]

*The Washington Family* works in other ways to underwrite Washington's farsighted perspective. While establishing the leader's status as a propertied planter, the anonymous slave at right may also quietly work to affirm the concreteness and attainability of Washington's projections. Detached but poised to serve, the slave can be read as an emblem of readily available and obeisant labor— and, as such, an evocation of the president's access to a

productive and pliable workforce capable of realizing his grand visions. Subtly casting Washington as a visionary and a manager of labor power, *The Washington Family* echoes promotional accounts that touted capital backers' successful organization and deployment of enslaved workers around the nascent federal city site.[44]

Even as it affirms the rationality and feasibility of the president's projections, *The Washington Family* manages to explore the broader Washington clan's relationship to the speculative federal city project. As period viewers often noted, the Ellicott plan serves as the primary pictorial and narrative "glue" for Savage's familial ensemble.[45] Spreading across the table, the plan connects the two halves of the figural tableau and submits to the pinches, prods, and tugs of three members of the Washington family. This structure works on one level to evoke the multigenerational family's commitment (present and future) to the capital project. Certain elements within the group attest in turn to the material character of these commitments. Between 1793 and 1798 Washington bought lots in at least five squares scattered across the planned city; all of these were investment properties, chosen with the idea that they might generate lucrative rents for, or be profitably resold by, Washington family members.[46] Two elements within Savage's figural tableau highlight areas on the city plan where the president purchased land (see figs. 3.7 and 3.8). The silver pommel of Washington's sword hovers over a spot on the painted map that corresponds to the location of square 21, where Washington bought four lots in 1794. While marking the line of Pennsylvania Avenue, the tip of Martha's filigreed fan also covers an area on the plan that corresponds to square 634, a wedge-shaped parcel across from the capitol that Washington bought in 1798 and "improved" with two rental townhouses.[47]

Fig. 3.7
*The Washington Family* (detail),
1789–96 (see fig. 3.5)

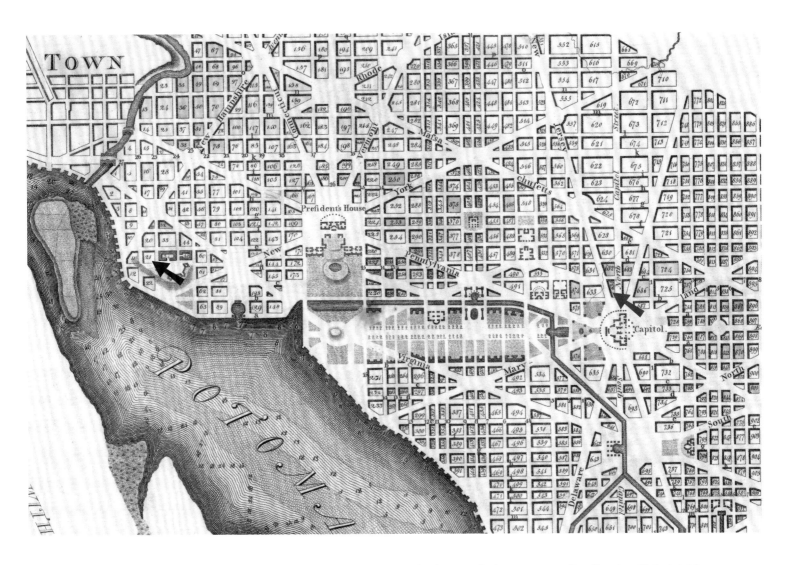

**Fig. 3.8**
*Plan of the City of Washington in the Territory of Columbia* (detail; red arrow: square 21; blue arrow: square 634), 1792 (see fig. 3.2)

By visualizing the Washingtons' sustained attention to, and investments in, the federal city project, Savage's portrait affirmed the venture's present and long-term viability. In using a familial framework to project a future for the capital scheme, *The Washington Family* simultaneously responded to satirical accounts that used the themes of birth and blood to critique the federal city venture. A popular 1790 *New York Journal* story, for example, used humorous personifications of the capital and Philadelphia to disparage the former city's prospects; after figuring Philadelphia as a healthy infant who bears "symptoms of stamina . . . long life and prosperity," the story casts "Patowmacus" (the capital) as an "illegal" or bastard "offspring" who was "feeble, and scarcely breathed in the birth, and lived but a few moments after the ceremony of baptism."[48] Aligning the capital with virtuous familial longevity, *The Washington Family* countered this and other critical commentary that used the tropes of illegitimacy and stillbirth to slander the federal city as an *ill*-conceived undertaking.

At the same time, in presenting the Washingtons as an ideal domestic group that coheres around real-estate speculation, Savage's canvas advances a new vision of

land-based kinship that reworks one of the period's most prevalent modes of group portraiture and gives striking expression to a novel understanding of familial property that emerged in the late eighteenth and early nineteenth centuries. *The Washington Family* firstly reconfigures the terms of the outdoor conversation-piece. As various scholars have shown, outdoor conversation-piece portraits affirmed the authority of aristocratic sitters by emphasizing their deep ties to familial land.[49] Johan Zoffany's *Three Daughters of John, Third Earl of Bute* and *Three Sons of John, Third Earl of Bute* (both 1763–64, Tate, London), for example, pictured their youthful sitters cavorting on the grounds of Luton Hoo, the family seat in Bedfordshire. Juxtaposed with views of fields and outbuildings, these scenes of outdoor fun bind the children of John Stuart to the natural life and landscape of the family's grand estate. Arthur Devis's *Henry Fiennes Clinton with Wife and Son* (ca. 1751, private collection) similarly ties its noble sitters to the landscape of Oatlands, the countryseat that Clinton (who was the ninth earl of Lincoln) maintained in Surrey. *The Washington Family* advances an account of familial landholding that diverges radically from these and other aristocratic precedents. If the customary conversation piece imagined rootedness in a heritable estate as the foundation of noble family identity, Savage's picture aligns the Washingtons with a mode of kinship defined by investment in fungible properties and premised on a fundamental alienation from the (commodified) landscape.

In so doing, *The Washington Family* visualized a new construct of familial property holding that period observers detected in all corners of the commercializing republic. Discussing speculation in upstate New York, J. Hector St. John de Crèvecoeur noted in 1801 that "wiser farmers content themselves with buying select parcels which they keep up as a precious reserve for their children."[50] Confronting a market society defined by volatility and class fluidity, middle-class Americans increasingly embraced land speculation as a means by which to buttress their domestic

existence, build a "precious reserve for their children," and secure their familial futures. By picturing the Washingtons gathered around a real-estate map and attending collectively to the details of land dealing, Savage's portrait renders the presidential clan as a kind of figurehead for this novel approach to the management of family property and posterity. In the process, *The Washington Family* works out an updated iteration of the traditional conversation piece keyed to the priorities of modern market society.

## CONCLUSION

In their respective likenesses of Washington and his family, Josef Perovani and Edward Savage highlighted the president's controversial efforts to finance, promote, and build the national capital. As we have seen, Perovani's and Savage's portraits countered the claims of the president's opponents by celebrating Washington's projective outlook and reaffirming the rationality and viability of the capital project. In the process, these works reimagined the president and his family as ideal embodiments of new forms of enterprise and familial landholding that were keyed to the challenges of modern capitalism: risk, uncertainty, the volatility of the market, and the tenuousness of class status.

In their efforts to glorify the president's real-estate ventures, *George Washington* and *The Washington Family* expanded the visual language that American artists used to represent facets of economic selfhood. Early American portraitists had previously employed certain customary signs to visualize the economic endeavors of their sitters: portraits of merchants used ledger books to evoke commercial success, and likenesses of planters featured views of cultivated fields.[51] By organizing their portraits around a real estate map aimed at investors, Perovani and Savage helped introduce a variety of attributes to the lexicon of fiscally themed portraiture, a type that spoke to the audacious puffery, speculative daring, and creative paperwork that came to define economic endeavor in the long nineteenth century. Later artists frequently incorporated promotional

and financial paperwork in their renderings of bankers, boosters, entrepreneurs, speculators, and developers. Ezra Ames's *Simeon de Witt* (ca. 1804, Zimmerli Art Museum, Rutgers University, New Jersey) and Samuel Waldo's *William L. Marcy* (1834, Albany Institute of History and Art, New York), for example, include maps that promote their sitters' administration of land speculation and canal development in New York State. In similar fashion, nineteenth-century portraits of businessmen were regularly used in stock certificates, corporate charters, and other documents to evoke their sitters' financial undertakings.[52] And vernacular likenesses frequently pictured everyday Americans with maps, deeds, and other real-estate documents that reaffirmed their investing savvy and proprietorship.[53]

Finally, while shaping the means by which American portraits represented modern economic endeavor, Perovani's and Savage's likenesses of Washington set the terms for a wave of nineteenth-century imagery that aligned the first president with market ideals. Several generations of print copies of *The Washington Family* kept alive the Washingtons' identity as audacious investors.[54] This all happened as countless commercial and financial documents—including banknotes, stock certificates, and mortgage deeds—included Washington's likeness in their compositions. Glorifying the president as an icon of prudent enterprise and heroic audacity, these portraits all harken back to the interpretations first advanced by *George Washington* and *The Washington Family*.

Notes

1 See, for example, Dorinda Evans, *The Genius of Gilbert Stuart* (Princeton: Princeton University Press, 1999), 60–74; Maurie McInnis, "Revisiting Cincinnatus: Houdon's George Washington," in *Shaping the Body Politic: Art and Political Formation in Early America*, ed. Maurie McInnis and Louis P. Nelson (Charlottesville: University of Virginia, 2011), 128–61; Maurie McInnis, "The Most Famous Plantation of All: The Politics of Painting Mount Vernon," in *The Landscape of Slavery*, ed. Angela Mack and Stephen Hoffius (Columbia: University of South Carolina Press, 2008), 86–114; Scott Casper, "The First Family: Seventy Years with Edward Savage's *The Washington Family*," *Imprint* (Autumn 1999): 2–15.

2 On Perovani's portrait, see Isadora Rose-de Viejo, *The Portrait of George Washington by Josef Perovani* (Madrid: Museo de la Real Academia de Bellas Artes de San Fernando, 1998); *Gilbert Stuart*, ed. Carrie Rebora Barratt and Ellen G. Miles (New York: Metropolitan Museum of Art, 2004), 173.

3 On Washington and the capital, see Kenneth R. Bowling, *The Creation of Washington D.C.: The Idea and Location of The American Capital* (Fairfax, VA: George Mason University, 1991); Sarah Luria, *Capital Speculations: Writing and Building Washington* (Hanover: University of New Hampshire Press, 2006); Tom Lewis, *Washington: A History of Our National City* (New York: Basic Books, 2015), 1–116.

4 "For the Maryland Journal," *Maryland Journal*, September 30, 1791, 3; "Essay on the City of Washington," *Gazette of the United States*, February 11, 1795, 2.

5 Bowling, *The Creation of Washington, D.C.*, 209–33; Bruce Mann, *Republic of Debtors: Bankruptcy in the Age of American Independence* (Cambridge, MA: Harvard University Press, 2002), 199–206; Aaron Sakolski, *The Great American Land Bubble* (New York: Harper & Brothers, 1932), 151–64.

6 These include John O'Connor, *Political Opinions Particularly Respecting the Seat of the Federal Empire* (Georgetown, MD, 1789); "The Federal City Ought to be on the Patowmack," *Maryland Journal*, January 22, 1790, 2; "For the Maryland Journal," *Maryland Journal*, September 30, 1791, 3; Tobias Lear, *Observations on the River Potomac* (New York: Loudon & Brower, 1794).

7 "For the Maryland Journal," *Maryland Journal*, September 30, 1791, 3; "The Federal City Ought to be on the Patowmack," *Maryland Journal*, January 22, 1790, 2.

8 These include Andrew Ellicott, *Plan of the City of Washington* (Philadelphia, 1792); James Thackara and John Vallance, "Plan of the City of Washington," *Universal Asylum and Columbian Magazine*, March 1792, 155; Samuel Hill, "Plan of the City of Washington," *Massachusetts Magazine*, May 1792, 284; Cornelius Tiebout, "Plan of the City of Washington," *New-York Magazine*, June 1792, 322.

9 Mann, *Republic of Debtors*: 166–206; Donald H. Stewart, *The Opposition Press of the Federalist Period* (Albany: SUNY Press, 1969), 33–70.

10 "Congress of the United States," *Baltimore Federal Gazette*, April 12, 1796, 2.

11 *Look before You Leap!* (New York: Andrew Maine, 1796), 56.

12 "Alexandria," *Charleston City Gazette*, September 20, 1797, 3.

13 Rose-de Viejo, *The Portrait of George Washington*, 5–19.

14 Rose-de Viejo, 8–9.

15 Narcisco G. Menocal, "Etienne-Suplie Hallet and the Espada Cemetery: A Note," *Journal of Decorative and Propaganda Arts* 22 (1996): 56–61; Paul Niell, *Urban Space as Heritage in Late Colonial Cuba* (Austin: University of Texas Press, 2015), 84–85, 95.

16 Rose-de Viejo, *The Portrait of George Washington*, 7.

17 On Perovani's work in Philadelphia, see "Painting," *Philadelphia Gazette*, September 22, 1795, 2.

18 "John Bill Ricketts," in Barratt and Miles, *Gilbert Stuart*, 210–12; Andrew Davis, *America's Longest Run: A History of the Walnut Street Theater* (University Park: Pennsylvania State University Press, 2010), 19–20.

19 Advertisement, *Baltimore Federal Gazette*, July 21, 1796, 3.

20 Advertisement, *New York Commercial Advertiser*, October 20, 1797, 3.

21 Rose-de Viejo, *The Portrait of George Washington*, 16–17.

22 Rose-de Viejo, 20–21.

23 On the treaty, see Samuel Flagg Bemis, *Pinckney's Treaty: America's Advantage from Europe's Distress* (New Haven, CT: Yale University Press, 1960); Jon Kukla, *A Wilderness so Immense: The Louisiana Purchase and the Destiny of America* (New York: Doubleday, 2009), 169–92.

24 "Treaty of Friendship, Limits, and Navigation between Spain and the United States," in *Treaties and Other International Acts of the United States of America*, ed. Hunter Miller, vol. 2 (Washington, DC: Government Printing Office, 1931), 319.

25 On Jáudenes's ambitions, see Barratt and Miles, *Gilbert Stuart*, 126.

26 On the black cockade's patriotic connotations, see Simon P. Newman, *Parades and the Politics of the Street: Festive Culture in the Early American Republic* (Philadelphia: University of Pennsylvania Press, 2010),161–66.

27 István Bejczy, *The Cardinal Virtues in the Middle Ages* (Leiden: Brill, 2011), 1–7; Charles S. Hyneman and Charles E. Gilbert, *The American Founding Experience: Politics, Community, and Republican Government* (Champaign-Urbana: University of Illinois Press, 1994), 211–15; Jeffry Morrison, *The Political Philosophy of George Washington* (Baltimore: Johns Hopkins University Press, 2009), 73–74.

28 John Adams, "Inaugural Speech," in *American State Papers: Documents, Legislative and Executive, of the United States* (Washington, DC: Gales & Seaton, 1833), 39.

29 Jeremy Bentham, *Defense of Usury*, vol. 3 (Edinburgh: William Tait, 1843), 22. On Bentham and prudence, see Emily C. Nacol, *An Age of Risk: Politics and Economy in Early Modern Britain* (Princeton, NJ: Princeton University Press, 2016), 115–18.

30 Adam Smith, *The Theory of Moral Sentiments*, vol. 2 (Basil: J. J. Tourneisin, 1793), 42. On Smith and prudence, see Nacol, *An Age of Risk*, 118–26.

31 See, for example, "Congress of the United States," *Baltimore Federal Gazette*, April 12, 1796, 2.

32 Henry Wansey, *The Journal of an Excursion to the United States of North America* (Salisbury: J. Easton, 1796), 222–23.

33 Ellen Miles, *American Paintings of the Eighteenth Century* (Washington, DC: National Gallery of Art, 1995), 146–58; Wendy Wick, *George Washington: An American Icon* (Washington, DC: Smithsonian Institute Press, 1982), 40–44; Hugh Howard, *The Painter's Chair: George Washington and the Making of American Art* (New York: Bloomsbury, 2009), 138–56.

34 *Pennsylvania Gazette*, March 21, 1798, repr. in David McNeely Stauffer, *American Engravers upon Copper and Steel*, vol. 1 (New York: Grolier Club, 1907), 811; "Remarks on the Paintings in the Columbian Gallery," *New York Morning Chronicle*, November 18, 1802, 3.

35 Edward Savage to George Washington, June 3, 1798, in *The Papers of George Washington*, *Retirement Series*, ed. William Wright Abbot, vol. 2 (Charlottesville: University Press of Virginia, 1998), 313.

36 See Scott Casper, "The First Family," 2–15; Susan Klepp, *Revolutionary Conceptions: Women, Fertility, and Family Limitation in America, 1760–1820* (Chapel Hill: University of North Carolina Press, 2009), 161–62.

37 Francois Furstenburg, *In the Name of the Father: Washington's Legacy, Slavery, and the Making of the Nation* (New York: Penguin, 2007), 76–78.

38 Brandon Brame Fortune with Deborah J. Warner, *Franklin and His Friends: Portraying the Man of Science in Eighteenth-Century America* (Philadelphia: University of Pennsylvania Press in association with the Smithsonian National Portrait Gallery, 1999), 21–49.

39 See Fortune, 37–42.

40 Fortune, 42–46.

41 See "Columbian Gallery," *New York Mercantile Advertiser*, November 19, 1801, 3.

42 Savage's Columbian Gallery displayed copies of the artist's engraving of Peale's Rittenhouse portrait and other scientific pictures. See "Columbian Gallery."

43 "Remarks on the Paintings in the Columbian Gallery." *The Washington Family* also organizes a far-reaching view for the spectator, unfolding a vista of the Potomac valley at the center of the scene that recedes toward a sunny horizon. Setting this deep view just above the unfurled plan, Savage's painting invites the spectator to imaginatively project the prospective city onto the Potomac valley—and, in so doing, identify herself with the future-oriented, speculative logic of the capital venture.

44 See, for example, "Alexandria," *Philadelphia General Advertiser*, April 17, 1793, 3.

45 See untitled notice, *Gazette of the United States* (Philadelphia), March 17, 1798, 3; "Remarks on the Paintings in the Columbian Gallery."

46 James M. Goode, *The Evolution of Washington, D.C.* (Washington, DC: Smithsonian Institution Press, 2015), 35–37; Jared Sparks, *Life of George Washington*, vol. 2 (London: Henry Colburn, 1839), 452; Sakolski, *The Great American Land Bubble*, 164.

47 Goode, *The Evolution of Washington, D.C.*, 33–35.

48 "For the New York Journal," *New York Journal*, August 31, 1790, 3.

49 See Ann Bermingham, *Landscape and Ideology: The English Rustic Tradition, 1740–1860* (Berkeley: University of California Press, 1989), 15–33; Ronald Paulson, *Emblem and Expression: Meaning in English Art of the Eighteenth Century* (New York: Thames & Hudson, 1975), 125–50.

50 J. Hector St. John de Crèvecoeur, *Journey into Northern Pennsylvania and the State of New York* (1801; repr. Ann Arbor: University of Michigan Press, 1964), 209.

51 Examples include John Singleton Copley, *Nicholas Boylston* (1767, Harvard Art Museums, Cambridge, MA), and John Smibert, *Francis Brinley* (1729, Metropolitan Museum of Art, New York).

52 See, for example, Charles Loring Elliott, *Colonel Samuel Colt* (1865, Wadsworth Atheneum Museum of Art, Hartford, CT), and Jacob Lazarus, *John Jacob Astor III* (1890, New York State Museum).

53 Examples include William D. Lechler, *John Gehr* (1840s, Waynesboro Historical Society) and *Ziegler* (1841, Hudson House Galleries, Funkstown, MD).

54 See, for example, A. B. Walter, *Washington Family* (ca.1840–75); James S. Baillie, *Washington Family* (1848–50); and Augustus Robin, *Washington Family* (1869).

256 nt

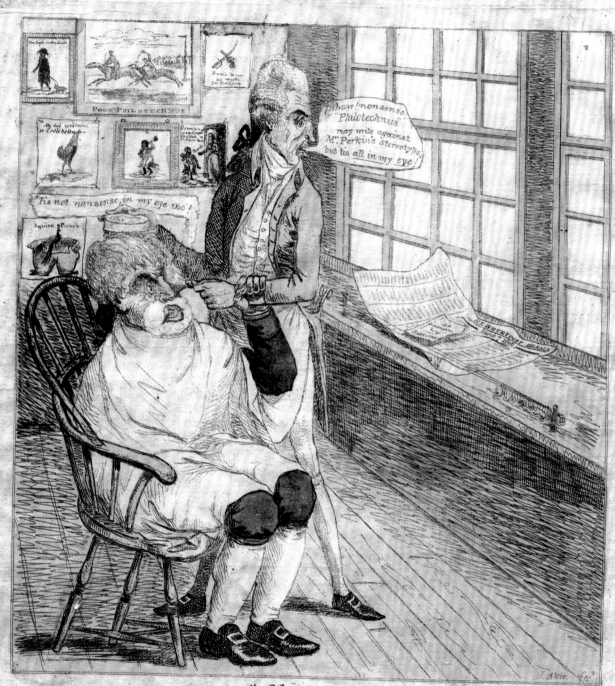

All in my eye!

# CARICATURE PORTRAITS AND EARLY AMERICAN IDENTITY

Allison M. Stagg

In the summer of 1793, Thomas Jefferson recorded in his diary a particularly noteworthy occurrence that had taken place during a cabinet meeting in Philadelphia. The entry discloses that, in front of members of Congress, President George Washington was shown a caricature print titled "The Funeral of the George W—n."[1] The image so angered Washington that he "was much inflamed, [and] got into one of those passions when he cannot command himself."[2] Further references to the caricature can be found in early American newspapers between July and December 1793, with one source even noting the destruction of the prints: "a representation of the President &c with a coffin and a guillotine, was stuck up in Philadelphia . . . but they were destroyed soon."[3] Unfortunately, no impressions of this print are known to exist today, so the specifics of how the unknown caricaturist chose to depict the face and body of the president are also unclear. However, the information gleaned from Jefferson's entry, various newspaper reports,

and Washington's own "inflamed" reaction suggests that it was a rather unflattering portrait of the president.

In the first few decades after the end of the Revolutionary War, American political caricature relied heavily on the approval and appreciation of those who were portrayed and their audiences. Although caricature prints made during this period were published with little frequency and their shelf life as objects of public interest were commonly short, the portraits of public figures found in these images impacted the society in which they served.[4] Designed primarily to respond quickly to unpopular laws and political incidents, or to commemorate topical events, such as presidential elections, these prints offered satirical portraits of politicians of varying levels of importance. For these men of influence in powerful positions, shaping a country that had only recently gained its independence from England, satirical prints were difficult to ignore and were of interest to the early American public. Documents from the period reveal that caricatures were not seen only by the limited few who kept them for the private enjoyment of their small fraternal societies; rather the majority of these prints were commonly available. Published first in major cities such as Philadelphia and New York, caricatures were

**Fig. 4.1**
*All in My Eye!* by James Akin, 1806
Engraving, 32.5 × 33 cm (12¹³⁄₁₆ × 13 in.)
American Antiquarian Society, Worcester, Massachusetts

sold in bookshops, where they were pasted in windows, attracting a diverse and constantly changing audience. Another venue for the display of caricature prints were the interiors of barbershops, where a distinctively male clientele waited their turn for a shave or haircut. Few early American caricatures depict the venues in which these kind of prints could be seen, with the exception of one rare caricature from the first decade of the nineteenth century that shows the interior of a barbershop located in Newburyport, Massachusetts (fig. 4.1). The display on the back wall of the shop features a selection of caricatures, some of which were on sale at the time this image was made.[5] Contemporary notices found in newspapers also shed some light on the visibility of caricatures to a passing public and include references to prints tacked on post office walls and placed on signposts and fences. These various locations suggest that the images were seen by many different people. Newspaper advertisements also announced the sale and location of new caricatures on offer.

Women in the late eighteenth and early nineteenth century were encouraged to ignore this type of visual imagery, but it would appear that some did not. Anyone could easily encounter caricatures on display in shop windows—that is, before they were destroyed or taken down. Furthermore, there are references in contemporary documents indicating that women purchased, gifted, and reacted to caricatures during this period. For example, while Abigail Adams was in London in the late eighteenth century, the wife of future president John Adams purchased British satirical prints for relatives and friends and sent them to Massachusetts. In at least one instance, Adams sent a caricature to a female friend in the United States. Meanwhile, Thomas Jefferson purchased caricature prints and sent them to his young daughters, specifically requesting that they share the prints with friends.[6]

Advertisements and descriptions found in early American newspapers further highlight that these caricatures circulated from city to city. Notices in newspapers outside of Philadelphia and New York provide detailed descriptions of prints available for purchase. Incredibly, despite being ephemeral objects, it is possible to locate for each of the roughly one hundred surviving caricatures made between 1789 and the early 1830s, at least one reference in a newspaper or letter. This information highlights that these images were relatively common objects found in everyday early American life. Some of the surviving satirical portraits, including the two caricatures that are the focus of this essay, *View of Con—ss on the Road to Philadelphia* (1790; fig. 4.2) and *Caucus Curs in Full Yell, or a War Whoop to Saddle on the People, a Pappoose* [sic] *President* (1824; fig. 4.3), bear evidence of their circulation, with creases revealing where they have been folded to fit into a pocket or an envelope.

Because of this accessibility and movement, the caricature prints depicting politicians of the early United States, such as George Washington, Thomas Jefferson, and Andrew Jackson, are important visual historical documents, detailing events of consequence to the people of the day. The design and format of early American caricatures from this period are similar to satirical prints made in London, yet the subject matter was based firmly on American issues for an American audience, focusing attention on what was significant to early American citizens. Caricature prints made during this time provide a brief window into what were considered to be the critical issues of the day. They are visual histories told by people who seemingly possessed little political power but who nonetheless effected change with their engraving tools and copper plates. The politicians who found themselves cast as the subjects of caricaturists' jokes were not able to control the satirical version of the story. The fact that not a single caricature

**Fig. 4.2**
*View of Con—ss on the Road to Philadelphia* by unknown artist ("Y.Z."), 1790
Engraving, 18.2 × 29.5 cm (7⅛ × 11⅝ in.), irregular
Historical Society of Pennsylvania

of Washington during his presidency has been located, despite the numerous references to visual attacks made on him, has itself contributed to how he is remembered, especially by historians: George Washington, founding father and an untouchable, infallible human being. The loss of the Washington caricatures taps into a broader issue surrounding early American identity and the ways in which everyday citizens visually saw the news unfolding. The dignified portrait paintings by celebrated artists such as Charles Willson Peale and Gilbert Stuart are calculated, idealized representations that remain loyal to the "real" emerging nation. With politicians bickering on the streets and in congressional meetings, newspapers enthusiastically reported on their various disagreements. These spectacles and the resulting—often sensationalized—news, set the stage for caricaturists to create pictures that dramatized the day's events. The politicians represented in caricatures had very little control over these satirical portraits or their widespread dissemination. Even if Washington or his supporters destroyed the caricatures of him, the descriptions that survive in newspapers and in archival documents provide evidence of a more tenuous American history.

The first caricatures made in the United States, such as the 1790 print *View of Con—ss on the Road to Philadelphia*, by an unknown artist, relied heavily on the formats of British caricatures from the late eighteenth century, with strong, blackened outlines and speech bubbles to assist the reader in understanding the subject matter. A decade later, James Akin, a native of South Carolina, self-identified as a serious caricature artist and began signing the prints he made. Akin's background and training in the fine arts brought a sense of gravitas to the medium of caricature, long considered a form of low art. His 1824 caricature of General Jackson, *Caucus Curs in Full Yell, or a War Whoop to Saddle on the People, a Pappoose President*, is an important departure from other early American caricature prints because of how the artist inserted his

keen interest of portraits and likenesses within a satirical narrative. Both caricature prints are remarkable documents, largely forgotten by scholars of early American history, and together they shed much-needed light on what the citizens of the day found most important at that point in time.

The term "ripped from the headlines" could easily be the tagline for the small number of caricature prints published in New York in 1790. Over the summer months rumors dominated the New York press, which reported that the capital city was to be moved to Philadelphia for a period of ten years while a new capital was to be built along the Potomac River—present-day Washington, DC. It did not take long for a number of amateur artists in New York to turn the headlines into visual attacks against the move. In total, four caricatures are known to have been published against the removal of Congress: three have survived, with a description of a fourth found in a letter from a Pennsylvania politician. What is surprising when considering these four caricatures is that while modern historians consider Thomas Jefferson and Alexander Hamilton as the men who were most influential in brokering the deal for the removal of Congress from New York, these prints focused primarily on the figure of Robert Morris, a wealthy Pennsylvania financier and a founding father who, aside from George Washington, was considered by many to be the "most powerful man in America."[7]

Out of the four caricatures published in reaction to the removal of Congress from New York, *View of Con—ss on the Road to Philadelphia* appears to have been the most widely available and known to audiences both in and out of New York. Here, the unidentified artist—known only by his initials, "Y. Z."—borrows from a tradition of British caricature, framing the rectangular scene with an

Fig. 4.3
*Caucus Curs in Full Yell, or a War Whoop to Saddle on the People, a Pappoose President* by James Akin, 1824
Etching with aquatint and engraving, 49.6 × 55 cm (19½ × 21¹¹⁄₁₆ in.)
Library of Congress

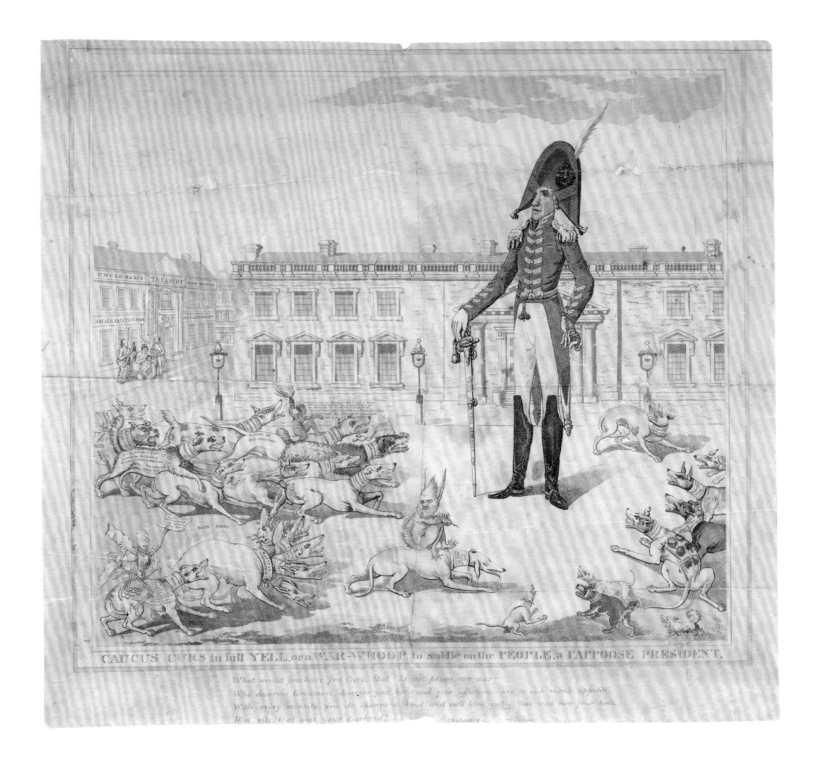

CAUCUS CURS in full YELL, or a WAR-WHOOP to saddle on the PEOPLE, a PAPPOOSE PRESIDENT.

What would you have, you Curs, that like not peace, nor war?
Who deserves Greatness, deserves your hate; and you affection are a sick man's appetite,
With every minute you do change a mind, and call him noble, that was now your hate,
How vile, that was your Garland!          Shakespeare.   Adams.

outline and providing a title with additional relevant text below and above the image. Robert Morris, one of the first Pennsylvania senators, is represented as the largest figure and as the politician responsible for the move. Only a few years prior to this caricature, Morris had sat for a portrait by the artist Robert Edge Pine (fig. 4.4). That painting and any further portrait engravings depicting Morris probably would have been of little importance to this unidentified caricaturist. Eager to design and print the image with immediacy before the news story of the removal of Congress lost its momentum with an interested audience, the artist was more likely influenced by newspaper remarks on the girth and size of Morris. Ensuring a perfected facial likeness was not a priority; all that was needed to ensure that New Yorkers read the caricature correctly and spotted Morris easily within the picture was to make Morris the focal point of the scene. The caricaturist succeeded in this by representing Morris larger than the other figures. Morris, who can be found on the left, is shown pulling members of Congress behind him. Directly behind Morris, on the ladder, are the members of Congress who supported the removal from New York (labeled "A: The Majority"), while the group of disapproving congressmen are further back, gripping a string as Morris pulls them along ("B: The Minority").

The caricaturist added additional visual markers to ensure that the print would be understood by any audience, even one unfamiliar with the situation. An uncomplicated background contains a fence and shrubbery, allowing for a sign pointing the way to Philadelphia to be made prominent. Morris is shown as if marching in the direction of Philadelphia; he is even depicted in line with the sign, pointing to the city. Morris holds in one hand a purse filled with gold, presumably preparing to bribe fellow delegates. A speech bubble from Morris's mouth proclaims his identity: "I am Robert Coffer." The caricaturist further added the initials "R. M." under the name "Robert Coffer" to avoid confusion.

Despite Morris's prominent size within the picture, none of the figures bear any defining characteristics. Instead, they are depicted as generic representations of a late-eighteenth-century American male. All are outfitted in the same manner: wearing a waistcoat and breeches, and topped with a brimmed hat. Nor are there any characteristics here to differentiate the identities of the politicians. All the men look to be roughly the same age and of the same demographic. Morris, the supposed villain of this narrative, gets off lightly by caricaturists' standards. The impression of his face, seen in profile, is rather determined as he leads his congressional crew south to Philadelphia. The caricaturist did not give Morris's figure negative attributes, such as devilish horns on his head, nor did he add any exaggeration, such as extending the girth of his stomach or the size of his nose, or preying on his age.

The potency and humor found in the caricature would have appealed to New Yorkers and those in New England who were uneasy about the capital city's move south. Although all four of the caricatures depicting Morris were published in New York, references found in newspapers outside the city and in private letters from politicians provide detailed descriptions of these satirical images. An example can be seen in an account published in a New Hampshire paper, which states, "The New-York papers teem with invectives against Congress, on account of the vote to meet the next Session at Philadelphia—and caricature prints are called in to aide the abuse of language. In one of [the caricatures] is represented the Hon. Mr. [Robert] M[orris] of the Senate as bribing the majority for their votes, and leading the minority by the nose."[8] Further to this are the surviving letters members of Congress to relatives and friends. One Pennsylvania delegate, in New York for the

**Fig. 4.4**
*Robert Morris* by Robert Edge Pine, ca. 1785
Oil on canvas, 92.4 × 74.6 cm (36 3/8 × 29 3/8 in.)
National Portrait Gallery, Smithsonian Institution

summer, sent his family a number of the 1790 caricatures, stating that such prints were, "sold about on the streets, expressive of the Spleen of the citizens on account of the Removal of congress."[9] The New York politician DeWitt Clinton wrote to his uncle George, then the Governor of New York, based in Albany, about *View of Con—ss on the Road to Philadelphia*, noting, "There is one [caricature] in which Morris is carrying a ladder of promotion on his back to Philadelphia filled with the majority & dragging the minority after him. One of the former holds a purse of gold in his hand and says, 'This is what influences me' intimating that some of the members were bribed."[10] Some of the very men that found themselves illustrated in caricatures wrote letters home to family and friends, discussing the prints in circulation and sending caricatures home to their wives and children. Theodore Sedgwick, a Massachusetts representative, wrote to his wife about caricatures sold on the street and included a copy of one. In the letter, Sedgwick claimed to have been depicted in the caricature, and he directed his wife to pay attention to one particular speech bubble, in which his likeness demands that Morris stop the removal.[11]

It is unlikely that Morris would have been immune to these caricatures, especially considering the many references to them in letters and newspapers. If Morris saw the *View of Con—ss on the Road to Philadelphia* or any of the other three prints made during the summer of 1790, he does not seem to have put his thoughts of them on paper. Similarly, it is impossible to know whether Andrew Jackson saw a caricature made of him in 1824 by the American artist James Akin.[12] *Caucus Curs in Full Yell, or a War Whoop to Saddle on the People, a Pappoose President* is a strong example of Akin's attempt to incorporate his training as a fine artist within his caricature portraits. In contrast to the caricatures featuring Morris, Akin's purpose in creating the image of Jackson, then a presidential hopeful, was not to mock him or stand in the way of his political rise, but rather to support his cause.

Akin's interest in caricature was likely influenced by his short time in London in the late 1790s. While there, Akin would have been surrounded by the abundance of caricature prints decorating shop windows. During his short time abroad, Akin became aware of the strong market for the prints and perhaps saw an opportunity to transfer this satirical culture to America. In London, he would have been witness to the voluminous output of British artists such as James Gillray and Thomas Rowlandson, whose exquisitely colored satirical prints enjoyed patronage by wealthy members of Parliament and the Royal Family. It was also in London that the first evidence of Akin's training can be discerned. He later boasted of having attended classes at the Royal Academy (his attendance supposedly sanctioned by the great artist Benjamin West) and having worked with James Heath, then principal engraver to King George III.

By late 1797, Akin had returned to Philadelphia, where he enjoyed professional associations with Charles Willson Peale and several of his progeny, particularly Rembrandt, Raphaelle, and the first son named Titian (soon deceased). Akin first made engravings after fine art portraits, including a print of Thomas Jefferson after Charles Willson Peale (fig. 4.5). By 1805, Akin had left Philadelphia for Newburyport, Massachusetts, where he was active in promoting his profession as an engraver, advertising in newspapers that he was proficient in producing portraits. In March 1805, for example, Akin noted that he was in possession of a physiognotrace, a device "for delineating Profile Likenesses" for silhouette portraits.[13] Additionally, Akin studied medicine and attended courses on anatomy both in London and in Philadelphia, information that he included in notices to prove to potential clients his devotion to the medium.[14] While few examples of Akin's early

Fig. 4.5
*Thomas Jefferson* by James Akin and William Harrison Jr. after Charles Willson Peale, 1800
Stipple and line engraving, 19.8 × 15 cm (7¹³⁄₁₆ × 5⅞ in.)
National Portrait Gallery, Smithsonian Institution

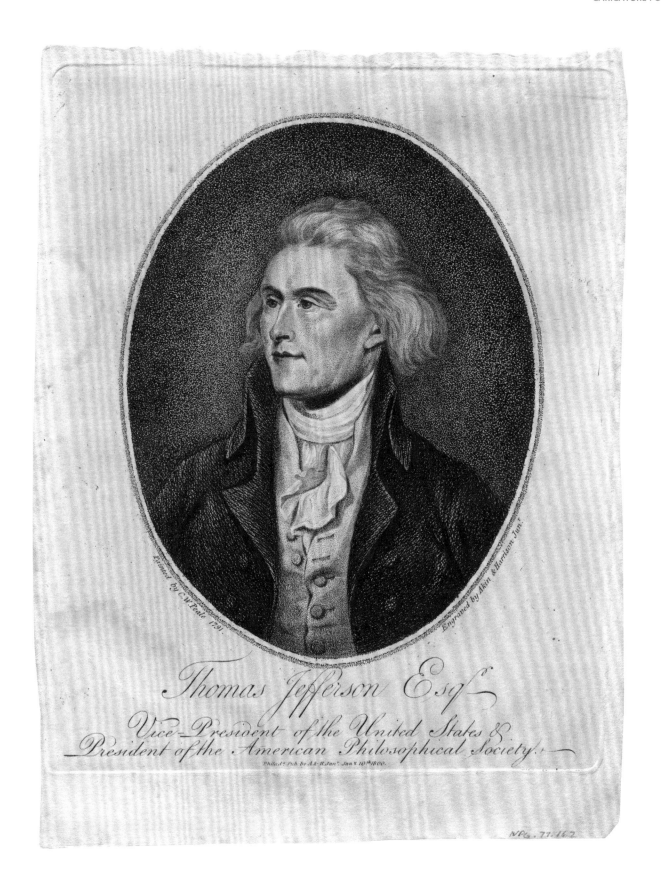

*Painted by C.W. Peale 1791.*

*Engraved by Akin & Harrison Junr.*

Thomas Jefferson Esqr.

Vice-President of the United States &
President of the American Philosophical Society.

Philadª Pub. by A & H Junr. Janª 10th 1800.

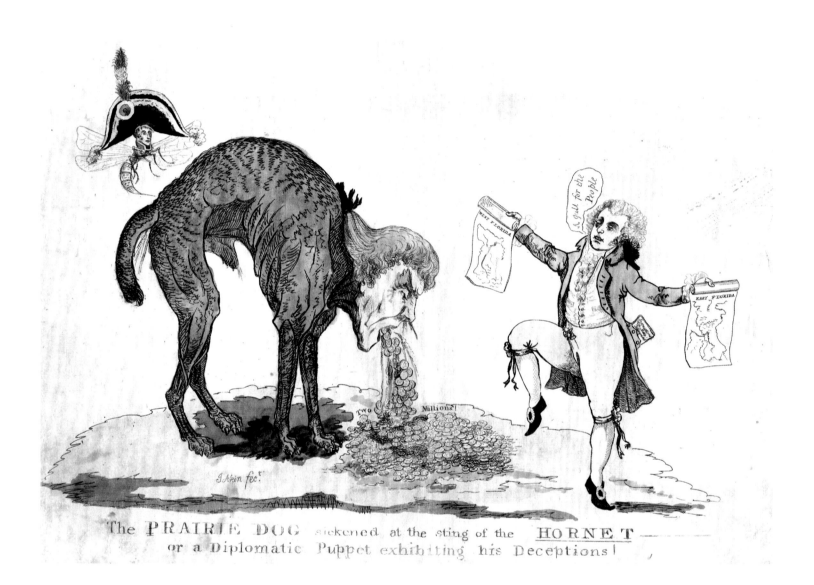

**Fig. 4.6**
*The Prairie Dog Sickened at the Sting of the Hornet or a Diplomatic Puppet*
*Exhibiting His Deceptions!* by James Akin, 1806
Hand-colored engraving, 35.5 × 46 cm (14 × 18⅛ in.)
American Antiquarian Society, Worcester, Massachusetts

engravings have survived, the evidence of his relationships with other artists, and references they made to Akin, suggest that he was regarded as a respectable artist. His transition into designing caricature prints, particularly the depiction of Thomas Jefferson in *The Prairie Dog Sickened at the Sting of the Hornet or a Diplomatic Puppet Exhibiting His Deceptions!* (1806; fig. 4.6), brought disapproval from friends and colleagues, who encouraged him to return to his fine art engravings.

In the first few decades after American Independence, a small number of caricatures were made in America, and they were done with different styles and levels of skill. Caricatures from this early period appear to have been made by separate hands, and very few, if any, can be linked together or to the same artist. Unlike the caricatures of the 1790s, in which the figures represented were often more generic, with words in speech bubbles associating figures with the persons they were representing, Akin used his skills as an engraver to produce strong portraits in caricature (see fig. 4.3). By actively promoting his business, advertising new caricatures for sale in newspapers, and signing the majority of his caricature prints, Akin also elevated the medium, placing caricature portraits within the same context as engraved portraits and historical scenes. As well, Akin requested the assistance of some of his more influential colleagues to ensure that his caricatures were successful. While no information is known about the unidentified caricaturist "Y.Z.," Akin was prolific in advertising his skills. Documents scattered amongst numerous historical societies and museums aid in providing a more concrete knowledge of the thought process that went into designing and printing his caricatures.

For example, there are a large number of surviving archival documents related to Akin's 1824 caricature *Caucus Curs in Full Yell, or a War Whoop to Saddle on the People, a Pappoose President*. For Akin, the idea of designing a caricature in support of Jackson had been germinating for some time, at least since 1819. In that year, five years before the caricature was completed, Akin traveled through several states and had stopped in the city of Washington, where he attended an open session of Congress. Disheartened in that session by the attacks on Jackson's character, Akin was prompted to create a caricature in support of Jackson and confided his plan to the artist Ralph Earl.[15] A letter from Akin to Earl, Jackson's friend and lifetime portraitist, was written with familiarity as Akin requested a portrait of Jackson in order to begin the caricature:

> Be pleased Sir to aid me. – I therefore make bold a request that you furnish me an outline of the Generals visage, & figure, that I may accomplish my purpose – I merely want the strong outlines of feature and figure, required in caricature . . . The sketch can be made on a large sheet, & folded in the letter form, & postage will only be made for a single letter.[16]

Because the caricature was intended to be in support of Jackson, Akin was interested in providing a strong likeness, and in order to do so, he required a sketch of the general from Jackson's own portrait painter, the artist most familiar with Jackson and the most capable of delivering such a true image. It is not clear if Earl responded to Akin's request; that same month, Earl's wife died in childbirth, and the majority of the letters sent to him at this time went unanswered.

However, Akin's representation of Jackson is not unlike the one found in a painting by Earl from 1818 (fig. 4.7). In both images, Jackson wears similar clothing and stands in the same posture, although Akin's picture shows Jackson wearing a large military hat and gives more prominence to the sword. Akin's letter to Earl refers to a meeting between the two artists, and because Earl was firmly based in Nashville in 1818, it is possible that they met there. If they did, Akin would likely have seen the completed portrait of Jackson hanging in Earl's newly opened Nashville Museum

(now the Tennessee State Museum), producing a memory of it that allowed him to reproduce a similar likeness in his 1824 caricature.

Between 1819, when the letter was written, and early 1824, no other Jackson caricatures are known to have been made by Akin. A number of archival documents can be found that provide insight into Akin's motive and thought process for the caricature. By 1824, Akin had returned from his various travels to Philadelphia, where the caricature was published, and it is obvious from his decisions after the print was made that he wanted the print to be known outside of that city. In late 1824, he sent a number of proofs of the caricature to newspaper editors, likely with a letter requesting that the print be posted in visible locations and asking the editors to reference the print in their papers. Akin chose newspapers with pro-Jackson tendencies that would have had an audience receptive to such imagery. A number of those newspaper editors wrote positively of the caricature print. The *Baltimore Patriot & Mercantile Advertiser*, for example, devoted almost one hundred lines to describing the caricature, beginning with an appraisal of Akin's depiction of Jackson: "General Jackson is standing, in full uniform, with his right hand resting on the hilt of his sword; he is calmly looking on the curs that are growling and barking at him . . . The likeness is excellent, and affords a very good representation in full length of the General."[17] The opinion piece goes on for several more paragraphs, offering a minute account of every inch of the print, before culminating with the following seal of approval: "This print is about 24 inches square, handsomely engraved, and of superior execution throughout." In Salem, Massachusetts, an opinion piece stated that, "Our attention was lately directed to a large print, executed in Philadelphia, which represented General Jackson as a tall, gaunt figure, standing before the president's house, beset by a number of hounds with collars."[18] Additionally, Akin sought approval from his artist friend Earl, also sending him an impression of the caricature and writing, "I enclose you a Caricature

in favour of Gen. Jackson, in opposition to the miserable herd of wretches who publish their pitiful resentments against the Man who saved them from the grasp of British Tyranny."[19]

Akin's desire to obtain a strong likeness of Jackson before beginning a caricature provides an opportunity to examine how Akin approached the medium of political caricature, and for what purpose. Akin had previously developed a keen interest in portraiture, leading him to become a collector of portraits after important American figures. In an earlier letter to Earl, Akin requested that he send him a self-portrait to decorate his parlor. Akin boasted to Earl that he was in the possession of portraits from "gentleman of the fine arts, both in Europe & America" and wanted to include Earl's portrait among them.[20] Akin's claim of having a collection of portraits may have been based in truth. In his youth, he displayed an interest in forming a collection of portraits of eminent men in the world of fine art. In the late 1790s, after returning from London, he advertised subscriptions for engravings to be based on a historical painting by the British artist Thomas Stothard and promised to be in possession of a number of paintings by the artist: "a very few valuable pictures I have." Further to this, Akin was concerned with the treatment of figures within the historical engravings, advertising that he was "highly ambitious in transmitting to posterity, portraits of some of the most illustrious characters," and he added information on the individuals whom he would depict in these historical engravings.[21] Akin's interest in surrounding himself with important artworks of the period, including self-portraits of the artists responsible for them, suggests that he viewed himself as an artist of considerable skill and merit who was expressing these virtues in visual satire.

Akin's choice to use the 1818 portrait of Jackson by

**Fig. 4.7**
*Andrew Jackson* by Ralph E. W. Earl, 1818
Oil on canvas, 240 × 146.7 cm (94½ × 57¾ in.)
Tennessee State Museum

Earl as a model may also have been a subtle attempt to showcase his knowledge and awareness of fine art. Earl's portrait was rather popular, having gained a great deal of attention from contemporaries for its accurate likeness of Jackson. Considered to have been the highlight of Earl's new museum in Nashville, local newspapers reported that, "In the contour of the head, and indeed the whole figure, the fidelity of the representation cannot be easily excelled."[22] Soon after, Earl received numerous requests for copies of his Jackson painting. Joseph Delaplaine, who was compiling his multivolume work of illustrated biographies *Repository of the Lives and Portraits of Distinguished American Characters*, asked if the full-length portrait was available for sale.[23]

While no references to the caricature have been located in Jackson's private papers, it is likely he knew of its existence. Several years later, in 1828, after Jackson had secured the presidential office, Akin sought a position in his administration. Penning a number of letters to Jackson and other members of his cabinet, Akin noted the prints he designed in support of Jackson, offering them as evidence of his loyalty to both Jackson and the American nation.

Caricature prints made during this period provide an alternative visual history that need to be considered equally alongside the more traditionally studied historical paintings and portraits. These satirical works highlight the issues and news of the day and offer an altogether different perspective on the world of early American politics and history. Despite being made relatively infrequently, and perhaps, at first, with a limited circulation, eventually caricature prints were seen by many: by those represented within the caricatures and by everyday citizens, who left references to prints, which over time have become unfamiliar but can be resuscitated.

Notes

1 According to Thomas Jefferson's diary entry from August 2, 1790, the full title of the caricature was "The Funeral of George W—n and James W—n, king and judge &c." James Wilson (1742–1798) was one of the first original Supreme Court judges to have been appointed by Washington. See "Notes of Cabinet Meeting on Edmond Charles Genet, August 2, 1793," in *The Papers of Thomas Jefferson Digital Edition*, Main Series, vol. 26 (May 11– August 31, 1793), ed. Barbara B. Oberg and J. Jefferson Looney (Charlottesville, VA: University of Virginia Press, 2008), http://www.upress. virginia.edu/content/papers-thomas-jefferson-digital-edition.

2 Ibid.

3 *Vermont Journal and Universal Advertiser*, August 26, 1793; *Hough's Concord Herald* (Concord, NH), August 29, 1793.

4 Caricature prints published in America after the Revolutionary War can be found primarily as reproduced illustrations in recent early American historical scholarship and biographies of the founding fathers, but there has been little recent scholarship devoted to furthering information of early American caricature. For an overview of early American caricature, see William Murrell, *A History of American Graphic Humor*, 2 vols. (New York: Whitney Museum of American Art, 1933–38), esp. vol. 1; Frank Weitenkampf, *American Graphic Art* (New York: Macmillan, 1924); and Allan Nevins and Frank Weitenkampf, *A Century of Political Cartoons: Caricature in the United States from 1800 to 1900* (New York: Scribner, 1944). An excellent study on British caricature from this period is Diana Donald's *The Age of Caricature: Satirical Prints in the Reign of George III* (New Haven, CT: Yale University Press, 1996). Also see Allison Stagg, "The Art of Wit: American Political Caricature, 1780–1830" (PhD diss., University College London, England, 2011).

5 Allison Stagg, "'All in My Eye!': James Akin and His Newburyport Social Caricatures," *Common-place* 10, no. 2 (January 2010), http://www. common-place-archives.org/vol-10/no-02/lessons/.

6 Abigail Adams to Elizabeth Cranch, July 18, 1786, in *The Adams Papers: Adams Family Correspondence*, vol. 7, *January 1786–February 1787*, ed. C. James Taylor et al. (Cambridge, MA: Harvard University Press, 2005), 256–60; Thomas Jefferson to Mary Jefferson, May 2, 1790, in *The Papers of Thomas Jefferson*, vol. 16, 405; Thomas Jefferson to Martha Jefferson Randolph, August 4, 1793, in *The Papers of Thomas Jefferson*, vol. 26, 617; http://www.upress.virginia.edu/content/papers-thomas-jefferson-digital-edition.

7 Charles Rappleye, *Robert Morris: Financier of the American Revolution* (New York: Simon & Schuster, 2010), 4.

8 *New Hampshire Gazette, and General Advertiser*, July 15, 1790.

9 This letter was transcribed in Joseph M. Beatty Jr., "The Letters of Judge Henry Wynkoop," *Pennsylvania Magazine of History and Biography* 38 (1914): 204.

10 DeWitt Clinton to George Clinton, July 20, 1790, Clinton Family Papers, New-York Historical Society.

11 Thomas Sedgwick to Pamela Dwight Sedgwick, July 4, 1790, Sedgwick Family Papers, Massachusetts Historical Society.

12 For more on James Akin, see Maureen O'Brien Quimby, "The Political Art of James Akin," *Winterthur Portfolio* 7 (January 1972): 59–112.

13 *Political Calendar and Essex Advertiser* (Newburyport, MA), March 4, 1805.

14 *Philadelphia Gazette & Daily Advertiser*, May 8, 1802.

15 James G. Barber, *Andrew Jackson: A Portrait Study* (Washington, DC: Smithsonian Press, 1991), esp. chap. 5–6, pp. 134–75.

16 James Akin to Ralph Eleaser Whiteside Earl, February 17, 1819, box 2, Earl Papers, American Antiquarian Society, Worcester, Massachusetts.

17 *Baltimore Patriot & Mercantile Advertiser*, November 11, 1824.

18 *Salem Gazette*, November 19, 1824.

19 Unfortunately, the location of this letter is not known. It was published in Murrell, *A History of American Graphic Humor*, 1:135. It has been reprinted in more recent scholarship with Murrell as the citation.

20 James Akin to Ralph Eleaser Whiteside Earl, December 27, 1818, box 2, Earl Papers, American Antiquarian Society, Worcester, Massachusetts.

21 *The Diary, or Loudon's Register* (New York), July 8, 1798.

22 *Nashville Whig and Tennessee Advertiser*, May 9, 1818; also quoted in Barber, *Andrew Jackson*, 42–43.

23 A series of letters survive from Joseph Delaplaine to Ralph Eleaser Whiteside Earl between September 1818 and April 1819, roughly during the same period that Akin wrote to Earl; Earl Papers, American Antiquarian Society, Worcester, Massachusetts.

# RECONSTRUCTION RECONSIDERED

## THE GORDON COLLECTION OF THE NATIONAL PORTRAIT GALLERY

Kate Clarke Lemay

In March 1863, a slave generally known as Gordon escaped his master's home in Mississippi and, after rubbing onion all over his body to throw off his scent, reportedly walked approximately eighty miles to Baton Rouge. There, he enlisted in the Union army, joining nearly two hundred thousand other African American soldiers in the fight against the Confederacy. Gordon had to undergo a medical examination as part of the recruitment process, and the doctors discovered severe scarring on his back, clear evidence of wounds caused by a whip.[1] Either a doctor took this photo of him, and it was subsequently reproduced, or the Baton Rouge–based photography team of McPherson & Oliver made photographs of him in more than one pose.[2] While the early history of these photographs remains somewhat opaque, they recorded—very clearly—the terrible abuse that Gordon had survived. One specific image was copied and mass-produced in the form of a carte de visite by commercial studios like that of Mathew Brady (fig. 5.1).[3]

The subject's scourged back captures the brutality of slavery. The Brady image was made into a woodcut that was reproduced in the July 4, 1863, issue of *Harper's Weekly* (fig. 5.2). In addition to the circular, which reached an extraordinarily wide audience of around two hundred thousand subscribers, cartes de visite featuring Gordon's likeness quickly found their way into the hands of abolitionists who used the image in their campaigns. One such campaign includes the frontispiece of a pamphlet by Frances Anne "Fanny" Kemble entitled *The Views of Judge Woodward and Bishop Hopkins on Negro Slavery at the South, Illustrated from the Journal of a Residence on a Georgian Plantation* (fig. 5.3). Kemble, a notable British actress, was married to Pierce Mease Butler, who had inherited a large group of plantations in Georgia. It was not a good match, however, and they divorced in 1848. The unraveling of the couple's marriage stemmed, in part, from their disagreement over slavery. Kemble went with Butler to see one of his plantations on St. Simons Island in 1838, and she was shocked by the conditions of slavery and the treatment of the slaves. Twenty-five years later, when she was living in England and felt she could convince British people to support the North in the American Civil War, she

**Fig. 5.1**
*Gordon* by the Mathew Brady Studio, 1863
Albumen silver print, 10.1 × 6.1 cm (4 × 2 ⅜ in.)
National Portrait Gallery, Smithsonian Institution

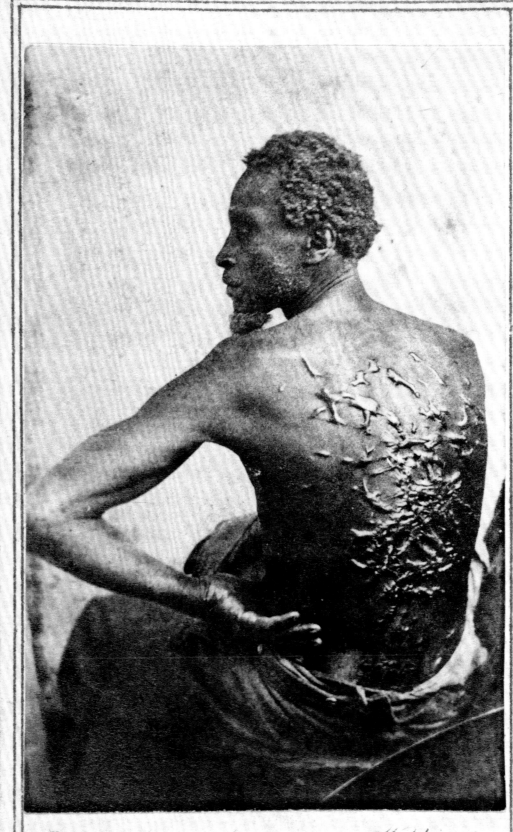

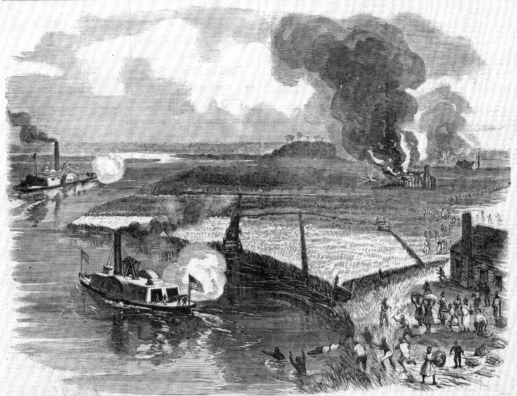

RAID OF SECOND SOUTH CAROLINA VOLUNTEERS (COL. MONTGOMERY) AMONG THE RICE PLANTATIONS ON THE COMBAHEE, S. C.—[SEE PAGE 427.]

## A TYPICAL NEGRO.

WE publish herewith three portraits, from photographs by M'Pherson and Oliver, of the negro GORDON, who escaped from his master in Mississippi, and came into our lines at Baton Rouge in March last. One of these portraits represents the man as he entered our lines, with clothes torn and covered with mud and dirt from his long race through the swamps and bayous, chased as he had been for days and nights by his master with several neighbors and a pack of blood-hounds; another shows him as he underwent the surgical examination previous to being mustered into the service —his back furrowed and scarred with the traces of a whipping administered on Christmas-day last; and the third represents him in United States uniform, bearing the musket and prepared for duty.

This negro displayed unusual intelligence and energy. In order to foil the scent of the blood-hounds who were chasing him he took from his plantation onions, which he carried in his pockets. After crossing each creek or swamp he rubbed his body freely with these onions, and thus, no doubt, frequently threw the dogs off the scent.

At one time in Louisiana he served our troops

as guide, and on one expedition was unfortunately taken prisoner by the rebels, who, infuriated beyond measure, tied him up and beat him, leaving him for dead. He came to life, however, and once more made his escape to our lines.

By way of illustrating the degree of brutality which slavery has developed among the whites in the section of country from which this negro came, we append the following extract from a letter in the New York *Times*, recounting what was told by

the refugees from Mrs. GILLESPIE's estate on the Black River:

The treatment of the slaves, they say, has been growing worse and worse for the last six or seven years.

Flogging with a leather strap on the naked body is common; also, paddling the body with a hand-saw until the skin is a mass of blisters, and then breaking the blisters with the teeth of the saw. They have "very often" seen slaves stretched out upon the ground with hands and feet held down by fellow-slaves, or lashed to stakes driven into the ground for "burning." Handfuls of dry corn-husks are then lighted, and the burning embers are whipped off with a stick so as to fall in showers of live sparks upon the naked back. This is continued until the victim is covered with blisters. If in his writhings of torture the slave gets his hands free to brush off the fire, the burning brand is applied to them.

Another method of punishment, which is inflicted for the higher order of crimes, such as running away, or other refractory conduct, is to dig a hole in the ground large enough for the slave to squat or lie down in. The victim is then stripped naked and placed in the hole, and a covering or grating of green sticks is laid over the opening. Upon this a quick fire is built, and the live embers sifted through upon the naked flesh of the slave, until his body is blistered and swollen almost to bursting. With just enough of life to enable him to crawl, the slave is then allowed to recover from his wounds if he can, or to end his sufferings by death.

"Charley Sloo" and "Overton," two hands, were both murdered by these cruel tortures. "Sloo" was whipped to death, dying under the infliction, or soon after punishment. "Overton" was laid naked upon his face and burned as above described, so that the cords of his legs and the

GORDON AS HE ENTERED OUR LINES.

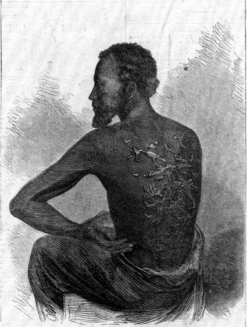

GORDON UNDER MEDICAL INSPECTION.

GORDON IN HIS UNIFORM AS A U. S. SOLDIER.

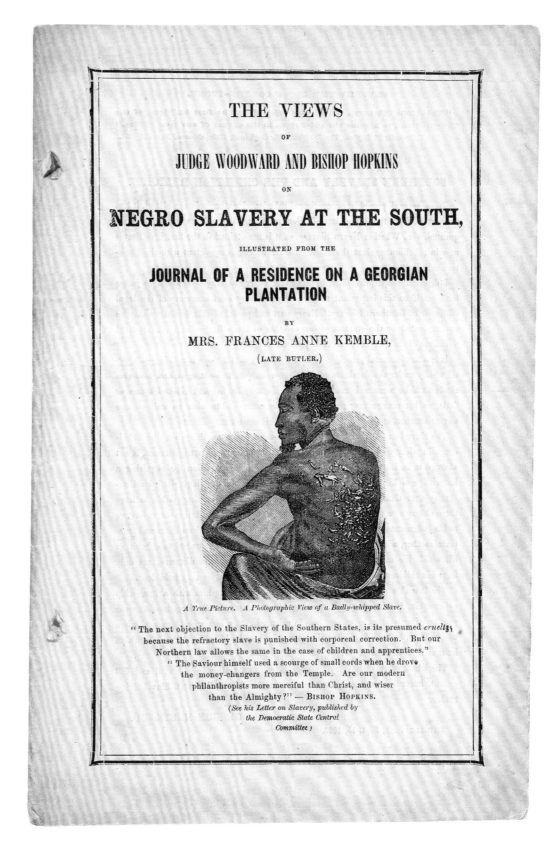

**Fig. 5.2**
Sheet from *Harper's Weekly*,
July 4, 1863, featuring three
portraits of Gordon
Wood engraving, 40.4 × 28 cm
(15⅞ × 11 in.)
National Portrait Gallery,
Smithsonian Institution

**Fig. 5.3**
Frontispiece of *The Views of
Judge Woodward and Bishop
Hopkins on Negro Slavery at the
South, Illustrated from the Journal
of a Residence on a Georgian
Plantation*, by Mrs. Frances Anne
Kemble, artist unidentified, 1863
Wood engraving, 22.6 × 14.8 cm
(8⅞ × 5¹³⁄₁₆ in.)
National Portrait Gallery,
Smithsonian Institution; gift of an
anonymous donor

penned an account of what she had witnessed. Her publication, which was distributed in both Europe (May 1863) and the United States (July 1863), features Gordon on the frontispiece. The image of the vicious and inhumane treatment of Gordon aided the abolitionist movement and spurred many free blacks to enlist in the Union army. The portrait of the black man's survival became a linchpin in the abolitionist cause as well as in the recruiting effort of the Union army.

The Smithsonian's National Portrait Gallery collection holds these three objects related to Gordon that date from 1863: the Kemble pamphlet, the *Harper's Weekly* wood engraving on paper, and a Mathew Brady Studio carte de visite copy of the original McPherson & Oliver photograph.[4] Some questions related to the history of the Civil War will never be resolved, but perhaps with a better sense of contextual knowledge, historians will interpret more from the objects themselves. The collection of objects of Private Gordon held in the National Portrait Gallery, for example, offers invaluable insights into the era of Reconstruction.

There were multiple images with his hand on his hips. However, the most arresting image of Gordon is the Brady photograph that features him in profile. He sits shirtless, with his left hand placed just above his belted trousers. He looks to his left, turning his head, but not gazing over his shoulder. His eyes remain open, and his mouth is firmly closed. His hair is closely cropped, but its coarse texture creates a slight bump just above his forehead. His goatee, with its light streaks of gray, appears to graze his shoulder. Gordon holds his left arm at an angle and uses his hand to gesture toward his back. He angles his elbow upward and outward, achieving his pose through a self-conscious effort. The placement of his arm flexes the sinews straight up through his shoulder, creating enough tension to make it physically uncomfortable for him. The inner arm's musculature creates a dark, shadowy line, and the outlined muscle demonstrates a fit, active body. His left hand vigorously turns upward and outward, proving an ample

view of his palm. The left arm takes up almost half of the picture's area, whereas the exposed back, distinguished by an abstraction of crisscrossing keloid scars marking the skin, takes up the remainder of the picture plane.

The images of Gordon have yielded discussions of black identity and its intersections with trauma, along with investigations into the man's real name. The recent appropriation of Gordon's image in the realm of contemporary art suggests that the scourged back remains a symbol of black personhood in the United States. The power invested in this iconic image and the fact that it remains relevant today attests to Gordon's legacy. He was more than his scars and the pity abolitionists felt because of them. He was an individual with ideas and personal actions. As this study of the Brady photographs reveals, his personhood means he was capable of subversion, rather than being a passive martyr. The scarred back not only exposes the unjust and horrific violence of an enslaved person, but also sheds light on the price he was willing to pay for freedom. Gordon was an active player in this situation and his scarred back in this series of images demonstrates how slaves were agents in freeing themselves.

The portrait of Gordon shattered any lingering assumptions about slavery as a nonviolent practice. Its iconoclasm undermines formal iconography as well, for any American who had attended the Exposition Universelle in Paris in 1855 would have seen Jean-Auguste-Dominique Ingres's oil paintings *Half Figure of a Bather* (1807; fig. 5.4). The subject—a woman bathing—had no connection to mythology and consequently shocked European audiences for decades before it was finally put on display in the Exposition Universelle. The back of the female bather then became so iconic and recognizable in mass culture that in 1924, the Dada and surrealist artist Man Ray created his photograph *Le Violon d'Ingres* as a nod to the neoclassical painter (fig. 5.5). Man Ray made a series of images of a woman, photographed from behind, with her arms pulled forward and her back marked with the *f*-holes of a stringed

**Fig. 5.4**
*Half Figure of a Bather* by Jean-Auguste-Dominique Ingres, 1807
Oil on canvas, 51 × 42 cm (20¹/₁₆ × 16½ in.)
Musée Bonnat, Bayonne, France

**Fig. 5.5**
*Le Violon d'Ingres* by Man Ray, 1924
Gelatin silver print, 29.6 × 22.7 cm (11⅝ × 8¹⁵/₁₆ in.)
Museum Ludwig Cologne, Photography Collections

instrument. Although the armless figure is somewhat unsettling, with a bit of paint, a twist of humor, and the right rephotographing of a print, Man Ray transformed the naked woman's back into a violin. Falling somewhere between Ingres and Man Ray were racy Victorian cabinet cards, similar to the bather paintings, that circulated in the United States en masse. Together, these images demonstrate how, from the mid-nineteenth century on, the naked back symbolized both the objectification and the appreciation of the human form.

Before Gordon's image was made and widely distributed, the naked back was a fetishized object. Interestingly, Ingres worked on his masterpiece *The Turkish Bath* from 1848 through 1863, finishing it just after the

image of Gordon appeared. Although one cannot see William Lloyd Garrison or other devout Quakers and dedicated abolitionists eagerly looking at images of a bare bather's back, much less at slightly pornographic cabinet cards, there is no question that the traumatic image of Gordon's scarred back and his gesturing arm broke through any illusions—particularly about slavery—that people may still have had.

Gordon's purposeful display of musculature in one image, particularly when seen alongside another (figs. 5.6 A and B), exhibits a meaningful capacity for discomfort. As he reaches his hand back, almost gesturing toward his scars, he activates his body, which, while aged, appears very strong. "Here is what I have endured," he

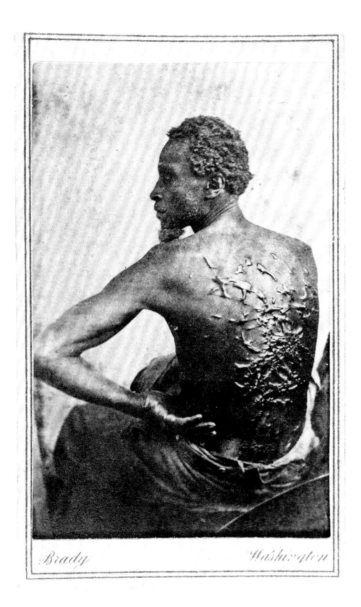

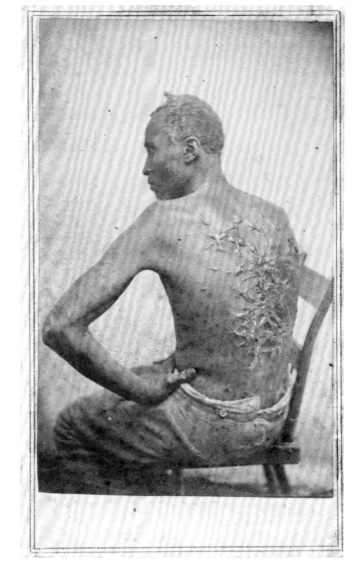

**Fig. 5.6A** (left)
*Gordon* by the Mathew Brady Studio, 1863
Albumen silver print, 10.1 × 6.1 cm (4 × 2 ⅜ in.)
National Portrait Gallery, Smithsonian Institution

**Fig. 5.6B** (right)
*The Scourged Back* by McPherson & Oliver, 1863
Albumen silver print, 10 × 6 cm (3¹⁵⁄₁₆ × 2⅜ in.)
International Center of Photography; purchase, with funds provided
by the ICP Acquisitions Committee, 2003

seems to say. The implication is subtle, but the combination
of his self-aware posture and his demonstration of strength
suggests Gordon's willingness to tolerate the pain again,
and perhaps even more, for his freedom.

## FROM SLAVE TO SOLDIER

A slave's life in Mississippi or Louisiana typically revolved
around raising crops of cotton. Slaves cleared land, burned
underbrush, took away logs, and split rails. They also carried
water, mended fences, spread fertilizer, and broke up
soil. During harvest time, a slave usually worked between
eighteen and twenty hours a day, sometimes picking
more than 300 pounds of cotton. Picking 150 pounds of
cotton per day was deemed satisfactory.[5] Without watchful
supervision, however, most slaves felt no obligation to
exert themselves. Gordon's lashed back, then, signifies the
slave who did not work—of a person who stood up to
the system. Racist ideology was also at play. Blacks were

thought to be a childlike race and therefore punishable. Overseers, who had no stake in the plantation themselves, who had no opportunity for ascension in their social status or economic wealth, were especially resentful and were often more cruel to the slaves than the owners were. Gordon was reportedly one of hundreds of slaves whose backs bore the welts of the whip.[6]

The display of the trauma of slavery inscribed on Gordon's back signals both a revelation and a confirmation for white audiences with abolitionist leanings. Abolitionists constructed a narrative of the slave-to-soldier transformation, and they published it most famously in *Harper's Weekly* on July 4, 1863 (see fig. 5.7). In what has been nicknamed the "Gordon Triptych," we see Gordon as he supposedly arrived at the enlistment station in Baton Rouge, in rags, on the left; Gordon's disfigured, whip-scarred back in the center; and Gordon in a Union soldier's uniform on the right. Gordon wears clothing in the carte de visite reproduced in the wood engraving on the left, but in the original carte de visite, one can see the homespun fabrics that were stitched into rags, which then created parts of what we identify as trousers and a shirt. Questions of the subject's identity continue to play out in the scholarship, but what is important is the redemptive undercurrent of this narrative: Gordon/the scarred slave/black suffering will be redeemed/excused/forgiven if he makes himself into a real citizen through the structured discipline of soldiering.

Many historians have written about Gordon's transformation from an enslaved person to a citizen soldier. David Silkenat points out that the Emancipation Proclamation (1863) was still very unpopular with large audiences in the North during the time of the "Gordon Triptych" publication. He agrees with scholar Carole Emberton, who writes that Gordon's transformation "played an important role in the redemptive narrative of the war" because it took a man who had been traumatized by his life as a slave and created a citizen-soldier out of him. Another

example is the testimony of Robert Cowden, who eventually became colonel of the 59th U.S. Colored Infantry, described the enlistment of that regiment in the vicinity of Memphis in May and June 1863. His words could easily be applied to the figure of Gordon:

> The average plantation Negro was a hard-looking specimen, with about as little of the soldier to be seen in him as there was in the angel in Michael Angelo's block of marble before he had applied his chisel. His head covered with a web of knotted cotton strings that had once been white, braided into his long, black, curly wool; his dress a close fitting wool shirt, and pantaloons of homespun material, butternut brown, worn without suspenders, hanging slouchily upon him, and generally too short in the legs by several inches . . . .
>
> The first pass made at him was with a pair of shears, and his cotton strings and the excess of his black wool disappeared together. The next step was to strip him of his filthy rags and burn them, and scour them thoroughly with soap and water. A clean new suit of army blue was now put on him, together with a full suit of military accoutrements, and a gun was placed in his hands, and, lo! he was completely metamorphosed, not only in appearance and dress, but in character and relations also. Yesterday a filthy, repulsive "nigger," to-day a neatly-attired man; yesterday a slave, to-day a freeman; yesterday a civilian, to-day a soldier . . .[7]

Once he became a soldier, Gordon would have been employed by the federal army as part of the occupying force in Louisiana. Previously enslaved, he now held authority. He also earned a new identity. Emerging from his rags, Gordon

## A TYPICAL NEGRO.

WE publish herewith three portraits, from photographs by M'Pherson and Oliver, of the negro GORDON, who escaped from his master in Mississippi, and came into our lines at Baton Rouge in March last. One of these portraits represents the man as he entered our lines, with clothes torn and covered with mud and dirt from his long race through the swamps and bayous, chased as he had been for days and nights by his master with several neighbors and a pack of blood-hounds; another shows him as he underwent the surgical examination previous to being mustered into the service—his back furrowed and scarred with the traces of a whipping administered on Christmas-day last; and the third represents him in United States uniform, bearing the musket and prepared for duty.

This negro displayed unusual intelligence and energy. In order to foil the scent of the bloodhounds who were chasing him he took from his plantation onions, which he carried in his pockets. After crossing each creek or swamp he rubbed his body freely with these onions, and thus, no doubt, frequently threw the dogs off the scent.

At one time in Louisiana he served our troops as guide, and on one expedition was unfortunately taken prisoner by the rebels, who, infuriated beyond measure, tied him up and beat him, leaving him for dead. He came to life, however, and once more made his escape to our lines.

By way of illustrating the degree of brutality which slavery has developed among the whites in the section of country from which this negro came, we append the following extract from a letter in the New York *Times*, recounting what was told by

GORDON AS HE ENTERED OUR LINES.

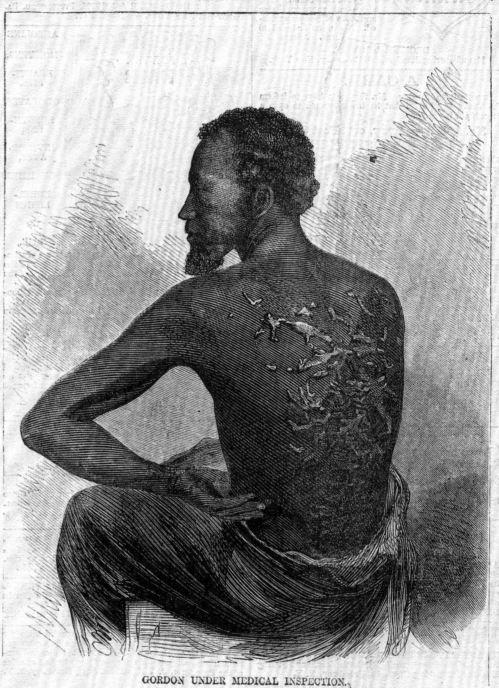

GORDON UNDER MEDICAL INSPECTION.

the refugees from Mrs. GILLESPIE's estate on the Black River:

The treatment of the slaves, they say, has been growing worse and worse for the last six or seven years.

Flogging with a leather strap on the naked body is common; also, paddling the body with a hand-saw until the skin is a mass of blisters, and then breaking the blisters with the teeth of the saw. They have "very often" seen slaves stretched out upon the ground with hands and feet held down by fellow-slaves, or lashed to stakes driven into the ground for "burning." Handfuls of dry corn-husks are then lighted, and the burning embers are whipped off with a stick so as to fall in showers of live sparks upon the naked back. This is continued until the victim is covered with blisters. If in his writhings of torture the slave gets his hands free to brush off the fire, the burning brand is applied to them.

Another method of punishment, which is inflicted for the higher order of crimes, such as running away, or other refractory conduct, is to dig a hole in the ground large enough for the slave to squat or lie down in. The victim is then stripped naked and placed in the hole, and a covering or grating of green sticks is laid over the opening. Upon this a quick fire is built, and the live embers sifted through upon the naked flesh of the slave, until his body is blistered and swollen almost to bursting. With just enough of life to enable him to crawl, the slave is then allowed to recover from his wounds if he can, or to end his sufferings by death.

"Charley Sloo" and "Overton," two hands, were both murdered by these cruel tortures. "Sloo" was whipped to death, dying under the infliction, or soon after punishment. "Overton" was laid naked upon his face and burned as above described, so that the cords of his legs and the

GORDON IN HIS UNIFORM AS A U. S. SOLDIER.

RECONSTRUCTION RECONSIDERED

was given $3 a month to buy clothes (as opposed to a white man's allowance of $3.50); for his service, he earned $7 a month (as opposed to the $13 earned by whites).[8] When *Harper's Weekly* circulated its special issue on the auspicious day of July 4 (fig. 5.7), that very same day, the Union army won the critical battle of the Civil War: the Siege of Vicksburg. The victorious army had also won the Battle of Gettysburg the day before. The Union army was winning the war.

Although President Lincoln authorized the employment of black soldiers even before the Emancipation Proclamation, interestingly, the federalization of black militiamen in Louisiana occurred after the fall of New Orleans in April 1862. General Benjamin F. Butler was in charge of the occupying forces in New Orleans.[9] Among Butler's subordinate officers was Brigadier General John W. Phelps, a West Point graduate and an abolitionist who believed black soldiers were essential. In addition to offsetting the federal manpower shortage in the area, Phelps believed exactly what *Harper's Weekly* had illustrated: that military structure would be a useful tool to facilitate the transition of blacks from slavery to freedom when the inevitable collapse of Southern society occurred. Phelps openly welcomed and even encouraged fugitive slaves to come into his lines. Then he organized them into five companies and gave them arms. Although Phelps soon quit the army, his superior, Butler, with the support of the War Department, continued to accept black men for federal service. At one point, black soldiers engaged in the Civil War numbered over 123,000—a force larger than the field armies that either Lieutenant General Ulysses S. Grant or Major General William T. Sherman directly oversaw at the height of their campaigns in 1864 and 1865.[10] Notably,

Fig. 5.7
Sheet from *Harper's Weekly* (detail), July 4, 1863, featuring three portraits of Gordon
Wood engraving, 40.4 × 28 cm (15 7/8 × 11 in.)
National Portrait Gallery, Smithsonian Institution

Butler accepted militiamen for service with their black officers; all had black captains and lieutenants. However, Butler's tenure as commander of the region was brief. He was replaced by Major General Nathaniel P. Banks, who disapproved of black officers and methodically removed them either from their rank or from the service.

Banks recruited fifteen thousand black soldiers by the end of August 1863. The black community in the South believed that enlisting would be the honorable path to citizenship. *L'Union*, the French-English Negro newspaper in New Orleans, published the following editorial:

To Arms! It is our duty. The nation counts on the devotion and the courage of its sons. We will not remain deaf to its call; we will not remain indifferent spectators, like strangers who attach no value to the land. We are sons of Louisiana, and when Louisiana calls us we march.

To Arms! It is an honor understood by our fathers who fought on the plains of Chalmette. He who defends his fatherland is the real citizen, and this time we are fighting for the rights of our race . . . We demand justice. And when an organized, numerous, and respectable body which has rendered many services to the nation demands justice—nothing more, but nothing less—the nation cannot refuse.

To Arms! Who would think to save himself by neutrality? Would the enemies of the country and of our race have more respect for those who hold themselves timidly apart than for the brave who look them in the face? In what century and in what land has man made himself respected in wartime by cowardice? The scorn of the conqueror is the recompense of weakness.[11]

Gordon's newly forged identity was one that could be shared with all the slaves who were being employed as soldiers. For hundreds of thousands of Americans, then, their collective identity was symbolized by this one specific icon: Gordon. Moreover, white doctors were confirming these transformations in their professional circles. Reuben Tomlinson wrote, "My faith is firm that the best thing that can be done for these men is to put them in the Army. They will learn there sooner than anywhere else that they are men. The improvement in the character and bearing of those who are now in the Army is so marked that every one notices it."[12]

## DOUBLE-CONSCIOUSNESS

Because recognition of the commercial possibilities of portrait photography coincided with the outbreak of the American Civil War, the carte de visite had an immense influence on how individuals thought about having their picture taken and with whom they chose to share those images.[13] Oliver Wendell Holmes acknowledged that the popular new "card-portraits" had become "the social currency, the sentimental green-backs of civilization."[14] Most likely, then, Gordon knew of the portable portrait and its power as he sat for the creation of his own likeness in the carte de visite. Even if he was shown the format just prior to sitting across from the camera, he would have had what W. E. B. Du Bois later described as a double-consciousness, or "this sense of always looking at one's self through the eyes of others."[15] Gordon almost casts a glance back over his shoulder. His intentional demonstration of his profile and the cocking of his elbow radiate an acute sense of self-awareness, or a double-consciousness; perhaps his pose can even be treated as self-expression. The Gordon in this photograph seems to want to convince viewers that he is ready for his future, whatever it holds, even if it involves combat.

## GORDON AS A PRECURSOR TO RECONSTRUCTION

What little we know about Gordon places him in Baton Rouge, and most likely in contact with photographers McPherson & Oliver. If we hold true that Gordon was photographed by McPherson & Oliver, he may well have been a part of the Siege of Port Hudson. McPherson & Oliver photographed Port Hudson, approximately twenty-five miles north of Baton Rouge, in 1863. They photographed it after the siege, which occurred between May 27 and July 9, 1863, and was the final engagement in the Union campaign to recapture the Mississippi River in the American Civil War. It is quite possible that Gordon was part of the assaulting forces, because General Banks, who commanded the 1st and 3rd Louisiana Native Guard, was in charge of the assault. This was the first time that African American troops participated in a Civil War battle.

The scars on Gordon's back signal the potential for further violence. The South was anxious, particularly in the late 1850s, and this anxiety intensified as time passed. Fear of slave uprisings took control of Confederate officials, who were going to such lengths as introducing bills in legislature that would allow punishment of slaves for any insult to a white person.[16] In Mississippi in 1862, for example, one citizen protested to the governor that "there is greatly needed in this county a company of mounted rangers . . . to keep the Negroes in awe, who are getting quite impudent. Our proximity to the enemy has had a perceptible influence on them."[17] The advancing war gave hope to the slaves, who began in greater numbers to refuse to work or to submit to punishment.

Across the South, especially, the arming of black men triggered great fear among whites. In the postwar period, Louisiana, in particular, was a hotbed of racism. As historian James K. Hogue points out, Louisiana was one of only three states where black slaves outnumbered free whites in the census of 1860.[18] Given the height of the tension in Louisiana, the federal army occupied it longer than any other state, from 1862 to 1877. Former Confederate soldiers did not welcome federal rule, instigating widespread white supremacist violence in the form of paramilitary action, overtly disobedient to federal law. What began as vigilante terrorism grew into an organized militia, the White League. This white supremacist militia was determined to use force to oust Republicans from power and end the army's constabulary role of surveillance over state elections. Although, during the early 1870s, when all the Republican state governments across the South showed dangerous signs of strain, Louisiana was the most precarious.

These contexts illustrate how violence most likely formed the base expectation Gordon had about postwar life. Gordon's display of his prewar scars reflects his shrewd assessment of what would come in the future. A free black man did not necessarily experience less violence than someone who was enslaved, and Gordon knew that. He knew how bad it was, and he had the scars to prove it. His cocked elbow seems to communicate his attitude, as if to say, "I've suffered this much. Who is to say I won't willingly endure the same, or worse?" Arming black men in effect created the ultimate weapon against the Confederate South, and, in the Reconstruction era, against the Democratic Party.

When black men had learned how to assert their authority and had developed the skills of soldiering, they endangered white supremacy. The 1873 Colfax Massacre was the culminating event of more than a decade of severe racial tension. In hindsight, it is clear that the hotly contested Louisiana governor's race of 1872 preempted the massacre. Although the Republicans narrowly won the contest, Democrats, angry over the defeat, turned to violence. In Colfax Parish, a white paramilitary force directly challenged the mostly black state militia, who were defending the Colfax Courthouse. More than three hundred armed white men, including members of white supremacist organizations such as the Knights of the White Camellia and the Ku Klux Klan, attacked the courthouse building. When the militia maneuvered a cannon to fire

on the courthouse, some of the sixty black defenders fled, while others surrendered. The rule of war protecting anyone who surrenders was ignored. The black defenders who were wounded in the earlier battle were singled out for execution; African Americans who had not been at the courthouse were victims of indiscriminate killing. Historians are not sure exactly how many black Americans were killed in what can only be described as savage butchery, but estimates immediately after the event fell between sixty-four and four hundred.[19] Only three whites were killed, and few were injured, in the largely one-sided battle of Colfax. After order was reestablished, approximately ninety-seven men were arrested and charged with violation of the U.S. Enforcement Act of 1870 (also known as the Ku Klux Klan Act, which prohibited groups of people from banding together "or to go in disguise upon the public highways, or upon the premises of another" with the intention of violating citizens' constitutional rights). Although a few were convicted, they were released in 1875, when the U.S. Supreme Court in *United States v. Cruikshank* ruled that the Enforcement Act was unconstitutional. The state of Louisiana never made any arrests.

The case of Colfax demonstrates the drastic failure of Reconstruction, which had been initiated by the federal government. In summary, its goal was to rebuild the South, construct new social roles for former slaves, and guarantee citizenship rights for black men. Reconstruction attempted to build an infrastructure that would provide education and jobs, and create a systematic means of upward mobility. As Edward L. Ayers writes, Reconstruction was America's first attempt to transform a defeated society through a sustained military occupation.[20] Although entirely too complicated to boil down to one narrative here, the failed project is in part due to the outcome of *United States v. Cruikshank*. Because state governments, and not the federal government, had jurisdiction over crimes committed by private individuals, they undermined any power the federal government had in the prosecution of racial terrorists in the South.[21]

In 1863, Frederick Douglass said, "Once the black man get upon his person the brass letter, U.S., let him get an eagle on his button, and a musket on his shoulder and bullets in his pockets, and there is no power on earth which can deny that he has earned the right to citizenship in the United States."[22] Gordon, with his active left arm and fully aware posture turned in profile, must have felt this better than anyone else did. His scars signaled that the South was not going to change easily. But as his cocked elbow insists in the arresting, iconic posture—he would take his chances.

## GORDON IN CONTEMPORARY DISCOURSE

Because the social disease of racism and prejudice remains frightfully relevant, the memory of black trauma in the United States is more important than ever. If audiences refuse to recognize trauma and its histories, social groups leave others to suffer alone, and racial tensions persist. Portraits, in that they innately recognize humanity, offer particularly influential tools for unlocking perceived differences among social groups. Moreover, studying portraits, such as that of Gordon, in their original contexts as well as in relation to the contemporary moment, helps to reveal the power of the art object in collective memory and in healing from social trauma.

Black contemporary artists have turned to the image of Gordon as a necessary and crucial component of work that addresses African American identity today. In her series *From Here I Saw What Happened and I Cried* (1995), Carrie Mae Weems appropriated photographic representations of nineteenth-century African Americans. She etched into glass

Fig. 5.8
*Black and Tanned Your Whipped Wind of Change Howled Low Blowing Itself—Ha—Smack into the Middle of Ellington's Orchestra Billie Heard It Too & Cried Strange Fruit Tears* by Carrie Mae Weems, from the series *From Here I Saw What Happened and I Cried*, 1995
Chromogenic print with sandblasted text on glass
45.6 × 45.6 cm (17¹⁵⁄₁₆ × 17¹⁵⁄₁₆ in.)
The J. Paul Getty Museum, Los Angeles; gift of Daniel Greenberg and Susan Steinhauser

BLACK AND TANNED
YOUR WHIPPED WIND
OF CHANGE HOWLED LOW
BLOWING ITSELF-HA-SMACK
INTO THE MIDDLE OF
ELLINGTON'S ORCHESTRA
BILLIE HEARD IT TOO &
CRIED STRANGE FRUIT TEARS

texts that lament the physical and symbolic violence to the black body and places those sheets of glass over the historic imagery. She chose to use the photograph of Gordon's back in her work *Black and Tanned Your Whipped Wind of Change Howled Low Blowing Itself—Ha—Smack into the Middle of Ellington's Orchestra Billie Heard It Too & Cried Strange Fruit Tears* (fig. 5.8). Taking a photographic copy of the National Portrait Gallery's carte de visite (see fig. 5.1), Weems presented the image on a blood-red background and framed it with a round, waffle-textured mat. She modified the image of Gordon by cropping it with the mat, creating a kind of zoom-like focus. Sand-blasted into the glass placed on top of the image are the words "Black and Tanned / Your Whipped Wind / of Change Howled Low/ Blowing Itself—Ha—Smack / into the Middle of / Ellington's Orchestra / Billie Heard It Too & / Cried Strange Fruit Tears." In effect, Weems layered a black experience of the nineteenth century under one of the twentieth. As art historian Cassandra Jackson explains, the work "collapses time frames, rejecting chronological histories for a palimpsest mode of expression that recalls both the idea of traumatic memory as well as that of testimony."[23] The placement of the fuzzy image of Gordon under the crisp letters referencing twentieth-century black culture, including the music of Duke Ellington and Billie Holiday, yields a visual intersection of two different times.

There is, as art historian Cherise Smith notes, "a long line of African American artists who have struggled against negative representations and fought for recognition."[24] In blocking from view what we know so well—Gordon's hand gesture—Weems forces us to look again at his image. In the history of photography, documentary photography has been used to create pseudoscientific racial classifications, which Weems's series *From Here I Saw What Happened and*

*I Cried* explicitly addresses. By appropriating the Gordon image, the artist calls critical attention to the ways in which the camera was implicated in the dehumanization of black people. Jackson notes how "the place of the photographer, the viewer, and that of the abuser are all one in the same, an elision that compounds the tension between past and present, while clarifying the way in which the photograph extends beyond such boundaries."[25] In Weems's own words, the exploration of trauma and violence endured by black Americans helped her "rise above the depiction of blacks always as a victim of the gaze."[26]

Ten years after Weems appropriated the image of Gordon, artist Hank Willis Thomas made his *B®anded* series, which looks at how black male bodies are represented in contemporary advertising. His work *The Chase MasterCard* features an inverted or flipped image of Gordon, so that he is pictured looking to his right. (Fig. 5.9) The image is severely cropped, showing only Gordon's lower face, his upper arm, and half his back, and it serves as the background for a fictionalized Chase Bank credit card. On the left, drawings of various types of slave shackles, strongly reminiscent of images used in abolitionist broadsides, form a visual ladder from top to bottom. Within the box of the MasterCard logo is another drawing of the schema of a slave ship, with its diagram of "tight packing," the method used by slavers to arrange the enslaved Africans and create space for more humans to transport. The date 1619 is presented in the "member since" space, alluding to the year the first slave ship arrived in Jamestown. The Chase logo tops the tagline "The Right Relationship Is Everything." By appropriating the image of Gordon and placing it within the context of a credit card—an object that millions use every day to pay for consumer goods—Thomas forces viewers to recognize the back of the slave as the base of American economy, and even to question their own part in an economic system that is anything but honest.

Juanjo Igartua and Darío Páez have written in their sociological study of collective memory how, as time passes,

Fig. 5.9
*The Chase MasterCard* by Hank Willis Thomas, from the series *B®anded*, made in collaboration with Ryan Alexiev, 2004
Lightjet print, 5.1 × 8.9 cm (2 × 3½ in.)
Courtesy of the artist and Jack Shainman Gallery, New York

the affective distancing from trauma allows people to better analyze the context in which the violence happened.[27] Almost a hundred and fifty years after the making of the photographs of Gordon, the legacy of the burden of the scourged back manifests itself in art like that by Thomas and Weems. They, and other activists, continue to confront a past through a sense of modern vulnerability. Through their work, Thomas and Weems intertwine Gordon's scars with echoes of gunshots and murders in the present. Black men in the United States suffer more murders by police than any other racial group, and witnesses of their murders have recorded and communicated these horrific events to a much broader audience through social media. While perhaps surprising to groups less directly affected by chronic violence, black Americans have been at the center of a long struggle for citizenship rights.

Although not openly discussed until the late twentieth century, the trauma of American slavery remains unforgotten in collective memory. For Maurice Halbwachs, the past is a social construction shaped primarily by concerns of the present. Halbwachs was the first sociologist who stressed that our conceptions of the past are affected by the images, thoughts, and ideas that society uses to address contemporary issues. In other words, collective memory is a reconstruction of the past, through the lens of the present. Public memory, he argues, emphasizes the collective experience over that of the individual.[28] A collective memory in this case has been built on images like that of Gordon—one that reintroduces the twenty-first-century viewer to this era of physical violence and oppression. Gordon's subversive pose has many consequences for the act of remembering. Appropriation of the past, such as Thomas and Weems have done with the image of Gordon, and therefore of the subversive acts of enslaved people, demonstrates how black Americans today are still processing and producing an identity. The very act of remembering violence on the black body implicates the value of citizenship.

The carte de visite of Gordon and its subsequent use in abolitionist propaganda speaks of an era in which Americans were desperate for change, and willing to expose violence in order to increase concern about oppression and racial injustice. These concerns remain familiar as artists engage with racial prejudice through the image of Gordon precisely because the brutality of slavery is so close to the experience of the brutalized black male body. The double-consciousness from the turn of the century has not just changed, it has evolved and adapted. In contemporary contexts, black Americans take on a more ruthless edge in their collective memory, in what only could be called a collective reckoning. The appropriation of Gordon's scourged back is a ruthless confrontation with realities of the past. Although individual memory of slavery has almost completely died out, there remains a powerful communication of trauma inherent in gazing on the scourged back. The image of the scars of slavery, originally made into a souvenir, a keepsake, or a "forget-me not," remains an intermediary between the past and the present, ever cautioning the future through the burdened legacy of memory.

Notes

1 The story of Gordon is based on text accompanying three images of a black man published in *Harper's Weekly*, July 4, 1863. David Silkenat thoroughly investigates the contradictions in *Harper's Weekly* and other sources. See Silkenat, "'A Typical Negro': Gordon, Peter, Vincent Colyer, and the Story Behind Slavery's Most Famous Photograph," *American Nineteenth Century History* 15, no. 2 (2014): 169–86.

2 For excellent discussion of Gordon's identity, see Silkenat, "'A Typical Negro,'" 169–86; and Bruce Laurie, *The "Chaotic Freedom" of Civil War Louisiana: The Origins of an Iconic Image*, Working Titles, vol. 2, no. 1 (Amherst: Massachusetts Review, 2016), e-book.

3 Recent research by historian Bruce Laurie suggests that the individual pictured in this image, widely known as "Gordon," was, in reality, named Peter. Before Laurie's discovery, the subject in these two different photographs of "Gordon" had been strongly argued to be two different people. Now, the photographs are recognized as depicting the same person, Peter. For the sake of consistency, the name "Gordon" will be used here to refer to both the collection and the individual.

4 The McPherson studio photograph that was reproduced as a carte de visite of Gordon, clothed, allegedly taken immediately after he reached the camp, has been proven to be of a different contraband, as slaves were called (see also note 5), than Gordon. See Laurie, *The "Chaotic Freedom" of Civil War Louisiana*.

5 John Hope Franklin, *From Slavery to Freedom: A History of Negro Americans* (New York: Vintage Books Edition, 1969), 192.

6 A private collector has one version of the "Gordon" photograph. On its verso is a facsimile printing of an original Official Report to Col. L. B. Marsh: "I have found a large number of the four hundred contrabands examined by me to be as badly lacerated as the specimen represented in the enclosed photograph," signed J. W. Mercer, Camp Parapet, LA, August 4, 1863. David Silkenat argues that this version, and the version held in the National Archives, were taken earlier than the version owned by the National Portrait Gallery. See Silkenat, "'A Typical Negro,'" 172–73.

7 Robert Cowden, 1863, quoted in James M. McPherson, *The Negro's Civil War: How American Negroes Felt and Acted during the War for the Union* (New York: Vintage Books, 1967), 170–71.

8 The Enlistment Act of July 17, 1862, outlines these figures; by early 1864, black soldiers were earning equivalent wages to whites.

9 Butler was highly disliked by Southerners. This is because, in response to women's disobedience and insulting disposition towards the occupying forces, he issued General Order No. 28. From his point of view, it allowed a soldier to use physical force on a woman if she attacked him, but Southerners interpreted the law as allowing women to be punishable by rape.

10 Joseph T. Glatthaar, *Forged in Battle: The Civil War Alliance of Black Soldiers and White Officers* (New York: The Free Press, 1990), 7–10. The Bureau of Colored Troops, with Maj. Charles W. Foster at the helm, administered more than 186,000 black and white officers and men.

11 *L'Union*, June 2, 1863, quoted in McPherson, *The Negro's Civil War*, 170, trans. Roger Des Forges.

12 Reuben Tomlinson to J. M. McKim, March 16 1863, McKim Papers, Cornell University Library, quoted in McPherson, *The Negro's Civil War*, 168.

13 The carte de visite ushered in a craze for portraiture, because it could be made relatively inexpensively. Once made en masse, portraits could then be distributed by the sitter just like a visiting or calling card. By the 1860s the fashion for collecting the carte de visite had become an international "cartomania." Between 1861 and 1867, more than three hundred million of these cartes de visite were sold in England alone. For more examples of cartes de visite featuring African American soldiers of the Civil War, see Ronald S. Coddington, *African American Faces of the Civil War: An Album* (Baltimore, MD: The Johns Hopkins University Press, 2012).

14 "Doings in the Sunbeam," *Atlantic Monthly*, July 1863, 16; also quoted in Coddington, *African American Faces of the Civil War*, xvi.

15 W. E. B. Du Bois, *The Souls of Black Folk* (New York: Oxford University Press, 2008), xiii.

16 Franklin, *From Slavery to Freedom*, 285.

17 Franklin, 285.

18 James K. Hogue, *Uncivil War: Five New Orleans Street Battles and the Rise and Fall of Radical Reconstruction* (Baton Rouge: Louisiana State University Press, 2006), 4.

19 Hogue, 111.

20 Edward L. Ayers, "The First Occupation," *New York Times Magazine*, May 29, 2005, 1.

21 See Charles Lane, *The Day Freedom Died: The Colfax Massacre, the Supreme Court, and the Betrayal of Reconstruction* (New York: Henry Holt, 2008).

22 Elsie Freeman, Wynell Burroughs Schamel, and Jean West, "The Fight for Equal Rights: A Recruiting Poster for Black Soldiers in the Civil War," *Social Education* 56, 2 (February 1992): 118–20, rev. and updated 1999 by Budge Weidman, https://www.archives.gov/education/lessons/blacks-civilwar, accessed November 9, 2017.

23 Cassandra Jackson, *Violence, Visual Culture, and the Black Male Body* (New York: Routledge Press, 2011), 32.

24 Cherise Smith, "Fragmented Documents: Works by Lorna Simpson, Carrie Mae Weems, and Willie Robert Middlebrook at The Art Institute of Chicago," *Art Institute of Chicago Museum Studies* 24, no. 2 (1999): 247.

25 Jackson, *Violence, Visual Culture, and the Black Male Body*, 34–35.

26 Susan Benner, "A Conversation with Carrie Mae Weems," *Art Week* 23 (May 7, 1992): 5, quoted in Smith, "Fragmented Documents," 256.

27 Juanjo Igartua and Darío Páez, "Art and Remembering Traumatic Collective Events: The Case of the Spanish Civil War," in *Collective Memory of Political Events: Social Psychological Perspectives*, ed. James W. Pennebaker, Darío Páez, and Bernard Rimé (Mahwah, NJ: Lawrence Erlbaum Associates, Publishers. 1997), 86.

28 Maurice Halbwachs, *On Collective Memory*, ed. and trans. Lewis A. Coser (Chicago: University of Chicago Press, 1992).

# CLOUD OF WITNESSES

## PAINTING HISTORY
## THROUGH COMBINATIVE PORTRAITURE

Christopher Allison

Portraits, as singular objects depicting individual persons, are, at first glance, history at the cadence of biography (and in the case of family portraits, genealogy). The portrait is less about what happened in the past, more about the people in it. Biography is history, of course, but its bounds are the self, reacting and intervening in the surrounding world. There have been creative approaches to biography and portraiture alike, attempts to remove the frame and let the life and the age in which the subjects lived bleed together. In these cases, the individual life becomes a microcosm of an age, a culture, a phenomenon, even a nation, and an interpretive angle on a given past. American art historians of the eighteenth and nineteenth centuries have used portraiture to tell stories about the American Revolution, the rise of a merchant aristocracy, a global "world of goods," the "refinement of America," and the formation of American identity.[1] But portraiture, like biography, also allows us to frame history in familiar

dimensions. Most individuals in modern Western culture conceive of their own lives in terms of personal biography lived in a singular body. The biography and the portrait both relate history, but they do so with a centering view on the embodied individual, constrained by the circumstances of birth and chance, reacting to the times, staring out toward an uncertain future. We can relate to that.

Yet what about the history of a community, a nation, a people? How do you depict their conflicts and triumphs, their anxieties, and their hopes? To depict that history, you have to bring the portraits together, combine them, and make their combination meaningful. The urge to combine portraits as witnesses to history in visual culture is old. Assembling witnesses has its roots in ancient, particularly biblical, texts, and became a central motif of early Christian visual culture. American history painters of the late eighteenth and early nineteenth century, all of whom got their start as portraitists, were particularly committed to continuing this tradition of gathering not just witnesses, but portraiture specifically, in their efforts to relate history. Because portraits represent the past best in groups, the artists and printmakers of the nineteenth century used combination picture engravings to tell the

**Fig. 6.1**
*The Nativity with the Prophets Isaiah and Ezekiel* by Duccio di Buoninsegna, 1308–11
Tempera on panel, 47.9 × 86.8 cm (18⅞ × 34⅛ in.)
National Gallery of Art, Washington, DC; Andrew W. Mellon Collection

history of seismic national events, such as the American Revolution and Civil War, as well as sectarian stories, such as the Colored Conventions movement or the progress of the Methodist Church. "Combination pictures," prints that assembled diverse media—especially portraiture—for historical commemoration, were a popular visual form in the nineteenth century. The artists and printmakers who made combination pictures sought to provide the public with access to their crafted visions of the past and spread them across American space. This combination of faces—portraits—looking at a singular person or event was a visual way of elevating historical events and establishing their truth, but it also taught Americans where to set their historical sights. Two historic combination pictures are excellent examples worth examining in depth, one national and one sectarian: John Binns and James Barton Longacre's *Declaration of Independence* (1818) and Theodosia and Charles Chaucer Goss's *The Founders and Pioneers of Methodism* (1873).

The practice in visual culture of assembling witnesses to historical events has significant roots in sacred art, which in turn took its lead from sacred texts. The Hebrew Bible and Christian New Testament lean heavily on the concept of witnessing to establish the veracity of sacred history, elevate its importance, and focus devotion. Witnesses had their legal uses as well. In Deuteronomic law, sins were proven not by a single witness but "at the mouth of two witnesses, or at the mouth of three witnesses," and this is how the transgression was "established."[2] Societies across the Near Eastern world used witnesses in similar ways. But witnesses were not used only to establish crimes. Isaiah invokes witnesses throughout his prophesy to establish truth claims, and he quotes the Hebrew God calling on his witnesses to attest to his singular reality, and by doing so, God promises redemption. "Let all the nations be gathered together, and let the people be assembled . . . let them bring forth their witnesses, that they may be justified."[3] In the book of Numbers, the Israelites, in setting up the wilderness

tabernacle, are commanded to encircle their tents to face inward to the location of the Hebrew God's presence in their midst.[4] The Christian Gospel writers used witnesses to attest to significant events, such as Jesus's birth, baptism, transfiguration, and his miracles, almost always in the presence of cited or implied witnesses. The reportage of Christ's resurrection is a particular witness-heavy event, in which the witnesses are actually named and numbered (even if the women cited did not technically qualify as witnesses under Roman and Jewish law).

The concept of witnessing is important in the description of Jesus's followers in the book of Acts, as they see themselves not yet as "Christians" but as "witnesses" to Jesus's life, death, and resurrection. The culmination of the discourse of witnessing in Biblical texts is a passage from Hebrews, which ties together the Hebrew Bible and the New Testament use of witnesses. The author, after narrating the faith of the great patriarchs of the Hebrew Bible, notes, "Wherefore seeing we also are compassed about with so great a cloud of witnesses, let us lay aside every weight, and the sin which doth so easily beset us, and let us run with patience the race that is set before us."[5] The passage describes a cloud of witnesses, the saints of old, encircling the living, surveilling but ultimately cheering them on towards victory. This is the textual basis for the visual tradition in sacred art of surrounding sacred events with witnessing people, saints, or angels.

In the late antique Mediterranean world, many Christians followed this lead by encompassing their worship spaces with iconic images of saints, angels, biblical narrative, and Jesus. After the fourth century CE, church spaces in the Eastern and Western Christian world were increasingly adorned with both the images and the relics of the saints. To enter a church was to be enveloped by the cloud of witnesses, in both image, substance, and imagination. This motif transferred to singular compositions as well: Duccio di Buoninsegna's *The Nativity with the Prophets Isaiah and Ezekiel* (1308–11) is a great example from the late medieval

period (fig. 6.1). It is an altarpiece that sat behind the altar in the cathedral in Sienna, Italy, for over two centuries. In the panel painting, the focal point is the infant Christ, immediately surrounded by his mother, Mary, along with a bull and a horse who peer into the manger. The mother and the animals are the first circle of witnesses looking at the newborn's swaddled body. This grouping is separated by the stable from an outer circle of other witnesses: St. Joseph, angels, sheep, shepherds, a toddler John the Baptist (taking a bath), St. Elizabeth, and other saints. On either end are Ezekiel and Isaiah with scrolls cascading from their hands, documentary evidence of their prophetic witness. This compositional approach of collecting witnesses to sacred events and arranging them in nested circles focused on a singular body would be a strong compositional tradition in sacred history painting for many years.

After the Renaissance, sacred art became increasingly focused on the more portable platform of the painted canvas. Here a long tradition of encircling witnesses continued. After the Reformations in Europe, the Council of Trent mandated that artists rein in their use of unnecessary figures in sacred history painting and compose nothing "disorderly" or "confusing."[6] The cloud of witnesses, they argued, had become overwhelming and distracted devotees; more focus was in order. But the use of encircling witnesses to observe sacred history continued, even if the figures were reined in. Caravaggio's famous *Doubting Thomas* (1601–2; fig. 6.2), for example, followed Trent's injunction to make sacred art less confusing, but Caravaggio still used a small symmetrical circle of clustered heads to witness Thomas's finger entering Christ's fleshy side. The visceral impact of Thomas's finger submerged in Christ's body is enhanced by the collective looking of all four parties, their eyes locked on the moment of bodily contact, collective witnesses of a resurrected body. Their collective looking directs the viewer's eyes to the focal point of devotion, in this case, Christ's body, while inviting the viewer to participate in their witnessing.

But none of these gathered witnesses were portraits, as such. Caravaggio worked from living models, and was criticized for it.[7] No one believed that the Roman models he solicited to sit for him were actually St. Thomas, or Jesus, or, in other cases, the Virgin Mary. For his heads to be portraiture, a direct connection would need to be made between the body depicted and the person it represented. While there was a belief that St. Luke had painted the Virgin's portrait, the figuration of classical and religious portraiture was largely speculation, informed by an iconic tradition, attuned to the needs of the narrative, articulated by gesture, sartorial signs, and facial expression. In the seventeenth century, there would be a collective move among history painters away from facial accuracy for the purposes of painting universal, nonspecific, and thus transcendent history. This would come to be known as "grand manner" painting. Most theorists of grand manner history painting saw the project as one of elevation, using, especially, Greco-Roman (sculpture), Italian Renaissance, and Baroque art as exemplars. The two pasts that qualified most for the grand manner treatment were classical and sacred history, believed to be worth elevating and the most universally transcendent.[8] But for much of history, as David Lowenthal has observed, these events were not even considered past, as such. In his classic *The Past Is a Foreign Country*, Lowenthal makes the point that during "most of history men scarcely differentiated past from present, referring even to remote events, if at all, as though they were then occurring." Cicero and Herodotus, St. Paul and Martin Luther, all largely lived in the same world. But in the middle of the eighteenth century, people became increasingly aware of the *pastness* of the past. The past was no longer a place for direct comparison, but came to be "conceived as a different realm." There was an emerging awareness that history was diverse, even exotic, that people did and thought about things differently than they did in the modern world. At the same time that the past was becoming glaringly distant, it also became prized, a

Fig. 6.2
*Doubting Thomas* by Caravaggio, 1601–2
Oil on canvas, 107 × 146 cm (42 × 57 in.)
Sanssouci Palace, Potsdam, Germany

"heritage that validated and exalted the present." [9]

This new historical awareness prompted artists to return to original sources as a way of visiting this foreign land and depicting it accurately, but also to gather its resources and ideas to validate modern history. This idea could be taken quite literally and induced many elite Europeans and Americans to travel to Italy and other places to experience and gather the relics of the past in order to encounter it firsthand. [10] The objects brought back by travelers became objects of study, but they also became relics that blessed their respective empires—French, German, Dutch, English, or Spanish. For aspiring artists, the so-called Grand Tour offered close encounters with the masterpieces of classical, Baroque, and Renaissance art, and an education in what made painting great and which pasts were worthy of elevation. As a result, eighteenth-century history painters rarely painted modern history; they and their patrons were so enamored with these vaunted pasts that their first choice was to paint classical or sacred history. When modern history was painted in the first half of the eighteenth century, the figures were often dressed in togas and set amid pillars in non-distinct Mediterranean settings. A major intervention in the genre came with the exhibition of American expatriate Benjamin West's *Death of General Wolfe* (1770; fig. 6.3) at the Royal Academy of Arts in London. The artist brought portraiture to history in an altogether new way.

West got his start as a portrait painter in greater Philadelphia, satisfying the nearly unquenchable thirst by colonial Americans for portraiture. But he aspired to more. While portraiture kept him and many other young artists (mostly) fed, history painting was understood to be the apex of artistic achievement. West dabbled a bit with history in America, but his interest in it accelerated after he embarked on a Grand Tour of Italy from 1760 to 1763, paid for by wealthy Philadelphia patrons. On his way home he stopped in London; he found work as an artist, and would never return to America. Amid various portrait commissions, he

completed several history paintings, mostly of scenes from classical or biblical history. His first major history painting was a scene from Roman history entitled *Agripinna Landing at Brundisium with the Ashes of Germanicus* (1768). King George III was so impressed with the painting that he became West's lifelong patron, which allowed West to devote most of his time to history. After *Agripinna*, West turned toward the *Death of General Wolfe.* Its subject was modern history, namely the death of Major General James Wolfe, a roundly disliked, sickly, and, at times, inept British general, who launched a daring—and successful—assault on French fortifications at Québec City in 1759. Amid his sickness, Wolfe was shot in the hand directing troops, and then fatally in the torso. He died in the arms of his officers just as the word of victory was delivered. Upon his death, the clouds parted and the sun streamed down upon the battlefield—the "Plains of Abraham"—leading many soldiers to interpret this as a sign of providential blessing. The battle effectively ended the American theater of the Seven Years' War and established British dominance in North America. As a result, Wolfe's death was interpreted as a heroic sacrifice for the good of the Empire. [11]

When West came to the subject, British culture had already become saturated with Wolfe paintings, prints, and sculpture. It was not so much the novelty of the history that made West's painting such a sensation, but rather how he chose to approach history on the canvas. West wrote to fellow artist Joshua Reynolds and explained that his method was akin to the historian's: "The subject I have to represent is the conquest of the great province of America by the British troops. It is a topic that history will proudly record, and the same truth that guides the pen of the historian should govern the pencil of the artist." [12]

Since the historical actors were mostly still alive, and since the objects, clothing, and even the setting were accessible, West embarked on a project of amassing artifacts and people to witness Wolfe's death in the painting while setting his scene in a realistic landscape.

Fig. 6.3
*Death of General Wolfe* by Benjamin West,
1770
Oil on canvas, 152.6 × 214.5 cm (59 × 84 in.)
National Gallery of Canada, Ottawa

West's expressed desire to depict history accurately did not preclude enhancement—indeed, elevation—including expanding the number of witnesses. Wolfe's death was attended by only a few people, but in the painting, thirteen witnesses are depicted. The focal point is Wolfe's dying body, articulated to match the traditional form of the Lamentation of Christ devotional genre, thus elevating Wolfe's death by associating it with Christ's body. An immediate circle of three witnesses attends to Wolfe, and then an outer circle looks from the periphery, broken into three distinct groups, through which the viewer can see the battle raging on in the background. West's use of modern dress is particularly important, and it was much noted at the time of exhibition. In many cases, he portrayed the figures in the painting with clothing, accessories, and weapons that he copied from life—modern objects. The Indian artifacts on the ranger and the face of the contemplative Mohawk warrior, for example, were modeled after objects in West's personal collection of American artifacts. Most important, for our purposes, West intentionally painted many of the figures from life, or from available portraits, thus capturing their faces with maximum accuracy.[13] They cluster in a circular formation around the bodily rupture of Wolfe; one officer's hand is submerged in the handkerchief that covers Wolfe's mortal wound, his body sacrificed for the good of the British Empire. In the painting, West dances between grand manner elevation and historical accuracy.

Joshua Reynolds, the first president of the Royal Academy of Arts in London and the greatest proponent of grand manner history painting, warned in 1771 against the portrait painter working on history, for precisely the skillset that West brought to his work. "A Portrait painter," he warned, "when he attempts history unless he is upon his guard is likely to enter too much into the detail." The result was that the "historical heads look like portraits and this was once the custom amongst those old painters who revived the art before general ideas were practiced or understood." For Reynolds, Baroque masters

like Caravaggio may have revived history painting, but their attention to realism, especially in faces, undermined the goal of history painting—to reduce particularity so as to elevate universal human ideals. "A History painter," Reynolds continued, "paints man in general, a Portrait painter a particular man and consequently a defective model."[14] But Reynolds was slightly off base with the trajectory of the times (and came to admire West's *Death of General Wolfe*). As eighteenth-century Anglo-Americans sought the blessing of the past to elevate their present, they also sought historical truth. This meant accurate and realistic detail. The renewed Enlightenment concern over deception, the interest in accessing primary sources and archaeological artifacts, and the desire for firsthand knowledge could coexist with the grand manner that Reynolds advocated. West's *Death of General Wolfe*, and, later, John Singleton Copley's *Watson and the Shark* (1778; see fig. 1.8) were the most important interventions in the genre, for their paintings brought the grand manner into the depiction of modern history *alongside* empirical accuracy. And they carried on the sacred tradition of gathering and encircling witnesses around a singular bodily event with transcending historical significance; they relied on portraiture of historical actors to do so.

Later on in his career, West's *The Death of Nelson* (1806) expanded this witnessing device by adding dozens of witnesses to Admiral Horatio Nelson's death onboard the *Victory* during the Battle of Trafalgar on October 21, 1805. Nelson was shot by a sniper from a nearby ship and was immediately attended by only four people. He was then brought to the lower deck and nursed beneath two guns. Even if the historical witnesses to his death were small in number (about four to six people), West expanded the deck of the ship to cram in as many as possible.[15] In the

Fig. 6.4
*Major General August de la Motte* by John Singleton Copley, 1787
Oil on canvas, 52.1 × 41.9 cm (20½ × 16½ in.)
Harvard Art Museums / Fogg Museum, Harvard University

**Fig. 6.5**
*Declaration of Independence* by John Trumbull, 1818
Oil on canvas, 365.8 × 548.6 cm (144 × 216 in.)
U.S. Capitol Building, Washington, DC

aftermath of the battle, West invited survivors not only to come to his studio and recount their experiences, but also to sit for a portrait. As a result, West accumulated fifty or more portraits, which he then transferred into the painting as witnesses to Nelson's heroic demise.[16] West quite directly gathered witnesses, heard their stories, and then encircled the portraits of them around Nelson's dying body. John Singleton Copley was similarly devoted to assembled portraits of witnesses in his composition of *The Defeat of the Floating Batteries at Gibraltar* (1791). The painting took him almost a decade, in part because he insisted on traveling to paint from life the portraits of the witnesses to the British victory and mercy mission at Gibraltar in 1782; in the summer of 1787, he traveled as far as Germany to paint two German officers (fig. 6.4).[17]

We have seen how American-born painters were crucial in marshalling their skills as portraitists in order to assemble circles of witnesses in their history paintings; however, most of the subject matter so far has been British imperial history. But Americans had their versions as well. The most familiar is John Trumbull's *Declaration of Independence* (1818; fig. 6.5), one of four Revolutionary War pictures commissioned by Congress. The painting was really a revised enlargement after a smaller 1786 edition. Trumbull was a Revolutionary War veteran, a student of West in London (imprisoned there for a time during the Revolution), and painted the original work in Paris at the invitation of Thomas Jefferson. Trumbull chose not to depict a scene true to history, but rather structured the composition in order that all the signers of the declaration could fit into the painting. Only forty-two of the fifty-six signers are depicted, however, because he excluded the signers for whom he could not find an accurate likeness. Every face was copied either from life by Trumbull, or from a life portrait.[18] Here we see again a history painting as an assemblage of portraits. Jefferson's body (not the document he holds) is the focal point, surrounded by a secondary circle, and then a broader circle around the periphery of the

room. Here Trumbull places primary authorial responsibility on Jefferson first, then the broader committee (John Adams, Benjamin Franklin, Roger Sherman, Robert Livingston), and then the rest of the signers of the document, who all collectively center their eyes on Jefferson handing the declaration over to John Hancock. But none of the figures are signing—or really doing—anything. They are looking, witnessing the moment. Even Jefferson only limply holds the corner of the manuscript. This defied the ideal that Reynolds had set forth for history paintings, which, he wrote, were not to be centered on "individual likenesses," but on "action."[19] There is no action in Trumbull's painting, but there are a lot of individual likenesses. The drama of the painting is the witnessing of the event.

One of the problems with history paintings is that they are enormous, almost by definition. Copley, West, and Trumbull used this monumentality to elevate the subject matter but also to create cultural buzz around the exhibition of these time-consuming projects. But after the buzz faded, the paintings' monumentality created very practical problems, especially in disseminating these visions of history. First of all, there was the problem of finding an interior space to house them. In America, this was particularly acute. Trumbull exhibited his painting in the major cities of the early republic—New York, Boston, Philadelphia, and Baltimore—renting halls large enough, such as Faneuil Hall in Boston, to accommodate the painting's size and the expected crowds. But in the end, the picture came to rest within the walls of the Capitol, and since 1826, it has been installed in the building's Rotunda. But how could people see the work after it stopped itinerating, besides by visiting it in Washington? The answer was, of course, through prints, which paved the way for history paintings

**Fig. 6.6**
*Declaration of Independence* by James Barton Longacre, after Gilbert Stuart, 1818
Etching and stipple and line engraving, 84.4 × 61 cm (33¼ × 24 in.)
National Portrait Gallery, Smithsonian Institution

to move through American culture. West and Copley both viewed prints as a means of disseminating their works and maximizing their profits. West, whose *Death of General Wolfe* was a ubiquity in Anglo-American print shops for decades, was the more adept of the two. Trumbull's image became equally iconic, largely thanks to an 1820 engraving made by Asher Durand, sometimes sold with a key that helped the buyer identify the historical figures and admire (or disdain) the artist's devotion to facial accuracy in assembling life portraits.[20] Later on, Trumbull's picture would be featured on the verso side of multiple forms of currency, commemorative stamps, and other objects.

Printmaking offered other opportunities for such assembled compositions, namely "combination pictures." The term emerged in the 1850s, but there are precedents from the early decades of the nineteenth century. Combination pictures were a popular format for historical narratives because of their ability to gather documentary and human witnesses in diverse media in a single engraving intended for mass distribution. One of the first combination pictures to relate American history was made by John Binns, an Irish immigrant and newspaper man who was well attuned to the virtues of print distribution. In 1818, Binns worked with artist James Barton Longacre to create a print that featured prominent objects and images related to early national history in the United States (fig. 6.6). The composition focused on the Declaration of Independence itself; the focal point is a facsimile of the document, which an advertisement noted was "engraved at the Department of State, with the original signatures constantly before the artists." The original document is surrounded by a symbolic cartouche, representing each state of the early republic. The "medallion portraits" at the top were explicitly the work of Longacre, copied from John Singleton Copley's portrait of John Hancock, one of Gilbert Stuart's portraits of George Washington, and Bass Otis's portrait of Thomas Jefferson. In the print, Binns and Longacre arranged the three likenesses, visually related them to the declaration, and encompassed

the text with a symbolic representation of each of the thirteen states, which seem to bind the new nation together in union.[21]

Combination pictures of this kind were used throughout the nineteenth century. The Civil War, for example, was an event that spawned many combination pictures, as artists sought to envision the conflict from its many complicated angles. Artists brought together the landscape (before and after the fighting), scenes of the battle itself, portraits of military commanders, and sympathetic images of families waiting for their loved ones at home. Portraiture dominated these compositions. One of the most remarkable combination pictures of the period is not about the Civil War, but rather religious history: Theodosia and Charles Chaucer Goss's *The Founders and Pioneers of Methodism: In All Parts of the World, and in All of Its Branches* (1873; fig. 6.7). It is, at first glance, overwhelming. But here we find an assemblage of generations of portraiture in diverse media over more than a century, reduced to common size, color, and ink, intended for the Victorian cabinet, drawing room, library, church, or Sunday school room. In this swirling cloud of 255 portraits of the "founders and pioneers" of Methodism, we can see a project of historical witnessing in its most complete expression.

The print was made in 1873 by artist Theodosia Goss and historian Charles Chaucer Goss—a crucial collaboration, much like Binns and Longacre's—and printed by Albertype process in the shop of famous landscape photographer and engraver Edward Bierstadt (an earlier version had appeared in 1867). Theodosia was a New York portrait artist who ran a "picture business" in Lower Manhattan from the

**Fig. 6.7**
*The Founders and Pioneers of Methodism: In All Parts of the World, and in All of Its Branches,* by Edward Bierstadt after Theodosia Goss and Charles Chaucer Goss, 1873
Collotype, 70 × 55 cm (27½ × 21⅝ in.)
American Antiquarian Society, Worcester, Massachusetts

# THE FOUNDERS AND PIONEERS OF METHODISM,

*In all parts of the World and in all of its Branches*

*Central Group  25 different portraits of John Wesley.  Inner Circle  The Wesley Family.  See Key.*

PUBLISHED BY MRS. G. G. ROSS, NEW YORK 1873

1850s through the 1880s. Even though she was a trained portraitist, in the 1860s her business turned decisively to enlargements—in various mediums—using her "Solar Technique." After the invention of solar enlargement techniques in the 1850s, many artists, particularly women, began using the photographic method to create highly accurate enlargements of photographs, which they then made into formal paintings and drawings.[22] The apparatus would be mounted on the roof of a studio; it condensed light from the sun through a set of mirrors and a ground glass lens, which then would project the condensed light through a photographic negative, through a copying lens, and onto a large sheet of sensitized paper or canvas, producing an image, which period sources described as "light and airy . . . no more than a thought, yet a perfect likeness and an admirable guide."[23] The lines left on the canvas or paper formed the underdrawing for subsequent "working up." This was most commonly done in crayon, charcoal, or India ink—though occasionally in oil if the work had been commissioned by a wealthy client. One of the immediate payoffs was artist-style portraits made from photographs—which gave the resultant objects a sense of refined gentility while maintaining the highest level of facial accuracy. People could take a photograph or ferrotype, or send an old family heirloom portrait—what Theodosia Goss called "the most sacred relics of the household"—and through enlargement, she could transform even the smallest likeness into a "beautiful LIFE-LIKE Portrait at full life size or smaller."[24] She also noted that she provided higher-quality services than her competitors did. They relied on ephemeral "chalky substances" while she finished her portraits in "oil or India-ink, as such Portraits only stand the test of time." She received rave reviews: "Almost surpasses the original," "This likeness of me surpasses all others," "Mrs. Simpson likes this the best." Accuracy and preservation of people were the watchwords of her business.[25] But the device could shrink objects as well, and this ability was crucial for her work in *Founders and Pioneers of Methodism*.

Charles Chaucer Goss was a historian and a Methodist minister in New York who had produced several large histories of the Methodist movement. The print was commissioned by Methodist dignitaries to celebrate one hundred years of Methodism in America. Methodism began in England as an evangelical renewal movement within the Anglican church. Despite these English roots, Methodism became a great American success story. Whereas in the eighteenth century Methodists trailed nearly every other sect, by the Civil War they claimed a third of American church membership.[26] This led President Ulysses S. Grant to quip in 1868 that "there were three great parties in the United States: The Republican, the Democratic, and the Methodist Church."[27] The Gosses chose to assemble portraiture in order to envision this history, which reflected the Methodist fondness for portraits. The print was a massive undertaking in time, energy, correspondence, and money, because the artists insisted on working from original portraits—"profiles, lithographs, engravings, daguerreotypes, miniatures and oil paintings." Charles explained in the key to the print that the project had not only cost him $3,000 to produce, but also took seven years to complete and over five hundred letters to coordinate. Charles moaned of how "difficult and onerous" the work was, so that he had been "hardly . . . able to please himself." But he hoped his collection of these "sacred relics," sent "hundreds of miles," would deserve the thanks of the whole church, "enabling so many worthies who toiled for one common object to be grouped together and transmitted to posterity."[28] The call went out across the Methodist world "on both hemispheres" for families and admirers to pack up their treasured pictures in a variety of media, and ship them to the Goss home in lower Manhattan. They did.[29]

Once the hundreds of objects arrived at the Goss home they were photographed, then painted in small, but common, format, probably on paper, and cut to ovoid shapes. This common reduction effaced the difference

between, say, miniatures and full-size portraits, and created a visual unity that masked the original medium. Once this was done, Charles, probably with a design in his mind, arranged the figures in their three concentric swirling groups. Once he had finalized the composition, a photograph was made by Theodosia of the whole. The negative was then put into Theodosia's solar enlarger, and projected onto a large, treated piece of paper that recorded a fine, wispy outline of the composition. It was from those thin outlines that she painted the image in "India-ink," as she did for so many clients through her solar enlarger. After the painting was finished, it went out to Bierstadt, came back, a copyright was sent to Washington in Theodosia's name, and the finished prints were then sold directly and by subscription from Theodosia's portrait studio in Manhattan.

Photographing the original objects not only allowed them to be reduced "to harmony of size, tone, and strength," but it also allowed Charles to flip the negative in order to change the direction the portrait was facing, so that all the portraits look inward to the center, to John Wesley's face. Methodism, like the United States, had many founders, but in the print, the Gosses made an argument for one—John Wesley—just as Trumbull had with his focus on Jefferson. Instead of, in the words of the author of the book of Hebrews, setting their eyes on Jesus, "the founder and perfecter of our faith," all eyes were set on John Wesley—the founder of their denomination and, for many Methodists, the perfecter of the Protestant Reformation. The arrangement also asserts a strong a patriarchal theme; in addition to being the founder, Wesley is depicted as a father and as an instrument of God who has been thrown into history, with an outward rippling effect across the world. Francis Asbury, the first American Methodist bishop, was not alone when he called John Wesley "dear old daddy."[30] Wesley's centermost portrait is not only surrounded by lesser versions of himself—"diverse . . . taken at different periods," so the viewer could "imagine for themselves which best represents him"—but just

outside his crowd of doppelgängers is his family. And as the circles move outward they denote a multigenerational expansion, even if it is a spiritual one. Despite the message of religious patriarchy as the seed of the expanding movement, the composition is bounded by portraits of the "Mothers of Methodism." This choice creates, quite literally, a women's sphere in which male leaders dwelt. If John Wesley was the founder and perfecter of the movement, then Methodist women would keep it safe and pure within their ethical orbit.

The faces are turned toward Wesley, but they also look directly at the viewer—as portraits tend to do. The role of vision in the piece is arresting. The three concentric circles, especially when viewed from an angle, have the anatomic construction of an eyeball: the pupil, the church father, John Wesley; the iris, filled with twenty-two portraits of Wesley, the color of the singular saint's life; and the sclera (or the white of the eye), filled with other Methodist saints. With this cloud of mostly dead Protestant saints looking at the viewer, we can recall, once again, the description in Hebrews 12 of an all-encompassing "cloud of witnesses" cheering the living on in their spiritual race, *and watching*. The assemblage of "life-like" portraits made an argument for the saints of the past, and if stared at long enough, the portraits start to shudder. Here the devotional use of the image comes into focus. These Methodists were supposed to fix their eyes on their founder, John Wesley—a gaze that should replicate the one life's piety in the many. At the same time, see the triumphant lives of those who had come before them, cascading outward from the saintly founder, but also cheering them on with an eternal liveliness.

Theodosia and Charles Goss gave Methodists a swirling cloud of witnesses, using portraiture to envision their history in a way that was both religiously meaningful and leveraged the Methodist love and collection of the portraits of their fellow saints, but also drew on a long tradition of assembling portraits as representations of witnesses to history. At the same time, Theodosia used her

print to make a plea for her business, imploring ordinary Methodists to pack up their treasured "Old Family Portraits" and send them to her studio so that their images would not be lost to destruction or decay—to history. "Secure the shadow," she wrote, "ere, the substance perish."[31] Theodosia's project begged that other clouds be brought near, into her studio, into the sights of her machinery, into her ability to give and sustain life through pictures of the living and the dead. And this was the point of gathering witnesses in visual art. Witnesses kept history from being lost and bolstered its truth claims, but it also focused the historical vision—the more witnesses, indeed portraits, the better. Collecting, assembling, and arranging them around important historical events and people was a means of establishing the truth of the event and focusing its transcendent importance.

Notes

1 For a selection, see Margaretta M. Lovell, *Art in a Season of Revolution: Painters, Artisans, and Patrons in Early America* (Philadelphia: University of Pennsylvania Press, 2005); Paul Staiti, "Character and Class," in *John Singleton Copley in America*, ed. Carrie Rebora Barratt (New York: Metropolitan Museum of Art, 1995), 53–77; David Jaffee, *A New Nation of Goods: The Material Culture of Early America* (Philadelphia: University of Pennsylvania Press, 2010); Jules David Prown, *John Singleton Copley*, vol. 1 (Cambridge, MA: Harvard University Press, 1966); Timothy H. Breen, "'The Meaning of Likeness': Portrait Painting in an Eighteenth-Century Consumer Society," in *The Portrait in Eighteenth-Century America*, ed. Ellen G. Miles (Newark: University of Delaware Press, 1993); Richard L. Bushman, *The Refinement of America: Persons, Houses, Cities* (New York: Knopf, 1992).

2 Deuteronomy 19:15 (King James Version).

3 Isaiah 43:9. See also Isaiah 8:2, 43:10–12, 44:8.

4 Numbers 2.

5 Hebrews 12:1

6 "The Council of Trent: The Twenty-Fifth Session," *The Canons and Decrees of the Sacred and Oecumenical Council of Trent*, ed. and trans. J. Waterworth (London: Dolman, 1848), 233–35.

7 Todd Olson, *Caravaggio's Pitiful Relics* (New Haven, CT: Yale University Press, 2014), 144.

8 Wayne Craven, "The Grand Manner in Early Nineteenth-Century American Painting: Borrowings from Antiquity, the Renaissance, and the Baroque," *American Art Journal* 11, no. 2 (1979): 4–6.

9 David Lowenthal, *The Past Is a Foreign Country* (New York: Cambridge University Press, 1985), xvi.

10 Lowenthal, xvi.

11 Fred Anderson, *The Crucible of War: The Seven Years' War and the Fate of Empire in British North America, 1754–1766* (New York: Alfred A. Knopf, 2000), 367, 373–78.

12 Emily Ballew Neff, "At the Wood's Edge: Benjamin West's 'The Death of Wolfe' and the Middle Ground," in *American Adversaries: West and Copley in a Transatlantic World*, ed. Emily Ballew Neff and Kaylin H. Weber (Houston: Museum of Fine Arts, Houston; New Haven, CT: Yale University Press, 2013), 69.

13 Vivien Green Fryd, "Rereading the Indian in Benjamin West's 'Death of General Wolfe,'" *American Art* 9, no. 1 (1995): 74. Neff, "At the Wood's Edge," 64–98.

14 Sir Joshua Reynolds, *The Life and Writings of Sir Joshua Reynolds: First President of the Royal Academy*, ed. Allan Cunningham (New York: A. S. Barnes & Burr, 1860), 64.

15 Neff, "At the Wood's Edge," 38–41.

16 "The Death of Nelson, by Benjamin West," Artwork Details, National Museums Liverpool, accessed August 14, 2016, http://www.liverpoolmuseums.org.uk/picture-of-month/displaypicture.aspx?id=274.

17 Theodore E. Stebbins Jr. and Melissa Renn, *American Paintings at Harvard, Volume One: Paintings, Watercolors, and Pastels by Artists Born before 1826* (Cambridge, MA: Harvard Art Museums; New Haven, CT: Yale University Press, 2014), 154–56.

18 Tanya Pohrt, "Reception and Meaning in John Trumbull's 'Declaration of Independence,'" *Yale University Art Gallery Bulletin*, 2013, 116–19.

19 Sir Joshua Reynolds, *The Literary Works of Sir Joshua Reynolds*, ed. Henry William Beechey, vol. 2 (London: G. Bell & Sons, 1890), 305.

20 "Declaration of Independence," *Evening Post* (New York), September 19, 1823.

21 "Declaration of Independence," *Daily National Intelligencer*, November 19, 1819.

22 Ella Maria Long, *The Art of Making Portraits in Crayon on Solar Enlargements* (Quincy, IL: E. Long, 1890); Mrs. Warren, "The Renumeration of Art in America: Crayon Photographs," in *The Ladies Treasury for 1882 a Household Magazine* (1882), 696–97.

23 Long, *The Art of Making Portraits in Crayon on Solar Enlargements*, 13.

24 Charles Chaucer Goss, *Methodism, Its Founders and Pioneers: Being an Explanatory Key to a Group of 255 Portraits, Entitled "The Founders and Pioneers of Methodism; In All Parts of the World and in All of Its Branches"* (New York: Mrs. C. C. Goss, 1873), 16.

25 Goss, 16.

26 Roger Finke and Rodney Stark, *The Churching of America, 1776–2005: Winners and Losers in Our Religious Economy*, rev. and expanded ed. (New Brunswick, NJ: Rutgers University Press, 2005), 55–116.

27 Quoted in David Hempton, *Methodism : Empire of the Spirit* (New Haven, CT: Yale University Press, 2005), 253.

28 Goss, *Methodism, Its Founders and Pioneers*, 4.

29 Goss, 2–5.

30 Francis Asbury to Jasper Winscom, August 15, 1788, in *Journal and Letters of Francis Asbury*, ed. Andre Roux, vol. 2 (Nampa, ID: Northwest Nazarene College, n.d.), online edition, accessed November 3, 2015, http://wesley.nnu.edu/other-theologians/francis-asbury/the-journal-and-letters-of-francis-asbury-volume-ii/francis-asbury-the-letters-vol-2-chapter-3/.

31 Goss, *Methodism, Its Founders and Pioneers*, 16.

# "LET ME TAKE YOUR HEAD"

## PHOTOGRAPHIC PORTRAITURE AND THE GILDED AGE CELEBRITY IMAGE

Erin Pauwels

In 1908, Samuel Clemens penned a grumbling inscription in the volume of short stories that had been published to commemorate his sixty-seventh birthday (fig. 7.1). "Of course they would frontispiece it with this damned old libel, which *began* as a libel when Sarony made it," he wrote, adding that it had "been used all over the world in preference to any later & better picture."[1] The inscription was not addressed to any specific reader, fan, or admirer, but was rather something that he placed in his personal copy of the souvenir book. Quietly residing in his private library as a kind of message to the ages, the publication serves as a permanent register of the author's intense distaste for a photograph that had been publically selected to represent him and his writing. Clemens was a notorious pack rat, and his voluminous surviving collection of press clippings, photos, and correspondence is filled with similar handwritten instructions, imprecations, and pithy asides— testament perhaps to Twain scholar R. Kent Rasmussen's speculation that the author regarded such materials as "mirrors reflecting the images Clemens cast on the world," important extensions of his carefully crafted public self.[2] By scrutinizing and editing his own archive of these reflected images, Clemens exercised authority over an area of his professional identity that tended to operate outside of his control, and found a strategy for re-inscribing these publically circulated materials with the irrefutable evidence of his individual creative voice.

In the case of his sixty-seventh-birthday volume, it was true that the frontispiece picture was not a particularly recent one. It had been created fifteen years earlier in 1893 by Napoleon Sarony, a Manhattan-based portraitist revered during the Gilded Age as "the father of artistic photography in America."[3] However, Clemens's specific description of the portrait as "libel"—a false printed statement with the capacity to damage his reputation—is one that begs further examination. It raises the intriguing question of how a photograph, and specifically this photograph, might have been perceived to misrepresent or even damage the public image Clemens guarded so closely.

Returning the picture to the context of its original creation and circulation helps establish that this informal charge was made less in reaction to the *appearance*

Fig. 7.1
Frontispiece of Clemens's copy of *Mark Twain's Sixty-Seventh Birthday*, 1902, featuring his inscription of 1908
Courtesy of Kevin Mac Donnell, Austin, Texas

S.L. Clemens

Of course they would frontispiece
it with this damned old libel, which
began as a libel when Sarony made
it, in my fortieth year — since which
time it has been used all over the world
in preference to any later & better picture.

S.L.C., April 1908.

of Sarony's image than to a significant change in the way portraits of prominent individuals were displayed, appreciated, and consumed during the decades around the turn of the twentieth century. Between 1860 and 1900, photographic portraiture emerged as a major American industry. At the start of this period, the commercial introduction of small, card-mounted photographic prints sparked a consumer frenzy popularly known as "cartomania." In the United States, cartes de visite and their slightly larger counterparts, cabinet cards, could be purchased in photographic studios for one dollar per dozen, or as little as a dime apiece, allowing even working-class consumers to own portraits of family, friends, and celebrities, and to display them side by side in specially produced albums.[4]

By 1882, sales of celebrity photographs totaled roughly one million dollars in New York City alone.[5] Scholars such as Barbara McCandless and Andrea Volpe have described how this "deluge" of portraiture within American visual culture altered the meaning of fame in the United States by democratizing the way public images were constructed and consumed by powerful and everyday citizens alike. Clemens's characterization of Sarony's photograph as a "damned old libel" demonstrates further how the boom of the late-nineteenth-century portrait contributed to a peculiar moment of conflict between two simultaneously evolving cultural phenomena: the emergence of modern, mass-media celebrity on the one hand, and the campaign to elevate photography to the status of fine art on the other. Both pursuits required novel strategies for asserting individual creative authority; for celebrities such as Clemens, it meant attempting to maintain control of a professional identity that was increasingly open to collective definition, and for ambitious photographers like Sarony, it meant persuading skeptical viewers that a medium conventionally associated with autonomous mechanical reproduction could also be a vehicle for personal and artistic expression. Against this backdrop, Clemens's claim of libel might be properly

understood as a contest of authorship, a dispute between subject and artist over who could rightfully determine the meaning of a publically circulated image. Yet however unwelcome these authorial intrusions were in Clemens's eyes, the gentle "libels" Sarony introduced to Gilded Age photographic practice in the United States were received with enthusiasm by a broader population of Americans who eagerly sought his expert help to reshape and reinvent the images they presented on the late-nineteenth-century public stage.

## PICTURES SPREAD AROUND THE WORLD

Looking closely at the portrait of Clemens reprinted in his birthday book, it is difficult to discern what could have troubled him about it so deeply. The picture shows the author at bust length, with his shoulders angled away from the camera so he seems to gaze with thoughtful abstraction at some point just behind the viewer (fig. 7.2). Though seemingly straightforward, the composition makes use of a sophisticated lighting technique that was synonymous with the Sarony Studio during the late nineteenth century and much admired in contemporary photographic circles for its technical complexity.[6] The side of the subject's face closest to the camera is cast in shadow, while the more distant side is brightly highlighted. In Sarony's photograph of Clemens, the result is that on the right, the author's jawline and the creases surrounding his eye are softened by shadow, while on the left, radiant light delineates the contour of his cheek, accentuating craggy furrows between his eyebrows, and worry lines beneath his eye and alongside his nose. Working without electricity beneath the skylights of his Union Square studio, Sarony achieved this effect through masterful control of the shutters, baffles, and mirrors used by photographers of the era to direct ambient sunlight onto the face of their

Fig. 7.2
*Portrait of Mark Twain* by Napoleon Sarony, 1893
Albumen silver print, 15.9 × 10.8 cm (6¼ × 4¼ in.)
Private collection

Mark Twain,

37 UNION SQR., N. Y.

portrait sitters. The rich range of tones that results lends a sculptural solidity to Clemens's photographed head and draws attention to the wild peaks and volumes of his famous mane of graying hair. From the dark ringlets curling behind his ear to the diaphanous white waves that rise cloudlike above his forehead, the writer's unruly locks seem to crackle with the electricity of unexpressed witticisms, the famous voice beneath the bristling moustache silenced only momentarily out of courtesy to the camera's operator.

Apparently unaware of Clemens's dislike for the portrait, Sarony regularly claimed it to be among the best he had ever taken, and in an 1894 newspaper interview, proudly recounted the circumstances of its creation. One day while out walking on Fifth Avenue, he had encountered the author in the street, and was struck immediately by the appearance of Clemens's iron-gray hair tumbling over his coat collar and sticking out from under his hat. The effect, the photographer recalled, "gave his head the massive appearance of the old type of patriarch." Running over and catching hold of his arm, Sarony implored, "Mark Twain, I want you to let me take your head, just as it is. Don't go to the barber until you see me." Several days later, Clemens appeared in the studio as requested to sit for his photograph, and in the end, Sarony felt satisfied he had succeeded in creating a portrait that was true to the vision he had that day on the street. In his view, the image lent the American humorist a gravitas and dignity while still retaining a sense of his lively, modern animation. It is, Sarony concluded, "a photograph of which I am justly proud."[7]

Initially, it seems Clemens was in agreement with this positive assessment. In a letter to his wife, Livy, dated November 18, 1893, he described visiting Sarony's studio and sitting for seven photographs, of which he reported there were "one or two very good negatives."[8] Apparently the portrait he would later describe as a "damned old libel" was among these, since that same year he lovingly inscribed an enlarged version of the photograph and gave it to Livy for her birthday.[9]

It was not until the following decade that his favorable opinion of the picture changed radically. His expression of distaste was not limited to a quiet inscription in his birthday volume, but also, beginning around 1905, was forcefully and frequently repeated in a variety of public forums. In a widely published letter to an admirer who had requested an autographed copy of the photograph (the request was denied), Clemens even suggested that he was not the portrait's true subject. Instead, in characteristic deadpan, he claimed that Sarony had for years been circulating a picture depicting a costumed gorilla in his place.

Denying earlier accounts of the portrait's creation, Clemens reported that the photographer had come to him one day in a thrill of excitement with the news he had recognized the author's long-lost great-grandfather in an exhibit of lowland gorillas then touring the United States. "I was deeply hurt but did not reveal this," the author confided, "because I knew that Sarony was not a man who would say an unkind thing about a gorilla wantonly." Eager to orchestrate a reunion, the photographer invited both author and gorilla to his portrait studio, and to demonstrate the family likeness that originally caught his eye, he borrowed Clemens's overcoat and put it on the animal. Initially the author could see only "passing resemblance" between himself and the ape, but once it was in costume, he was forced to concede that "The result was surprising. I saw that the gorilla, while not looking distinctly like me, *was* exactly what my great grandfather would have looked like if I had had one." It was then that the troublesome seeds for "libel" were sown. According to Clemens, "Sarony photographed the creature dressed in that overcoat, and spread the picture around the world. It has remained spread around the world ever since . . . It is not my favorite but to my exasperation it is everybody else's."[10]

Though clearly meant to amuse, the story of the gorilla imposter helps illuminate the source of Clemens's frustration as well as his later charge of libel. The problem was not simply that he found the picture unflattering (though this

is certainly implied), but also—and, it seems, even more troubling—that Sarony had let the photograph be "spread around the world."

Indeed, whether fueled by the photographer's pride in the image or a shared public enthusiasm, the portrait of Clemens was reproduced in massive numbers during the decades following its creation. Sarony was among the leading producers of carte photographs during the peak years of cartomania. He estimated that, during the 1880s, his massive studio on Union Square filled orders for more than one thousand photographs a day, and that over the course of his three-decade-long career he personally created more than two hundred thousand portrait photographs.[11] The nature of Sarony's business was so well known by the 1890s that Clemens could hardly have been unaware of the intended public circulation of his image. In fact, he was acquainted with the photographer socially and had posed for him at least twice before, in the 1870s and in 1883, when Sarony produced a series of publically circulated carte portraits of Clemens and the novelist George Washington Cable to promote the duo's "Twins of Genius" lecture tour.

What made the 1893 portrait different is that it seemed to take on a life of its own once loosed in the realm of mass media. In addition to the cartes de visite and cabinet cards produced by the Sarony Studio, it appeared in countless newspapers, magazines, and books, and was the basis for popular illustrations, such as the chromolithographic label pasted inside every box of "Mark Twain" brand cigars, a product that, like the portrait's other iterations, was circulated and sold without the author's (or Sarony's) consent.

Though the practice of creating commercial products that exploited celebrity likeness expanded exponentially during the Gilded Age, it was not exactly a new phenomenon. Cultural historian Leo Braudy has traced this history back to what he calls the "seedtime of modern visual celebrity" in the late eighteenth century.[12] During this period, the large-scale dissemination of printed books,

caricatures, pamphlets, newspapers, and magazines—which Daniel Boorstin referred to as "the graphic revolution"—played a material role in introducing famous individuals to their would-be fans.[13] This new availability of information about prominent individuals, and the sense of presumed intimacy it engendered, fostered what Braudy calls "a new quality of psychic connection between those who watch and those who, willingly or not, perform on the public stage."[14]

Entrepreneurs in Europe and the United States were quick to grasp the commercial possibilities of this development. In 1774 Josiah Wedgwood introduced a series of small portrait medallions he called "Illustrious Moderns," featuring the faces of Hume, Voltaire, and Boswell on earthenware pitchers, plates, figurines, and even flatware. Benjamin Franklin, during his time as diplomatic envoy to France from 1776 to 1778, found himself to be another surprised subject of this early craze for celebrity. His face appeared on handkerchiefs, pocketknives, and clocks. It was etched on the lids of snuffboxes and set into rings like a jewel.[15] Allegedly, King Louis XVI, having grown weary of the attention lavished upon the popular American ambassador, even had Franklin's likeness reproduced inside a porcelain chamber pot and sent to the home of a particularly indefatigable female admirer.[16] Bemused by the attention, Franklin described the variety of objects on which his portrait image could be found in a letter to his daughter written in 1776. He reported that the array of "pictures, busts and prints (of which copies upon copies are spread every where) have made your father's face as well known as that of the moon." In a joking aside, he noted that he dare not do anything that would cause him to run away from his public position as his "phiz would discover him wherever he should venture to show it."[17]

Though Franklin's statement was made in jest, the idea that an individual might be outnumbered and pursued by reproductions of his own "phiz," or face, had come to seem more of a reality by Clemens's day. In a 1905 interview, he described feeling "persecuted" by Sarony's photograph,

which appeared "every week in some newspaper somewhere or other," and arrived in the mail almost daily accompanied by an autograph request. Whereas Franklin regarded the novel sight of his own famous phiz with amusement, Clemens described the badgering ubiquity of Sarony's photograph as a "distressing" intrusion upon his private life and work.[18] Indeed, Clemens's biographer Albert Bigelow Paine, who recalled the author's angry outbursts each time he spotted the offending portrait, reflected, "It was a good photograph, mechanically and even artistically, but it did not please Mark Twain."[19]

The substitution of Clemens's real name with that of his creative alter ego is telling in this context. Mark Twain was not only a pseudonym printed on the title page of Samuel Clemens's books, but also the public face with which he met the world, and in many ways, his most cherished work of fiction. The author first used the pen name in early 1863 as a way to mask his identity while working as a freelance journalist, but by the turn of the twentieth century, the two names were used more or less interchangeably, with "Clemens" describing the private individual and "Twain" the dramatic embodiment of his authorial voice. The boundary between these two facets of identity seems to have been murky even for the author himself. In his notebooks, Clemens defined his professional alter ego as "my double, my partner in duality, the other and wholly independent personage who resides in me."[20] By these terms, Twain was at once integral to Clemens's sense of self and capable of autonomous performance in the public sphere. This "conspicuous and performed identity," as historian Philip Fisher phrased it, was inseparable from Clemens's public existence, making the personage of Mark Twain both a valuable avatar and a strategic front in the author's negotiation of the unfamiliar territory of mass-media celebrity.[21]

Clemens's peculiar relationship to his own public image explains why the author, though initially happy with Sarony's photograph, found it a source of distressing persecution as its popularity grew during the decade following its creation. In its inescapable ubiquity, this picture spread around the world—employing "Sarony" lighting, matching Sarony's vision, and boasting to be the best Sarony had ever created—presented an unwelcome challenge to Clemens's position as controlling author of his own public persona. It was not that Sarony's portrait was libelously false, but rather that it interfered with the carefully edited fictions Clemens preferred be cast upon the world. In other words, when he let the photographer "take his head" that day in 1893, he had not been aware that he was surrendering it completely.

## THE PHOTOGRAPHIC STAGE

Sarony was, of course, not the first American photographer to trade in public images, but the ideals he introduced at the start of his photographic career in the 1860s represented a significant cultural and aesthetic change from previous practices. During the antebellum and Civil War years, the leading figure in American portrait photography was Mathew Brady, whose photographic galleries in Washington, DC, and New York were popular destinations, not only for having portraits made, but also for viewing images of others. Beginning in the 1840s, Brady invited prominent authors, politicians, performers, and military heroes to be photographed in his studio with the intent of assembling what he called a "Gallery of Illustrious Americans." He envisioned the project as a means of inspiring his countrymen and communicating the greatness of his contemporaries to future generations. Lining the walls of his gallery in neatly hung rows, these portraits helped define a visual language of social respectability for mid-nineteenth-century viewers with their simple, upright poses and straightforward presentations of individual likenesses. Subjects as professionally and physically diverse as Reverend Lyman Beecher, General Winfield Scott, the sculptor Harriet Hosmer, and the circus performer "General Tom Thumb" (Charles Sherwood Stratton) all appeared

in Brady's photographs standing before similar monotone backdrops and beside a neoclassical column or a handsome carved parlor chair. With their oblique references to the classical past or contemporary middle-class interiors, these understated portrayals framed individual likeness within a standardized formula of upright respectability, emphasizing the qualities shared by accomplished Americans rather than their personal idiosyncrasies.

Through the consistency of their compositions, Brady's portraits did important cultural work for the viewers of his time by presenting the honored status of his illustrious subjects as a rank to which all might aspire. According to Alan Trachtenberg, the possibility of demonstrating allegiance with the respectable, mainstream values these portraits symbolized was one of the chief attractions in posing for a Brady photograph. Moreover, the viewing experience at Brady's gallery was less like walking through a museum, where one might only look passively at the images on display, than what Trachtenberg calls a "theater of desire," where viewers could envision themselves embodying society's highest ideals through similarly staged portraits of their own. Anyone who could afford the price of a picture might take the photographic stage and imagine his or her own image displayed among the ranks of illustrious Americans adorning Brady's walls. The personal transformation promised by this theater of desire helped define the nineteenth-century photographic gallery as "a new kind of city place devoted to performance: the making of oneself over into a social image."[22]

During the Gilded Age, the photographic studio's importance as a theater of desire only increased, as did the cast of allowable characters through which one might express and perform one's social image. By the late 1860s, it became less desirable to blend discretely into the ranks of figures on display in an illustrious gallery, and Sarony's success as a photographer stemmed from his abandonment of the conventional portrait formulas in favor of a process that was deeply in tune with this new privileging of

individuality. In her analysis of the market for celebrity portraits before and after the Civil War, Barbara McCandless argues that whereas antebellum photographers such as Brady created portraits of political and intellectual elites that were "meant to inspire and educate," Sarony's postwar portraits celebrated "theatrical personalities in character, displaying the emotional intensity of their fictional roles and freezing them in a photographic moment."[23]

Moreover, they suggested a means whereby everyday Americans could make their own social images more theatrical in nature. Though Sarony is best remembered today for his portraits of performers, Gilded Age observers praised the dramatic approach he applied to all of his subjects, employing costume, set pieces, and photographic special effects to create portraits that improved upon natural appearances and expressed the individuality and style of subject and artist alike. Contemporary critics proclaimed in astonished tones that "Sarony's photographs are not only finely executed and good as likenesses, but they are pictures. He seizes whatever is picturesque in his subject, and turns it to the best advantage, so that very plain people are astonished to find out how many good points they possess." Put in slightly different terms, a man who had recently visited the photographer's studio remarked, "I never knew I had such a good-looking wife until Sarony took her photograph."[24] Where Brady Studio photographs helped define and support a unified social ideal, Sarony performed improvements on an individual level, locating the good points and attractive features of even the plainest subjects. In this way, the photographic theater of desire was reconfigured in the latter half of the nineteenth century from a space that promised access to a prescribed set of ideals for self-improvement to one where individual public image could be amplified and glamorized to express one's inherent celebrity potential.

Sarony first wielded his powers of photographic invention upon himself in the early 1860s, when he refashioned his own public image (along with his career)

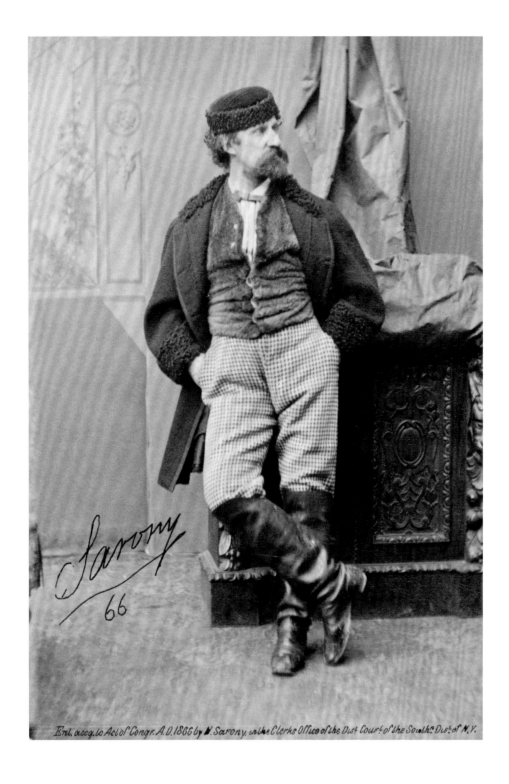

from unassuming New York City lithographer to debonair, bohemian photographic artist. Napoleon Sarony was born in Québec in 1821 to a French-Canadian mother and a Prussian father, and immigrated to the United States when he was around twelve with his older brother Oliver. To support himself and his talent for drawing, he took an apprenticeship with the lithographer Charles Risso, and later worked with Henry R. Robinson and Nathaniel Currier before starting his own lithographic firm, Sarony & Major.[25] In 1863, deciding his talents were being wasted in these "mechanical arts," he moved to Europe to study painting and to learn the photographic trade from his brother, who relocated to the seaside town of Scarborough, England, during the 1840s, and successfully established a reputation there as a fashionable society portraitist.[26]

After opening his first independent photographic studio in Birmingham, England, around 1864, Sarony devoted considerable energy toward refining a dashing new public image for himself. The photographer was barely five feet tall, almost completely bald, and had a large Roman nose that reportedly showed the impact of a youthful love of boxing, so his own photographic transformation was surely instructive for smoothing and flattering the images of even the most difficult future cases. Surviving self-portraits from this period show him experimenting with pose as well as different personae and unorthodox costumes—checkered pants and fur coats paired with bowlers or kepis—before settling upon a signature look in which period newspapers invariably described him: knee-high riding boots, a shearling vest worn inside out so the wooly side showed, a voluminous goatee and moustache, and an astrakhan cap cocked at a jaunty angle (fig. 7.3).

In anticipation of his return to the United States in 1866, Sarony circulated his first self-portraits in this attire

**Fig. 7.3**
*Self-Portrait* by Napoleon Sarony, ca. 1864
Albumen silver print, 10 × 6 cm (4 × 2⅜ in.)
Harvard University Fine Arts Library; Special Collections

through the New York photographic community, and his colleagues recalled the effect was "like a meteor from a clear sky." With his confident air and eccentric look, Sarony cut a figure of unforgettable artistic originality that seemed to point the way toward a new and dynamic creative practice for American photography. "How we raved over his work and effects," one contemporary recalled, "and wondered what secret process he used, forgetting it was the man not the process" who was responsible for the results.[27] Indeed, during a historical moment when few considered photography to have real artistic potential, Sarony precociously claimed that there was little distinction between the images he created and those of artists working in other media. As he put it, "I think my work proves that photography has aspects personal and individual apart from mechanical considerations. The camera and its appurtenances are, in the hands of an artist, the equivalent of the brush of the painter, the pencil of the draughtsman, and the needle of the etcher."[28]

The value of this personal and individual investment in photographic work was certified in 1884 by Sarony's groundbreaking victory in the Supreme Court case of *Burrow-Giles Lithographic Company v. Sarony*, which created the first legal precedent for the definition of photography as form of art. The suit arose when the Burrow-Giles Lithographic Company reproduced a portrait Sarony had taken of Oscar Wilde (fig. 7.4), making it the basis for a trade card advertising the Ehrich Brothers Department Store (fig. 7.5). When Sarony sued for breach of copyright, the lithographic company did not bother to deny they had used his photograph—as it was plain that they had. Instead, they challenged the photographer's claim to copyright on more fundamental terms, arguing that his image contained no original content worthy of protection—after all, Sarony had not invented Oscar Wilde, they argued, he had only reproduced his likeness.

The contemporary press eagerly latched on to the comedic potential of this legal conflict. The *New York Times*

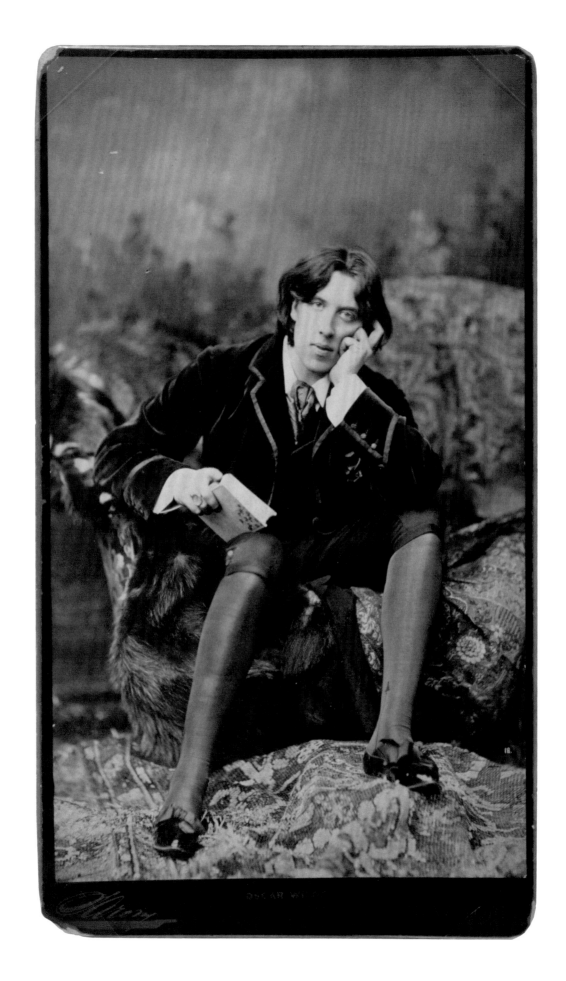

146

**Fig. 7.4**
*Oscar Wilde, No. 18*
by Napoleon Sarony, 1882
Albumen silver print,
30.1 × 18 cm (11.9 × 7 in.)
Library of Congress; Prints and
Photographs Division

**Fig. 7.5**
Trade card for Ehrich Brothers
Department Store by Burrow-Giles
Lithographic Company, 1883
Chromolithograph
Courtesy Granger

reported the case's details under the scoffing headline "Did Sarony Invent Oscar Wilde?" and a journalist writing for the *St. Louis Globe-Democrat* adopted a similarly unsympathetic tone, noting that the circumstances of the case, which required the famous photographer to prove his portrait was original, placed Mr. Sarony in a very embarrassing position: "To secure copyright protection on his picture, he must either show that he projected and evolved Oscar Wilde, as one does a poem or a novel or a cookbook; or failing that, he must get a patent on the distinguished aesthete in the manner of a new rat-trap or can-opener."[29]

Sarony, of course, had no wish to claim he had invented Oscar Wilde himself, but he did insist on being credited as the author of Wilde's public image. Just as he would later describe his vision for a portrait of Mark Twain as an "old type of patriarch," the photographer staked his creative claim to Wilde's portrait on the ideal composition he had imagined for his subject's representation.

The image in question, known as *Oscar Wilde, No. 18*, was one of around twenty-five portraits Sarony created in January 1882, when Wilde was just beginning his yearlong lecture tour of the United States. The photograph shows the poet in a relaxed seated position on a couch draped with carpets and fur. With one hand, he balances his book of poetry on his knee, and with the other he cradles his head in a gesture of thoughtful melancholy—a pose that serves the dual purpose of establishing Wilde's romantic character and foregrounding his shapely, stocking-clad legs, thereby showcasing the aesthetic costume of a velvet jacket and knee breeches with which he remains enduringly associated. The young poet was not well known in the United States prior to his tour, and though Sarony usually approached his celebrity subjects and often paid them for their likenesses, in this instance it was Wilde and his managers who enlisted the famous photographer's help in constructing a persuasive public image of the poet in the role of aesthete. First produced as cabinet cards, the photographs were meant to serve as press images and

souvenirs of Wilde's appearances. Ultimately, they became the basis for most nineteenth-century mass-media images of Wilde, and even today remain the photographer's best-known and most-reproduced work. Documents from the 1884 Supreme Court case argue that the defining features of these popular portraits—Wilde's dreamy expression and posture, as well as the artfully composed setting—were all aspects of the photographer's vision and had been produced "entirely from Sarony's own original mental conception to which he gave visible form by posing the said Oscar Wilde in front of the camera, selecting and arranging the costume . . . suggesting and evoking the desired expression."[30]

In the end, the Court agreed, ruling in Sarony's favor that his creative intervention in posing, arranging, and staging his subject was what elevated the portrait of Wilde from "mere mechanical reproduction" to the realization of "ideas in the mind of the author given visible expression."[31] In other words, it was not the photograph's subject matter that constituted its original content but the way that subject matter was composed and transformed according to the unique vision of the photographic artist.

Certainly, Sarony's method in the portrait studio relied more upon realizing creative vision than on the practical mechanics of picture making. Like many photographers of the late nineteenth century, he did not operate his own camera or develop and print his own plates. Instead, in a precursor to what A. D. Coleman would term "the Directorial Mode" of photography, Sarony conceived a scene and composed its elements, and then focused his full attention on his subject, coaxing him or her into the desired expression while cuing his trusted cameraman Ben Richardson to make exposures using subtle hand signals.[32]

The intensity of Sarony's personal and emotional investment in this process was a popular aspect of his studio lore. One frequently repeated story involved a series of photographs taken in 1868 of the Italian actress Adelaide Ristori in the role of Marie Antoinette (fig. 7.6).

Fig. 7.6
*Adelaide Ristori as
Marie Antoinette*
by Napoleon Sarony, 1868
Albumen silver print
15.9 × 10.8 cm (6¼ × 4¼ in.)
Harvard Theatre Collection,
Houghton Library, Harvard
University

Although the session reportedly began like any other, with the actress in costume before the camera enacting scenes from her current play, Sarony and Ristori at some point were said to enter a kind of trance induced by their photographic collaboration. While the actress performed and the photographer encouraged—suggesting positions and signaling for exposures to be made—both artist and subject were swept away in the emotional reenactment of Marie Antoinette's final moments. At the height of this performance, the actress tore off her wig and bonnet and cast them aside (where they remain visible in the lower portion of the photograph), and the usually nimble photographer, forgetting himself, toppled backward from his posing platform and fell with a crash, breaking the spell that had gripped the studio. Afterward, Sarony recalled only the powerful communion that existed between himself and his subject in that fleeting moment, saying, "Why I actually saw Marie Antoinette before me and not her mimic . . . I have a negative to prove [it]."[33] By implying that his portrait was something more than simply a reproduction

MAUDE BRANSCOMBE.

37 UNION SQUARE, N. Y.

**Fig. 7.7**
*Portrait of Maude Branscombe* by
Napoleon Sarony, ca. 1880
Albumen silver print
15.9 × 10.8 cm (6¼ × 4¼ in.)
The New York Public Library; Billy
Rose Theatre Division

of an actress performing, Sarony aligned his craft as
a photographer with theater's alchemical potential to
transform reality. On the photographic stage as well as the
dramatic one, individuals might truly become the characters
they played and, through these acts of fiction, persuade
willing onlookers of some alternate version of truth. Like
the brush of the painter or the pencil of the draughtsman,
Sarony's camera was his tool for conducting these artistic
transformations, for documenting and preserving them so
that the theater of desire might be opened to the widest
possible audience.

The persuasiveness of Sarony's photographic fiction is
perhaps best illustrated through a series of portraits created
between 1878 and 1880 that transformed a little-known
actress named Maud(e) Branscombe into an international
celebrity. Diminutive, with large blue eyes, an even brow,
and pert, foxlike features, Branscombe typified the ideal
feminine beauty of her day, and Sarony's photographic
portraits, which depict her in a kaleidoscope of varying
personas—fashionably dressed in plumed hats and
beribboned bonnets, or in dramatic costume, wearing the
wimple of a Carmelite nun or the jeweled headdress of an

odalisque—quickly became among the studio's top sellers (fig. 7.7). In reality, Branscombe had gone largely unnoticed on the theatrical stage until she became the muse of Sarony's studio.[34] In an era before fashion models, there was little framework for understanding commercially circulated portraits of relatively anonymous individuals, and uncovering the truth of this mysterious beauty's identity became the subject of international speculation. In September of 1880, the *New York Times* published an article titled "Maud Branscombe—A Woman Whom Nobody Knows." Citing a biography concocted by Parisian newspapers based on Branscombe's photographs, the *Times* reported Branscombe's life as the stuff of contemporary melodrama, describing a string of jilted lovers, an abandoned baby, and a stint as dancer in a California gold-mining camp.[35] Fueling this intrigue was the fact that although Branscombe's image was legion, she herself seemed to be in scarce supply. Despite pleas for information from newspaper reporters in New York and Paris, Branscombe could not be located for comment, and no one claiming to know her came forward to fill in the missing details. As the *Times* reporter noted wistfully, "Maud's portrait is everywhere. Maud is nowhere." The result was a famous face that seemed to exist only in the photographic form of her public image, leading the newspaper to wonder if she ever existed, or was "merely an abstract idea of beauty created by some imaginative painter"—or, more properly in this case, an imaginative photographer. Looking at rows of Branscombe's photographs, one learns more about her malleability as a model than her identity as an individual. Most visible is the artistic component of Sarony's photographs: the lighting, costume, pose, and compositional choices, the creative interventions and experiments that distinguished artistic photography during this period by visibly expressing "ideas in the mind of the author." Indeed, once Branscombe stepped forward to collect upon her media renown, many judged that she did not live up to the fantastic vision Sarony's photographs produced. Wooed by the fictions of

photography, Branscombe's admirers were disappointed to discover, as a writer for *Vanity Fair* later recounted, that, "The photographs did it! They pictured a feminine face so close to artistic ideality as to arouse marvel. . . . The Maude Branscombe of real life was a diminutive, colorless little woman, with a fine profile and that was all."[36]

If Branscombe, and countless others among Sarony's portrait subjects, required his photographic fictions to lend substance to their public images and reshape their characters for the media stage, Samuel Clemens could not resist undoing them to reclaim controlling authorship of his own. Considering his harsh reaction to the appearance of Sarony's photograph in his sixty-seventh-birthday volume, it is interesting to consider a self-portrait caricature he created for circulation at that same event (fig. 7.8). Etched on a copper plate and then printed, the caricature was presented as a gift to the fifty distinguished guests who attended his party. Like Sarony's photographic portrait, the drawing offers a head-and-shoulders view of its subject, but here the body is delineated by two wavering lines defining the shoulders of a misshapen overcoat, on top of which appears a lumpy head crowned with peaks of wispy hair, and scribbly eyebrows masking eyes of two different sizes and shapes.

Though sketchy in form, Clemens's self-portrait bears striking resemblance to Sarony's photograph in the details it does include—the peaks and projections of the hair, the carefully delineated details on the left side of the face and the soft shadowed jawline on the other. It is almost as if the self-portrait caricature attempts to reclaim the unruly, mass-produced image by re-authoring it in the original hand of Mark Twain. The most notable difference, of course, is that the caricature has been left without a mouth, an omission that renders the depicted subject uncharacteristically speechless. An inscription contained protectively within the outlines of the torso's form simultaneously offers explanation for this lack and claims the last word in describing the picture's appearance: "I cannot make a good mouth, therefore leave it out. There is enough without it

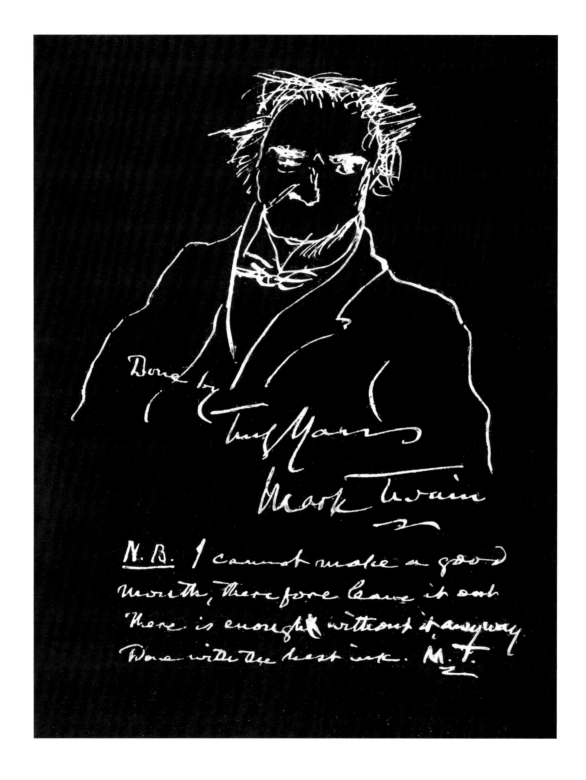

anyway." Enough, that is, to cast an image on the world that pointed back insistently to its subject as a voice of singular importance in determining its meaning. Whereas Sarony, as a type of creative author that was just emerging during the late nineteenth century, took extraordinary measures to make his voice heard through his photographic fictions, Clemens exercised his ability to retain control of the characters he created along with the power to speak for his own public image. In both cases, the expanding stage of mass media presented an unprecedented platform for expressing artistic identity and redefining an author's relationship to his work.

**Fig. 7.8**
Mark Twain caricature self-portrait, 1902
Etched copper plate with leather cover and ribbon
16 × 10 cm (6⁵⁄₁₆ × 3⁷⁄₈ in.)
Archives of American Art, Smithsonian Institution; John White Alexander
Papers, 1775–1968, bulk 1870–1915

## Notes

1 Clemens's personal copy of the birthday volume, which was published by Harper & Brothers in 1902, is now in the private collection of Kevin Mac Donnell. I am indebted to independent scholar Barbara Schmidt and the comprehensive collection of Mark Twain quotes, primary documents, and resources on her website twainquotes.com for bringing this inscription to my attention.

2 R. Kent Rasmussen, ed. *Dear Mark Twain: Letters from His Readers*. (Berkeley: University of California Press, 2013), 3.

3 "The Arts – Napoleon Sarony," *Daily InterOcean*, November 15, 1896, 35.

4 Andrea Volpe, "Cartes de Visite and the Culture of Class Formation," in *Middling Sorts: Explorations in the History of the American Middle Class*, ed. Burton J. Bledstein and Robert D. Johnston. (New York: Routledge, 2001), 157–69, 158.

5 Barbara McCandless, "The Portrait Studio and the Celebrity: Promoting the Art," in *Photography in Nineteenth-Century America*, ed. Martha A. Sandweiss (New York: Harry N. Abrams, 1991), 48–75.

6 See Felix Raymer, "Under the Skylight—Sarony Lighting," *Camera* 5, no. 1 (January 1901): 7, and J. B. Schriever and Thomas Harrison Cummings, *Studio Portraiture & Studio System*, vol. 6 of *The Complete Self-Instructing Library of Practical Photography* (Scranton, PA, 1902). Sarony's technique for lighting his portrait subjects is described with admiration in numerous nineteenth-century trade journals, but became explicitly attached to his name in early-twentieth-century photographic manuals.

7 "Famous Snap Shots: Sarony, the New York Photographer Writes of His Art," *North American*, March 23, 1894, 6a.

8 Clemens's letter to his wife is reprinted in Dixon Wecter, ed., *The Love Letters of Mark Twain* (New York: Harper & Brothers, 1949), 278–79. Though seemingly pleased with the photographs themselves, Clemens does register irritation that slow delivery of the final prints had not allowed them to be included with several "other tokens of love & remembrance" included in a birthday parcel.

9 The inscribed portrait photograph Clemens gave his wife for her birthday on November 27, 1893, is in the collection of Kevin Mac Donnell of Austin, Texas, and I am grateful to him for bringing its existence to my attention.

10 S. L. Clemens to Mr. Row, November 14, 1905, in *Mark Twain's Letters*, ed. Albert Bigelow Paine, vol. 2 (New York: Harper & Brothers, 1917), 785–86.

11 Sarony provided this estimate in Gilson Willets, "Photography's Most Famous Chair," *American Annual of Photography* 13 (1899): 56–62. Slightly different modern accounts are offered by McCandless ("The Portrait Studio and the Celebrity") and in Ben L. Bassham, *The Theatrical Photographs of Napoleon Sarony* (Kent, OH: Kent State University Press, 1978). Unfortunately, since Sarony's negative collection disappeared during the 1920s, an accurate accounting of his artistic output is impossible to determine with certainty.

12 Leo Braudy, *The Frenzy of Renown: Fame & Its History* (New York: Vintage Books, 1997), 452.

13 Daniel Boorstin, *The Image: A Guide to Pseudo-Events in America* (1961; repr. New York: Vintage Books, 2012).

14 Braudy, *The Frenzy of Renown*, 380.

15 Braudy, 452–53.

16 This possibly apocryphal story about a chamber pot given to Comtesse Diane de Polignac comes from the memoirs of Madame Henriette de Campan, the lady-in-waiting to Marie Antoinette. It is also recounted in numerous contemporary sources, including Walter Isaacson, *Benjamin Franklin: An American Life* (New York: Simon & Schuster, 2003), and Paul M. Zall, *Benjamin Franklin's Humor*. (Louisville: University of Kentucky Press, 2005).

17 Benjamin Franklin to Sarah Bache, June 3, 1779, in *Mr. Franklin: A Selection from His Personal Letters*, ed. Leonard W. Labaree and Whitfield J. Bell Jr. (New Haven, 1956), 45–46, quoted in Michael Madow, "Private Ownership of Public Image: Popular Culture and Publicity Rights," *California Law Review* 81, no. 1 (January 1993): 125–238, 149.

18 S. L. Clemens to Mr. Row, November 14, 1905, 785–86.

19 S. L. Clemens to Mr. Row, November 14, 1905, 785.

20 Mark Twain, *Mark Twain's Notebook*, ed. Albert Bigelow Paine (New York: Harper & Brothers, 1935), 248–49.

21 See Philip Fisher, "Appearing and Disappearing in Public: Social Space in Late-Nineteenth-Century Literature and Culture," in *Reconstructing American Literary History*, ed. Sacvan Bercovitch (Cambridge, MA: Harvard University Press, 1986), 155–88. See also Randall Knoper, *Acting Naturally: Mark Twain in the Culture of Performance* (Berkeley: University of California Press, 1995).

22 Alan Trachtenberg, *Reading American Photographs: Mathew Brady to Walker Evans* (New York: Hill & Wang, 1989), 42.

23 McCandless, "The Portrait Studio and the Celebrity," 67.

24 "Sarony," *Frank Leslie's Illustrated Newspaper* 671 (August 8, 1868): 322, col. D.

25 Hyacinthe-Poirier LeBlanc de Marconnay, "Napoléon Sarony," *Le Populair, Journal des Intérêts Canadiens* 74 (September 27, 1837): 3–4.

26 Erin Pauwels, "Sarony's Living Pictures: Photography, Performance and American Art, 1865–1900" (PhD diss., Indiana University, 2015).

27 W. A. Cooper, "High Lights in Photography, No. 4: Napoleon Sarony," *Photo-American* 5, no. 11 (September, 1894): 323–27, 324.

28 William R. Bradshaw, "The Nude in Art: An Interview with Napoleon Sarony," *Decorator and Furnisher* 26, no. 3 (June 1895): 91–93.

29 "Oscar Wilde Once More," *St Louis Globe-Democrat*, December 23, 1883, issue 216, col. B.

30 Burrow-Giles Lithographic Company v. Sarony, 111 U.S. 53 (1884).

31 Burrow-Giles Lithographic Company v. Sarony.

32 A. D. Coleman, "The Directorial Mode: Notes toward a Definition," in *Photography in Print: Writings from 1816 to the Present*, ed. Vicki Goldberg (Albuquerque: University of New Mexico Press, 1981), 480–91. For Sarony's working methods, see Beaumont Newhall, "Sarony's Cameraman," *Image: Journal of Photography of the George Eastman House* 1, no. 6 (September 1952): 3–4.

33 "Women before the Camera," *Omaha Daily Bee*, December 10, 1893, 16.

34 Sarony's protégé José Maria Mora also created numerous portraits of the actress, and Branscombe's role as muse was the subject of some rivalry between the two photographers.

35 "Maud Branscombe—A Woman Whom Nobody Knows," *New York Times*, September 5, 1880.

36 Leander Richardson, "Vanished Beauties of Our Stage: Memories of Five Famous Actresses," *Vanity Fair* 3, no. 5 (January 1915): 27-29, 27.

# SOUL-SEARCHING

## THE PORTRAIT IN GILDED AGE AMERICA

Akela Reason

In P. G. Wodehouse's "The Artistic Career of Corky," one of the earliest stories to feature his well-loved characters Jeeves and Wooster, the protagonist Bertie Wooster attempts to help his friend Corky, a feckless artist who has inadvertently created a horribly unflattering painting of his wealthy uncle's young son, whom Corky has no reason to love. Corky concludes that, while he has failed to produce an accurate likeness of the child, he has unwittingly captured his essence: "My private impression is that, without knowing it, I've worked that stunt Sargent used to pull—painting the soul of the sitter. I've got through the mere outward appearance, and have put the child's soul on canvas."[1] Corky's failed portrait recalls the painter John Singer Sargent's talent for painting children, including those from similarly privileged families. Sargent, for example, had stunning success with his portrait of the toddler *Béatrice Goelet*, which the critic Mariana Van Rensselaer called "a pearl among pictures," both for the likeness and for his ability to see, "not only form and color with clearness and acuteness, but also the baby soul behind them."[2]

While Sargent is perhaps the best-known portraitist to capture the inner lives of his sitters, he was far from alone. Portraying the soul was a requirement for any successful portraitist living in the Gilded Age. The term, coined by Mark Twain and Charles Dudley Warner, who authored *The Gilded Age: A Tale of Today* in 1873, implied the period's embrace of superficial—or outright false—appearances, masked beneath a thin veneer of gold.[3] Given Twain's damning estimation of the era's shallowness, one might wonder how the period is so often associated with portraitists who attempted to reveal the depths of the human soul. Indeed, in contrast to Twain's superficial schemers, the Gilded Age portraitist was expected to consider the essence of an individual by moving beyond the surface—looking beneath the gilding, as it were—to get at what lay underneath.

In Wodehouse's story, Corky's distress humorously calls attention to the ways that critics and writers of the Gilded Age expected the successful portrait to transcend superficial likeness in order to reveal the essence, or soul, of the sitter. While a good likeness remained essential, it was only one element of an estimable portrait. The

Fig. 8.1
*Edith Mahon* by Thomas Eakins, 1904
Oil on canvas, 50.8 × 40.7 cm (20 × 16 in.)
Smith College Museum of Art; Purchased with the Drayton Hillyer Fund

finest examples of the genre required the artist to capture the inner life of the sitter, revealing aspects unseen. The identification of this inner aura lent tremendous authority to critics and observers who discerned qualities that they themselves admitted were not physically apparent. Indeed, critics routinely equated the ability to render a subject's "true nature" with the painter's talent as a portraitist. A writer for the *Independent*, for example, described "the quality of genius" in a portrait by J. Alden Weir at the 1882 National Academy Annual accordingly, stating, "It is all there; the outward appearance of the man and something more—namely, the fact that the man is soul-endowed."[4] When using the expression "the soul," writers typically meant something akin to personality, including the distinctive inner traits and the psychological depths of the individual, which, as much as physical appearance, made one unique. This tendency led, arguably, to some of the most compelling portraits ever painted, such as Sargent's *Daughters of Edward Darley Boit* and Thomas Eakins's *Edith Mahon,* works that arrest the viewer even when he or she knows little about the sitter. In this way, these portraits, which rest on subjective individuality, paradoxically become appealingly universal expressions of humanity.

Several scholars have acknowledged the significance of interiority in Gilded Age portraiture, but the reasons for this development remain less fully explored. Art historian David Lubin, in his book *Act of Portrayal*, attributes the inward turn to "the economic interdependence fostered by industrialization and urbanization." Susan Sidlauskas, in her examination of European and American painting of the period, considers the issue from a different perspective by exploring the close relationship between "two different *kinds* of interiors: the body and the inner chambers of the house," showing how artists positioned human figures within domestic spaces to reveal the psychological. Scholars have also acknowledged how immigration and the social upheavals of the period influenced portraiture. In an essay on society portraits of the Gilded Age, Barbara Gallati

writes that "the pressing need for a stable identity was a by-product of the new social patterns generated by an increasingly urban population."[5] Not surprisingly, each of these authors identifies influences beyond the realm of the fine arts that had profound implications for portraiture, an outlook that can be extended and broadened. While Lubin and Gallati each considered the work of writers, such as Henry James and Edith Wharton, in their examinations of Gilded Age portraiture, interest in the inner life of individuals extended far beyond the work of painters and novelists. Indeed, in their desire to capture the unseen, portraitists were far from alone: they co-existed with writers and intellectuals who defined a new sense of selfhood that celebrated individual, subjective experience in their work. Heralding this changing notion of the self, life writing became more personal and novels more psychological, the social sciences entered the academy, and portraitists like John Singer Sargent and his Gilded Age peers began to capture the souls of their subjects.

While painted portraiture remained largely focused on elites, the emphasis on interiority in both writing and the arts opened the genre to include those not typically the subject of formal portraits. This is not to say that Gilded Age portraiture offered a level playing field—far from it—in an era where the society portrait dominated many portraitists' output. However, from time to time, socially marginalized individuals began to appear alongside such glittering likenesses, as the primacy of the external gave way to the interior. This is especially apparent if we shift our scope beyond the painted portrait to consider other forms of representation, including memoirs, journalism, prints, photographs, and illustrations. The new focus on the interior is evidenced in the countless compelling portrayals of women and children, including those on the margins of society. It is revealed in the depictions of ordinary "citizen" soldiers, whose contemplative faces show the strain wrought by combat and loss. It can also be seen in representations of Native Americans and African Americans,

who appeared with greater individuality in text and image in this period, first in journalism and life writing and then in the fine arts.

Art historians in recent decades have examined the focus on interiority in the painted portraits of the Gilded Age mostly through close readings of individual paintings. Two works that figure in this scholarship serve as examples of both the soul portrait and of the art-historical literature about the trend: Thomas Eakins's portrait of Edith Mahon (fig. 8.1) and John Singer Sargent's *The Daughters of Edward Darley Boit* (fig. 8.3). Both portraits came about through friendships between the painters and their subjects, perhaps allowing for the greater intimacy that seems revealed on canvas. Although the two works are quite different—one a portrait of four children scattered about an interior, the other a close head-and-shoulders view of a middle-aged woman—each seems to tell us about the inner life of the sitters. In addition, both portraits suggest something not only about the sitters themselves but also about humanity at differing stages of life. The girls in the Sargent painting have been read as representing different moments of adolescent girlhood, with their distinct ages reinforced through their gestures, posture, and placement in the room. The Eakins portrait, with its intense scrutiny of the face, has been thought to indicate the "wear and tear" inherent in the life of an aging woman of the Gilded Age.[6] In this way, the portraits provide glimpses of inner emotions and diverge from the flattering society portraits of the period, which highlight status and the accoutrements of wealth.

However, not all portraits displayed such depths, and not all artists possessed the insight of a Sargent—or even the accidental revelations of a Corky. More importantly, the lack of this ability did not deter patrons, suggesting that baring one's soul was not the object of everyone commissioning a portrait in this period. There are numerous portraits from the Gilded Age that are largely descriptive, rather than psychologically revealing. Many American

elites turned to fashionable European painters for full-length pictures that captured their material gifts, including grand interior spaces and elaborate costumes made from rich fabrics adorned with expensive embellishments. Such careful attention to dress sometimes leaves the viewer with the impression that the sitter is secondary to their accoutrements. G. P. A. Healy, whose long career extended into the Gilded Age, painted many images in which costume dominates the composition. His portrait of the soprano Emma Cecilia Thursby (fig. 8.2) is a fine example of this type of work. In the image, Thursby is shown at full length in a beautifully embroidered blue satin gown, with lace trim. She holds sheet music in her gloved hands, indicating her talent as a singer. The portrait is richly detailed and highly accomplished but does little to suggest Thursby's inner life, in stark contrast to Eakins's portrait of Edith Mahon, who was also a talented musician.[7]

Eakins's *Edith Mahon* is part of a group of head-and-shoulders portraits by the artist that give the viewer the uncanny feeling of being in communion with an actual person. Eakins renders Mahon's likeness so distinctly, down to the slight fleshiness of her aging neck, that the viewer suspects they would know her immediately were she to materialize in the flesh. Not only are the details of physiognomy flawlessly executed, but the view is close enough to take in the reddened eyes, glistening with moisture, suggesting sorrows unseen. In addition to these physical details, there is a wistfulness in Mahon's gaze and posture that allows the viewer to detect unknown difficulties and disappointments. As art historian Betsy B. Jones concludes, Mahon "appears to be a woman who has confronted a difficult life with stoicism and resolve." Indeed, she faced the sorts of personal tragedies familiar to many adults: a failed marriage and the loss of a loved one—in her case, one of her three children.[8] Mahon's circumstances and Eakins's depiction of her echo the sentiment of suffragist Elizabeth Cady Stanton who, in her well-known speech of 1892, "Solitude of Self," spoke

on behalf of "the individuality of each human soul," which must be equipped to handle the challenges and disappointments of life alone, using reserves of inner strength. Stanton's speech affirmed that women should not be coddled, declaring that they, like all individuals, faced "the fierce storms of life" alone.[9] Her eloquent argument for political rights spoke of universal truths and a new understanding of self. Mahon's face shows evidence of having experienced such trials but not of having succumbed to them. Unlike some of Eakins's *portraits d'apparat*, Mahon's portrait does not allude to her profession as an accomplished pianist. Instead, it concentrates intensively on her face and does not show her hands.

Art historian David Lubin aptly compares Eakins's tight composition with the advent of the close-up in the new medium of silent film, though it is really film that mimicked portraiture, with its frequent focus on the face.[10] Eakins himself explored the potential of the still camera but in that medium rarely used the tight close-up that he reserved for portraits like Mahon's. The intimate view of Mahon privileges the viewer with a sense of familiarity, as if she were, in fact, an old friend. We read the face as a window into the interior and find a quiet, yet genuine, personality coming through the canvas, revealing what contemporaries would call the soul.

Sargent's *The Daughters of Edward Darley Boit* (fig. 8.3) similarly captures its four sitters in a quiet mood as they pause in recognition of a presence outside the canvas. Unlike the intimate closeness of the Eakins composition, Sargent places the Boit girls at a remove from the viewer, scattered unorthodoxly in an interior where the uneven light leaves two of the girls in shadow. In spite of the physical distance, there is a sense that the viewer may be intruding upon the girls, interrupting their insular childhood world for a moment, catching them being children outside the realm of adults. The two youngest girls most directly engage with the viewer; the next eldest sister keeps her distance, regarding the intrusion warily; while the oldest pointedly ignores the adult gaze as she leans against one of the tall Japanese vases that dwarf their corner of the room.

As Erica Hirshler notes, some critics have questioned whether such an unusual composition really qualifies as a portrait, as it treats the girls' physical appearance so unequally; Sargent's placement of the eldest girl in profile and in shadow surely did not suggest portraiture. Yet *The Daughters of Edward Darley Boit* is a portrait and it *did* capture the girls in ways that reveal far more than their appearances. Hirshler suggests that the exploration of the psychological dimensions of the painting has largely been a preoccupation of modern art historians, but even some of Sargent's contemporaries at least hinted that the "inner lives" of the girls were integral to the portrait.[11] For example, Henry James, who was a friend of Sargent, admired the painting, noting the intimate glimpse of the children "in their happy play-world." While the word "happy" might give one pause, as the girls do not appear in the least ebullient, it might also indicate the carefree isolation of the girls from the concerns of adulthood. This is further suggested by James's description of the girls, who "detach themselves, and live with a personal life."[12] Art historians' interest in the girls has been intense, with many scholars identifying each child by name (or by first initial in Lubin's case), hoping, to differing degrees, to bind the meaning of the painting to the individuals represented—in essence, wondering how keen were Sargent's abilities as a reader of their souls?

Two years before Sargent completed his portrait of the Boit children, James had begun crafting his important psychological novel *The Portrait of a Lady*, a work full of inner life that was a signal success for the author, who became intimately identified with the genre. His story of Isabel Archer, a young woman who gains a substantial

**Fig. 8.2**
*Emma Cecilia Thursby* by George P. A. Healy, 1879
Oil on canvas, 172.7 × 109.2 cm (68 × 43 in.)
New-York Historical Society; gift of the Estate of Ina Love Thursby

inheritance and enters into a marriage that quickly becomes unhappy, is driven almost entirely by character. The action, as it were, comes from within. As literary scholar Michael Gorra observes in his meticulous study, *Portrait of a Novel*, James understood that the actions of women, like Isabel (who occupied the same social tier as the Boit daughters), were circumscribed by their sex. In order to craft a novel so tethered to its female protagonist, James had to propel the story through different means. James's solution to this "problem" was to place "the center of the subject in the young woman's own consciousness." According to Gorra, James believed that Isabel's "adventures would lie not in the outward events of her life, but rather in her comprehension of them, in an inner drama that might, to her, seem as enthralling as any tale of pirates or caravans."[13] While, as Gorra demonstrates, James was not the first author to use character to drive a novel's plot, his success with *The Portrait of a Lady* reflected his exceptional ability to plumb the depths of the soul.

In the two painted examples of high art above, we can glimpse what Sargent's contemporaries meant when they described a portrait as being "soul-endowed." These works ask the viewer to care about an individual unknown to them, to read faces and postures to find clues to the inner realm of their being. James's novel similarly asks us to pay attention to what lies beneath the surface. But if one can care about four little girls, an aging female musician, or a fictional American heiress, could the focus on the interior open the door to viewing others less privileged than these examples? What makes these subjects suitable for representation? Is it their appearance or individuality that renders them compelling?

The painted portrait and the psychological novel were, with notable exceptions, populated and consumed primarily by elites, but after the 1880s, print media began to expand significantly, permitting a much wider audience to access images and texts with the potential to reveal the "inner lives" of others. Most notably, the advent of commercial halftone printing in the 1880s led to the proliferation of an astonishing number of images, including portraits. The rise of muckraking journalism and progressive reform movements drew attention to a more diverse population. Subjects included the poor, the disadvantaged, the intellectual, and the reformer. While paintings of non-whites were less common, popular journals featured photographs of Native Americans, African Americans, and other minority populations.

If we look to these mass-produced images, might we still find evidence of soul portraits? The Danish-born journalist Jacob Riis often used photos of the poor in his public lectures, articles, and books, which exposed the harsh realities of the poverty in New York's slums. Riis steadfastly refused to view his photographs as anything more than visual evidence in support of his larger cause to improve urban housing conditions. Although Riis did not consider his photographs works of art, modern viewers frequently fail to observe this distinction, finding tremendous power in some of his best images. Not all of Riis's photos are masterpieces, but in some, his sympathy and respect for his sitters transforms them into something more than documentary subjects. *"I Scrubs," Little Katie* (fig. 8.4) is a good example of this. Unlike some of his subjects, who were captured by surprise in Riis's early experiments with flash photography, Katie is carefully posed. She appears, in fact, much like a middle-class matron before a portrait photographer, who might be capturing her likeness for family and friends. Yet, instead of the composed background of a photographer's studio, Katie stands outside before a brick wall at the West Fifty-Second Street Industrial School. Her pose is not unlike that of the second-youngest Boit daughter, who stands at

**Fig. 8.3**
*The Daughters of Edward Darley Boit* by John Singer Sargent, 1882
Oil on canvas, 221.9 × 222.6 cm (87 3/8 × 87 5/8 in.)
Museum of Fine Arts, Boston; gift of Mary Louisa Boit, Julia Overing Boit, Jane Hubbard Boit, and Florence D. Boit in memory of their father, Edward Darley Boit

**Fig. 8.4**
*"I Scrubs," Little Katie* by Jacob A. Riis, ca. 1890
Gelatin dry plate negative, 10.2 × 12.7 cm (4 × 5 in.)
Museum of the City of New York

the left in Sargent's painting, with one exception being that Katie's hands are clasped in front of her, rather than behind. Her gaze is no less direct. In her small, tidy person, we see the embodiment of her statement to Riis: "I scrubs." She appears self-possessed and capable but with a careworn look that hints at her circumstances: Katie, aged nine, kept house for herself and her three older siblings after the death of her parents. Although she is small, we sense the maturity she must have developed in response to her

situation. Katie's visage is haunting and Riis's photograph of her is potent. *Scribner's Magazine* recognized the power of the image and placed a painted version, by Irving R. Wiles, on the opening page of Riis's article "Children of the Poor." Another hallmark of Katie's humanity is that Riis allowed her to transcend the raw identifications of so many of his poor subjects by giving her name. We can argue over whether or not Riis captures little Katie's soul, but if we accept for the moment that he does, what can she tell us about Gilded Age portraiture?[14]

In order to reflect on Katie, we need to consider why she might have been a worthwhile subject. Children, especially white children, offered Riis his best hope for

stirring middle-class sympathies. A prevailing attitude of the period ascribed poverty to genetic inferiority. This belief was connected with an important strain of Gilded Age thought that cultivated the pseudoscientific "typing" of individuals by race and ethnicity, often understood today under the banner of Social Darwinism. Riis himself, in spite of his sympathies for the poor, was guilty of such racism, especially in his sometimes crude descriptions of Chinese and Italian immigrants. One need not look far for evidence of racism during the Gilded Age, including the appalling ethnic displays at World's Fairs, which reinforced a belief in a racial hierarchy that placed Anglo-Saxons at the top. Yet countervailing ideas that relied on empirical evidence to debunk scientific racism also flourished in this period. Sociologist Frank Lester Ward was among those who argued that the poor were not genetically deficient but merely materially disadvantaged, and that efforts to aid them were not misguided but were a sign of human strength. Anthropologist Franz Boas also challenged racist beliefs through his notion of cultural relativism and his attack upon evolutionary or comparative racial hierarchies. Although Riis at times seems an adherent of Social Darwinist thinking, his focus on his subjects' environment and his acknowledgment of a "deserving" poor muddies his stance. Riis describes Katie's character in word and image as scrupulous, and tells us through her story that she is the victim of want and circumstance rather than natural law. Her inner life—perhaps translated by middle-class readers as her moral compass—is important in claiming the viewer's sympathy. We must know her in order to care about her.[15]

Concomitantly, other strains in American thought placed increasing value on the inner workings of the mind and the influence of experience on the self. Henry James's brother, William, helped shape modern selfhood through his work in psychology and philosophy. His identification of a "stream of consciousness" influenced psychology, life writing, and fiction—opening the door to the writing of disjointed narratives drawn from inner experience.[16]

In the realm of philosophy, he was instrumental in the development of pragmatism, which is grounded in experience. For William James and the pragmatists, "the cash value" of an idea is subjective in that it is only valid to the extent that we find it useful. According to James, "our ideas (which themselves are but parts of our experience) become true just in so far as they help us get into satisfactory relation with other parts of our experience."[17] In this way, the utility of an idea is conjoined with our own experience. The interconnection of thought and experience also admits that an idea's usefulness may change in response to new experiences. Although James's pragmatist writings were not published until 1907, he had, in both his public and private writings, been preoccupied with thought and experience for some time. Further, other pragmatist thinkers, such as Oliver Wendell Holmes, had also considered the profound influence of experience in his published work in the 1870s and 1880s. Indeed, the opening paragraph of Holmes's *The Common Law* (1881) boldly asserted, "The life of the law has not been logic; it has been experience."[18] The personal, subjective nature of experience established the potential, not always founded in actual practice, for authority to exist outside of the circumstances of one's birth.

Where one *does* find this put into practice is in the expanding tradition of life writing in the late nineteenth century, which also influenced visual culture of the period. Scholars of life writing observe a change in tone accompanied by an increase in the quantity of memoirs and biographies written after the American Civil War. This movement seems to foreshadow developments in Gilded Age portraiture. Modern biography has its origins in early modern Europe, when "the new science, with its emphasis on experience, the inductive search for truth in a world of particulars, and the critique of traditional authority, combined with Christian humanism's and Puritanism's valuing of the individual conscience and consciousness to constitute a new world view distinctly

hospitable to biography."[19] While this development significantly changed the tone of life writing, it was not until the late nineteenth century that private life, thought, and personality became so integral to biographical and autobiographical writing, leading to what Virginia Woolf in the 1920s would call the "new biography," wherein the "inner life of thoughts and emotions" predominate.[20] Americans innovated by "inventing a set of new markers of identity, grounded imaginatively in the country itself, in its distinctive psychological, geographical, historical, and ethnographic characteristics."[21] Indeed, Americans reveled in self-invention, breaking down the barriers of biographical significance.

The 1880s witnessed some of the best-known memoirs of the period, including Mark Twain's *Life on the Mississippi* (1883), Ulysses S. Grant's *Personal Memoirs of Ulysses S. Grant* (1885), and Lucy Larcom's *A New England Girlhood* (1889), each of which expanded upon the traditional categories of life writing: Twain through his humor and well-known persona, Grant by his plain-spoken writing and humble origins, and Larcom with descriptions of her youth working in a New England textile mill. Personal accounts, such as Grant's phenomenally successful memoir, became much more commonplace by the 1890s.[22] Not only had the range of individuals subject to biographical study expanded, but the intimacy of the approach to life writing had also changed. In this pre-Freudian era, no one expected excessive contemplation of the self, but they did want to understand the person, and his or her motivations and concerns. As historian Joan Waugh has observed of Grant's widely admired memoir, "Grant declined the opportunity to bare his soul, but he nonetheless managed to infuse his memoirs with a uniquely personal tone" that allowed

readers to feel a connection with the former president. This may have been quite enough soul for his audience; it certainly was for the avant-garde writer Gertrude Stein, a pupil of William James, who adored Grant's book and would create category-defying autobiographical writing of her own.[23]

Most Gilded Age publishers brought forth memoirs and biographies that highlighted the lives of prominent white men; however, the new emphasis on experience and the inner life opened opportunities for others to present their stories. Booker T. Washington's autobiography *Up from Slavery* (1901), for example, a complicated work written for a white readership by the former slave and African American leader who headed the Tuskegee Institute in the Jim Crow South, proved highly successful, both as serialized in *Outlook* and in its final published form. Historian Robert J. Norrell argues that the book not only told Washington's story, but also "functioned ever after as a fundraising tool for Tuskegee Institute."[24] Given the imperative of convincing whites to support the education and employment of African Americans, Washington was especially concerned with his self-image. In his writings, he is unfailingly upbeat in his assertions of the value of hard work, yet cautious and humble about the expectations of black Americans, intent on winning over a potentially hostile audience. Washington, who labored over his public image, was equally concerned with his visual representation. The frontispiece of the first edition of *Up from Slavery* featured a portrait of the public Washington by the accomplished pictorial photographer Gertrude Käsebier. In the image, Washington appears as a respectably dressed educator, seated at a desk with papers before him. He gazes directly at the viewer, asserting his steadiness and alluding to the inner strength that allowed him to rise to his acclaimed position. He radiates a sober responsibility that challenged the pervasive racial stereotypes of the period. Whether or not one can glimpse Washington's soul through his well-crafted public persona, we can certainly understand through

Fig. 8.5
*Zitkala-Sa* by Gertrude Käsebier, ca. 1898
Platinum print, 15.9 × 11.4 cm (6¼ × 4½ in.)
National Museum of American History, Smithsonian Institution

his self-presentation the interior qualities that contributed to his success.

As many scholars have noted, photography, as a reproducible, mechanical medium, faced skepticism regarding its status as an art.[25] This was no less the case when it came to portrait photography. With the easy circulation of cartes de visite, artistic portrait photographers, like Käsebier, sought to distinguish their work from the mundane likenesses captured by commercial photographers. The ubiquity of photographic images in the Gilded Age, which witnessed the introduction of Kodak's democratization of the camera, increased the necessity for discernment. As Shawn Michelle Smith has written, "most turn-of-the-century critics found it difficult to call the process of setting up a camera, pushing a button, and perhaps mixing some chemicals an artistic production, and they consequently deemed the photographic portraitist's art to be something else, namely, his or her ability to depict the inner soul of an individual in a representation of external countenance."[26] Much like the portrait painter, the portrait photographer sought to capture the inner life of the sitter, regardless of some critics' perceptions of the medium's limitations. The ability to represent the inner life remained key, especially for pictorial photographers like Käsebier, who hoped to establish photography as an art equal in stature to painting.

Gertrude Käsebier's photographs of Native American advocate Zitkala-Sa (Gertrude Bonnin, née Simmons; fig. 8.5) reflect a different aspect of the self-presentation of a non-white sitter. The images taken between 1898 and 1902 come from a period in which Simmons adopted the name Zitkala-Sa (Red Bird) as she reckoned with her dual heritage as the child of a Yankton Sioux mother and a white father. Zitkala-Sa left the Pine Ridge Agency reservation as a child to attend a Quaker-run school in Wabash, Indiana, further complicating her identity. In 1900 she published semi-autobiographical accounts of the deleterious effects of her schooling in the *Atlantic Monthly*. With the second

installment, "The School Days of an Indian Girl," she described the sometimes brutal treatment Indian children received from those who sought to assimilate them. Through her rich prose, Zitkala-Sa conveys the sense of disorientation she experienced as a small girl far from home, as she is forced to forsake all of her ideals and beliefs in order to become "civilized." She describes how missionaries lured her away from her family with the promise of sweet red apples that never materialized, offering an indictment of the duplicity of her new caregivers. Her tale is harrowing and personal, suggesting a modification of the captivity narrative, in which the subject does not find redemption in Christian belief, but rather in her rejection of it. In spite of the account of her childhood education, Zitkala-Sa also described her continuing connection to the system in which she was trained through her role as a teacher at the Carlisle Indian Industrial School and her feeling of dislocation when she returned home to see her mother at Pine Ridge. Throughout her essays, she finds herself unmoored from her identity as a Sioux, while largely rejecting her assimilated self.[27]

Zitkala-Sa's divided self is visualized in Käsebier's photographs through the use of dress and setting. In some images, Zitkala-Sa wears Western dress. In a white gown, she appears seated or standing before a light or floral backdrop. In these photographs, she holds either a book or the violin that she came east to study—symbols of intellect and culture. In other images she is shown in Indian dress; as if to make the contrast with her Anglo identity more striking, her clothing and the backdrop are dark. The shift between the two sets of images in content and tone may reinforce some of the beliefs of the period—contrasting the "civilized" Indian with the romanticized native—yet they also clearly relate to the divisions that

**Fig. 8.6**
*The Veteran (Portrait of George Reynolds)* by Thomas Eakins, 1885
Oil on canvas, 56.5 × 38.1 cm (22¼ × 15 in.)
Yale University Art Gallery; bequest of Stephen Carlton Clark, B.A. 1903

Zitkala-Sa described in her articles for the *Atlantic Monthly.* At least one image in the series gives a clearer sense of the comingling of two cultures in its representation of Zitkala-Sa in the white Western gown but with Indian accoutrements. Although her profile pose turns her gaze from the viewer, the focus on Zitkala-Sa's face is more intense, lending a feeling of authenticity to the image, eliding the binary divisions so strongly enforced in the other photos. In this image we see the character of a woman in two worlds. Unlike Edward S. Curtis's images of Native Americans, Käsebier's depictions of Zitkala-Sa show her as an individual and not as an example of a vanishing race. Although Käsebier's photographs were never intended to accompany Zitkala-Sa's texts, they reveal a similar sense of agency in the sitter's desire to present her own story.[28]

Portraits of white males were not immune to the transformations in ideas of selfhood and portraiture in the Gilded Age. While there are certainly many portraits of white men that seem more intent on demonstrating wealth, stability, or traditional notions of manhood, others suggest the fraying of those edges in a willingness to move beyond the external to get at what lay beneath. The Civil War aided and abetted this new presentation of masculinity. Although sculpted memorials and history paintings of the war tended to immortalize the heroism of its participants, there was also a darker side to representations of the war, especially in the fiction of writers like Ambrose Bierce and Stephen Crane, whose realism highlighted the senseless brutality of war. In his short story "Chickamauga" (1889), Bierce, a veteran of the Union army, provided graphic descriptions of damaged bodies and death that were anything but glorious. Veterans of the war bore both physical and psychological scars. Artists, in myriad ways, also captured the damage of war in their representations of veterans. The vulnerability conveyed in Thomas Eakins's portrait of George Reynolds, which he titled *The Veteran* (fig. 8.6), hints at the consequences of war. Reynolds served in the Union army from 1861 to 1864 and fought in several important battles. Kate Kernan Rubin

has described the painting as "a psychological portrait of a scarred and introspective individual." Further, she believes that "We not only read Reynolds' character, but also his past, in the details of his face and hands."[29] The sensitivity of Eakins's portrayal of Reynolds indeed suggests that Reynolds, like Edith Mahon, suffers from a psychological loss, quite apart from any physical wound he may have received in the war. Several scholars, Rubin among them, have discussed Eakins's use of generic titles, like *The Veteran*, as an indication that the artist was interested in depicting "types."[30] While the identification of types was commonplace in the period, I find the application of this idea to Eakins less convincing due to the crisp individuality of the artist's physical and psychological representations of his sitters. Instead, I see these titles as part of the period's interest in biography. The titles do not simply suggest a generic type but offer a description of the sitter as he or she appears in the work. In the case of Reynolds, who was also an artist, Eakins seems to fix solely upon his identity as a veteran through his emphasis on the interior vulnerabilities of his subject instead of suggesting the creative potential offered by Reynolds's profession.

The wounds of war were not so visible in other depictions of the war's veterans, especially in the sculpted monuments of the Gilded Age. Sculpture presented challenges to those portraitists who sought to capture the souls of their sitters. The solidity of the medium itself often precluded the convincing representation of something as ethereal as the psyche. Of the many sculptors of the period, Augustus Saint-Gaudens was able, in his public monuments, to suggest the "something more" that signaled the essence of the person depicted. Although he crafted many masterful portraits, not all hint at the depths that portrait painters could more easily achieve in paint. His profile portraits

Fig. 8.7
*Admiral David Farragut* by Augustus Saint-Gaudens, 1880
Bronze on granite, 2.7 × 5.3 × 2.9 m (9 ft. × 17 ft. 6 in. × 9 ft. 6 in.)

can be quite delicately rendered, but the pose and the nature of relief are best at conveying external traits. In the round, Saint-Gaudens could also effectively capture fleeting moments, such as the wind blowing back the coat of Admiral David Farragut (fig. 8.7) in what was the artist's first major public monument and one of his most successful portraits. The critic Mariana Van Rensselaer admired the portrait of Farragut in all of its details, but especially for the life that Saint-Gaudens was able to breathe into the figure. In her praise of the figure, Van Rensselaer suggests the problems of the medium: "from top to toe, this statue of St. Gaudens's . . . is a living portrait—not, as so often has been the case with our figures of a similar sort, the cast-iron imitation of what seems to have been a cast-iron original."[31] The portrait sculptor faced a very different task than those working in two-dimensional media—namely, to create something timeless and permanent that somehow also captured a sense of life. This was often achieved through gesture, pose, and allusions to movement or setting. In the case of the Farragut memorial, Saint-Gaudens suggested life through all of these means. According to Royal Cortissoz, Saint-Gaudens produced "a figure instinct at every point with the energy and strength of a man fronting perils in the open air, amid great winds and under a vast sky."[32] The sculptor masterfully endowed his bronze with vitality—a rare quality in the period's public monuments.

By 1916, when P. G. Wodehouse wrote his tale about Corky, modernism had already shaken the art world. The avant-garde challenged the realist bedrock of the soul portrait, which became increasingly associated with cultural conservativism. Abstraction offered new possibilities for capturing the essence of the sitter. As with the Gilded Age, these changes in the art world reflected larger social, economic, and political currents. Yet there remained one constant between these two very distinct periods: the sitter was always considered more than his or her likeness. One can argue that portraiture has always sought to encompass more than literal representation, but there is a continuity in the outlook of modernist artists with the Gilded Age portraitists who sought to capture the soul. Modernists, like Charles Demuth in his poster portraits or Marsden Hartley in his abstract *Portrait of a German Officer* (1914), merely took the portrait to the next level, eliminating the likeness, for the sake of capturing the "something more."

Notes

1 P. G. Wodehouse, "The Artistic Career of Corky," in *Carry On, Jeeves* (New York: Penguin Books, 1982), 46. When the story was published in 1916, Sargent had largely given up portraiture, yet his reputation as a painter of the soul endured.

2 M. G. Van Rensselaer, "American Artists Series: John S. Sargent," *Century Magazine*, March 1892, 798.

3 Mark Twain and Charles Dudley Warner, *The Gilded Age: A Tale of Today* (1873; New York: Penguin Books, 2001).

4 "Fine Arts: The Academy Exhibition," *Independent*, April 6, 1882, 8.

5 David M. Lubin, *Act of Portrayal: Eakins, Sargent, James* (New Haven, CT: Yale University Press, 1985), 8; Susan Sidlauskas, *Body, Place, and Self in Nineteenth-Century Painting* (Cambridge: Cambridge University Press, 2000), 2; Barbara Dayer Gallati, ed., *Beauty's Legacy: Gilded Age Portraits in America* (New York: New-York Historical Society; London: D Giles Limited, 2013), 12–13.

6 The expression "wear and tear" comes from nineteenth-century physician Silas Weir Mitchell, who became well known for treating nervousness, or neurasthenia, in women. For an overview of the influence of neurasthenia on the fine arts in America, see Katherine Williams et al., *Women on the Verge: The Culture of Neurasthenia in Nineteenth-Century America* (Stanford, CA: Iris and B. Gerald Cantor Center for Visual Arts at Stanford University, 2004).

7 Gallati provides a useful discussion of European portraitists active in America. For Healy's portrait of Thursby, see Gallati, *Beauty's Legacy*, 122–23.

8 Linda Muehlig, *Masterworks of American Painting and Sculpture from the Smith College Museum of Art* (New York: Hudson Hills Press, 1999), 136.

9 David A. Hollinger and Charles Capper, eds., *The American Intellectual Tradition*, vol. 2 (New York: Oxford University Press, 2001), 40, 42.

10 David Lubin, "Edith Mahon," in *Thomas Eakins*, ed. John Wilmerding (Washington, DC: Smithsonian Institution Press, 1993), 164. Lubin expanded upon his interpretation of Eakins's portrait of Mahon in *Inventing the Psychological*, ed. Joel Pfister and Nancy Schnog (New Haven, CT: Yale University Press, 1997).

11 Erica E. Hirshler, *Sargent's Daughters: The Biography of a Painting* (Boston: Museum of Fine Arts, 2009), 97–116; 94.

12 Henry James, "John S. Sargent," *Harper's New Monthly Magazine* 75 (October 1887): 688.

13 Michael Gorra, *Portrait of a Novel: Henry James and the Making of an American Masterpiece* (New York: Liveright Publishing, 2012), 69.

14 The most recent discussion of little Katie appears in Bonnie Yochelson, *Jacob A. Riis: Revealing New York's Other Half: A Complete Catalogue of His Photographs* (New Haven, CT: Yale University Press, 2016), 142–43.

15 For an overview of these ideas, see George Cotkin, *Reluctant Modernism: American Thought and Culture, 1880–1900* (New York: Twayne Publishers, 1992), 51–73.

16 William James, *Principles of Psychology, Volume I* (New York: Henry Holt, 1890), esp. chapter 9: "The Stream of Thought."

17 William James, *Pragmatism and Other Writings* (New York: Penguin Books, 2000), 30.

18 Louis Menand, *Pragmatism: A Reader* (New York: Vintage Books, 1997), xx–xxi.

19 Catherine N. Parke, *Biography: Writing Lives* (New York: Routledge, 2002), 12.

20 Barbara Caine, *Biography and History* (New York: Palgrave Macmillan, 2010), 40.

21 Parke, *Biography*, 24–25.

22 Ben Yagoda, *Memoir: A History* (New York: Riverhead Books, 2009), 113.

23 Joan Waugh, *U. S. Grant* (Chapel Hill: University of North Carolina Press, 2009), 206, 210.

24 Robert J. Norrell, *Up from History: The Life of Booker T. Washington* (Cambridge, MA: Harvard University, Press, 2009), 223.

25 For a recent discussion of this debate in the early history of photography, see Sarah Kate Gillespie, *The Early American Daguerreotype: Cross-Currents in Art and Technology* (Cambridge, MA: MIT Press, 2016).

26 Shawn Michelle Smith, *American Archives: Gender, Race and Class in Visual Culture* (Princeton, NJ: Princeton University Press, 1999), 60.

27 For a recent exploration of Zitkala-Sa's life, see Tadeusz Lewandowski, *Red Bird, Red Power: The Life and Legacy of Zitkala-Sa* (Norman: University of Oklahoma Press, 2016.)

28 On Käsebier's photographs of Zitkala-Sa, see Barbara L. Michaels, *Gertrude Käsebier: The Photographer and Her Photographs* (New York: H. N. Abrams, 1992), and Michelle Delaney, *Buffalo Bill's Wild West Warriors* (Washington, DC: Smithsonian Institution Press, 2007).

29 Kate Kernan Rubin, "The Veteran," *Yale University Art Gallery Bulletin* 39 (Winter 1984): 22; 23.

30 For a discussion of this literature, see Martin Berger, *Man Made: Thomas Eakins and the Construction of Gilded Age Manhood* (Berkeley: University of California Press, 2000), 109–10.

31 Mariana Van Rensselaer, "Mr. St. Gaudens's Statue of Admiral Farragut in New York," *American Architect and Building News*, September 10, 1881, 298.

32 Royal Cortissoz, "Augustus St. Gaudens," *North American Review*, November 1903, 725.

# PLAYING AGAINST TYPE

## FRANK MATSURA'S PHOTOGRAPHIC PERFORMANCES

ShiPu Wang

Frank Sakae Matsura (松浦栄, 1873–1913) must have been a hoot of a friend.[1] If you happened to live in Okanogan, Washington, between 1908 and 1913, you might have been inclined to swing by his photography studio to have a series of playful portraits taken (fig. 9.1). You would not have needed an appointment or a special reason to enter the artist's wooden shack. Many people chose to stop in when they were looking for a way to cap off a glorious excursion in their Model T or in need of a place to gather with a gang of pals. To use our contemporary parlance, Matsura's studio was, by all accounts, the area's "party central."

Located opposite the post office on the town's main street, the structure's most prominent feature was a striped awning that announces, "FRANK S. MATSURA PHOTOGRAPHER / SOUVENIR POST CARDS." This was the place to have formal, serious portraits taken; it was also arguably *the* store in the region to procure picture postcards, exotic gifts, or other tchotchkes for holidays and special occasions (fig. 9.2). But as this curious self-portrait suggests, what lies behind the walls of the storefront is another space, made possible by the town's sole and beloved Japanese immigrant, whose piercing gaze and camouflaged presence behind the rack of postcards on the print's right side only make whatever exists beyond that doorframe seem more mysterious.

Thanks to the approximately 2,500 surviving images made by Matsura, we can see now, more than a century later, what went on in that hidden space just behind where Matsura is standing in the photograph.[2] As it turns out, women and men, whites and Native Americans, flocked to Matsura's studio to let their hair down, so to speak. Appearing in front of his camera(s), they were free to play, be silly, and act with a kind of freedom encouraged and facilitated by the "party master" himself, as he often joined in on the horseplay.

Different from the large corpus of photographs by Matsura, "the documentarian" who chronicled the region's economic developments, his portraiture reveals a nuanced picture of the lives in a borderland town where everyone was, to varying degrees, in diaspora.[3] Matsura's formal portraits of/with his Native American

Fig. 9.1
Frank Matsura, *Matsura's Friends Sit Outside His New Store*, 1908
Frank Matsura Photographs (35-01-85), Manuscripts, Archives, and Special Collections (MASC), Washington State University Libraries

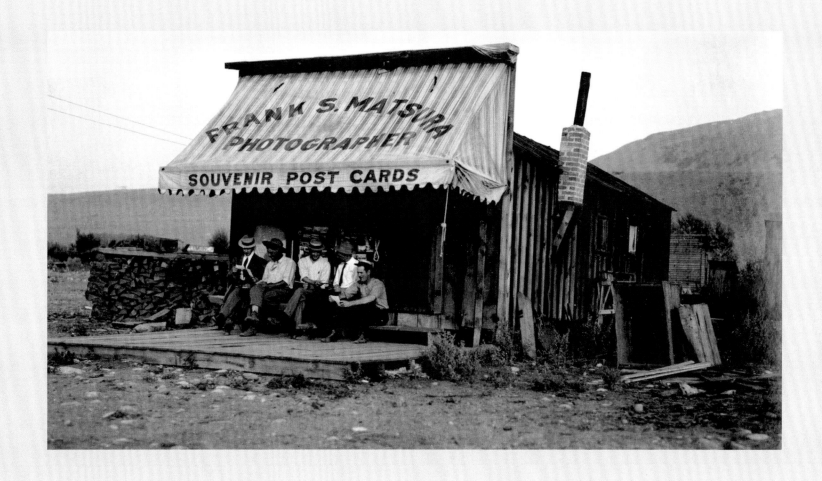

**Fig. 9.2**
Frank Matsura, *Interior of
Matsura's Photo Gallery and
Studio*, ca. 1908
Digital print from negative
MASC 35-01-12, Washington
State University Libraries

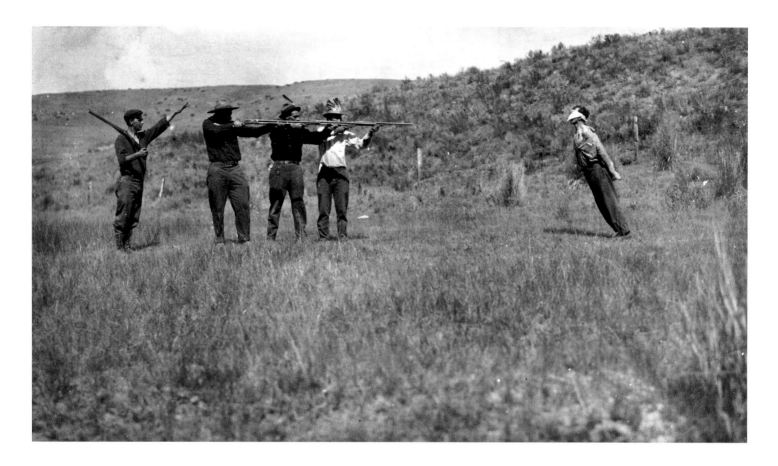

clients/friends, and his racial mixing/crossing in visual terms, complicate and challenge the existing, received history of so-called American Frontier photography. They can be regarded as an alien's indirect but critical commentary on U.S. policies concerning race, assimilation, and miscegenation, among other things.[4] But in many of Matsura's seemingly ephemeral and inconsequential portraits into which the photographer inserted himself, Matsura deployed visual strategies that indicate a sophisticated grasp of photography's perceived verisimilitude and inherent performativity—an understanding that while photographs have the appearance of reality or truth, what they capture is a moment of conscious acting for the camera and the imagined viewer.

A close examination of these (self-)portraits allows us to activate more critical readings of Matsura's ostensibly casual imprints of private moments. As a form of

entertainment for the Okanogans, the photographs from Matsura's "playground" represent, appropriate, and subvert the kind of heteronormative, gendered imagery produced by Matsura's contemporaries on the frontier.[5] Such imagery offers insights into not only Matsura's diverse photographic practices but also portraiture's multivalent function as a constitutive means for a diasporic person (and his cohort) to foster a sense of community and (re)construct a new identity, far and away from his place of birth.

"Frank's home is in Tokyo, but he says that he likes living under the stars and stripes pretty well," an *Okanogan Record* article proclaimed.[6] He emigrated from Japan to the United States in 1901, and after spending less than two years in the Seattle area, he moved to Okanogan County. Having left his old life (an upper-class upbringing) behind, the thirty-year-old bachelor seemed to have become an "everyman," working as a hotel handyman, shop owner,

and beloved photographer of the people. Matsura's photographic skills and equipment, however, suggest that he had privileged access to and advanced familiarity with recent photographic technology, something that a working-class man would not possess. In particular, some of his portraits demonstrate his technical capabilities in creating optical illusions that are part and parcel of the medium's built-in (and contested since its invention) verisimilitude.[7]

For example, in one of his photographs, it looks as though a group of four men has just succeeded in shooting a blindfolded man whose stiff body is shown toppling over (fig. 9.3). Matsura leveraged the camera's slow shutter speed to capture the falling man, adding a sense of immediacy to an image of an ostensibly dangerous encounter. The "realism" of the scene is deceiving, of course. This is, in fact, one of a series of photographs in which Matsura and friends enacted fictitious scenarios. In an accompanying image from the same session, for example, an armed "Indian," or rather, an actor with feathers in his cap and a blanket wrapped around his waist, points his rifle at a group of gambling men, their arms raised as their playing cards lie fanned out on the table; Matsura is one of the subjects.[8] In another shot that demonstrates Matsura's sense of humor and astute grasp of optical illusions through photography, his good friend Mathilda Schaller appears to be performing a handstand on a chair; in reality, she is holding the chair with extended arms and Matsura turned either the negative or camera upside-down.[9] In other instances, Matsura experimented with double exposure by combining two images into one. For example, in one photograph, a woman appears to be on both sides of a small desk; one subject writes while the other observes.[10] In another portrait, Matsura merged two separately photographed figures into a single portrait (fig. 9.4): Matsura appears to be writing in the lower half of the picture, and a young woman with a lace dress and coiffed hair hovers behind him. The composition suggests a link between the two figures: perhaps Matsura is writing to or

Fig. 9.3 (opposite)
Frank Matsura, *Untitled (Enactment for Entertainment), ca. 1910*
Digital print from negative
Jason Benjamin Digital Image Collections, no. Z00688, Okanogan County Historical Society, Washington

Fig. 9.4 (above)
Frank Matsura, *Untitled (Writing a Letter), ca. 1910*
Digital print from negative
MASC 35-52b-003, Washington State University Libraries

about the woman pictured. Such confident deployment of photographic "tricks" to construct visual narratives in the aforementioned examples further indicates that Matsura brought preexisting knowledge and technical know-how to a small town that, for all intents and purposes, was working hard to catch up with modernity.[11]

In many ways, Matsura was an atypical "frontier" photographer during a time when American-born white men Edward S. Curtis and Major Lee Moorhouse were deemed most prominent. The stylized or melancholic portrayals of Native communities in Curtis's and Moorhouse's photographs, ripe with the trope of the "noble savage," were the predominant representations for public consumption in the first decades of the twentieth century.[12] As scholar Glen M. Mimura put it, Matsura instead "vibrantly documented an alternative vision of his corner of the American West that continues to unsettle the national imaginary," with the "national imaginary" referring to a received Manifest Destiny narrative that valorized the imperatives of westward expansion in the United States, as well as the mythology of Native Americans as a "vanishing race" doomed to extinction. Matsura produced pictures, and particularly portraits, that show the varied, everyday lives of Native Americans, homesteaders, and migratory workers that the other photographers tended to gloss over. Matsura's ability to present an "alternative vision" was likely informed by his perspective as an immigrant of a racial minority and his friendships with an ethnically diverse group of residents. But Matsura's progressive upbringing in fast-changing, cosmopolitan Tokyo also made him an unusual contributor to the American borderland town. As a foreigner from fin-de-siècle Japan, he carried with him technologies and ideas of modernity, an open-minded attitude, and empathetic curiosity toward all peoples that manifested most emphatically in his playful self-portraits and portraits with friends.

Matsura's self-portraits (fig. 9.5) point to an astute recognition of photography's ability to cast one's own

image anew—a re-presentation of self—in varying ways. In the dozen exposures on a five-by-seven-inch glass plate, Matsura performed a myriad of expressions that range from solemn to nonchalant to naughty. Wearing a three-piece suit (without the jacket in some) and alternating between a bowler hat and a flat cap, Matsura portrayed himself as a serious, dapper, relaxed, and silly man. His direct gaze, an unequivocal engagement with the camera (by extension, the imagined viewer), in these self-portraits, along with a quartet of pictures showing him in a clown suit, illustrate Matsura's understanding of photographic imagery's inherent performativity, that what the camera captures is a momentary impression of a sitter/model enacting a version of him- or herself.[13] Acknowledging photography's inherent, contradictory ephemerality (of the moment of exposure) and permanence (of the negative's replicability), Matsura offers multiple versions of himself to the viewer—and to us, more than a century later. The "real" Matsura, the self-portraits seem to suggest, could be seen in any, all, or none of these images.

Such a deft interrogation and grasp of photography's contested verisimilitude and its entertainment value may have come from Matsura's exposure to the medium's vital place in late-nineteenth-century Japanese visual culture. Photography played an instrumental role, literally and figuratively speaking, in Japan's modernization programs under the Meiji Restoration, which began in the period following Emperor Meiji's ascendency to the throne in 1867.[14] Confronted by the pressures and threats from European and American colonial powers, including U.S. Navy Commodore Matthew C. Perry's visit in 1852–53 to compel Japan to open its ports to American trade, the Meiji

Fig. 9.5
Frank Matsura, *Untitled (Self-Portraits Created with a Multiplying Camera)*, ca. 1910
Digital print from negative
Frank Matsura Collections, no. 367316, Okanogan County Historical Society, Washington

government recognized and presented photography as a critical tool for "augmenting its project of 'Civilization and Enlightenment' (*bunmei kaika*)" that aimed to modernize the nation through technological advances— the establishment of a postal system and the use of steam engines and gaslights, among other things.[15] As art historian Maki Fukuoka points out, superstitions associated with photography, such as a picture "taking" and "shortening" a sitter's life, and practitioners' heavy reliance on foreign materials and products, made critics view this Western import with ambivalence, if not suspicion or outright objection.[16] But such objections could not stop photography from proliferating in major Japanese cities. For example, Tokyo's Asakusa district, a seventeen-thousand-square-foot entertainment hub, alone had "more than forty" studios at its peak in the early 1880s, offering photographic portraiture as an affordable form of entertainment, one that delighted patrons with images of their likeness captured by a mechanical contraption.[17] The entertainment value of such portraits was enhanced by photographers' manipulation of the final products, such as adding colors to the clients' faces to make them more vibrant and "life-like" or staging shots of people "in action," as seen in the exquisite portraits and genre scenes that were produced in the Japanese port city of Yokohama in the latter part of the nineteenth century. Artists active in this area at the time included the Japanese photographer Kusakabe Kimbei, the Italian-British photographer Felice Beato, and the Austrian photographer Baron Raimund von Stillfried. Beyond its aim to amuse and delight, the type of photographic portraiture produced in an era of dramatic, national transformations also served as a critical means of constructing a new Japanese identity, on the part of both the Japanese consumers who commissioned them and the photographers who created them.[18]

It was in this milieu that Matsura most likely acquired his awareness or knowledge, if not training, of the latest photographic technologies and practices. While there is no direct evidence pointing to Matsura's learning from or

working in any of the photographic studios in Tokyo, the pastor who baptized him in 1888, Kumaji Kimura, was said to have been a student of Renjo Shimooka.[19] Shimooka was a pioneer photographer in nineteenth-century Japan who, as Fukuoka points out, opened successful studios in both Yokohama (1862) and Asakusa (1882), and even erected a life-sized photographic figure of himself outside his Asakusa shop that exemplified the "playfulness and visual curiosity" as well as the popular forms of entertainment that permeated throughout the area and era.[20] Tasuo Kurihara, a Japanese photographer and devoted Matsura biographer, suggests that it was from Kimura that a young and curious Matsura learned English and acquired sufficient technical proficiency to be able to start his photography business in Okanogan.[21]

By all accounts, Matsura's studio provided Okanogans with abundant entertainment and satisfied their growing appetite for portraiture and other photographic documentation, as those in Tokyo's Asakusa did for fin-de-siècle Japanese consumers.[22] As both a gift and souvenir shop and a technologically sophisticated photographic studio, Matsura's business met a variety of demands, from formal studio portraits to group shots of local sports teams. The artist even offered to print "photos on pillow tops," according to his business card. At the same time, his many playful (self-)portraits with friends point to the way in which he presented photography to Okanogans as an accessible and amusing way of capturing moments of their lives. In one light-hearted image, Matsura and two other men rub their stomachs "after [a] big dinner," and in another, a man slumps over a handrail for no apparent reason ("a happy moment," Matsura called it).[23] Matsura's humor undoubtedly also helped make sitting for portrait sessions a fun event in a remote town where the residents staged their own forms of entertainment, as Matsura appeared to be the go-to guy for photographing bands of musicians, teams of ball players, holiday parades, and other recreational activities. Local Native Americans reportedly thought

Matsura "took funny photographs" as well, indicating that his playful portraits circulated and were seen by those beyond his close circle of friends. As Tim Brooks of the Colville Reservation Museum told Kristin Harpster, Native Americans like his grandmothers, who knew of and sat for Matsura, "went along with it" because they liked Matsura and, more importantly, because they were pleased that "Matsura was preserving their history by recording them not only in their tribal dress (which he said they voluntarily wore to his studio), but also while wearing work clothes. They thought he captured a changing time by photographing them in settings that reflected the move away from teepees and into frame homes." Brooks's statement echoes that of the Native American writer and curator Rayna Green: "What [Matsura] shows of Indians . . . what he shows of this frontier world, is not deviance and heartbreak and isolation. . . . His images of Indian ranchers and cowboys alone give us a better sense of what and who Indians were during those awful years after reservationization."[24]

Green's and Brooks's statements are worth foregrounding here to illustrate not only Matsura's success as a beloved photographer, but also the vital ways in which his approaches to portraiture appealed to and met the needs of a changing community. Through visual representations that served as both records of transformation and sources of entertainment, Matsura's portraiture contributed to the construction of new identities for Native Americans and white homesteaders alike. That is to say, through performing/playacting in front of his camera, local residents were able to re-present themselves in a manner of their choice, at least in pictures. And Matsura's photographic practices allowed and encouraged his friends/sitters to reveal or become whoever they saw themselves to be or however they wished to be perceived—the kind of freedom that appealed to the westward migration's participants. Matsura emphasized a give-and-take collaboration, inviting his sitters to contribute to his picture making. It is this respect for the agency of

his models that distinguishes his portraiture from that by well-known frontier photographers, such as Curtis and Moorhouse. For example, it was reported that Curtis would supply costumes and props to his Native models to replace their contemporary clothing or accessories—signifiers of modernity or economic development and adaptability—that might betray the kind of appearance or sentiment of a remote (different) culture belonging to a bygone era. There were also instances in which the photographs were retouched to remove existing elements to make the scenes more "authentic" (read: undeveloped or un-modernized) for the mainstream consumers. It should be noted that neither Curtis nor Moorhouse were known to have compelled by force Native Americans to participate, but the Native models by and large did not have much (if any) influence on how the photographers presented and sold their portraits, either.[25]

What also separates Matsura's work from the work of others is his consistent participation in those portrait sessions, for by partaking in the pictorial playacting himself, he disturbs the conventional power relationships between the photographer (active/in control) and the subject (passive/in submission). Matsura, as a picture maker who is both a minority and émigré, has implied dominance over his photographic subjects of both whites and non-whites—a reversal of the typical power paradigm between white frontier photographers and racioethnic minority subjects. But by stepping in front of the camera himself, Matsura further complicates the picture. He creates a level playing field within his photographic space—at least in visual terms—for different races and genders to live and play together.

The entertaining but constitutive ways in which Matsura's fun (self-)portraits contribute to the identity construction/formation of Matsura and his friends are best illustrated by his pictures taken with a multiplying camera that allowed him to make stamp-size multiple exposures.[26] In numerous sessions, Matsura and his companions freely demonstrated their close relationships and, in some cases,

enacted dynamic, visual contrasts between supposedly "feminine" and "masculine" roles or types. For instance, Mathilda Schaller, Matsura's good friend, appears with an unidentified young woman in a series of portraits in which they take turns to act as the (dominant/strong) one who comforts or offers support to the other.[27] *Frank Matsura and Norma Dillabough* (fig. 9.6) portrays the photographer with Norma Dillabough, whose family owned the Elliot Hotel where Matsura was a handyman. The friends act like a young couple—embracing, smoking, clowning around (by covering themselves in playing cards), and even fighting, with Dillabough threatening to give Matsura a slap on the face. The series of portraits presents a play on opposites and reversals: the couple not only switch sides but also swap roles as the active/dominant figure. While Matsura (wearing the "Derby," or the bowler hat) performs a man's tender gesture of lifting a woman's chin in one picture, Dillabough returns the favor in another by making the same gesture, with Matsura as the recipient, now wearing the same flat cap that is almost falling off Dillabough's head in the other image. Matsura's awkwardly placed and tentative finger in one photo, and his suppressed smile and rigid body in another, appear to contrast with other more naturalistic portraits in which he and Dillabough sit calmly with locked arms and torsos. The set of twenty images collectively evidence their comfort with and visible affection for one another. Their on-camera role-playing concludes (if one reads the images from the upper left to the lower right) with a shot of the couple coyly shielding their kiss from the imagined viewer's—and society's—prying eyes.

These playful portraits belie the social decorum that women and men were expected to maintain. Matsura's physical interactions with his female sitters would not have been appropriate in public. And he was indeed known as a gentleman who was "circumspect in his relationships with women" and was said to have regularly requested that his female sitters have a chaperone when entering his studio.[28] His (self-)portraits nevertheless show a different

picture of physical intimacy among the women and men who joined Matsura in having fun. One assumes that they all understood photography's permanence and perceived "truth," yet they still participated in extensive and seemingly carefree playacting that the public might not approve of. Such portraits thus suggest that within the confines of Matsura's studio, serving perhaps as a safe space dissociated from the regulatory paradigm of social norms, inhibitions could be suspended and boundaries could be crossed, at least in visual terms.

One possible explanation for Matsura's easy rapport with and respect for women has to do with his progressive upbringing that was atypical of a son of a Japanese "warrior-families" class (*shizoku*) in a patriarchal society that was still shedding its feudal past. Matsura's uncle and adopted father, Masashi Okami, along with the Okami family, undoubtedly played an instrumental role in providing young Matsura with the kind of education that would inform his photographic representations in Okanogan. The Okamis founded the Shoei Girls' Junior and Senior High School, still in operation today in Tokyo. A twenty-year-old Matsura taught at the Sunday school of Shoei Elementary, where his uncle was the principal, and assisted in administrative work from 1893 to 1896.[29] In his 1905 *Okanogan Record* article, entitled "Education of the Japanese Women," Matsura indeed articulated rather enlightened views on Japanese women's invaluable contribution to the nation's strength and pride. Published during the ongoing Russo-Japanese War, Matsura's article began by praising Japan's achievements as a rising power, particularly in light of the nation's "brilliant victories" against a "gigantic foe for the sake of justice and right." Japan's success can be attributed, Matsura argued, to a long

Fig. 9.6
Frank Matsura, *Matsura and Norma Dillabough Studio Portraits*, ca. 1910
Digital print from negative
Frank Matsura Photographs, MASC 35-01-21, Washington State University Libraries

tradition of strong and virtuous women raising generations of patriotic sons who bravely and skillfully defended their nation. But Japanese women, traditionally regarded as "sinful by nature . . . and inferior beings by birth," as Matsura pointed out, were more than dutiful mothers. They were men's equals: "The oldest Japanese records invariably record that women were regarded as equal to men in every respect; they enjoyed the same consideration and right as men," Matsura asserted, and women were well-versed in both literature and "military tactics and arts." As such, women and men all contributed to the development of a modern Japan and "respect for deities, purity, resoluteness, faithfulness, and loyalty were necessary qualities that made up womanhood," qualities that an upstanding man was expected to possess as well.[30]

Judging by his varied representations of women that extend beyond the customary domesticity, Matsura's liberal attitude enabled him to create an environment in which his friends felt safe and free, to various extents, to present themselves to the camera as they chose. And as the playful and intimate portraits (especially those including Matsura himself) indicate, Matsura's female friends placed their trust in him as well. Appearing in front of his lens, these women performed expressions of the kind of freedom that the frontier promised to offer—it was a "qualified" freedom, though, because American women who moved west were by no means completely released from the restrictive grasp of social conventions and expectations simply because they now lived in the "Wild West." Historian Glenda Riley's groundbreaking scholarship has demonstrated that nineteenth-century American women were regarded as "repositories of virtue and piety" whose "moral superiority" made them "natural-born" guardians of home and family,

as well as "saviors of democracy," in the westward/ frontier narratives. Riley was quoting Catharine Beecher, an influential nineteenth-century educator and proponent of domestic philosophy, who argued that women's mission was to go west as "teachers of children, immigrants, and the unschooled lower classes."[31] Only gradually did the "feminine value systems" that constrained women to the domestic and their "moral guardian" role in the frontier environment become more flexible and liberating, according to Riley.[32] With the participation of the women in Okanogan, Matsura's (self-)portraits appear to have captured those changing, liberating moments that frontier women were experiencing.

One could also argue that Matsura's camera facilitated a kind of liberation under the guise of photographic horseplay and entertainment, which extended to portrayals of same-sex role-playing. Young women and men enacted fluid masculine-feminine/dominant-submissive dynamics that seem to defy social expectations or rules. The aforementioned pictures are only a few of those in which Matsura's models explore and subvert, intentionally or not, a wide range of conventional gender types. Other examples worth noting, such as *Dollie Graves and Pearl Rasilbarth at Matsura's Studio* (ca. 1911; fig. 9.7) and *Two Young Men Pose for Portraits at Matsura's Studio* (ca. 1912), go further in their expressions of intimacy.[33] To be sure, both pairs of women and men wore accepted, gender-specific attire, such as lacy blouses and suits, and the omnipresent props, including hats, bonnets, and pipes (all recurring in Matsura's repertoire, incidentally), were deployed to signify the conventional, gendered roles that the same-sex models were performing. For example, the dark-haired Pearl Rasilbarth dons the bowler hat in four of the dozen photos (wearing a dark jacket in one) marking her "male" role, whereas the light-haired Dollie Graves is hatless in most, save for a bonnet on her head in two of the pictures to highlight her "femininity." But, as if to make the portraits more entertaining (and complicated), in the two pictures

**Fig. 9.7**
Frank Matsura, *Dollie Graves and Pearl Rasilbarth at Matsura's Studio*, ca. 1911
Digital print from negative
MASC 35-16-109, Washington State University Libraries

showing the women locking lips, Rasilbarth and Graves took turns to wear the hat and jacket to be the "man" in the pairing. The other two jolly young men also share a passionate embrace and a kiss so deep that their faces are buried in the shadow. One of them wears a bonnet to be the "woman" in the picture, perhaps to help explain or even justify, to a casual viewer, his kissing another man. But considering the models' candor, spontaneity, and unequivocal acknowledgement of and engagement with the camera (and the potential viewer), the perceived "naturalism" in the same-sex role-playing suggests a degree of comfort and trust that these borderland residents had in Matsura, to allow his camera to witness and capture intimate aspects of these women's and men's lives to varying degrees.

The existence of same-sex relationships, cross-dressers, and transsexuals was indeed a reality that the historical construction of the "American West" myths in the twentieth century had ignored, omitted, or suppressed, as historian Peter Boag and other scholars have argued and shown. More pervasive than exceptional, men (and women) engaged in same-sex sexual activities, and some women passed as men for their entire adult lives without anyone's knowledge, until after their deaths. Contrary to the rigid, two-sex/two-gender binary system that was perpetuated and reinforced in the historical imaginary or even subsequent scholarly work, Boag points out that the frontier was much more varied and ambiguous concerning sexual and gender identities. In the numerous cases that he unearthed and examined in his scholarship, Boag shows that cross-dressers, transsexuals, and homosexuals did not fit into a broader "progress narrative" of the frontier—a place that would be transformed from "a state of wilderness and savagery to an acceptably settled landscape fully integrated into the nation"—for they introduced variables and confusion into the westward expansion story. Contemporary accounts and historical studies alike have thus hidden "behind the skirts of the progress narrative," Boag argues, and explained

(without much rigor) these transgendered and transgressive behaviors as "merely due to a westering process that, thank goodness, was as ephemeral as the frontier."[34]

Boag's research may help make sense of the apparent comfort and joy in "role-playing," or cross-dressing, among Matsura's models. Matsura's (playful) portraits, ostensibly for entertainment purposes, convey a higher degree of "truth" of these residents' lives, more than those formal and contrived portraits produced on commission and for general consumption. There are indeed a few more pictures in Matsura's oeuvre that further illustrate, if not evidence, the fluidity of gender that Boag has uncovered. *Woman in Men's Clothing Smokes a Cigarette on Front Stoop* (ca. 1911; fig. 9.8) looks to be one of a pair of outdoor portraits, along with *A Woman in Drag Sits on a Stoop and Smokes Cigar* (ca. 1910), that show two women, dressed in men's clothing, sitting and smoking in public view.[35] In addition to the ties, pants, and boots, all elements of a traditional men's ensemble (as opposed to women's lacy blouses, for example), they also wear suspenders that help flatten their chests, which appear to have been wrapped in layers underneath the shirt—a common practice in female-to-male cross-dressing. The inclined smoker, in particular, exudes a sense of ease and confidence, as she directly engages the camera, her squinting eyes (probably due to the bright sun) adding a tinge of flirtation or even dare to her expression. Her pose (bent right leg, outstretched left leg, angled left arm), and her fanned-out fingers that nonchalantly hold up the cigarette or cigar to her mouth, contribute to a kind of masculine swagger she represents/performs to Matsura's camera and, by extension, the viewer. Along with another outdoor photograph, *Cowgirl in Alpaca Chaps Stands beside Her Horse* (ca. 1910), these portraits indicate the models' willingness and possibly desire to let Matsura capture their proud display, in broad daylight, of their self-representations and, by implication, their capability of performing roles and jobs predominately associated with men.[36] Matsura's portrayals of active and confident women who appeared at

Fig. 9.8
Frank Matsura, *Woman in Men's Clothing Smokes a Cigarette on Front Stoop*, ca. 1911
Digital print from negative
MASC 35-04-07, Washington State University Libraries

ease in their "chosen skin," cross-dressing or not, further demonstrate the critical ways in which Matsura offered portrait photography as a fun, nonjudgmental means both for residents to visually document their lives and celebrate their identities, and for Matsura himself to embrace and become an integral member of his new community.

Matsura's enormous corpus of photographs merits further critical studies on such topics as his acquisition and application of what were then the latest photographic technologies, and his documentarian strategies vis-à-vis

other visual records of the frontier. His (self-)portraits, both casual (as in the fun "selfies") and formal (as in those taken with Native Americans), illuminate a nuanced deployment of photographic portraiture as a critical means to articulate dynamic relationships, to represent differences, and to generate shared diasporic experiences in a borderland town. His myriad visual investigations of "otherness" in terms of gender and race are, and should continue to be, relevant to our discourses concerning contemporary visual culture, race relations, and politics of identity.

Notes

1 I must acknowledge Mark O'English, University Archivist at Washington State University Libraries' Manuscripts, Archives, and Special Collections; Richard Ries at the Okanogan County Historical Society; and Joann Roe for their generosity in answering inquiries, hosting research visits, and providing digital images over the years. I thank Anthony W. Lee, Sandra Matthews, Joseph Jeon, and Seth Bruder for their insightful feedback as well.

2 Matsura's extensive oeuvre of glass plate negatives, from which digital prints have been made for this essay, is divided between collections at the Okanogan County Historical Society and Washington State University, Pullman. According to the archives, Matsura's prodigious output occurred between 1907 and his death, at age thirty-nine, in 1913.

3 The diasporic conditions apply to not only homesteaders' westward journey in pursuit of economic opportunity, but also Native Americans' loss of homeland and forced relocation into reservations—for instance, the Colville Indian Reservation sits in the southeastern part of Okanogan County, a 5,211 square mile region with more than 12,500 residents, according to the 1910 census, cited in Joann Roe's pioneering study, *Frank Matsura, Frontier Photographer* (Seattle: Madrona Publishers, 1981), 21. I use both "borderland" and "frontier" in this essay but prefer the former for its connotation of the implied tension in the contacts between peoples/cultures/ economic-political interests without mythologizing or leaving unquestioned an expansionist impulse and history embedded in the term "frontier."

4 I analyzed the visual rhetoric of racial politics in Matsura's work in "Going 'Native' in an American Borderland: Frank S. Matsura's Photographic Miscegenation," *Trans-Asia Photography Review* 5, no. 1 (Fall 2014), http://hdl.handle.net/2027/spo.7977573.0005.103. An expanded chapter on Matsura's portraiture is in my book, *The Other American Moderns: Matsura, Ishigaki, Noda, Hayakawa* (University Park, PA: Penn State University Press, 2017), 8–37. My analyses benefited from two important studies: Kristin Harpster's "Visions and Transgressions in Early-Twentieth-Century Okanogan: The Photography of Frank Matsura" (master's thesis, Washington State University Pullman, 1998), a thorough consideration of Matsura's visual strategies before Glen M. Mimura's theoretical intervention, "A Dying West? Reimagining the Frontier in Frank Matsura's Photography, 1903–1913," *American Quarterly* 62, no. 3 (September 2010): 687–716.

5 I am guided in part by art historian Abigail Solomon-Godeau's proposition: "It is properly the work of historians and critics to attempt to excavate these coded and buried meanings, to bring to light those rhetorical and formal strategies that determined the work's production, meaning, reception, and use"; "Who Is Speaking Thus? Some Questions about Documentary Photography," *Photography at the Dock: Essays on Photographic History, Institutions, and Practices* (Minneapolis: University of Minnesota Press, 1994), 169–83. I also keep in mind the late photographer-theorist Allan Sekula's argument that "the meaning of any photographic message is necessarily context-determined," as opposed to an "intrinsic or universal meaning" that a photograph may carry. How/where an image is produced/received is of paramount importance in any investigation of a photographic work. Sekula, "On the Invention of Photographic Meaning," in *Thinking Photography*, ed. Victor Burgin (London: Macmillan, 1982), 84–109.

6 *Okanogan Record*, March 1, 1907. Biographer Tatsuo Kurihara uncovered that Matsura came from the Matsura clan, who ruled the Hirado Domain in the modern-day Nagasaki Prefecture. By the time Sakae (Frank), the eldest son of Yasushi Matsura, was born in 1873, his family had become part of the *shizoku*, the "warrior-families" class that was created to absorb the samurai warriors under the Meiji Restoration as a way to weaken their political influence. Young Sakae lost both parents to illness before he turned nine. In 1886 he was sent to live with his father's younger brother, who married into the Okami family and took their last name. Kurihara, *A Man Named Frank: Memories of Sakae Matsuura, Photographer of the West* (Tokyo: Joho Senta Shuppankyoku, 1993), 43–47.

7 For example, the French photographer Hippolyte Bayard (1801–1887) created his infamous *Self-Portrait as a Drowned Man* in 1840, after Louis-Jacques Mandé Daguerre (1787–1851) in France and William Henry Fox Talbot (1800–1877) in England reportedly preempted Bayard in announcing their respective inventions of photography in 1839. Bayard, who obviously did not drown himself, used the self-portrait as a performed protest against how he was unfairly treated in France. See, among many studies, Jillian T. Lerner's "The Drowned Inventor: Bayard, Daguerre, and the Curious Attractions of Early Photography," *History of Photography* 38 (2014): 218–32.

8 The photographs are in the Okanogan County Historical Society's collections. My thanks to Richard Ries for directing my attention to this set of pictures.

9 Frank Matsura, *Mathilda Schaller in an Optical Illusion with a Chair*, ca. 1912, Frank Matsura Photographs, Negative 35-04-48, Manuscripts, Archives, and Special Collections, Washington State University Libraries.

10 Frank Matsura, *Optical Illusion as Woman Poses with Herself at Desk*, ca. 1909, Frank Matsura Photographs, Negative 35-08-56.

11 By the time Matsura arrived in the Okanogan Valley, in 1903, there were "cows and cowboys, kids and one-room schools, steamboats round the bend, railroads in the offing, and telephone lines looping across the brown hills," along with "three main street saloons, two hotels with dining rooms (the Central and the Riverside), and several restaurants," as historian Murray Morgan stated in his introduction to Roe's *Frank Matsura*, 12.

12 Mimura, "A Dying West?" 714. In addition to Mimura's comparative analysis, see other studies of Curtis's and Moorhouse's photography: Shannon Egan, "'Yet in a Primitive Condition': Edward S. Curtis's North American Indian," *American Art* 20, no. 3 (Fall 2006): 58–83; Shaman Zamir, "Native Agency and the Making of 'The North American Indian': Alexander B. Upshaw and Edward S. Curtis," *American Indian Quarterly* 31, no. 4 (Fall 2007): 613–53; and Steven L. Grafe, *People of the Plateau: The Indian Photographs of Lee Moorhouse, 1898–1915* (Norman: University of Oklahoma Press, 2005), and "Lee Moorhouse: Photographs of the Inland Empire," *Oregon Historical Quarterly* 98 (Winter 1997–98): 426–77.

13 The glass negative is the sole surviving (but cracked) plate in the Okanogan County Historical Society collections. The quartet of self-portraits in clown costumes (ca. 1908) is part of the Frank Matsura Photographs, Negative 35-01-02.

14  W. G. Beasley, *The Meiji Restoration* (Stanford, CA: Stanford University Press, 1972). Marius B. Jansen, "The Meiji Restoration," in *The Nineteenth Century*, vol. 5 of *The Cambridge History of Japan*, ed. Marius B. Jansen (New York: Cambridge University Press, 1989), 308–66.

15  John W. Dower, "Introduction," in *A Century of Japanese Photography*, ed. Japan Photographers Association (London: Hutchinson, 1971), 9.

16  Maki Fukuoka, "Selling Portrait Photographs: Early Photographic Business in Asakusa, Japan," *History of Photography* 35, no. 4 (2011): 356–57.

17  Fukuoka, "Selling Portrait Photographs," 362–63. She also suggests that the success of the photographic studios was due in large part to portraiture's affordability: "In 1878, 15 *sen*, the cost for a portrait in collodion positive on glass, was the average amount earned daily by a male farmer and one-third of a metal smith's daily earnings. In other words, having a portrait photograph of oneself was not prohibitively expensive but fairly affordable" (365).

18  See Mio Wakita, *Staging Desires: Japanese Femininity in Kusakabe Kimbei's Nineteenth-Century Souvenir Photography* (Berlin: Reimer, 2013), and "Sites of <Disconnectedness>: The Port City of Yokohama, Souvenir Photography, and Its Audience," *Transcultural Studies* 2 (2013): 77–129; Luke Gartlan, *A Career of Japan: Baron Raimund von Stillfried and Early Yokohama Photography* (Leiden and Boston: Brill, 2016); and Melissa Banta and Susan Taylor, eds., *A Timely Encounter: Nineteenth-Century Photographs of Japan* (Cambridge, MA: Peabody Museum Press, 1988).

19  Kimura traveled to the United States in 1870, studied in a seminary, and was ordained by the Classis of New Brunswick of the Reformed Church in 1882. See his diary, *Kimura Kumaji Nikki* (Tokyo: Tokyo Joshi Daigaku Fuzoku Hikaku Bunka Kenkyujo, 1981).

20  Fukuoka, "Selling Portrait Photographs," 371–73. The first large-scale survey of Shimooka's oeuvre, *A Retrospective on Shimooka Renjo, 100 Years after His Death*, went on display at the Tokyo Metropolitan Museum of Photography and the Shizuoka Prefectural Art Museum in 2014, with an accompanying catalogue, *Shimooka Renjo: A Pioneer of Japanese Photography* (Tokyo: Kokushokankokai, 2014).

21  Kurihara, *A Man Named Frank*, 60–68.

22  For a comprehensive study of the westward population's appetite for photographic portraiture, of both the homesteaders and Native Americans, see Carol J. Williams's *Framing the West*, (Oxford: Oxford University Press, 2000).

23  *Matsura and Two Men Hold Their Stomachs after a Big Dinner*, 1909 (Frank Matsura Photographs, Negative 35-01-56), and *A Happy Moment*, ca. 1910 (35-42-03).

24  Harpster interviewed Tim Brooks on October 3, 1998; Harpster, "Visions and Transgressions in Early-Twentieth-Century Okanogan: The Photography of Frank Matsura," 107. Green, "Rosebuds of the Plateau: Frank Matsura and the Fainting Couch Aesthetic," in *Partial Recall: Photographs of Native North Americans*, ed. Lucy R. Lippard (New York: The New Press, 1992), 51–52.

25  See Aaron Glass, "A Cannibal in the Archive: Performance, Materiality, and (In)Visibility in Unpublished Edward Curtis Photographs of the

Kwakwaka'wakw Hamat'sa," *Visual Anthropology Review* 25, no. 2 (Fall 2009): 128–49; and my comparative analyses in "'Going Native' in an American Borderland," and *The Other American Moderns*, chap. 1.

26  The "Inventory of Estate of Frank S. Matsura" lists a "multiplying camera" and varying sizes of single, double, and multiple film holders. According to the George Eastman Museum's curator of technology collection, Todd Gustavson, while Eastman Kodak Company did manufacture cameras with "indexing repeating backs and multiple lens sets," Matsura's camera was probably altered and outfitted for his particular photographic endeavor, not a camera widely available for purchase. My thanks to Richard Ries for sharing with me his research inquiries.

27  Frank Matsura, *Mathilda Schaller, Matsura and Friends*, ca. 1911, Frank Matsura Photographs, Negative 35-16-100.

28  Roe, *Frank Matsura*, 17. Matsura was known to have been a bachelor all his life. In Roe's original research, she encountered an elderly Caucasian woman who claimed to have had some sort of a romance with Matsura. The relationship could not be verified, however. Joann Roe, personal correspondence with author, November 4, 2014.

29  Okami, a distinguished polymath, became a Christian in 1878 and served as an elder at Tokyo's Daimachi Church, where Pastor Kimura presided and baptized young Matsura. Kurihara, *A Man Named Frank*, 60–68.

30  "Education of the Japanese Women," *Okanogan Record*, March 31, 1905.

31  Glenda Riley, *Confronting Race: Women and Indians on the Frontier, 1815–1915* (Albuquerque: University of New Mexico Press, 2004), 12, 18.

32  Riley, 12. For women's evolving roles in the frontier narratives, see also Riley's *The Female Frontier: A Comparative View of Women on the Prairie and the Plains* (Lawrence: University Press of Kansas, 1988).

33  Frank Matsura, *Two Young Men Pose for Portraits at Matsura's Studio*, ca. 1912, Frank Matsura Photographs, Negative 35-15-48.

34  For Boag's extensive studies, see "Go West Young Man, Go East Young Woman: Searching for the Trans in Western Gender History," *Western Historical Quarterly* 36, no. 4 (2005): 477–97; and *Same Sex Affairs: Constructing and Controlling Homosexuality in the Pacific Northwest* (2003) and *Re-Dressing America's Frontier Past* (2012), both published by University of California Press. My thanks to Cheryl Gunselman, Manuscript Librarian at Washington State University, Pullman, for pointing me to Boag's research.

35  The titles identifying the figures as women and the use of the word "drag" are not Matsura's, as many of his photographs were titled by the Washington State University librarian(s) who processed the Judge William Compton Brown Papers, 1830–1963. Brown had acted as custodian of Mastura's photographs and personal effects after the photographer's death in 1913 and his papers, including Matsura negatives, were donated to the university in 1966.

36  Frank Matsura, *Cowgirl in Alpaca Chaps Stands beside Her Horse*, ca. 1910 (Frank Matsura Photographs, Negative 35-04-01), and *A Woman in Drag Sits on a Stoop and Smokes Cigar*, ca. 1910 (35-04-34).

# THE OTHER'S OTHER

## PORTRAIT PHOTOGRAPHY IN LATIN AMERICA, 1890–1930

Juanita Solano Roa

Let us begin with a portrait of a man standing in front of a painted landscape. The subject is shown wearing a scarf, a *carriel*, modern pants, and a striped jacket.[1] He leans upon a classical balustrade, and there is a potted plant neatly positioned at his feet in the foreground of the picture (fig. 10.1). Taken in 1912 in Medellín, by Colombian Benjamín de la Calle, the photograph brings to the fore a series of apparent contradictions: first, the juxtaposition of a typical Andean peasant with characteristically European architectural devices; second, the contextualization of the scene in a Mediterranean landscape; and third, the deliberate intention to hide—behind the plant—the bare feet of the subject. Such presumed inconsistencies appeared throughout the production of portrait photography in Latin America during the long nineteenth century (1789–1914). They were signs of a more complex history in which Latin American citizens tried to define their identities through both an exploration of their own roots and identification with hegemonic European culture.

**Fig. 10.1**
*Alejandro Ramírez* by Benjamín de la Calle, 1912
Digital positive from dry-plate glass negative
Biblioteca Pública Piloto, Medellín, Colombia

The history of Latin American photography during this period must be understood in different terms from those of the European tradition. Indeed, it might be considered "backwards." "Backwardness" should be understood here not as a pejorative term, but as a methodology that enables a different perspective—one that is, on the contrary, productive. "Backwardness" not only sheds light on other aspects of the photographic object, but it also considers "the Others"—the subjects who have been relegated to a marginal position—as central. In opposition to traditional approaches where the vintage *positive* copy of a photograph is the object to be analyzed, this study examines the particular circumstances that affected Latin American photography and led to the collection, conservation, and preservation of the *negative* originals.

The analysis of these negatives has been completed through modern digital copies (scans), which have enhanced the optical aspects of the images and distanced the reading from material considerations. The latter, in many cases, point to social, political, and economic circumstances that have not been fully considered in many of the histories told so far. For example, many of the photographs from this period were carefully retouched by

photographers for different purposes, such as altering the color of skin, eliminating indigenous people from urban vistas, or adding artifice and effects that were not part of the original shot. This manipulation, in many cases visible only on the negative plate, completely changes the original understanding of the images and raises debates related to the transparency of the photographic object. Here, a "backwards approach" permits a broader perspective. If we agree that the photographic medium is a dispersed one—divided between the shooting, the selection of the image, the editing process, and the final positive print— then the negative as a point of reference might be equally as important as its positive version, if not more so. Although this methodology might be problematic, precisely because we are not dealing with the final image, it sheds light on other issues—the "backward" issues—that shaped and forged the construction of identities in modern Latin America. It also raises theoretical questions regarding the "construction" of the photographic image. It forces us to question *where* exactly the image lies, or if any one state is more "complete" than the other.

Photography, characterized by its alleged transparency and objectivity, was unveiled in Europe in 1839 and became the principal means by which to symbolically capture and conceal identities; portraiture, therefore, played perhaps the biggest role in the configuration of the medium. In Latin America, the invention of photography, and its early arrival to the continent in December of that same year, coincided with post-independence political processes and discourses. As opposed to the European experience, where national consolidation and an established visual imaginary existed prior to the invention of photography, in Latin America the medium developed during the processes of nation building in the postcolonial period and, in many cases, before the consolidation of fine art academies. Therefore, the photographic image played a crucial role in the definition of identities, which were different from and specific to each geographical area. Any attempt to homogenize, or

rather to trace, the distinctive character of Latin American photography would fail to describe the complexity of the production. Instead, this critical analysis of three case studies will delineate some of the strategies utilized in the artistic and commercial work of studio photographers from different regions through the ideas of progress, modernity, and race. The work of Benjamín de la Calle and the studio Fotografía Rodríguez (Horacio Marino and Melitón Rodríguez) in Colombia; Martin Chambi in Peru; and Romualdo García in Mexico fostered the construction of particular identities through portrait photography.

## SUPPORTING AND CHALLENGING THE CONSTRUCTION OF THE *RAZA ANTIOQUEÑA:* FOTOGRAFÍA RODRÍGUEZ AND BENJAMÍN DE LA CALLE

Benjamín de la Calle's studio and Fotografía Rodríguez emerged as commercial enterprises precisely at the moment when Medellín became Colombia's second-largest city, as well as the industrial center of the country. The department of Antioquia, with Medellín as its capital, cultivated a strong discourse of identity around the notion of progress, with particular attention to the idea of a new race, namely the *raza antioqueña* (Antioquian race).[2] From the early nineteenth century, the notion of progress fostered and imposed material and ideological exigencies in the region. These ideas reached their pinnacle at the time when the two studios were active, and despite the critical analysis that such notions have received since then, such an ideology still underscores discourses of identity in the region. The alleged *raza antioqueña* took advantage of the economic boom that came from gold mining, coffee, and the minor impact that the turn-of-the-century civil wars had on the region in order to proclaim a "superior race" that distinguished the Antioqueños from the rest of the country. Indeed, by 1910 a group of intellectuals formulated a series of discourses surrounding identity and proclaimed that if "there is place in Latin America, where the ideal rock of a superior race exists, that place is Antioquia."[3]

**Fig. 10.2**
*Henrique Uribe* by Fotografía Rodríguez (details), 1893
Dry-plate glass negative
Biblioteca Pública Piloto, Medellín, Colombia

Portrait photography played a fundamental role in the definition of this "new race" as it visualized or challenged what the aforementioned intellectuals claimed through speech and text. Indeed, this visual discourse was perhaps even more relevant, since a large part of the population was illiterate. Photographs, on the other hand, circulated widely in the form of cartes de visite, postcards, and albums. These ideas were internalized and adopted by many, thereby becoming part of the "visual economy" of the civilizing program that was taking place in the city.[4]

Immersed in this circle of intellectuals and artists, the Rodríguez brothers, Horacio Marino and Melitón, developed a pictorial style nonexistent in other parts of Colombia and rarely found in photographic studios across Latin America. Not only did they create elaborate artistic images, but they also utilized interventions, such as negative retouching and double exposures, to conceive different realities. The core of their production was the creation of portraits for the elite class of Medellín, a branch of the society that aspired to become more modern, progressive, and "whiter" than the rest of the country. To be white was to be closer to the European model of progress and hence in a position of inherent power. Like any type of ideology, the *raza antioqueña* discourse was naturalized and became part of the normative vision followed not only by the Rodríguez brothers and the elite class, but also by the government and the church. The photographs taken by the Rodríguez brothers reflected a coherent system of ideas and beliefs that maintained the status quo of a class hierarchy that privileged the elite. This was not a one-way relationship; rather, these forces continually and mutually reinforced each other.

In the portrait of Henrique Uribe, for example, visual production and ideology intertwine (fig. 10.2).[5] The picture depicts a half-body shot of the sitter: a young man wearing a suit, a black top collar shirt, and a big checkered tie. When perpendicular light hits the negative, it looks like any other portrait. However, when turned slightly, so as to make the light hit the glass plate at a 45-degree angle,

the retouching process that the image has gone through becomes visible. The face of the sitter has been overtly manipulated in order to produce a whiter and smoother surface, imitating a porcelain effect. When analyzed with raking light, the smooth effect is replaced by a series of graphite strokes that cover the skin of the sitter. Although negative retouching was a common practice across the globe, the amount performed on the negatives from the Rodríguezes' studio surpassed the general use of this manipulation technique. This is especially striking in their portraits of young people, in which the intention was not only to correct skin defects or aging—as most other photographers did—but also to whiten and smoothen the face of the sitters. As one chronicler of the time put it, the Antioquian clientele had many demands: there were "ugly ladies who want[ed] to look pretty, one-eyed and cross-eyed people who want[ed] to appear with good eyes, whites who [did] not accommodate to the shadows and blacks who want[ed] to look white."[6] Thus, the final portraits "naturally" embodied and naturalized racist ideologies as the graphite strokes literalized the rhetorical violence that was perpetuated by the theory of the *raza antioqueña*. Ultimately, what was seen as an imaginary—the invention of the idea of a new race—had real, lived consequences, which today are perceptible only if we look at them through the "backward" approach. In other words, the negative versions of these images make visible the ideology behind their construction.

Parallel to their commercial work, the Rodríguez brothers, and in particular Melitón (the younger of the two), developed an important body of art photography. One of his most emblematic images is a photograph entitled *The Angel of Hope* (El ángel de la esperanza), originally taken in 1909 (fig. 10.3). The picture shows a lumberjack

**Fig. 10.3**
*The Angel of Hope* by Fotografía Rodríguez, 1909
Digital positive from dry-plate glass negative
Biblioteca Pública Piloto, Medellín, Colombia

**Fig. 10.4**
*Tomás González B. and Wife: San Cristobal* by Benjamín de la Calle,
date unknown
Digital positive from dry-plate glass negative (left); original gelatin dry-plate
negative (right)
Biblioteca Pública Piloto, Medellín, Colombia

sitting in the middle of a theatrically staged forest. The man holds an ax in his right hand and leans his head on his left one. Behind him appears the ghostly figure of an angel. The winged figure lays a hand on the man's head, looks up, and points with the other hand at the heavens. With this image, the viewer is transported into witnessing a private moment of a spiritual force changing the destiny of a harried soul. Melitón's picture did not attempt to prove the existence of celestial beings, nor did it intend to deceive the viewer. Rather, by creating a metaphorical connection between religion and photography, Melitón intended to underscore both Catholic beliefs and aesthetic experience without abandoning the reference to his family's spiritualist ties.[7] *El ángel de la esperanza* appropriated the standard representation of sacred subjects, such as the guardian angel, an iconic figure that was profusely depicted not only in Baroque and Renaissance painting but also in popular printed media. Melitón sought, as did many other photographers of his time, to emphasize the "material" manifestations of the unseen utilizing a shared visual vocabulary of mass-produced religious imagery. In *El ángel de la esperanza*, the photographer opted for a popular subject in which his viewers were well versed and thus engaged an immediacy of spiritual commitment.

In 1912, the same photograph was published in a Colombian journal entitled *Avanti*, a title, meaning "to move forward" in Italian, that clearly referred to the idea of progress. Taking advantage of photography's polysemic characteristics, the editors of the magazine changed the title of the picture. They noted that, "considering the absence of a more appropriate name, we have given it [the title of] *El Angel del Trabajo* [*sic*] [The Angel of Work], which is in our opinion the one that most closely approaches the beautiful ideal it represents."[8] Although the photograph was exactly the same, this time its reading was linked to one of the *raza antioqueña*'s most important ideological features: the hard-working man protected by his faithful devotion to God. If an iconic image of the Antioquian race had to be chosen,

it would be one that depicted a combination of Catholic beliefs and the Antioqueños' progressive and hard-working attitude. In *El ángel del trabajo*, the attention first given to the angel in the previous version of the photograph is displaced to that of the white working man. Here, the low quality of the reproduction de-emphasizes the artifice created by the photographer, instead directing attention to the subject itself. The discourse of the *raza antioqueña* was so strongly embedded in the mentality of the intellectual elite that the title found to describe Melitón's photograph reflected this already naturalized ideology.

Working during the same period as Fotografía Rodríguez, Benjamín de la Calle focused on marginalized types. His images responded to and challenged the progressive discourse fostered by the upper class. De la Calle's portraits represented a struggle for acceptance from and incorporation into a highly divided class society, which rejected anything that disturbed its conservative moral standards. De la Calle, a gay man immersed in a corrective society and thus an outsider himself, visualized through photography a spectrum of the Colombian population that lacked visual representation in a dignifying way: peasants, artisans, prostitutes, cross-dressers, and people of African and Indigenous descent, among others.

Photography served as a commemorative, social, and political device; it became an "active" object capable of triggering affective engagements through images that were often considered objective and transparent. In the same way that the medium was able to materialize ideologies, it could also resist them by working as a tool that visualized other realities, which, unless photographed or articulated through a visual media, would otherwise be forgotten. As seen in the picture first described in this essay, the portrait of Alejandro Ramírez (fig. 10.1), de la Calle utilized different strategies to dignify his sitters and thus give them an image that represented their ideal selves, which did not necessarily conform to societal expectations. In Medellín, peasants and working-class people wandered barefoot around the city

up until the 1930s. The use of shoes was not a common practice until a Rockefeller Foundation campaign to improve public health conditions was implemented under the banner of a "civilizing" initiative, which in reality addressed economic interests in the commercialization of coffee.[9] In this photograph, the potted plant was utilized as a device that hides the fact that the sitter is barefoot, thus giving the man a different status. De la Calle used this strategy frequently, sometimes replacing the plant with an animal skin that lay over a sitter's feet or hiding them behind an artificial balustrade. In many cases, that simple act signified not only the recognition of the sitter's aspirations, but also a distinction between photography as an indexical trace of the present and photography as medium that portrayed a possible longed-for future or past.

In a wedding portrait, also taken by de la Calle, Tomás González B. and his wife pose in front of a landscape backdrop (fig. 10.4). He wears a black suit and she a rather simple dress—most likely her Sunday best, but not a proper wedding dress considering the dark color of the garment. Nonetheless, what stands out from this picture is the woman's veil, which was not real but rather an addition by the photographer's hand. Utilizing the same red ink that the Rodríguez brothers used for whitening of the skin of their sitters, de la Calle hand-painted the veil, which the bride presumably could not afford, into the photograph. De la Calle's intervention is barely visible in the positive copy but is clear on the negative. Through the incorporation of the hand-painted veil, de la Calle was simultaneously elevating the social standing of the couple and fulfilling an aspirational desire that could only become real through photographic representation. As Christopher Pinney has stated in relation to postcolonial Indian and African photography, "there is an articulated recognition by photographers that their task is to produce not an imprisoning trace of their sitters but to act as impresarios, bringing forth an ideal and aspirational vision of the bodies that sitters wish themselves to be."[10]

Both the Rodríguez brothers and de la Calle were using a similar type of photography for very different purposes: one studio aligned with the hegemonic discourse of a "white," modern, and progressive society, while the other challenged those very ideas. These two cases are exemplary of how photography and ideology intertwine in different ways. With the Rodríguez brothers, ideology was turned into image; in the work of de la Calle, image worked as ideology.

## BORDERING *INDIGENISMO*: THE CASE OF MARTÍN CHAMBI

Martín Chambi was Peru's first indigenous photographer and arguably one of the most important practitioners of his time in Latin America. Chambi's interests went beyond his talent as a studio photographer and a photojournalist. His work was grounded in a larger project that encompassed both an aesthetic and a social interest in photography. In particular, the link between his practice and the philosophy of Peruvian *Indigenismo* (Indigenism) was crucial for the promotion of his work on a sociopolitical level. Although he did not directly pertain to the official *Indigenista* group, his images promoted a sense of local national pride that was absent from the work of other photographers from the region. His vistas of the Andean South were seen as "national subjects in artistic form," aligning with the general debates that were taking place in the country and the intersection between art and nationalism.[11]

Chambi, originally from Coaza in the department of Puno, established himself in Cusco in the 1920s after studying photography in Arequipa with Max T. Vargas and later with Carlos and Miguel Vargas, two of the most prominent photographic studios of the time in Peru.[12] His

Fig. 10.5
*Organ Player at the Capilla de Tinta, Sicuani, Cusco*, by Martín Chambi, 1935
Digital positive from dry-plate glass negative
Archivo fotográfico Martín Chambi

arrival in the southern part of the country coincided with the moment in which the intellectual sphere of Cusco consolidated its discourse against the centralization of power in the capital and instead promoted a regional identity based on their indigenous cultural roots. Chambi's images played a crucial role in the definition of these identity discourses, which, although divergent in their particularities, departed from a rejection and denouncement of the political and economic exploitation of the indigenous people. The two main currents of *Indigenismo* in Cusco that emerged at the time of Chambi's activities in the region were those of historian and anthropologist Luis E. Valcárcel and historian and sociologist José Uriel García. Through the now famous book *Tempestad en los Andes* (Tempest in the Andes), published in 1927, Valcárcel argued in favor of a "pure" indigenous race that could be rescued through historical and archaeological investigations. García, on the contrary, proposed that *mestizaje* (race mixing) was precisely what enhanced the "improvement" of the race, thus creating the figure of the "new Indian" in his book of the same title (*El nuevo indio*), published only three years after Valcárcel's work. García thought that post-conquest colonial history was a process of cultural growth that should be taken into account in the creation of this new race.[13]

Although usually classified as *Indigenistas*, Chambi's photographs did not strictly align with either Valcárcel's or García's ideas. His work gravitated between an aesthetic interest in photography, which positioned the Indian in a romanticized Andean environment, and the more touristic and archaeological approach, which documented and promoted the historical part of Cusco. In addition to these two types of photography, he also worked as a commercial studio photographer. Although he considered all variants of his work in his broader conception of art photography, it is the latter group of images that caught the attention of curators and academics internationally starting in the late 1970s.[14] This approach discarded a large portion of his production, which did not appeal to the modern

black and white aesthetic in vogue at that time.[15] Indeed, Chambi colored many of his prints with monochrome inks, pleasing the public of *his* time, which appreciated the addition of color as an artistic effect in photography.[16] As noted by Jorge Latorre, this "embellishment" elicited criticism from *Indigenistas* such as Uriel García, who claimed that Chambi had no clear ideological position and thus was not able to interpret the real issues of the indigenous people.[17] However, Chambi did engage with sociopolitical issues, but he did so, perhaps, on such a metaphorical level that his visual statements might have gone unnoticed. Furthermore, some of his comments were only accessible to a well-educated public and they took place, mostly, through images that belonged to a different category, which stood between the studio portrait and the documentary photograph.

In *Organ Player at the Capilla de Tinta, Sicuani, Cusco* (1935) and *Boy and Policeman, Cusco* (1924), Chambi captured outdoor scenes in which he simulated the studio environment (figs. 10.5 and 10.6). The first photograph depicts a man playing an organ in a small room. The enclosed space recalls the photographer's studio with its painted backdrop and props utilized to stage a shoot. The European organ contrasted not only with the location of the scene, decorated with hand-painted murals in a local and rather impoverished architectural environment, but also with the musician himself—that is, an indigenous man. Together, the man and the instrument represent the encounter of two cultures, indigenous and European, embodying the continuation of a relationship that was imposed during the colonial period—this time, however, under different terms. Indeed, the date that appears handwritten on the back wall in the picture, July 28, 1935, makes reference not only to the year in which the photograph was taken, but also to Peru's independence day in 1821. Therefore, *Organ Player* is not a photograph that aims at exalting indigenous folklore and culture, as did many of Chambi's photographs of musicians playing local instruments such as harps,

*quenas*, and *pututus*.[18] Rather, it is a picture that makes a sociopolitical statement. Here the indigenous person is in control of the instrument; the instrument, or the "colonizing artifact," does not impose itself over the local man. The juxtaposition of the two, in this particular situation, reverses the status of the indigenous man, empowering him while celebrating the moment of national emancipation. Indeed, the drawing on the wall is Peru's code of arms, and one cannot help but wonder if the man plays the national anthem so as to make a perfect conjunction between the visual, the aural, and the performative. In this photograph Chambi explored portraiture in a different way: he did not aim at portraying a specific person, the character, or the individual, but rather a shared subjectivity, which was under scrutiny precisely at the historical moment.

Furthermore, *Organ Player* was taken in Sicuani, the town where Chambi opened his first photographic studio and where he presumably learned the art of composing an artificial scene for the camera, using an enclosed environment, defined background, and props to tell a story. In this photograph, taken years later, after his move to Cusco, this same compositional strategy was translated to an image that was made outside the strict understanding of the photographic studio. Moreover, the character of the image aligned with the documentary tradition of capturing a scene not accessible to the general public that engaged with some sort of informative value. The situation was clearly staged for the camera and it informed the viewer in a meaningful, layered, and perhaps even obscure way. Some scholars have pointed out the remarkable fact that the photographer's work did not explicitly address many of the evident social gaps and inequalities that were so apparent in the Cusco society of the time.[19] As signaled by José Carlos Huayhuaca, Chambi did not engage directly with sociopolitical issues, nor did his photos convey a tone of open denunciation.[20] He did, however, elevate the status of the Indian both through his own performativity (we see him posing both as an Indian in romanticized landscapes and as

a "Westerner" wearing a suit in his studio) and through his photographs of a varied spectrum of people.

In *Boy and Policeman,* Chambi responded to another photographic tradition—namely, the type photograph. Here, he took a frontal full-body shot of a policeman holding by the ear a young, presumably poor child. The picture works as visual evidence of the man capturing the criminal child, or rather of his work as authority controlling disobedience. It follows the traditional variety of type photography, in which the repetition of subject and gesture (such as, for example, a water carrier carrying a water jar or, in this case, a policeman capturing a criminal) rather than the distinctiveness of the individuals is portrayed.[21] This repetitiveness signaled the uses of this type of image, which was created to classify and compare, turning individuals into facts and categories to be "scientifically" studied. Here, however, the outdoor setting and the more casual aspect of the picture eclipsed the quasi-scientific aspect of the photograph, humanizing both the police officer and the criminal and thus making a sociopolitical statement regarding the status of the underprivileged and their relationship with authority.

There is some sort of humor in the picture. The policeman does not punish the child in a procedural or official way; rather, he playfully "pulls his ear" (*le da un tirón de orejas*), an old school gesture used mostly to reprimand children for unacceptable behavior. The background of the picture parallels the characteristics that represent each of the sitters, juxtaposing discipline and disobedience in a visual way. The policeman, associated with the law, control, organization, and surveillance, stands over a perfectly aligned set of paving stones (square, straight, and organized), while the child, linked to the idea of criminality, rebellion, and noncompliance, stands over small, abundant, and disorganized rocks. The garments of the characters also follow the same pattern of opposites: the policeman is fully dressed in a clean uniform, while the child poses in a ragged outfit. In this photograph, Chambi

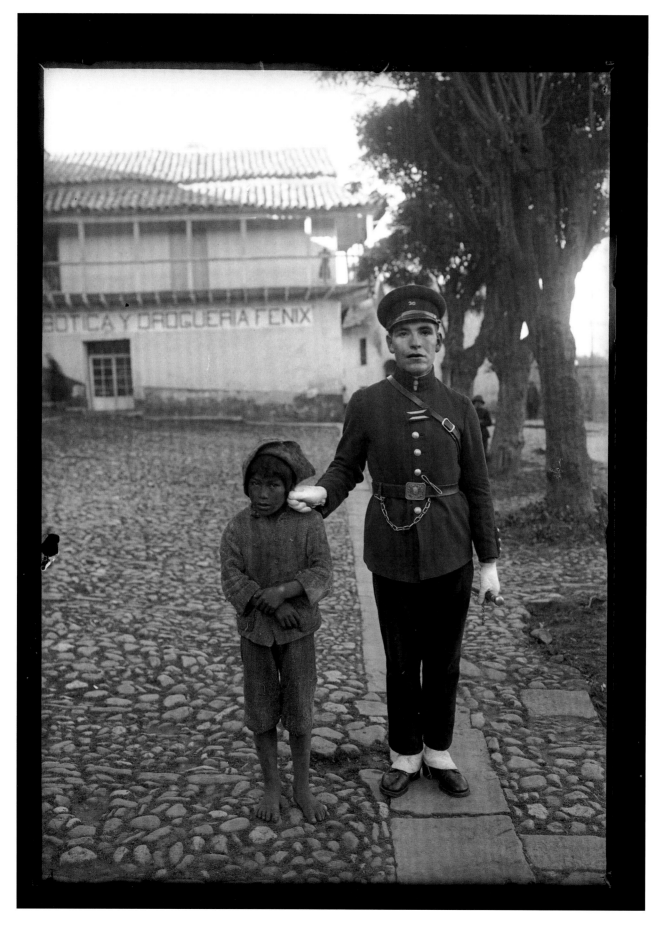

repeats the same visual play that served as a reminder of the oppositional forces that were in dispute at the time: aristocracy versus working class, white versus Indian, patriarchal values versus progress.

If we understand Indigenism's central goal as one that vindicates the rights and culture of indigenous people, distinguishing them from idealized and idyllic sentimentality, then Chambi's work aligned with the movement in general terms. Although in conflict with the details of certain Indigenist proposals, his photographs positioned the Indian in equal standing with the rest of the Peruvian society. His images made a statement regarding the status of his people, national identity, the frictions and differences between the social classes, and the strong contrast between the benefits of the white elite and those of the Indian population. Ultimately, Chambi's photographs responded to a Hispanophile ideology in formation, which led to discourses in which the Indian was blamed for the country's misfortunes. One such discussion was pronounced by the philosopher Alejandro Deustua in 1937, when he proclaimed that "Peru owes its misfortunes to the indigenous race, which psychic degeneration has taken on the biological rigidity of a being that has definitely stopped evolving, and which has failed to contribute to the mestizo the virtues of a progressive race."[22]

## POSTMORTEM PHOTOGRAPHY:
## ROMUALDO GARCÍA AND *LOS ANGELITOS*

Recognized as "the photographer of the dead," Romualdo García emerged as a commercial photographer in Guanajuato, Mexico, by the end of 1880s. He became the most prominent practitioner of this region, photographing not only the emergent bourgeoisie but also the middle and lower social classes. At the time of his flourishing career,

Fig. 10.6
*Boy and Policeman, Cusco,* by Martin Chambi, 1924
Digital positive from dry-plate glass negative
Archivo fotográfico Martín Chambi

Mexico was under the regime of Porfirio Díaz (president 1876, 1877–80, 1884–1911), a thirty-three year period known as the *Porfiriato* in which the country entered modernity through a strong process of industrialization, a centralized government, the straightening of local capital and foreign investment. This progressive development, based on a positivist doctrine, took place, however, at the expense of a largely disenfranchised working-class and indigenous population.

García specialized in portraiture, documenting the large spectrum of a stratified society. He never challenged the Porfirian regime, nor did he engage with the bourgeoning political environment that ultimately led to revolution in 1910. García did not see photography as a sociopolitical tool, and thus he rarely took his camera outside the studio or confronted traditional values. His photographs followed the tradition of French photographic studios, achieving international recognition at the Paris Exposition Universelle from 1889 where he was awarded a bronze medal.[23] However, he has received historical recognition not for his studio portraits, but rather for the large number of photographs he took of deceased children. During the *Porfiriato*, a period of "progress," life expectancy reached only thirty years, and infant mortality was as high as 30 percent. Thus, photography became the main means of preserving the memory of often-brief lives.

Photographing the dead was a common practice throughout the long nineteenth century. Many practitioners specialized in this apparently macabre tradition, which consisted in taking a portrait of the cadaver right after a beloved had passed away. It was a practice that required specific skills, and therefore it was very well paid. Many photographers advertised it as a one of their specialties, including García. However, postmortem photography is one of the few photographic genres that has disappeared over time. Its history can be traced back to that of colonial painting, in which deceased children were portrayed in the form of *angelitos* (little angels).[24] In the Catholic tradition, it

was believed that baptized children died free of sin and thus went directly to heaven, avoiding purgatory and becoming angels. Therefore, deceased children were portrayed in the form of saints, virgins, or other martyrs, de-emphasizing individuality and rather focusing on their condition as pure souls free from sin. With the advent of photography, and the continuation of the tradition—now also followed by the less affluent social classes—the individual character of the sitter was introduced as an important feature.

While maintaining the ritual of dressing up the cadaver in the form of a religious character, or through the inclusion of symbolic objects, the presence of an adult in the photograph (or the child's siblings) was an innovation utilized as a strategy to retain the identity of the *angelito*. This is seen, for example, in a picture by García in which a mother holds her deceased baby in her arms (fig. 10.7). The child is dressed in the form of baby Jesus, with a robe covering his body, a crown of thorns on his head, and a large cross in his hands. In many cases, the referent for the child's costume did not come from the pictorial tradition, but rather from popular prints (*cromos*) that circulated widely amongst the population. The *cromos* would provide the direct source material for the seamstresses who produced these costumes, which were specifically designed for the funerary ritual.[25]

Indeed, what differentiated the Mexican version of postmortem photography from that of the rest of the world was precisely the ritual surrounding the tradition. In Mexico, the relationship with death was a particular one, ultimately becoming one of its "National totems."[26] Death, or rather the flirtation with it, was one of the seminal characteristics of Mexican popular culture and one that is still present both visually and discursively.[27] In opposition to the European and American experiences in which death tended to be denied, in Mexico it was embraced. While the loss of a child was a distressing experience, it was also celebrated due to the angelical transformation. The indigenous past intertwined with Catholic worship, creating a syncretic ritual in which

popular culture and European values nourished each other. Some of the ritual's aspects involved, for example, taking the cadaver from house to house in order to bring the blessings of the *angelito* to relatives and friends.[28] In Spain, where the tradition originated, after the death of a child, family and friends would spend the night singing and dancing to the sound of guitars and castanets. In Mexico, the ritual was also combined with local celebrations of the Day of the Dead by the indigenous and black populations, who honored those who had passed away with traditional African dances and music or offerings in the form of food (usually corn, *nopales*, and harvest fruit). Ultimately, photographing the deceased child with the donations and family members became part of the ritual, especially in rural areas. In most of the cases, the photographs were later used as part of domestic altars, which were worshiped particularly during the Day of the Dead.[29] The pictures were also printed on postcard paper and circulated among family and friends to announce the death of the *angelito*.

In a photograph of a dead child taken outside the photographer's studio it is possible to perceive the popular aspects of the ritual (fig. 10.8). The baby lies in a small bed fully covered with flowers; he is dressed in white and wears a silk robe from which a sacred heart hangs on the left side of his chest. He has a big crown on his head, probably imitating the representation of a Catholic saint. The photograph was taken in a private environment, as can be discerned from the background of the image, and his mother was included in the picture. It is a photograph charged with all the syncretic aspects of the ritual: the overtly ornate decoration of the cadaver, the flower offerings, and the intimate and personal location (as opposed to the studio).

**Fig. 10.7**
*Woman with Boy Dressed as Nazarene* by Romualdo García, ca. 1910
Digital positive from dry-plate glass negative
Acervo de la Fototeca Romualdo García. Museo Regional de Guanajuato Alhóndiga de Granaditas

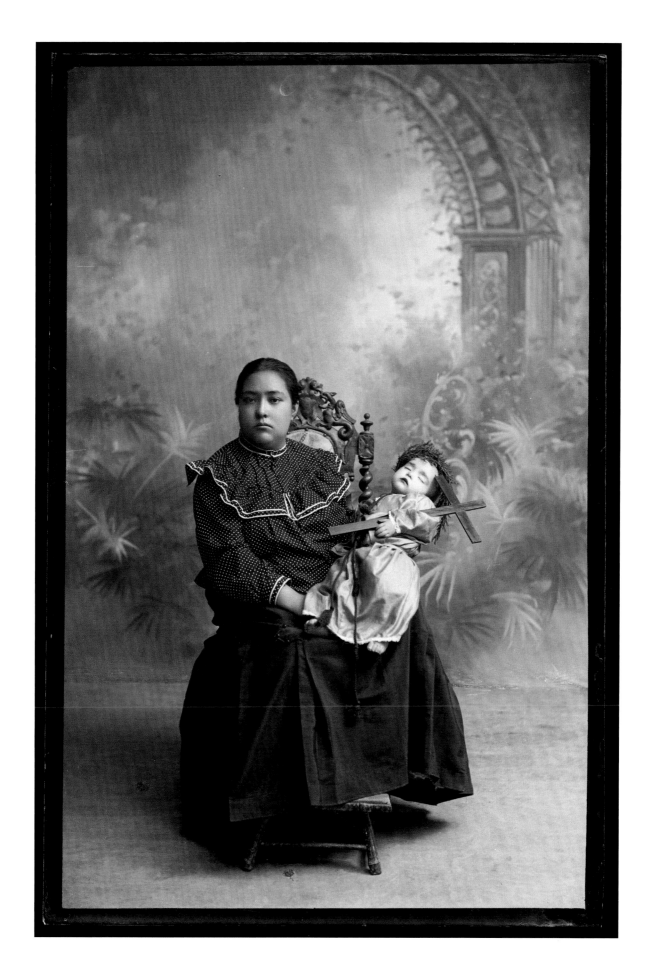

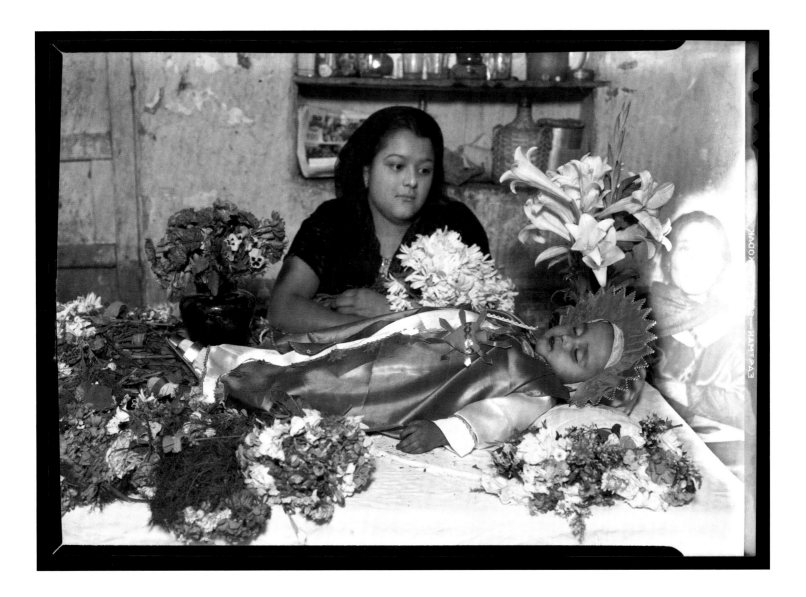

**Fig. 10.8**
*Untitled* by Romualdo García, date unknown
Digital positive from security film
Acervo de la Fototeca Romualdo García. Museo Regional de Guanajuato
Alhóndiga de Granaditas

García's postmortem photographs had a double function. On the one hand, they acted as objects that mediated between the living family and an absent presence, symbolizing it through representation. On the other, these photographs constituted the ultimate materialization of an idea in the form of an indexical trace (whether sacred or not) of the relationship to death or a nonexistent body. The genealogy of these objects can be traced back to the Middle Ages when death masks were created in order to preserve the presence of a departed one—a tradition that extended until the nineteenth century. Both masks and photography shared the characteristic of being indexical traces—that is, objects that depend on a referent in order to exist. Thus, these objects bore with them not only the most literal mimetic representation of the departed, but also their "presence" through the kinetic relationship created between the commemorative object and the beloved's body, as both photography and masks were literally *in contact with* the cadaver.

Postmortem photographs also relate to another kind of object that makes visible the invisible—*acheiropoietic* objects, or those not made by human hands. Examples include religious icons such as the Turin Shroud and the Veil of the Veronica, which both represent the image of Christ and are said to have come into being miraculously rather than being created by people. But of the few *acheiropoietic* objects that remain today, Mexico owns the most representative in the Americas: namely, the Virgin of Guadalupe. According to the myth, this object corresponds to a cloak in which the image of a *mestiza* (mixed race) Virgin appears miraculously as proof of the Virgin's apparition and petition to build a chapel to the Indian Juan Diego.[30] The photographs of *angelitos* act in a very similar way to *acheiropoieta*: they are created by non-human hands (photography was thought to be the art of light itself), they represent sacred and pure souls that went to directly to heaven (exactly as the Virgin did), and they are worshiped and exalted by their beloved ones. Thus, postmortem

photography acquired a different meaning in Mexico. Not only did it function as an object to preserve memory, it also acquired a syncretic sacred status.

Therefore, García's recognition as "the photographer of the dead" was, and is, considered praise in Mexico. This was not the case in other places of the world, such as France, where Nadar—perhaps the most famous photographer in Paris during the nineteenth century—refused to take pictures of dead bodies (with the exception of the postmortem portrait of his close friend Victor Hugo) as this was seen as a "lowbrow" aspect of the photographer's profession. The highly recognized status of García in his profession signals once more the ideological differences with his European counterparts. In Mexico, the local tradition emerged through the appropriation of European culture as a contestation from within.

———————

As seen in these case studies, portrait photography not only played a pivotal role in the construction of identities in Latin America, it also promoted or challenged the status quo, creating tensions between the European hegemonic culture and the local culture of each particular geographic region with which it intertwined. As the "backwardness" of pictures became a necessary condition for the existence of their "frontal" counterparts, the newly created hegemonic culture (within Latin America, which was in itself an already secluded culture) needed something to be positioned against, be it the *mestizo*, the Indian, the black, or the peasant. Ultimately, it was a continuation of the ideology pursued during the colonial period, this time, however, absorbed *within* the post-independence nations even as they tried to forge their own, non-European identities. A close look into the object-ness of photographs and a deeper understanding of them through the "backwards methodology" permits a broader consideration of what these images were meant to be, produce, and acknowledge, shedding light on that which is not immediately seen but is physically and rhetorically present.

## Notes

1 A *carriel* is a typical leather bag used most prominently by men. It is a distinctive accessory from the region of Antioquia in Colombia.

2 Colombia has a centralized government, but the territory is divided into thirty-two regions called departments. These subdivisions are granted a certain degree of autonomy and are ruled by a governor, who is elected through popular vote.

3 "[. . .] que hay un lugar en la América latina en que existe esa roca ideal de una raza superior, y ese lugar es Antioquia." Libardo López, *La Raza Antioqueña* (Medellín: Imprenta La Organización, 1910), 7–8. It is important to note here how, in Colombia, this type of regionalist discourse developed parallel to a national identity. See Nancy Appelbaum, *Muddied Waters: Race, Region and Local History, 1846–1948* (Durham, NC: Duke University Press, 2003). Unless otherwise noted, all the translations are by the author of this essay.

4 For a further discussion of the idea of visual economy, see Deborah Poole, *Vision, Race and Modernity: A Visual Economy of the Andean Image World* (Princeton: Princeton University Press, 1997).

5 Most of the photographs discussed in this part of the text exist only in their negative version. Since the studios of both Benjamín de la Calle and Fotografía Rodríguez were commercial enterprises, the positive versions remain in family albums and private collections. The positive images analyzed here are contemporary scans of the negatives.

6 "[. . .] feas que quieren quedar bonitas, tuertos y bizcos con los ojos buenos, blancos que no se acomodan con las sombras y negros a quienes hay que hacer blancos." P.N.G., "Pequeña Historia de la Fotografía en Antioquia," *El Esfuerzo* (1895), in *Hágase la Luz: Pastor Restrepo Maya (1839–1921)*, ed. Juan Camilo Escobar Villegas (Medellín: Fondo Editorial Universidad EAFIT, 2014), 77–83.

7 Melitón's family was accused of pursuing spiritualist meetings and promoting a different type of belief that challenged that of the Catholic Church. His mother was one of the most popular mediums in the region, and his father encouraged the gatherings and was thus directly linked with the practice. Spiritualism was common among the radical liberals in Colombia and their beliefs were based on proposals such as Allan Kardec's *The Spirit's Book*, which was translated into Spanish and published in Medellín in the 1870s. It is not clear if spiritualist practices continued throughout the Rodríguez family, but there is definitely a history that links Melitón to it.

8 "A falta de un nombre más apropiado, le hemos dado el de El Angel del Trabajo, que es a nuestro entender el que más se aproxima al bellísimo ideal que representa." "El Angel del trabajo," *Avanti* (Medellín), 1912, 136.

9 In 1919, a campaign to fight ankylostomiasis (a disease acquired when hookworm larvae enter the body through the soles of the feet) was implemented by the Rockefeller Foundation in Colombia. The disease was particularly rampant among coffee pickers who worked barefooted in the fields, and their incapacity to work affected the production of Colombia's most important export crop. The campaign was utilized as a strategy to penetrate Latin American states and ultimately benefit from the exploitation of raw materials in the region. See Claudia M. García and Emilio Quevedo, "Uncinariasis y café: Los antecedentes de la intervención de la Fundación Rockefeller en Colombia, 1900–1920," *Biomédica* 18, no. 1 (1998): 5–21.

10 Christopher Pinney, "Notes from the Surface of the Image: Photography, Postcolonialism, and Vernacular Modernism," in *Photography's Other Histories*, ed. Christopher Pinney and Nicolas Person (Durham, NC: Duke University Press, 2003), 213–24.

11 Natalia Majluf and Edward Ranney, *Chambi* (Lima: Asociación Museo de Arte de Lima, 2015), 27.

12 Carlos and Miguel Vargas are known as the Vargas Brothers.

13 See Poole, *Vision, Race, and Modernity*, 182.

14 See, for example, the exhibition *Projects: Martin Chambi and Edward Ranney*, held at the Museum of Modern Art in New York in March 1979, or *Martín Chambi (1891–1973) Photographer of Cuzco*, held at the Art Museum of the University of New Mexico that same year. More recent exhibitions, in particular *Chambi*, which took place at the Museo de Arte de Lima (MALI) in 2015 and was curated by Natalia Majluf and Edward Ranney, have made an effort to incorporate and understand the photographer's larger and complex body of work.

15 See Michelle Penhall, "The Invention and Reinvention of Martin Chambi," *History of Photography* 24, no. 2 (Summer 2000): 106–12.

16 See Andrés Garay, *Chambi por sí mismo* (Peru: Universidad de Piura, 2006).

17 Jorge Latorre and Ana Balda, "Neobarroco fotográfico: Martín Chambi y sus maestros Arequipeños," in *Lámparas de mil bujías: Fotografía y arte en América Latina desde 1839* (Madrid: Editorial Fog, 2018).

18 *Quenas* are the traditional wooden flutes from the Andes and *pututu* is the term utilized in Quchua to make reference to a series of various trumpet-like instruments.

19 See Majluf and Ranney, *Chambi*, and José Carlos Huayhuaca, *Chambi, photographe* (Lima: IFEA, 1990).

20 Majluf and Ranney, *Chambi*, 22.

21 For more information on this, see Deborah Poole, "An Image of 'Our Indian': Type Photographs and Racial Sentiments in Oaxaca, 1920–1940," *Hispanic American Historical Review* 84, no. 1 (2004): 46.

22 Orin Starn, Carlos Iván Degregori, and Robin Kirk, *The Peru Reader: History, Culture, Politics* (Durham, NC: Duke University Press, 2005), 269.

23 Claudia Canales, *Romualdo García: Un fotografo, una ciudad, una época* (Guanajuato: Ediciones La Rana, 1998), 27.

24 The tradition in painting expands to modern times. Artists such as Frida Kahlo, Juan Soriano, Olga Costa, David Alfaro Siqueiros, and Gabriel Fernández Ledesma have been invested in the topic. See Edward Sullivan, *The Language of Objects in the Art of the Americas* (New Haven and London: Yale University Press, 2007), and Gutiérrez Aceves, "Imágenes de la inocencia eterna," *Artes de México* 15 (Spring 1992): 27–49.

25 Daniela Marino, "Dos miradas a los sectores populares: Fotografiando el ritual y la política en México, 1870–1919," *Historia Mexicana* 48, no. 2 (1998): 213.

26 Claudio Lomnitz, *Death and the Idea of Mexico* (New York: Zone Books, 2005), 23.

27 Today, the relationship between Mexican culture and the cult of death has even become a stereotype.

28 Andrea Cuaterolo, "La visión del cuerpo en la fotografía mortuoria," *Aisthesis* 35 (2002): 55.

29 See Marino, "Dos miradas a los sectores populares," 209–76.

30 For a broader analysis of the history of the Virgin of Guadalupe, see Janette Favrot Petersen, *Visualizing Guadalupe From Black Madonna to Queen of the Americas* (Austin: University of Texas Press, 2014).

# PHOTOS OF STYLE AND DIGNITY

## WOODARD'S STUDIOS AND THE DELIVERY OF BLACK MODERN SUBJECTIVITY

Amy M. Mooney

"Why are there not more colored photographers?"

—W. E. B. Du Bois, 1923

Ever aware of the power held by photographers, W. E. B. Du Bois made a call in the pages of *Crisis* magazine for more African Americans to consider the profession, noting it to be "a fine and paying career for artist and artisan, man and woman."[1] More to his point, however, was the medium's potential for social service as well as its ability to capture the "delicate beauty of tone" of African American skin. Counseling readers to avoid the "horrible botch" of white photographers who "make the heart ache," Du Bois noted the success of the Scurlock Studio, as well as the work of Cornelius M. Battey and Arthur Bedou, then posed the question meant to encourage more African Americans to take up the charge of representation. William E. Woodard responded to this call, establishing photography studios during the 1920s through the 1940s in Chicago, Cleveland, Kansas City, and New York City. With subjects ranging from female impersonators such as Bonnie Clark (fig.11.1) to activist Ida B. Wells-Barnett, Woodard's Studio developed visual strategies of representation that are in keeping with those employed by photographers such as

James VanDerZee and James Allen. When compared to works by contemporary artists such as Aaron Douglas and Archibald Motley, the portraits of Woodard's Studio further underscore the shifting expectations of the genre, especially as the circulation of these images dramatically increased during this era. As patrons' likenesses were reproduced in the pages of newspapers like the *New York Amsterdam News* and the *Chicago Defender*, as well as magazines such as *Abbott's Monthly* and the *Messenger*, these portraits transitioned from serving solely as representations of individuals to representing the collective imaginings of a modern black consciousness.

Woodard's Studio generated an archive that directs us to view photography as a social process central to the conceptualization of the "New Negro." As a rhetorical device in play since 1895, the New Negro represented the objectives of black intellectuals who understood the value

Fig. 11.1
*Chorus Line* (including Bonnie Clark, fourth from the left) by Woodard's Studio, ca. 1920
Black-and-white print, 35 × 28 cm (13¾ × 11 in.)
Beinecke Rare Book and Manuscript Library, Yale University

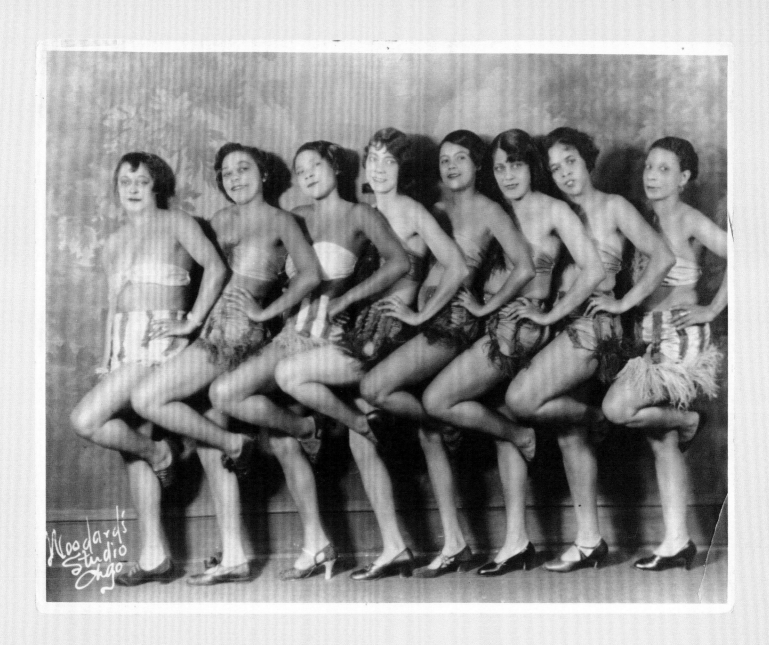

of visual imagery in swaying public opinion.[2] Its tenets gradually shifted from its Victorian origins to a more fluid sensibility that incorporated the contradictions and changes of modernity. More than a rebuttal of the racist imagery of the early twentieth century or an attempt to fill in the lacunae of history, these photographs allow us to critique and interpret history.[3] Woodard's photographs refute the conservative essentialization that has characterized scholarship on the black bourgeoisie, allowing for a broader consideration of the work accomplished by the photographer, the subjects, and the subsequent circulation of these images.[4] In Woodard's work, we see the assertion of black individuals as viewing subjects who were deeply vested in the negotiations between individual and collective identities, supporting a far greater inclusivity in regards to class, gender, and sexuality than previously imagined. His emphasis on entrepreneurial growth and civic custodianship did more than establish a black middle class. Portrait studios such as Woodard's served as a mixing point between classes, offering a highly sought-after service that promised acceptance and welcomed all to "call and get acquainted whether you make a sitting or not."[5] The *Defender*'s proclamation that "Chicagoans have become so 'Woodardized' that nothing but the most veritable stranger would think of patronizing any other studio"[6] not only promotes the specific studio, but also hints at the ways that Woodard's photographs functioned as a site of intersectionality. From the representation of glamorous entertainers to the documentation of formidable activists, Woodard's photographs represent socially and historically constructed "selves that could only be understood—and understand themselves—in relation to others."[7] Further, the portraits generated during this era allowed subjects to critique, interpret, and shape identity to such an extent that their efforts continue to impact contemporary consciousness.

## THE MAKING OF THE WOODARD'S STUDIO FRANCHISE

According to an announcement placed in the *Chicago Defender*, William Edward Woodard established his photographic studio in Chicago in 1920.[8] His earliest listings note that his training was gained in "the finest of loop studios."[9] For those unfamiliar with Chicago's segregation, this likely indicates that he apprenticed at one of the downtown studios owned and largely patronized by whites, such as Moffet Studio or Raymoor. Studios that served African American patrons, including Sexton and Maxwell or William Prentiss Greene, were largely centered south of the downtown area called the Loop.[10] Training as an apprentice was common, though by 1910 the study of photography was integrated into many art schools, colleges, and universities; the program at Tuskegee was of particular note due to the work of C. M. Battey.[11] In his early advertisements for the studio, Woodard stressed the artfulness of his approach. His offer of "Real Art" connects him to ongoing debate as to the role of photographers as creators rather than simple recorders of images. Promising "class and charm," Woodard noted that his skill in photographic manipulation was especially distinguished by its "radiant" and "alluring" portrayal, as well as its "touching individuality."[12] His engagement with the language of portraiture was in keeping with Charles H. Caffin's assertions in his 1910 book *Photography as Fine Art* that the photographer "must have sympathy, imagination, and a knowledge of the principles upon which painters and photographers alike rely to make their pictures."[13] Surveying Woodard's work, it is clear that, like portrait painters of his era, he understood that the expectations of the genre included capturing the sitter's character and establishing a relationship with the viewer.

Fig. 11.2
*Portrait of Harris Gaines* by Woodard's Studio, ca. 1920
Gelatin silver print, 19 × 11.4 cm (7½ × 4½ in.)
Chicago History Museum; Collection of Irene McCoy Gaines

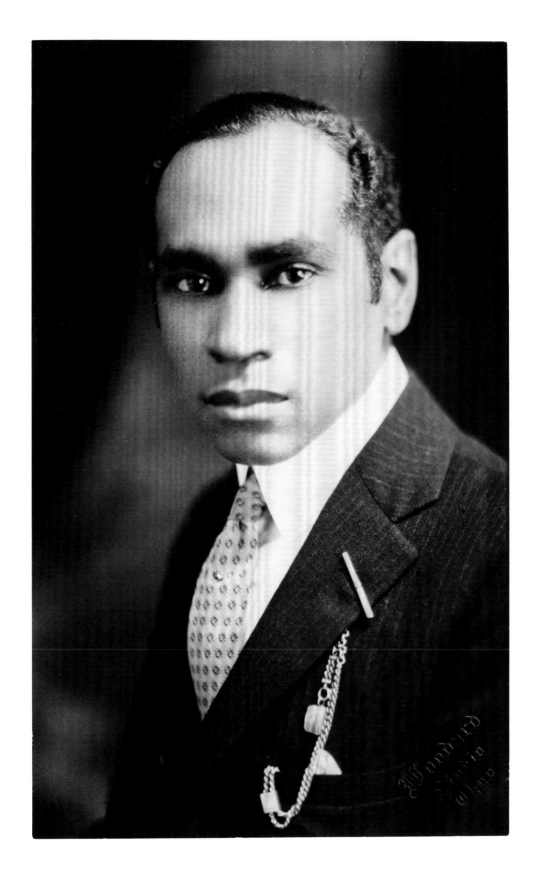

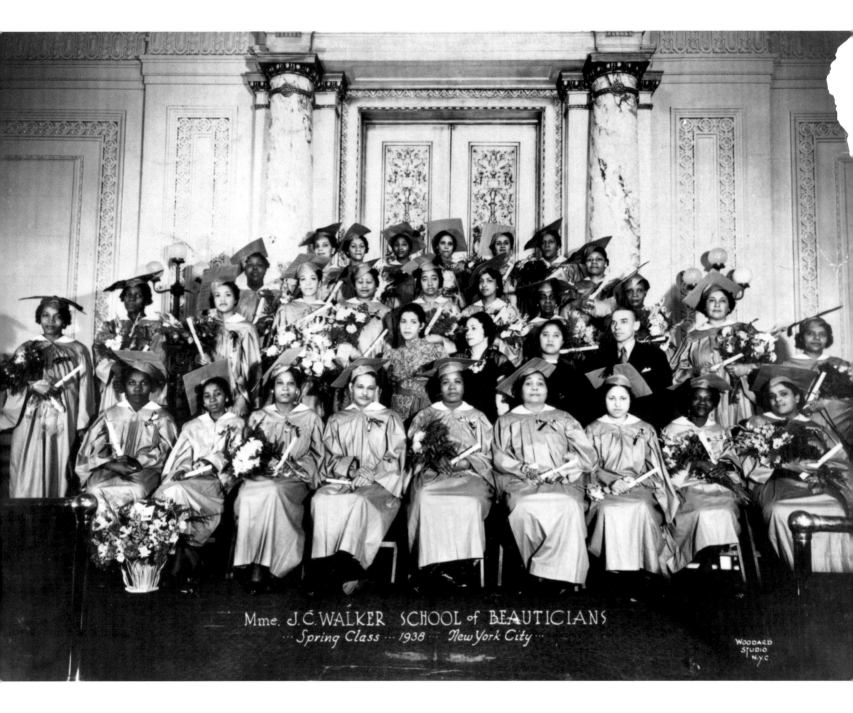

**Fig. 11.3**
*Mme. J. C.* [sic] *Walker School of Beauticians Spring Class* by Woodard's
Studio, 1938
Black-and-white print, 28 × 35.6 cm (11 × 14 in.)
Chicago Public Library, Woodson Regional Library, Vivian G. Harsh Research
Collection of Afro-American History and Literature; Marjorie Stewart Joyner
Collection

By 1923, Woodard announced the opening of a new studio in Kansas City, managed by his relatives James and Dewey Woodard. Early success necessitated the hiring of additional photographers, including Miles Webb and Harold E. Young, who were noted as "very capable artists."[14] Charles Evans Woodard, William's nephew, also joined the Chicago practice, serving as his assistant.[15] Receptionist Lottye Hale Jacobs played a central role in the business and was celebrated in the pages of the African American periodical *The Light: America's News Magazine* for her contributions in shaping the "modern photographic studio." Readers learned that, at Woodard's, Jacobs ensured a lasting relationship with the studio because she could "tactfully take you in hand" and "become the most valuable person in the world to you." She had "the knack of drawing out the best expression" and for "putting the client at ease." Jacobs led the customer to select the portraits that were not only "best suited to the subject," but also showed the subject at her or his "best possible advantage."[16] Her efforts reveal the studio's investment in the portrait as a validating social exchange.

Citing increased opportunities, Woodard relocated to New York City in 1932, yet he took care to assure his Chicago clientele that other skilled photographers would see to their portraiture needs.[17] Drawn to Harlem, he established his studio just blocks away from the successful Guarantee Photo Studio run by James VanDerZee. There, he hired and trained Winifred Hall Allen, who took over and renamed the studio after Woodard returned to Chicago in the early 1940s.[18]

Overall, Woodard's Studio portraits are brightly lit, with the subject angled to the most flattering position. For headshots, like that of Assistant State Attorney Harris Gaines, the photographers seemed to favor an atmospheric background that added a bit of tonal texture to the image (fig. 11.2). The focus is central and sharp. Often the photographers directed the light toward one side of the sitter's face, making the most of the medium's ability to register contrast. For group portraits, Woodard and his team worked both in the studio and on site with the logistical challenges seemingly well resolved in the resulting images. During this period, the studio also broadened its approach to the portrait, moving from a standing or seated pose with the subject positioned against painted background or heavy velvet drapes to a closer-cropped focus on the subject's face.

Different formats, however, remained available as a sort of menu displayed on the walls of the studio, allowing clients flexibility in determining how they wanted to be represented. Some, even into the late 1930s, favored a more formal throwback to the Victorian era, choosing iconographic additions such as plants and books, or background landscapes like those used by African American photographer Thomas Askew.[19] This range in style allowed patrons to craft images that secured their reputations and established a sense of historic presence previously denied to black subjects. The studio's diversity in approach also blurred class and professional lines as the aesthetics and mores of respectability adapted to the emerging professional possibilities within urban centers such as Chicago and Harlem. Surveying the work of VanDerZee, Kobena Mercer noted that the photographer's subjects "present a compelling view of people transforming their collective past as they embraced the promise of modernity in one of the world's most sophisticated cities."[20] Not only is this observation applicable to the work of Woodard's Studio, but it also notes the temporal process of fashioning a portrait.

In effect, through the work of the present, the portrait secures an individual's place in the past and in the future. Throughout the 1920s and 1930s, individuals and agencies employed the portrait as a social tool, one that afforded engagement with the psychology, technology, and possibility of modern life. In many of his promotions, Woodard boasted of maintaining the most up-to-date camera equipment. Due to the era's developments in halftone printing, his efforts were reproduced and disseminated, making his subjects models of possibility,

a celebration of diverse black achievement and everyday lives. Woodard considered himself an artist, capable of transforming his patrons before the camera's gaze, utilizing its aesthetic capacities as well as the traditional tools of portraiture, such as prop and pose. When exhibited, his work garnered critical acclaim for the finish of his prints and the manner in which he portrayed his subjects.[21] Additionally, the work of the studio was seen through the burgeoning African American press, circulating nationwide and contributing to the development of a public sphere in which blackness was synonymous with style and dignity.

Several significant holdings of Woodard's Studio images exist, though not as the archives of the studio's own practice. Rather, the photographs are preserved as historic documents within the archival collections of others. The situatedness of the photographer's contributions—where such images are encountered—provides insight as to their social function and value. The circulation of Woodard's images, as well those of other African American portraits, is also critical to this understanding. Hundreds of visitors may have seen Archibald Motley's *Portrait of My Grandmother* (1922) when exhibited at the Art Institute of Chicago, but thousands more saw it when reproduced on the pages of *Crisis* magazine that same year.[22] Not only did such exposure benefit the artist's interest in becoming a professional portraitist, but it also provided another layer of self-recognition for audiences. Motley's empathetic rendering of his paternal grandmother, Emily Sims Motley, a former slave, allowed others to see her as a representation of their own relatives, forming bonds around the shared experiences of family, memory, and the history of slavery.

Similarly, because of photography's capacity for reproduction, Woodard's photos could be experienced as a private object or a public spectacle, both evoking personal connection with the image. From distribution through the Associated Negro Press, Woodard's photographs appeared in newspapers such as the *Baltimore Afro-American*, ensuring the broadest exposure and connections possible

for his clientele. Working with local business groups such as Madame C. J. Walker's School of Beauticians, the photographer published his work within an ever-expanding sphere, merging public and private functions (fig. 11.3). Toward this end, Woodard placed advertisements in the sources that featured his photographs, capitalizing on the effect of the work, letting the likenesses of individuals and groups serve as evidence of the ways that he could similarly apply his skills to potential customers. Development in black consumer culture also informed Woodard's practice as clients sought to align their economic, social, and political agency. Woodard's most productive years correspond with the development of "Don't Spend Your Money Where You Can't Work" campaigns that unified diverse segments of African American populations.[23] His decision to advertise exclusively within the burgeoning black press and his regular contributions to historic projects that celebrated black achievement, such as John Taitt's *Souvenir of Negro Progress* (1925), shed light on the ways that the photographer envisioned the merger of a commercial consciousness with a collective aesthetic and a social purpose. Through the inclusive language of his advertisements, he distinguishes himself as an advocate, stating, "Our people needed a studio where they could have their work done properly by one of their own Race."[24] Noting that his patrons "come from all walks of life," Woodard frequently offered discounts and coupons to "bring these high-grade pictures within the reach of all."[25]

Another unity-building aspect of studio portraiture was the way that it was influenced by photojournalism. This period is marked by the emergence of black media celebrities who also impacted black consumer culture by offering modes of dress and pose that were then emulated by the general populace. After 1920, portraits demonstrate an almost universal assumption of celebrity posturing, reflecting a shift in photographers' approaches toward their subjects.[26] Instead of the so-called respectable classes eschewing the expressions and gestures of stage performers,

**Fig. 11.4**
*Portrait of Clarence Muse and Elliot Carpenter* by Woodard's Studio,
ca. 1937
Gelatin silver print, 15.9 × 21 cm (6¼ × 8¼ in.)
The Schomburg Center for Research in Black Culture / The New York
Public Library; Division of Photographs, Helen Armstead Johnson Theater
Collection

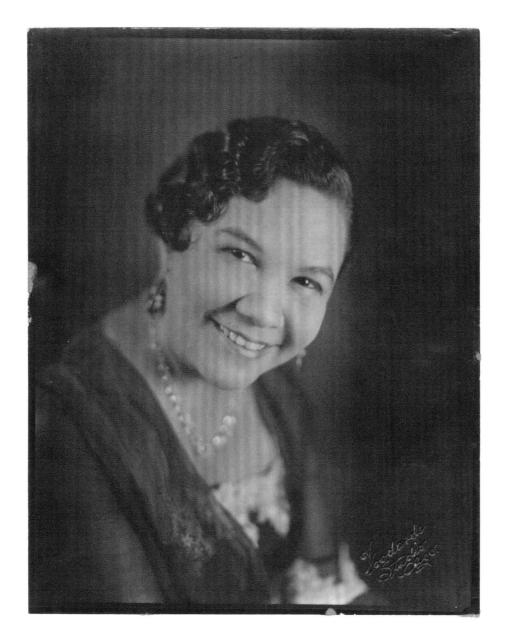

Fig. 11.5
*Portrait of Mauvolyene Carpenter*
by Woodard's Studio, ca. 1930
Gelatin silver print
25.2 × 20.3 cm (9$^{15}$/$_{16}$ × 8 in.)
The Schomburg Center for
Research in Black Culture / The
New York Public Library; Division
of Photographs, Helen Armstead
Johnson Theater Collection

their glamorous close-ups become the fashionable mode of presentation. Like his contemporaries, Woodard composed and lit his uncelebrated subjects to the same effect as his star patrons. Their accomplishments, taste, and presence were detailed in black media, affording careful study and emulation. During this era, popular black magazines and newspapers devoted pages to stage performers as well as privileged social clubs; thus the intermingling of classes was visually presented to readers through photographic portraits, if not actually experienced.[27] Forming a diverse visual composite, the images constructed a collective consciousness, "staging a realm of receptivity" around blackness that countered the absence of everyday black life in the white press as well as the circulation of derogatory images that perpetuated racism.[28]

Besides shared aesthetics, innovations in technology and financial investment were also factors that appealed across class lines. Woodard frequently claimed to create

new formats of photography such as the "semi-miniature" or unique mountings to attract clientele who, likewise, imagined themselves as part of the avant-garde.[29] In 1927, the studio invested $1,500 in a "new, expensive CirKut camera" that was suited for group photos, allowing a panorama span yet capable of making "each face as clear and distinct as an individual photograph."[30] In addition to maintaining a parlor-like studio setting for the viewing comfort of his clientele, Woodard also invested in marking his Bronzeville community with his brand, purchasing a large electric sign to hang from his second-floor studio, just above the neighborhood landmark of Stovall and Hudson Pharmacy.[31] Woodard also donated his photographic services to community fundraisers, providing further evidence of his broad approach to community building and strategic entrepreneurship.[32]

The Woodard portraits in the Elliot Carpenter collection provide a particularly engaging intersection of theatricality and middle-class prosperity that bridge the photographer's work in Chicago with his work in New York City.[33] Elliot Carpenter was a pianist, composer, arranger, conductor, and song stylist. His prolific career, conducted in both United States and Europe, included highlights such as performances at the Folies Bergère, a feature of his hands playing "As Time Goes By" in the film *Casablanca* (1942), and a collaboration with Langston Hughes on a song called "America's Young Black Joe" (1942). In a sitting for Woodard around 1937, Carpenter cast himself next to the famed actor Clarence Muse as they engaged in research for their upcoming production *Spirit of Youth*, a movie that featured the boxer Joe Louis (fig. 11.4). They are positioned as formally dressed intellectuals, seated at a large desk poring over an oversized photo album and sheet music. Carpenter holds a pen in hand as if prepared to capture any forthcoming inspiration from the pages that show architectural wonders. Neither man looks at the camera; both fix their gaze on the materials before them. With the painted foliage background and a curtain pulled to the side,

this artful composition seems to harken back to a traditional portrait style, like the kind employed by Askew, as a means of demonstrating his sitter's intellectual capacities and middle-class aspirations.[34] Muse and Carpenter's styling seems at odds with the contemporary subject of their collaboration, yet it establishes a critical connection with the past. By evoking an earlier aesthetic, these performers, who might be denied the tenets of respectability because of their race, profession, and engagement with populous activities such as boxing, linked their own contemporary consciousness with the black aristocratic aesthetic of Du Bois and his ilk.[35] In collaboration with Woodard, they crafted identities that were fluid, looking to past and present, demonstrating the ever-evolving nature of the New Negro.

Carpenter married Chicagoan Mauvolyene Rollins in 1914. Their travels brought them into Woodard's studios upon several occasions, resulting in a unique body of images taken over a span of time.[36] Additionally, Woodard photographed their circle of contemporary performers. Like portraits shared with family and friends, this collection of images demonstrates the role that photographs play in memory, reflection, and self-validation. For performing professionals, the circulation of such images was also important in securing future employment opportunities.[37] As a collection, they help to visualize the intersectionality that informed black identity during this era. The Carpenters represent the mixing between individuals of different classes and professions, levels of education, and degrees of social activism that characterized modern urban centers. After touring in Europe with her "international music luminary" husband, Mauvolyene returned to Chicago, establishing an independent career in civil service, ranging from positions within Bronzeville's Democratic Party to an appointment as the first African American election commissioner and social service investigator for the Chicago Police Department. As with other African American families during the Great Depression, the Carpenters supplemented their income with lodgers (waiters, factory workers, and unemployed

individuals) who joined the household, providing a mixture of perspectives and experiences that informed their sense of community. Previously, in the 1920s in New York City, Mauvolyene was a lodger herself, cohabitating with a variety of theatrical professionals whose style of self-presentation made a lasting impression.[38] Her 1932 portrait, a close-up with her head tilted just slightly for a flattering effect, is in keeping with the glamorous stage conventions of the day (fig. 11.5). A similar shot from this session was reproduced in the *Chicago Defender* with the announcement of her new position with the police department. It is telling that this civil servant, extolled as "an efficient worker," chose a representation that would be just as appropriate for a Broadway audition, thus resisting more conservative expectations.[39] Surveying the five different sessions in which Mauvolyene posed for Woodard—from an elegant Victorian profile, to a stylish flapper, to a dutiful daughter posed with her mother, to a glamorous career activist, to a proud owner of a luxurious fur coat—it is evident that the studio provided the opportunity to refashion one's likeness through the agency of photography.

## CHICAGO'S NEW NEGROES AND THE SHIFTING FRAMEWORK OF UPLIFT

By the late 1920s, the Great Migration had brought significant population growth and expanded the black professional class in Chicago.[40] Their engagement of photographers such as Woodard made it possible to earn the income that Du Bois spoke of and to support the development of social and political agency. Despite escaping the Jim Crow South, migrants continued to face discrimination. Weekly summaries of racial disparities and injustices were chronicled in the nationally distributed *Chicago Defender*.[41] Since the Emancipation Proclamation, black political leaders looked to the educated elite to assume the role of advocating for civil rights for all. Their efforts formed the ideology of racial uplift, which too often

reinforced an "us versus them" perspective, re-inscribing class divisions.[42] By the 1920s, however, a more inclusive perspective emerged and photography was among the tools employed by black agencies and social organizations that sought to document collective social advancement.

One organization that focused on the realization of a visual compendium was the Washington Intercollegiate Club. Membership was open to anyone who had college credit and curiosity. Meetings were held at the Wabash YMCA on Chicago's South Side and their programs reflected a liberal and diverse set of interests ranging from birth control to the lasting impact of imperialism.[43] The group published the "Wonder Books," two volumes that total over five hundred pages of essays, photographs, advertisements, and lists of black agency and creativity. Conveying diverse points of view, the texts reveal the myriad expectations that black youth negotiated as they were schooled in the previous generation's strategies for uplift yet sought to visualize black modern subjectivity and to generate broader dialogues on black cultural capital.[44] As one of the official photographers for both the 1927 and 1929 editions, Woodard's Studio helped to visually express the group's objectives.

For volume one, *The Negro in Chicago 1779–1927*, Woodard was responsible for several hundred yearbook-style headshots that then were artfully set.[45] In the pages that presented the group's members, twelve individual oval portraits are arranged alphabetically on a drawing of an Egyptian obelisk topped with two angels supporting a crest with the club's heraldic shield (fig. 11.6). The obelisk is flanked by listings of the member's name, alma mater, and social organizations to which she or he

**Fig. 11.6**
*Portraits of Members of Washington Intercollegiate Club* by Woodard's Studio, reproduced in *The Negro in Chicago 1779–1927*
Photomechanical reproduction, 20.3 × 27.8 cm (8 × 10¹⁵⁄₁₆ in.)
Chicago Public Library, Woodson Regional Library, Vivian G. Harsh Research Collection of Afro-American History and Literature

CAMPBELL, MAYBELLE
Alpha Sigma Alpha
Lambda
Englewood H. S.            '20
Chi. Normal C.            '22
Columbia S. of Music      '24
R. Nathaniel Dett Club
Teacher, Rogers School
"Handle with care the
child"

CHILDS, ALFRED
Marlin H. S., Texas    '20
Prairie View Sate Nor-
mal,                   '21
Royal Arch Mason
Appomattox Club
Salesman, Victory Life Ins.
"No crown is worth its
glory that is not by might
and main"

COTTY, HERBERT
Ky. State C., Frankfort, Ky.
Athletics, Eight Letters.
Y. M. C. A.
Post Office Clerk
"When we build, let us
build forever"

DANCER, INEZ
Detroit H. S.,            '20
Detroit City College
Stenographer
"Never grow old, age is
a disease of the mind"

DONNELLY, CLEOPHUS L.,
Houston H. S.,           '20
McCarrie School of
Mechanical Dentistry
King David Lodge, No. 100
"Be Sincere"

FALLS, REGINA
Alpha, Sigma Alpha
Lambda
Englewood H. S.,         '22
Chi. Normal C.,          '24
Loyola University
Needlework and Craft
Club—Art Institute
Allied Negro Educational
Ass'n
"Give to the world the best
you have"

CHAPMAN, F. H.,
Theta, Alpha Phi Alpha
Ballard Normal S., Ga., '16
Lincoln U., Pa., A.B.    '20
Varsity Football and
Baseball Star
U. of Michigan, M. D.   '28
"It is never to late to do
good"

COMPTON, LENA
Charlton H. S. Texas,   '19
Honor Student
Tuskegee Institute,     '22
Chi-Tuskegee Club
Stenographer-Bookkeeper
"Simplicity, Sincerity and
Service"

CRESS, HENRY
Wendell Phillips H. S., '20
Crane Junior C.,        '22
U. of C.                '23
Boy's Conference
Christian Endeavor-Metro.
"Seek a strong body and a
prepared mind"

DAVIS, La FERN
East St. Louis H. S.,   '17
Ill. State Normal       '21
Chi. Normal C.,         '27
Roamer Basketball Team
Playground Instr., Bd. Ed.
"A woman can if she will"

FALLS, ARTHUR G.
Theta, Kappa Alpha Psi
Englewood H. S.,        '18
Crane Junior C.,        '20
Northwestern U., M. D.  24
National Medical Ass'n
Surgical Dispensary Staff,
Provident Hospital.
"Never admit defeat"

GARTH, VIVIAN L.
Knoxville College H. S.
A. & I. State Normal
Nashville               '23
Northwestern University
National Training School
Pres., Girls' Council
"Service and progress go
hand in hand"

belonged, as well as a brief aphorism frequently referencing the themes of uplift. Each subject is formally dressed for the occasion and posed at a flattering angle. Some are positioned against the studio's painted pastoral scenes, while others selected a plain dark curtain. A few look off to the distance, while others gaze directly at the camera. In some cases, the subject's gaze aligns with their chosen maxim—the direct, confident stares of LaFern Davis and Arthur G. Falls seem fitting in light of their respective statements: "A woman can if she will" and "Never admit defeat." Continuing the Egyptian motif, each obelisk is anchored with a drawing of three pyramids that is diagonally crossed with a label for "The Intercollegian." The conflation of Woodard's headshots with ancient Egyptian iconography testifies to the long shadow of Howard University professor Alain Locke and his influential 1925 essay on the legacy of the classical civilization inherited by modern African Americans.[46] At the time of its publication, Locke had recently lectured in Chicago at the opening of the Art Institute of Chicago's *Negro in Art Week* exhibition.[47]

The Wonder Books read as indices of those seeking progress. Dedicated to "those students and far sighted citizens who gave in order that the youth of tomorrow might be inspired to become courageous leaders," the editor requested readers "to cultivate habits of thrift and thoroughness" and to lay the foundation for "the sound basis of character, practical sense, energy, [and] integrity."[48] Within the trajectory of uplift, such a charge may sound proscriptive and even oppressive, but within the pages of this volume, and even more so in volume two, published in 1929, the conceptualization of self and society broadened to include topical essays on contemporary issues usually thought to be beyond the range of the middle class.[49]

Labor relations, women's roles in industry, and a satirical examination of the rhetorical expectations of the "Old" and "New" Negro were all among the concerns discussed and photographed within the Wonder Books' pages. Intercollegiate editor Frederic Robb followed much

of Locke's characterization of the mindset of the "New Negro," noting her/his political advocacy for achieving social justice as well as "better schools, more teachers with higher salaries, numerous parks and playgrounds, sanitary alleys, [and] paved streets." For Robb, and members of the Intercollegiate, the New Negro "supports human principles . . . has a scientific mind . . . is broad minded, [is an] opposer of war and welcomes criticism as a stepping stone to progress." Broadening previous definitions, they proclaimed that, as "a fusion of all races of the world," the New Negro was an evolving and all-encompassing twentieth-century black identity.[50]

The Wonder Books demonstrate that Woodard's Studio and their patrons sought to "accommodate diversity," allowing for the "celebration of ambition with the ideas of common interest in what Stephanie Shaw calls 'socially responsible individualism.'"[51] Their inception of the New Negro included urbanity, modernity, and, most importantly, civility. More than a set of mores governing comportment, civility was an extension of oneself to another, reflecting a desire for mutual recognition and a form of activism that has historically been overlooked. Actions of civility, as varied as they may be, are central to the formation of a collective consciousness and acceptance of difference. Its progressive visualization included Woodard's photographs of factory workers, X-ray machinery, soldiers, gas stations, and buildings, as well as honorary pictures of the elite "Old Settlers," African Americans who made Chicago their home prior to the twentieth century. In total, the Wonder Books served as a portrait of the civility necessary to support black daily life. As Adam Green has noted, the framework for uplift became a "composite orientation melding the interests of diverse communal constituencies, rather than consolidating the authority of one."[52]

Fittingly, Woodard placed a full-page advertisement in the Wonder Books that addressed the studio's role in fostering such a diverse community. In addition to a portrait

of each staff member, the ad included a photograph of a well-appointed, salon-like living room where potential patrons could comfortably convene and view samples of work and the "fine quality mountings" frequently mentioned in the studio's promotions. By establishing such spaces, Woodard created a place for a social viewing that not only ensured his success, but also afforded the opportunity for careful study of the way that his previous subjects chose to have themselves represented. His salon became an ever-evolving primer on who was who and what to wear as well as the diverse ways that black modern lives were being lived.

## CRITICAL MEMORY

From the anti-lynching lantern lectures of Ida B. Wells to the lithographs commissioned by the Communist Party USA, as well as those from the National Association for the Advancement of Colored People, social activists have relied on portraiture's capacity to elicit empathy as a motivational force. Woodward's portrait of renowned artist Aaron Douglas (fig. 11.7) and Douglas's own portraits of Clarence Norris and Haywood Patterson (fig. 11.8) highlight this impact and the development of critical memory. Douglas visited Woodard's Studio in 1930 when he was in Chicago to paint a mural for the Sherman Hotel. Subsequently, his portrait was published in the photogravure section of the *New York Amsterdam News*, documenting the artist's accomplishments nationwide. Through his numerous drawings for *Crisis*, the journal *Opportunity*, and the literature of the Harlem Renaissance, Douglas visualized the self-determinacy of the New Negro, offering a complex synthesis of sources and perspectives. Politically engaged, Douglas embraced a broad conceptualization of the New Negro that, like that of his contemporaries such as Zora Neale Hurston, was inclusive and diverse, cutting across the lines of gender, class, and particular professions.

In his photograph, Douglas is formally attired and stares directly at the camera. No prop or background is

FROM ALL PARTS OF THE COUNTRY come inducements the mural paintings of Aaron Douglas, New York artist. Rec... Mr. Douglas has completed work for Fisk university an... Sherman House hotel of Chicago. Many of his drawings have used as covers for Opportunity and Crisis magazines.
Photo from Woodard Studio, Chic...

**Fig. 11.7**
*Portrait of Aaron Douglas* by Woodard's Studio, ca. 1930, reproduced in the *New York Amsterdam News*, December 3, 1930
ProQuest LLC; ProQuest Historic Newspapers

included. Instead, Woodard brought his large-format camera close to the artist, tightly cropping his subject within a shallow picture field. The effect is frank and stark, communicating the commitment that Douglas and other artists made to the creation of a new art form that reflected black modern subjectivity. Although known for his signature "Afro-Deco" style, Douglas's academic training easily adapted to the hyperrealism needed for his empathetic and powerful depiction of two of the young African American men who, along with seven others, were falsely accused of raping two white women in 1931.[53] Their likenesses serve as documentation of the racism in the United States that allowed these nine innocent black men to be sentenced to death and incarcerated.

The controversy over the case against the Scottsboro Boys lasted over a decade, with accusations, trials, and retrials keeping this tragedy in contemporary consciousness. Through his pastel renderings of the heads of Clarence Norris (left) and Haywood Patterson (right) (fig. 11.8), Douglas suggests what it means to be an African American living under the threat of injustice and violence. The artist was inspired by the International Labor Defense, the legal arm of the Communist Party that took up the case, and published a pamphlet featuring "photographs of Norris and Patterson surrounded by the phrases 'save our lives,' 'they must not burn,' and 'join the fight to free them.'"[54] Such imagery references the anti-lynching campaigns that have been a "constitutive element of black visuality" developing alongside and influencing the visual campaigns for the New Negro.[55]

Like his own portrait, Douglas's rendering is frank, stark, and effective. The men stare out at the viewer with no contextualization, their floating heads seemingly

**Fig. 11.8**
*Clarence Norris and Haywood Patterson* by Aaron Douglas, ca. 1935
Pastel on paper, 41 × 37.1 cm (16⅛ × 14⅝ in.)
National Portrait Gallery, Smithsonian Institution; conserved with funds from the Smithsonian Women's Committee

severed from their bodies.[56] Just as the likenesses of Norris and Patterson reference the broader history of the nine Scottsboro defendants, their image has contemporary resonance, speaking back to viewers on the continuance of discrimination and violence against black lives. Through their meticulously depicted individual characteristics, their portraits link the past with the present with stark brutality becoming a means by which we can "assess ongoing crises faced by black subjects."[57]

Through the efforts of Douglas and Woodard, the critical memory of "framing and mobilizing African American social and political identities" becomes illuminated and again charged. For Woodard's Studio, photographing Douglas was an opportunity to portray a fellow activist who was equally invested in crafting modern black subjectivity. The media circulation of this honorific portrait reinforces the cultural capital of both the artist and the photographer within their larger communities as well as our contemporary consciousness. Likewise, Douglas's transference of the likenesses of Norris and Patterson from a consciousness-raising pamphlet to an honorific portrait ensures a continued engagement with and awareness of this history.

## THE WOODARD WAY

With their recommendation that you "Have an immortal reproduction of yourself made today the Woodard way," the photographers recognized that the commissioning of a portrait is layered with expectations.[58] It indicates self-worth and a desire to be remembered beyond the constraints of time and place. It imagines that a likeness can communicate interior qualities such as respect, ambition, and civility. As an object, its reproduction, circulation, and preservation reflect social capital, determining its value in the past, present, and future. Woodard's work demonstrates how "portraiture was—and is—to be understood as one of the ways in which social groups and individuals (collectively and individually) represent themselves to themselves."[59]

Looking at the depth and breadth of the hundreds of photographs that were produced in Woodard's Studio, we can better understand the Harlem Renaissance as "not only a moment characterized by a call for more virtuous black images and more depictions of the middle- and upper-class black elite" but also as an era that fostered intersectional social consciousness. [60] If we can keep in mind the fluidity of modern identity and see these earlier sources as some of the many sites "of the continuous production, definition, and redefinition of roles and behaviors,"[61] we can understand that Woodard's photographs not only provide critical memory of black subjectivity, but also foster our own contemporary consciousness and actions of civility.

Notes
The initial researching and writing of this essay was supported by a short-term fellowship from the Black Metropolis Research Consortium. Its final form would not be possible without the sabbatical support of Columbia College Chicago and a fellowship from the American Council of Learned Societies. I would like to thank Beverly Cook, Cynthia Fife-Townsel, Michael Flug, and Tim Samuelson for their assistance in locating many of the rich resources included in my project. At the Schomburg, I would like to thank Linden Anderson Jr., Alexsandra M. Mitchell, and Mary Yearwood. Navigation of the collections at the Chicago History Museum was greatly facilitated by Ellen Keith. Tempestt Hazel provided a close read and excellent research assistance. I would also like to express my appreciation to Wendy Wick Reaves and the National Portrait Gallery and Smithsonian staff for their editorial support, scholarship, and extension of their network of resources. Valerie, Esme, and Geof, for you, I am always grateful.

1 "Photography," *Crisis* 26, no. 6 (December 1923): 249–50.

2 See Henry Louis Gates, Jr., "The Trope of a New Negro and the Reconstruction of the Image of the Black," *Representations* 24 (1988): 129–55, and Martha Jane Nadell, *Enter the New Negroes: Images of Race in American Culture* (Cambridge, MA: Harvard University Press, 2004).

3 The underlying theoretical framework of this essay was influenced by Leigh Raiford, "Photography and the Practices of Critical Black Memory," *History and Theory, Theme Issue* 48 (December 2009): 112–29.

4 On class fluidity, see Davarian L. Baldwin, *Chicago's New Negroes: Modernity, The Great Migration, and Black Urban Life* (Chapel Hill: University of North Carolina Press, 2007), and Adam Green, *Selling the Race: Culture, Community, and Black Chicago, 1940–1955* (Chicago: University of Chicago Press, 2007).

5 "Woodard Photos," *Chicago Defender*, August 28, 1920.

6 *Chicago Defender*, November 3, 1923.

7 Catherine Soussloff, *The Subject in Art: Portraiture and the Birth of the Modern* (Durham, NC: Duke University Press, 2006), back cover.

8 "Woodard's Studio Closes Its Doors," *Chicago Defender*, January 16, 1932.

9 Little biographical information on Woodard is known. The 1930 U.S. Census lists him as born in Texas ca. 1892, with his parents originally from Georgia. *The Light: America's News Magazine* noted that he was from Mart, Texas, and had attended Atlanta Baptist College (a precursor of Morehouse), where he excelled in wrestling. After graduation, he sold insurance in Tennessee, but was drawn to Chicago and its opportunities for African American migrants. See "Woodard Has Lavish Studio in New Forty-Seventh Street Spot," *The Light: America's News Magazine* 4, no. 36 (July 28, 1928): 2.

10 See D. A. Bethea, *Colored People's Blue-Book and Business Directory of Chicago, IL*, (Celerity Printing Co., 1905), 32, 79. For a comprehensive listing of early Chicago photographers, see *Chicago Photographs 1847 through 1900 as Listed in Chicago City Directories* (Chicago: Chicago Historical Society, 1958).

11 Miles Webb, an African American photographer who would join the Woodard Studio in 1925, advertised his "Practical School of Photography" in *Crisis* from January through December 1914.

12 "Photos of Style and Dignity," *New York Amsterdam News*, November 2, 1935.

13 Quoted in Jewelle Gomez, "Showing Our Faces—A Century of Black Women Photographed," in *Illuminations: Women Writing on Photography from the 1850s to the Present*, ed. Liz Heron and Val Williams (London: I. B. Tauris, 1996), 450.

14 *Chicago Defender*, November 3, 1923.

15 U.S. Census Report 1930; Census Place: Chicago, Cook, Illinois; Roll: 420; Page: 1A; Enumeration District: 2431; Image: 1015.0; FHL microfilm: 2340155. Although I have yet to ascertain a connection, Jeanne Moutoussamy-Ashe lists a photography studio in Dallas run by Emma King Woodard active in the 1940s. See *Viewfinders: Black Women Photographers* (New York: Dodd, Mead, & Company, 1996), 52, 182.

16 "Shopper's Guide," *The Light: America's News Magazine* 3, no. 25 (May 14, 1927): 3. Jacobs also assisted Woodard in taking photos and established her own studio in Chicago's South Center building.

17 Two sources specifically address this move. In an interview with Woodard on September 21, 1936, Myrtle E. Pollard noted that the photographer came to New York as "there were more people here; it was believed that the market was wider." Pollard also sat for a portrait at Woodard's and included it in her thesis. See *Harlem As Is* (thesis, College of the City of New York, 1936), 259. Thanks to Emilie Boone for making me aware of this resource. Also see "Woodard's Studio Closes Its Doors."

18 For information on Hall, see Jeanne Moutoussamy-Ashe, *Viewfinders*, 60–61.

19 Thomas Askew contributed to the albums compiled by W. E. B. Du Bois for the Paris Exposition Universelle of 1900. See Shawn Michelle Smith, *Photography on the Color Line* (Durham, NC: Duke University Press, 2004).

20 Kobena Mercer, *James VanDerZee: 55* (London: Phaidon, 2003), n.p. (1).

21 "Lobby Notes," *Chicago Defender*, March 21, 1925.

22 The image was reproduced in *Crisis* 28, no. 3 (July 1925): 134–35. The artist was again featured with a photo of himself and of his 1924 painting *Mending Socks* (mislabeled "The Grandmother") in *Crisis* 33, no. 7 (May 1927): 27.

23 For this movement's impact on class-consciousness, see Baldwin, *Chicago's New Negroes*, 237–40.

24 "William E. Woodard Making a Fine Reputation," *Chicago Defender*, July 3, 1920.

25 "William E. Woodard Opens Studio," *Chicago Defender*, May 22, 1920; "Woodard Studio," *Chicago Defender*, March 31, 1923.

26 Rodger C. Birt, "A Life in American Photography," in *VanDerZee, Photographer 1886–1983*, by Deborah Willis-Braithwaite (New York: Harry N. Abrams, 1993), 44.

27 Racially restrictive rent covenants made it more likely for lower and middle classes to be mixed together; see Baldwin, *Chicago's New Negroes*, and Mary Pattillo, *Black Picket Fences: Privilege and Peril among the Black Middle Class* (Chicago: University of Chicago Press, 1999), 19.

28 Romi Crawford, "Yours in Blackness: Blocks, Corners, and Other Desires," *NKA* 34 (Spring 2014): 81.

29 Advertisement for Woodard's Studio, *Chicago Defender*, May 17, 1923.

30 "$1500 in New Equipment," *The Light: America's News Magazine* 3, no. 44 (September 9, 1927): 12.

31 The sign is mentioned in an advertisement in the *Chicago Defender*, July 7, 1923, and the location of the studio in relation to the pharmacy is in an advertisement in the *Chicago Defender*, December 9, 1922.

32 While in Harlem, one example included the Gay Dumb Belles Bridge Club's annual children's party. See *New York Amsterdam News*, June 5, 1937.

33 This collection was assembled through the work of Helen Armstead Johnson and can be accessed through the Schomburg Center for Research in Black Culture, Manuscripts, Archives and Rare Books Division, The New York Public Library.

34 In addition to Smith, *Photography on the Color Line*, see David Levering Lewis and Deborah Willis, *A Small Nation of People: W. E. B. Du Bois and African American Portraits of Progress* (New York: HarperCollins, 2003). See also Deborah Willis, "Photography 1900–1979s," in *The Image of the Black in Western Art: The Twentieth Century*, vol. 2, ed. David Bindman and Henry Louis Gates Jr. (Cambridge, MA: Harvard University Press, 2014), 105–28.

35 For perspective on the politics of boxing and black sport culture, see Baldwin, *Chicago's New Negroes*, 193–232.

36 The finding aid for the Elliot Carpenter papers at the New York Public Library describes Carpenter and Rollins as both originally from Philadelphia; however, the 1920 U.S. Census lists her birthplace as Indiana. U.S. Census Report 1920; Census Place: Manhattan Assembly District 21, New York, New York; Roll: T625_1224; Page: 37A; Enumeration District: 1439; Image: 695.

37 As evident on the reverse of many of the photos included in the Helen Johnson Armstead collection, performers frequently included contact information, biographical overviews, and listing of past projects.

38 According to 1920 U.S. Census, she lived at 708 W. 141th Street with musician Julius Elsey and his family, along with other boarders. The collaboration between Mauvolyene and Woodard resulted in images that merge theatrical expression and gestures with the conventions of the more self-contained bourgeois formats favored by patrons of James Allen. See Camara Holloway, *Portraiture and the Harlem Renaissance: The Photographs of James L. Allen* (New Haven, CT: Yale University Art Gallery, 1999).

39 "Investigator: A Scrap Book for Women in Public Life," *Chicago Defender*, October 22, 1932. The photo accompanying the article is credited to Woodard.

40 Christopher Reed, *The Rise of Chicago's Black Metropolis 1920–1929* (Urbana: University of Illinois Press, 2011), and James R. Grossman, *Land of Hope: Chicago, Black Southerners, and the Great Migration* (Chicago: University of Chicago Press, 1989), provide the historic impact of the Great Migration in Chicago, noting the conflicts between migrants and previously established residents, who referred to themselves as "old settlers."

41 See Ethan Michaeli, *The Defender: How the Legendary Black Newspaper Changed America* (New York: Houghton Mifflin Harcourt, 2016), as well as my forthcoming essay "Strategies for Visualizing Chicago's Cultural Capital: The Black Portrait," in *Root, Branch, and Blossom: Social Origins of Chicago's New Negro Intellectuals and Artists*, ed. Richard Courage and Christopher Reed (Urbana: University of Illinois Press, 2018).

42 For the complicated trajectory of uplift ideology, see Kevin K. Gaines, *Uplifting the Race: Black Leadership, Politics, and Culture in the Twentieth Century* (Chapel Hill: University of North Carolina Press, 1996).

43 See Green's study of the objectives and history of the Washington Intercollegiate Club in "The Rising Tide of Youth: Chicago's Wonder Books and the 'New' Black Middle Class," in *The Middling Sorts: Explorations in the History of the American Middle Class*, ed. Burton J. Bledstain and Robert D. Johnston (New York: Routledge, 2001): 239–55.

44 In addition to Pierre Bourdieu, *Distinction: A Social Critique of the Judgment of Taste*, trans. Richard Nice (Cambridge, MA: Harvard University Press, 1984), 6, see Diane Grams, *Producing Local Color: Art Networks in Ethnic Chicago* (Chicago: University of Chicago Press, 2010), 72–73.

45 Green credits Charles Dawson for both volumes, but Edythe Williamson and Bill Moore are listed as the "art editors" for volume 1; see Frederic H. H. Robb, ed., *The Negro in Chicago, 1779–1927*, 2 vols. (Chicago: Washington Intercollegiate Club of Chicago and International Negro Student Alliance, 1929), 1:8.

46 Alain Locke, "The Legacy of the Ancestral Arts," *The New Negro* (New York: Albert & Charles Boni, 1925), 254–67.

47 Lisa Meyerowitz, "The Negro in Art Week: Defining the 'New Negro' through Art Exhibition," *African American Review* 31, no. 1 (Spring 1997): 75–89.

48 "Foreword," in Robb, *The Negro in Chicago 1779–1927*, 1:4.

49 Green notes similar efforts towards homogenization present in earlier class studies such as Franklin Fraiser's *Black Bourgeoisie: The Rise of the Middle Class* (1957), countering that the "middle class was hoping to escape from itself." See "The Rising Tide of Youth," 245.

50 Robb, *The Negro in Chicago 1779–1927*, 1:16.

51 Quoted in Green, "The Rising Tide of Youth," 247.

52 Green, 248.

53 Richard Powell, *Black Art: A Cultural History* (London: Thames & Hudson, 2002), 44.

54  James A. Miller, Susan D. Pennybacker, and Eve Rosenhaft, "Mother Ada Wright and the International Campaign to Free the Scottsboro Boys, 1931–1934," *The American Historical Review* 106, no. 2 (April 2001): 387–430.

55  Raiford, "Photography and the Practices of Critical Black Memory," 112.

56  Susan Earle, *Aaron Douglas: African American Modernist* (New Haven, CT: Yale University Press, 2007), 24.

57  Raiford, "Photography and the Practices of Critical Black Memory," 115.

58  "Photos of Style and Dignity," *New York Amsterdam News*, November 2, 1935.

59  Marcia Pointon, *Hanging the Head: Portraiture and Social Formation in Eighteenth-Century England* (New Haven, CT: Yale University Press, 1993), 4.

60  Miriam Thaggert, *Images of Black Modernism: Verbal and Visual Strategies of the Harlem Renaissance* (Amherst: University of Massachusetts Press, 2010), 5.

61  Ellen Wiley Todd, *The "New Woman" Revised Painting and Gender Politics on 14th Street*, (Berkeley: University of California Press, 1993), xxviii.

# SIDE EYE

## EARLY-TWENTIETH-CENTURY AMERICAN PORTRAITURE ON THE PERIPHERY

Jonathan Frederick Walz

"I can't see you any longer when I look."

—Pablo Picasso, as voiced by Gertrude Stein

"Due to [Charles Demuth's] being cross-eyed, one eye sometimes looked at his nose, and he never looked right at you."　　　　　　　　—William Carlos Williams

"We talk and think 'off' the object rather as an astronomer looks 'off' a star, because acuity or sharpness are greater away from the centre."　　　　　—Michael Baxandall[1]

**Fig. 12.1**
*Poster Portrait: Duncan* by Charles Demuth, 1925
Poster paint on pressed-paper board, 50.8 × 59.7 cm (20 × 23½ in.)
Alfred Stieglitz/Georgia O'Keeffe Archive, Yale Collection of American Literature, Beinecke Rare Book and Manuscript Library, Yale University

As a genre, portraiture is a social contract that relies particularly heavily on two of its constituent components in order to function successfully: a "speech act" on behalf of the artist and recognition of the subject by viewers. From the fifteenth through the nineteenth centuries, the speech act in question equated to the artist's implicit pictorial assertion or "decree" that the portrait object, apart from its physical location and its social context, bore some sort of easily verifiable *visual* relationship (formal and mimetic) to the portrait's subject.[2] Viewers receive mimetic, or imitative, portraits as aesthetic assertions and then test their truth-value based on their personal recognition of the sitter. Portraiture's bias towards proximity rewards family, friends, and neighbors more readily than more distant viewers, who may have to suspend their disbelief—or, to put it another way, put their trust in tradition and provenance—in order to overcome the limitations imposed by time and space.

A number of American avant-garde artists of the early twentieth century deliberately questioned (even broke or eliminated) various elements of the social contract of portraiture that they inherited. In pursuit of new modes of representation, these modernists shunned long-held portrait conventions, such as rendering likeness from direct

observation, upholding principles of realistic illusionism, and locating the self in facial features. Instead, they followed the late-nineteenth-century French Symbolist tenet of *correspondance* (correspondence), in which the artist, rather than depicting superficial appearances, creates the visual equivalent of thoughts or feelings evoked by the subject.[3] To accomplish these ends, American writers, filmmakers, artists, and composers on both sides of the Atlantic creatively experimented with varying means to express identity, including, among other examples, colored shapes, mathematical equations, military symbols, cloud formations, or items associated with the "sitter."[4] The portraits that they created, though unconventional, nevertheless fulfilled the traditional functions of the genre: evidentiary, commemorative, biographical, and political.

## PERIPHERIES AND PORTRAITURE

The theoretical model of center and margins, grounded in the sociological construct of metropole and periphery, offers a useful means by which to view and understand these non-mimetic representations of specific individuals that flourished in the second and third decades of the twentieth century in the United States.[5] These curious objects engage with the edges of the mainstream in at least five ways. First, since at least the Renaissance, when debates about the status of the artist—as craftsperson and copyist or as scholar and inventor—trended, theorists relegated portraiture, as imitative and therefore uncreative, to near the bottom of the hierarchy of appropriate subjects for high art, just above landscape and still life. Sir Joshua Reynolds, president of the Royal Academy in London, confirmed and ensconced these attitudes in the late eighteenth century: "In the same rank [as 'painters who have applied themselves more particularly to low and vulgar characters'], and, perhaps, of not so great merit, is the cold painter of portraits."[6]

Second, as representational illusionism has long held a stranglehold on the genre, these extraordinary non-mimetic images occupy the margins of the discourse surrounding portraiture itself. The genre's practices have become so entrenched as to be considered "natural," even today. Art historian Dorinda Evans notes the historical unlikelihood of challenging the genre's conventions, stating that, "By definition a representation of a specific person, the portrait might be expected to be the last art form to sever or substantially diminish its connection to the objective world. To be considered successful, even in the profitable practice of flattering the subject, the portrait had to have meaning in the form of an identifiable sitter."[7] Portraiture's engrained traditions offered irresistible temptations to early-twentieth-century modernists, who viewed all customs derived from classical antiquity to be fair game for abandonment, stretching, or complete reimagination. Its lowly status (according to Reynolds et al.) also provided a "safe space" for experimentation. If portraiture already occupied the margins, then who of importance in the art world (or really anywhere) would truly note—or give credence to—examples that violated the long arm of its "laws"?

Third, the physical production of this subgroup of images embraces the literal or figurative sidelong glance. The artists who created these odd portrayals deliberately employed peripheral vision—that is, a way of knowing the subject that subverts the dominant epistemological strategy of direct observation—in order to generate what the French call *le portrait oblique* (indirect portrayal). Instead of conducting real-time sittings, American modernists followed several innovators: Pablo Picasso and Henri Matisse, who finished visual "likenesses" without the presence of the subject;[8] Marius de Zayas, who generated caricatures, both "relative" (based on superficial appearance) and "absolute" (grounded in unobservable qualities), in the absence of the personalities portrayed; and Gertrude Stein, who created anomalous and abstruse "word portraits" in the privacy of her apartments at 27, rue de Fleurus, in Paris.[9] Stein, in particular, championed the circumlocutory sight of the French Cubists.[10] Though analytical portrait compositions of the Cubists often featured known individuals (gallerists,

lovers, other artists), they conveyed the subject from various perspectives, underscoring not only the multiplicity of the subject but also the stream of consciousness of the artist (and, by extension, the viewer).[11] (Stein's own textual efforts in this regard could be read as *circling around* the ostensible focus of each prose poem.) Several artists utilized the aesthetic strategy of *le portrait oblique* to convey "messages" that would have been too bald, too awkward, to state in forthrightness and in person. For example, Katherine Dreier revealed her strong feelings about Marcel Duchamp in an expressionist painting (*Abstract Portrait of Marcel Duchamp*, 1918); Arthur Dove fabricated a metonymic assemblage as an unsentimental tribute to his mentor, champion, and friend Alfred Stieglitz (*Portrait of Alfred Stieglitz*, 1924); and Charles Demuth encapsulated his liminal standing (as disabled, as queer, as exiled) in an indirect and coded self-portrait (*My Egypt*, 1927).[12]

Fourth, the avant-garde is, by definition, a subsection literally at the foremost edge of a larger contingent. This military term gained currency in the nineteenth century as progressive artists increasingly viewed themselves in opposition to—rather than allied with—mainstream culture. The stance became constitutive and self-reinforcing, as controversial works polarized audiences, pigeonholed artists, and delimited taste. Here we should remember that Alfred Stieglitz, an early outlier in advocating for modern art in the United States, commenced his exhibition activities in 1905 with the opening of the Little Galleries of the Photo-*Secession*. Any negative criticism received by the artists who showed their work in this space (nicknamed "291" after its address on New York's Fifth Avenue) only strengthened the resolve of this cultural kingpin and the acolytes around him. At the same time, their inhabitation of the perimeter provided the freedom necessary to produce innovative work.

Fifth, there seems to be a correlative impulse behind the florescence in Western culture of avant-garde art and what David Joseph Singal denominates "the quintessential aim" of modernism, particularly the "heal[ing of] the

sharp divisions that the nineteenth century had established in areas such as class, race, and gender."[13] Significant developments in the breakdown of these categories and the reintegration of their members into wider society occurred during the first quarter of the twentieth century in the United States—which Marcel Duchamp called "the country of the art of the future"—and by artists marginalized for reasons like sexual orientation, ability, ethnicity, and gender.[14] Marsden Hartley crafted an image of his unrequited lover in *Portrait of a German Officer* (1914); Andrew Dasburg, who, like Charles Demuth, lived with a permanent injury to one of his hips, produced *Coordinated Explosion: Portrait of Carl Van Vechten, A Cubist Portrait* (1914); Georgia O'Keeffe, of Irish and Hungarian parentage, created *Untitled (Abstraction/Portrait of Paul Strand)* (1917); and New Woman Florine Stettheimer innovated "group pictures," such as *Studio Party, or Soirée* (n.d.).[15] In the "land of the free"—and with nothing to lose—these and other sidelined American artists seem to have been disproportionately willing to utilize peripheral portrait tactics.

## A FEW FUNCTIONS OF PORTRAYAL
### Evidence

Portraits are documents or records. On a foundational level, all art objects, including portraits, are indexical vestiges of human effort. Signatures and dates, when they exist, substantiate authorship and execution. Given the genre's definitional operation to represent real (not imaginary) and specific (not generic) individuals, portraiture confirms the existence of the sitter, as well as of the artist. Some jurisdictions, even today, disallow cameras and other mechanical recording devices in the courtroom, necessitating the presence of an artist to document the proceedings.

In late 1923 Charles Demuth began an extended series of symbolic likenesses of friends and colleagues, works he called "poster portraits" for their flat, matte surfaces and their graphic, advertisement-like style. The artist completed *Poster Portrait: Duncan* (fig. 12.1) in the first wave of this

campaign, in time for Alfred Stieglitz to include the panel in 291's blockbuster exhibition *Seven Americans* in early 1925. Charles Duncan was a visual artist and poet who made his living painting signs. The first letter of his Christian name and the whole of his family name appear in the top half of the bifurcated composition. The portrait is a two-dimensional still life, similar to Demuth's *Spring* (1921), an image of overlapping commercial fabric samples; it features an imaginary book of verse flanked by the edges of publications comparable to the "little magazines" depicted in Demuth's *Longhi on Broadway* (1928).[16] The middle section suggests a transparent lens or prism that elongates the lower stems of the word "DUNCAN" and yields a rainbow effect. The dominant hue of the opus cannot be ignored: pink. The French word for this color—*rose*—puns on the full-blown blossom at bottom center, distinguished by its serrated leaves and short thorns. This imagery is not a coincidence. Both Demuth and Duncan knew and revered the French-born *provocateur* Marcel Duchamp, who adopted the persona of Rrose Sélavy and completed his magnum opus, *The Bride Stripped Bare by Her Bachelors, Even*, known as *The Large Glass* (see fig. 13.1, p. 250), only a couple of years prior to this poster portrait's appearance.[17] Both artists were in Stieglitz's circle and both had also contributed poems to the short-lived journal *The Blind Man* in support of Duchamp's ignominious *Fountain* (1917).[18] The picture's overarching conceit is that artist and "sitter" share a mutual admiration for a modernist friend and practitioner, whose punning and inscrutability play out on center stage here.

In contradistinction to Demuth's symbolic material goods, Katherine Dreier utilized a different stratagem in her *Preliminary Study for "Abstract Portrait of Dr. Vassily Zavadsky"* (fig. 12.2).[19] Greatly influenced by

**Fig. 12.2**
*Preliminary Study for "Abstract Portrait of Dr. Vassily Zavadsky"*
by Katherine Dreier, ca. 1931
Graphite on paper, drawing: approx. 5.7 × 5.4 cm (2⅛ × 2¼ in.)
Beinecke Rare Book and Manuscript Library, Yale University

the Theosophical beliefs and non-objective facture of Expressionist Wassily Kandinsky, Dreier composed a handful of "psychological portraits," of which *Abstract Portrait of Marcel Duchamp* (1918) is probably the best known, because Dreier bequeathed it to the Museum of Modern Art, New York. Rather than employ tangible objects and letterforms that reference the subject, Dreier believed she was creating a realistic snapshot of the subject's interior state. "Instead of painting the sitter as seen ordinarily in life, the modern artist tries to express the character as represented through abstract form and color," she explained in *Western Art and the New Era*. "The new form . . . gives chance for the different sides of a character, as well as a greater range of emotion[,] to be portrayed."[20] With a few simple graphite lines Dreier conveys a dynamic personality that radiates energy.

Despite their contributions to international modernism, neither Charles Duncan nor Vassily Zavadsky became household names. Internet searches on each reveal very few hits. Nevertheless, the evidence of their portraits confirms their prior existence. What little we know about their personal lives and professional careers has been researched and cobbled together by curious scholars; these images have fostered such inquisitiveness.

## Commemoration

In a maneuver that overlaps with its evidentiary function, portraiture marks events (weddings, elections, wars), recapitulates relationships (friend, lover, ruler), and stimulates memory (distant relative, missing child, deceased leader). The genre is associated with past events, particularly death and mourning. In his 1435 treatise *On Painting*, Leon Battista Alberti remarked, "[P]ainting certainly has in itself a truly divine power, not only because, as they say of friendship, a painting lets the absent be present, but also because it shows [to] the living, after long centuries, the dead, so that [these] become recognized with the artist's great admiration and the viewer's pleasure."[21] The past

(the way a sitter once looked), the present (the observer's contemporary experience), and the future (the death-to-come of the subject, artist, and viewer) all converge in these everyday objects.

Elsa von Freytag-Loringhoven was a German-born artist and poet who, along with Marcel Duchamp, pioneered found-object sculpture in the United States. Her assemblage *God* (fig. 12.3), comprising a metal sink trap mounted onto a wood miter box, remains an icon of American Dada. At some point during a temporary relocation to Philadelphia, the artist took the queer item to the studio of Morton Schamberg, who photographed it several times, causing later confusion as to authorship of the three-dimensional work.[22] Its tongue-in-cheek humor is both blasphemous (making the holy profane) and scatological (making the private public). The rectified readymade's uncertain ontological status—Is it junk or art? Is it an idol or a deity?—continues to puzzle viewers.

Slicing through these philosophical quandaries, Wendy Steiner boldly construed the sculpture specifically *as a portrait* in her 1977 essay "The Semiotics of a Genre: Portraiture in Literature and Painting," though she never fully parsed out how she reached this identification.[23] Viewed in the light of Friedrich Nietzsche's proclamation of the death of God—that is, "the ending of Christian values . . . [in the search] for a new value system in a changed world"[24]—and in the shadow of World War I, Steiner's recognition makes sense. Von Freytag-Loringhoven's "posthumous" portrait fully embodies its purpose to convey implicit character through external appearance. But it also participates in—even foregrounds—the genre's preoccupations with memorialization.

## Biography

The commemorative function of portraiture, wherein the living recall the dead, presupposes life stories with beginnings, middles, and endings. Portraits can also amplify aspects of these personal narratives to convey a larger sense of the sitter than the momentary glimpse afforded by a single facial view from a fixed vantage point. Exceptional artists understand that even though images present all information simultaneously, viewers will move their eyes around even the most basic of compositions to create a sequence of perceptual and analytical episodes. Biography's relationship to portrayal dates back to the earliest human civilizations. Its literary origins are thinly veiled in the etymology of the English term, from the Greek *bio-* (life) plus *-graphiā* (writing).

A failed mural commission at Radio City Music Hall in the autumn of 1932 and Alfred Stieglitz's ongoing semi-public affair with the much younger writer and photographer Dorothy Norman contributed to a sustained depression for Stieglitz's wife, Georgia O'Keeffe. In February 1933 she was hospitalized for psychoneurosis and cardiac arrhythmia. She spent from late March to mid-May in Bermuda to try and recuperate but she remained thin and affectless. Fleeing the interpersonal, financial, and physical stresses of Manhattan, she repaired to the Stieglitz homestead at Lake George, in upstate New York, where she spent most of the remainder of the year, unable to pick up a pencil or paintbrush until October. O'Keeffe's mood improved dramatically with the early December arrival of the writer Jean Toomer, who had recently lost his wife in childbirth. The two supported each other's grieving and became emotionally close and physically intimate. In her subsequent passionate correspondence to Toomer, O'Keeffe informed him that a Lake George landscape (fig. 12.4), which she had produced a decade prior, functioned as a non-mimetic portrait of the author.[25] *Paper* birches seem an appropriate stand in for a writer, and trees are natural biographers in their dendrochronological longevity and

**Fig. 12.3**
*God* by Elsa von Freytag-Loringhoven, ca. 1917
Wood miter box, cast iron plumbing trap; height 31.4 cm (12⅜ in.), base 7.6 × 12.1 × 29.5 cm (3 × 4¾ × 11⅝ in.); Philadelphia Museum of Art; The Louise and Walter Arensberg Collection, 1950

record keeping. O'Keeffe emphasizes the narrative qualities in this painting with its strongly contrasting repoussoir and background, alluding to the inescapable presence of sequential time.

In the same year that O'Keeffe and Toomer spent time together at Lake George, Yasuo Kuniyoshi completed *Weather Vane and Objects on a Sofa* (fig. 12.5). The painting later won first prize in the American section of 1939's Golden Gate International Exposition in San

Francisco. Though the picture reflects the artist's turn, after his first trip to Europe, to straightforward observation (his previous compositions relied exclusively on imagination and fantasy[26]), even so it functions as an *indirect* self-portrait by way of still life. Kuniyoshi later acknowledged the genre's peripheral nature and emotional potential: "Still life is out of mode right now, but you can use symbols to say clearly how . . . sorrow or gladness is felt deeply in your heart."[27] Scholars have aptly drawn attention to the biographical nature of the artist's still lifes of the 1930s and 40s. In regards to *Weather Vane*, Susan Lubowsky has noted that "Kuniyoshi's personal history is revealed symbolically in [the picture], painted after his appointment as instructor at the Art Students League. The sculpture mold, the folk art weathervane, the grapes and avocados (a reminder of his days picking fruit in Fresno), and the photograph [*sic*], all recall his experience as an artist in [the United States].

**Fig. 12.4**
*Birch and Pine Trees—Pink* by Georgia O'Keeffe, 1925
Oil on canvas, 91.4 × 55.9 cm (36 × 22 in.)
Colby College Museum of Art; Lunder Collection

**Fig. 12.5**
*Weather Vane and Objects on a Sofa* by Yasuo Kuniyoshi, 1933
Oil on canvas, 86.4 × 152.4 cm (34 × 60 in.)
Santa Barbara Museum of Art; gift of Wright S. Ludington

An assiduous collector, Kuniyoshi continued to incorporate Americana into his compositions, as well as objects which appealed to him for their shape, color, or texture."[28] This considered selection process—finding, adding, displaying, rearranging, and interpreting still-life items—is analogous to the intertwined processes of personal shopping and identity construction. "The complexity of these activities," observes Helen Molesworth, "is that deciding what one likes, establishing one's preferences, cobbling them together over a period of trial and error into one's tastes, is in many ways synonymous with the creation and presentation of the self."[29]

O'Keeffe's and Kuniyoshi's examples demonstrate that the arenas of landscape and still life—two genres in which the presence of humans is absent, or of lesser importance—lend themselves readily to symbolic associations with particular individuals. Their respective structures of multiple components, over which the eye tracks in a concatenation of visual "events," corresponds to the usual narrative organization of biography.

## Politics

If "the personal is political," as second-wave feminism would have it, then portraiture is arguably the most partisan genre of all, given its obligatory basis in social relations. This category of images participates in an inescapable network of potential interactions: sitter and painter, sculptor, or photographer; subject and community; artist and art market; image and academia; patron and institution; object and viewer. Governments have long understood the power of portraiture to exert control, to maintain order, to extend discourse, and to further their interests. These performances also extend to the micro level of interpersonal dynamics, where these objects can proportionally wield as much power between two individuals as on a national stage. The highly personal symbolic valence of non-mimetic portraits in particular lends itself especially to currency between an intimate couple or members of an in-crowd.

Rebecca Salsbury Strand James employed these strengths in the private portrait *Paul* (fig. 12.6). The picture, a painstakingly created reverse oil painting on glass, is similar in size and scale to a letter, drawing, or photograph. Indeed, the dominant black circle suggests the aperture of a camera, completely appropriate as the image's subject is lens-based artist Paul Strand. The conflated letterforms of "P" and "R" at lower right refer to the Strands' decade-long relationship and recently failed marriage (they had divorced in 1933). The composition's inescapable focus (so to speak) is the pearl oyster shell (half, not whole) at center. No matter the origins of this object, the genus represented—*Pinctada*, distinguished by its notch and nacre—turns irritants (sand granules) into things of beauty (gems), an emblematic act that the artist appropriates.[30] As Karli Wurzelbacher has noted, James titled other shell pictures *Peace*; in this context, *Paul* functioned as a visual treaty, literally and figuratively.[31]

Rebecca James was the "closest Taos friend" of artist Cady Wells.[32] She crafted a non-mimetic likeness of Wells—*Cady Making a Nice Speech* (fig. 12.7)—in 1934, the same year she produced *Paul*.[33] The pane presents an azure disc upon which hovers a red-black majuscule "C," with a treble clef and sixteenth note, respectively, as bilateral serifs. The head and hood of a cobra rise inside the letterform; the rearing snake clasps a single forget-me-not flower in its mouth.[34] The artist's choice of serpent raises tempting (!) associative possibilities: members of the genus *Naja* are Old World cobras, widespread across Asia, a region of the world in which Wells was particularly interested; the common names of the spectacled cobra (*Naja naja*) and monocled cobra (*Naja kaouthia*) connect these varieties to the realm of vision; and the frequent domestication of these reptiles as entertainment adds "charming," and performativity more

**Fig. 12.6**
*Paul* by Rebecca Salsbury Strand James, 1934
Oil on glass, 24.8 × 19.7 cm (9¾ × 7¾ in.)
Harvard Art Museums/Fogg Museum; Isabella Grandin Bequest Fund

**Fig. 12.7**
*Cady Making a Nice Speech* by
Rebecca Salsbury Strand James,
1934
Oil on glass
26 × 21 cm (10¼ × 8¼ in.)
The Eugene B. Adkins Collection
at Philbrook Museum of Art,
Tulsa, and the Fred Jones Jr.
Museum of Art, University of
Oklahoma, Norman, Oklahoma

**Fig. 12.8**
*Rebecca S. James* by Cady Wells,
1952
Yarn on linen
40 × 35.6 cm (15¾ × 14 in.)
New Mexico Museum of Art;
gift of the E. Boyd Estate, 1975

broadly, to the interpretive equation. The implication (abetted by the piece's title) is that Wells possessed the ability to enchant his interlocutors—but that one would not want to cross him.

Wells celebrated the mutually constitutive bond of amity in the handwork textile *Rebecca S. James* (fig. 12.8). The central motif features Rebecca James's name and the date of her fifty-ninth birthday. December twenty-first is also the winter solstice and Wells, notwithstanding the inexorable deep darkness of this segment of the calendar year, emphasizes the energy of the sun's renascence that morning (rather than the uncertain outcome of its nadir the previous evening). The object's materials recall New England samplers and Navajo weavings, as well as Hispanic *colchas*, a Spanish colonial form of needlework in whose twentieth-century revival James participated. In this piece, a highly unusual object within the artist's oeuvre, Wells chose literally to reinforce his figurative "ties" to James in a medium—embroidery—at the margins of the realm of fine arts.[35] The names of two geographic locations, St. Croix and Antibes,

far from the intellectual and aesthetic metropoles of New York and Paris, further underscore the outlier status of these two modernist comrades.[36]

These exchanges of peculiar likenesses exemplify the kind of diplomatic savvy and social benefit documented and analyzed in the early twentieth century by anthropologist Marcel Mauss.[37] Unconventional portraiture served other political ends as well in the 1910s and 1920s. For example, in late 1913 and early 1914 Andrew Dasburg denominated several non-objective canvases as representations of the wealthy socialite Mabel Dodge, ingratiating himself with the "sitter" and positioning himself (as well as his subject) at the forefront of contemporary art and philosophy. Similarly, Alfred Stieglitz pressed three of Charles Demuth's poster portraits (such as fig. 12.1) into service as propaganda, announcing the avant-garde to the uninitiated who visited the watershed exhibition *Seven Americans* in 1925.[38]

## MODERNISM, MARGINS, AND MIMESIS

Daniel Joseph Singal characterizes the phenomenon of modernism as a "full-fledged historical culture much like Victorianism or the Enlightenment."[39] If, as he argues, the Victorians wished intensely to maintain their deeply ingrained distinctions between races, classes, and genders, the modernists demanded the analysis and subsequent synthesis of these and other dichotomies by combining "the objective and subjective, the empirical and the introspective—breaking apart conventional beliefs and rejoining the resulting fragments in a manner that creates relationships and meanings not suspected before."[40] It should not surprise us, then, that the modernists considered above blurred the boundaries of the genre of portraiture with, for example, still life or landscape. In the same way, some modernists moved away from the outer appearance of physiognomy (imbricated from antiquity with notions of family, status, and duty) to privilege other ways of knowing the subject, "opening the self to new levels of experience" and "fusing together disparate elements of that experience

into new and original 'wholes.'"[41] Erika Doss also notes that, in contradistinction to the rigid societal, intellectual, and visual components of Victorian culture, "modernism was essentially processual, a culture of becoming rather than of being."[42] The American avant-garde in the second and third decades of the twentieth century jubilantly participated in this paradigm shift, producing radically different depictions of the same sitter: for instance, Marsden Hartley as an arrangement of associative objects on a windowsill, as an anthropomorphic amalgamation of brightly colored triangles, and as a giant eye possessed of outer and inner sight.[43]

In the early twentieth century, "[o]ne could no longer presume a static, fixed, externally evident character," Wendy Wick Reaves observes. "[I]dentities became multiple, mutable, fractured, invented, or disguised."[44] These fundamental changes in underlying assumptions about the nature of selfhood and the location of truth, as well as the means of representation, produced likenesses drastically different from Victorian portraits, as the examples discussed in this essay demonstrate. If visibility, as Michel Foucault asserts, is a trap, then modernist portrait makers attempted to avoid this trap (as well as its Victorian corollary of classifying) by employing "unreadable," heavily coded, or shifting signifiers for identity. Sometimes the maker herself was uncertain what a certain constellation of shapes and colors might mean, as when Georgia O'Keeffe discussed the unconventional portrait *Black and White* (1930): "[I]f [the sitter] saw it he didn't know it was [for] him and wouldn't have known what it said. And neither do I."[45] Despite the radical reimagination in the early twentieth century of the *form* of portraiture, the genre's *function*—as evidence, as biography, as commemoration, as political discourse— remained the same. Indeed, given the now much more difficult task of matching portrait subject to portrait object, it is through their interpersonal operations and social uses that contemporary scholars and viewers have been able to identify many of these unconventional likenesses at all.

Notes

1 Gertrude Stein, *Writings, 1903–1932: Q.E.D., Three Lives, Portraits and Other Short Works, The Autobiography of Alice B. Toklas* (New York: Library of America, 1998), 713. Emily Farnham, interview with William Carlos Williams, in *Charles Demuth: Behind a Laughing Mask* (Norman: University of Oklahoma Press, 1971), 9. Michael Baxandall, *Patterns of Intention: On the Historical Explanation of Pictures* (New Haven, CT: Yale University Press, 1985), 6.

2 As Stephen Perkinson has convincingly argued, during the Middle Ages (that is, *before* the fifteenth century), "physiognomic likeness was not a precondition for representation, and highly abstract images were perfectly capable of representing their subjects" through inscriptions, heraldry, regalia, and pose." Stephen Perkinson, *The Likeness of the King: A Prehistory of Portraiture in Late Medieval France* (Chicago: University of Chicago Press: 2009), 23n81 and passim. Laura Jacobus has recently made the case for early Trecento mimetic portraits in Padua's Arena Chapel: "[T]he concept and practice of portraiture as the exact reproduction of physical likeness existed in the medieval period, and . . . examples of such portraits were produced in Italy as early as the beginning of the fourteenth century. This is very much earlier than the Florentine marble busts that are often (though not necessarily correctly) accepted as the first instances of such portraits." Laura Jacobus, "'Propria Figura': The Advent of Facsimile Portraiture in Italian Art," *The Art Bulletin* 99, no. 2 (June 2017): 73 and passim.

3 This trope is most transparent in Alfred Stieglitz's titling of his cloud photographs as *Equivalents*; that is, the atmospheric conditions that he captured on film somehow matched his feelings and provided a visual counterpart, such that he could then communicate those emotions to—or evoke those sentiments in—others.

4 Regarding these last, Wanda M. Corn denominates them as "referential portraits," as this subset of images "allows for multiple and often free-floating meanings, which interpreters privy to the sitter's character and to the working of the avant-garde and other subcultures, such as that of the homosexual community, may be able to read. Since the references are often very private, or intentionally elusive, they can escape detection and decoding." Wanda M. Corn, *The Great American Thing: Modern Art and National Identity, 1915–1935* (Berkeley: University of California Press, 1999), 203.

5 For a cogent discussion of this theoretical model, see bell hooks, *Feminist Theory: From Margin to Center* (Boston: South End Press, 1984).

6 Joshua Reynolds, *Seven Discourses on Art* (London: Cassell & Co., 1901), http://www.gutenberg.org/files/2176/2176h/2176-h.htm.

7 Dorinda Evans, "An American Prelude to the Abstract Portrait," in *This Is a Portrait If I Say So: Identity in American Art, 1912 to Today*, by Anne Collins Goodyear, Jonathan Frederick Walz, and Kathleen Merrill Campagnolo, with Dorinda Evans (New Haven, CT: Yale University Press, 2016), 11.

8 See Jonathan Frederick Walz, "Performing the New Face of Modernism: Anti-Mimetic Portraiture and the American Avant-Garde, 1912–1927" (Ph.D. diss., University of Maryland, 2010), chap. 2, 46–83.

9 The exception to the rule is Virgil Thomson, who insisted on composing his musical portraits in the presence of his sitters. See Jonathan Frederick Walz, "Virgil Thomson/*Portrait of Florine Stettheimer*," in Goodyear, Walz, and Campagnolo, *This Is a Portrait If I Say So*, 162.

10 Mabel Dodge, in a sense the expatriate poet's mouthpiece, observed that "Gertrude Stein is doing with words what Picasso is doing with paint." Mabel Dodge, "Speculations, or Post-Impressionism in Prose," *Arts & Decoration*, March 1913, 172.

11 For a succinct account of William James's idea of "stream of consciousness" and how it influenced Gertrude Stein's writing and Pablo Picasso's paintings, see Patricia Leighten, "Vase, Gourd, and Fruit on a Table" (catalogue no. 4) and "Shells on a Piano" (catalogue no. 6) in *Picasso and the Allure of Language*, by Susan Greenberg Fisher et al. (New Haven, CT: Yale University Press, 2009), 47–53, 62–69.

12 Katherine S. Dreier, *Abstract Portrait of Marcel Duchamp*, Museum of Modern Art, New York (279.1949), http://www.moma.org/collection/works/79378; Arthur Dove, *Portrait of Alfred Stieglitz*, Museum of Modern Art, New York (193.1955), http://www.moma.org/collection/works/98208; Charles Demuth, *My Egypt*, Whitney Museum of American Art, New York (31.172), http://collection.whitney.org/object/635.

13 Daniel Joseph Singal, "Towards a Definition of American Modernism," *American Quarterly* 39, no. 1 (Spring 1987): 12.

14 "The Nude-Descending-a-Staircase Man Surveys Us," *New York Tribune*, September 12, 1915. Henry McBride Papers, Yale Collection of American Literature, Beinecke Rare Book and Manuscript Library, Yale University.

15 Marsden Hartley, *Portrait of a German Officer*, the Metropolitan Museum of Art, New York (49.70.42), https://www.metmuseum.org/art/collection/search/488486; Andrew Dasburg, *Coordinated Explosion: Portrait of Carl Van Vechten, A Cubist Portrait*, Myron Kunin Collection of American Art; Georgia O'Keeffe, *Untitled (Abstraction/Portrait of Paul Strand)*, Georgia O'Keeffe Museum, Santa Fe (2007.01.004), http://contentdm.okeeffemuseum.org/cdm/ref/collection/gokfa/id/770; Florine Stettheimer, *Studio Party, or Soirée*, Beinecke Rare Book & Manuscript Library, Yale University, New Haven (YCAL MSS 20), https://brbl-dl.library.yale.edu/vufind/Record/3520301.

16 Charles Demuth, *Spring*, Art Institute of Chicago (1989.231), http://www.artic.edu/aic/collections/artwork/74375; Charles Demuth, *Longhi on Broadway*, Museum of Fine Arts, Boston (1990.397), http://www.mfa.org/collections/object/longhi-on-broadway-35067.

17 Robin Jaffee Frank, *Charles Demuth: Poster Portraits, 1923–1929* (New Haven, CT: Yale University Art Gallery, 1994), 42–47.

18 Marcel Duchamp, *Fountain* (1964 replica), Tate (T07573), http://www.tate.org.uk/art/artworks/duchamp-fountain-t07573.

19 The final painting is unlocated at present, although a reproduction appears in *Reflections on the Art of Katherine S. Dreier* (New York: Academy of Allied Arts, 1933), 5. I would like to thank Francis M. Naumann for drawing my attention to this image and publication.

20 Katherine S. Dreier, *Western Art and the New Era: An Introduction to Modern Art* (New York: Brentano's, 1923), 112.

21 Leon Battista Alberti, *On Painting: A New Translation and Critical Edition*, trans. Rocco Sinisgalli (New York: Cambridge University Press, 2011), 44.

22 In denominating *God* as queer—"something that isn't one thing or another"—I follow Jamie Q's zine *What Makes an Object Queer?* (Picton, Ontario: Spark Box Studio, 2011), inspired by Sara Ahmed, *Queer Phenomenology: Orientations, Objects, Others* (Durham, NC: Duke University Press, 2006).

23 "Under the stimulus of [Gertrude] Stein's portraiture and the avant-garde painting of the period, Picabia, De Zayas, Marsden Hartley, and a number of other artists of the Stieglitz and Arensberg circles attempted a reversal of the norms of painted portraiture parallel to that by Stein in writing. Picabia represented Stieglitz as 'a malfunctioning camera with the word "IDEAL" inscribed above it in heavy Germanic type.' Morton Schamberg [*sic*] sculpted God out of a plumber's joint, and Marsden Hartley painted an abstract *Portrait of an Officer* with the initials of the subject as the only [*sic*] representational element in the painting. All these works, though dependent on the iconic properties of their medium—as Stein was at last dependent on the symbolic properties of language—function primarily as symbols of a more or less conventional sort. They are symbolic indices, as Stein's . . . portraits are iconic indices." Wendy Steiner, "The Semiotics of a Genre: Portraiture in Literature and Painting," *Semiotica* 21, no. 1 (1977): 117.

24 Norman F. Cantor, *The American Century: Varieties of Culture in Modern Times* (New York: HarperCollins, 1997), 11–12.

25 O'Keeffe to Toomer, Lake George, February 8, 1934, Collection of American Literature, Beinecke Rare Book and Manuscript Library, Yale University, repr. in Jack Cowart and Juan Hamilton, *Georgia O'Keeffe: Art and Letters*, ed. Sarah Greenough (Washington, DC: National Gallery of Art, 1987), 218.

26 See Lloyd Goodrich, "Yasuo Kuniyoshi, 1889–1953," in *Yasuo Kuniyoshi*, by Susan Lubowsky et al. (New York: Whitney Museum of American Art, 1986), n.p.

27 Yasuo Kuniyoshi, "Preliminary Notes for an Autobiography," August 1944, typescript, 17A and 17B, unmicrofilmed, Kuniyoshi papers, as cited in Gail Levin, "Between Two Worlds: Folk Culture, Identity, and the American Art of Yasuo Kuniyoshi," *Archives of American Art Journal* 43, no. 3/4 (2003): 5–6.

28 Susan Lubowsky, "East to West," in Lubowsky et al., *Yasuo Kuniyoshi*, n.p. Lubowsky calls the standing picture a "photograph," but the Smithsonian American Art Museum curators have identified it otherwise: "Partially hidden, a reproduction of a portrait by Francisco de Goya represents the European old-master painting tradition that Kuniyoshi admired." "*Weathervane and Objects on a Sofa* by Yasuo Kuniyoshi," *The Artistic Journey of Yasuo Kuniyoshi*, online exhibition catalogue, Smithsonian American Art Museum, https://2.americanart.si.edu/exhibitions/online/kuniyoshi/1933-objects-on-sofa.cfm. The image is likely the *Portrait of Tadea Arias de Enríquez* now in the Museo Nacional del Prado, Madrid.

29 Helen Molesworth, "Rrose Sélavy Goes Shopping," in *The Dada Seminars*, ed. Leah Dickerman and Matthew S. Witkovsky (Washington, DC: Center for Advanced Study in the Visual Arts, National Gallery of Art, in association with D.A.P./Distributed Art Publishers, 2005), 175.

30 There are *Pinctada* species native to the Gulf of Mexico and the Pacific Ocean. Paul Strand worked in Mexico from 1932 to 1934. That said, the object in question could have been obtained through previous gift or purchase; shells are easily portable and it is not unusual to find them long distances from their initial source. The trade of brightly colored spiny oysters (*Spondylus*) from Central America north to the Pueblo tribes is an especially important example and precedent, given James's relocation to Taos. The genus name *Pinctada* alludes, in a roundabout way, to the creative act itself: The denomination is New Latin from the French *la pintade*, or "guinea fowl," associating the blotchy gray and white exterior of the mollusk with the mottled plumage of *Numida meleagris*. The French term *pintade* derives from the Portuguese *pintada*, or "painted," from the Latin *pingere*, "to decorate or embellish." See R. A. Donkin, *Beyond Price: Pearls and Pearl-Fishing: Origins to the Age of Discoveries* (Philadelphia: American Philosophical Society, 1998), 26. According to the staff at the Museu Nacional do Azulejo in Lisbon, Portugal, "At the start of the seventeenth century, Lisbon began producing altar frontals with 'birds and foliage' [patterns] inspired [by] Asian textiles including, among others, *chitas* (chintz), also known as *pintados*, or stamped Indian fabrics."

31 See, for example, Rebecca Salsbury Strand James, *Peace* [a painting of a clam and a scorpion shell], ca. 1937, reverse painting on glass, 8 x 10 inches, Georgia O'Keeffe Museum, Santa Fe, New Mexico (2010.02.001). Karli Wurzelbacher, currently a University of Delaware doctoral candidate, has proven a collegial and generous interlocutor on the subject of Rebecca Salsbury Strand James's reverse glass paintings. I owe her a debt for sharing her groundbreaking research with me, in particular, for taking the time to craft an informal written analysis of Harvard's *Paul*, which she willingly imparted. Her dissertation and related research will prove important additions to the literature on American modernism. E-mail correspondence with the author, July 22, 2016.

32 Lois P. Rudnick, "'Under the Skin' of New Mexico: The Life, Times, and Art of Cady Wells," in *Cady Wells and Southwestern Modernism*, ed. Lois P. Rudnick (Santa Fe: Museum of New Mexico Press, 2009), 51.

33 I would like to thank Karli Wurzelbacher for drawing my attention to this image.

34 Although members of the genus *Myosotis* have five petals and the flower depicted only has four, given its yellow "eye," blue color, and the broader context, it seems that a forget-me-not was likely what Rebecca Salsbury Strand had in mind.

35 According to James's biographer Suzan Campbell, the "small painting [*Shell on Sand*] is typical of the gifts she often gave Wells, for whom she had deep affection." See Sotheby's, *American Paintings, Drawing and Sculpture* (New York: Sotheby's, 2004), lot 133, http://www.sothebys.com/en/auctions/ecatalogue/2004/american-paintings-drawings-and-sculpture-n07997/lot.133.html. Wells's embroidery is just another element of the ongoing provision of presents and souvenirs to each other by the two artists.

36 For more about early- to mid-twentieth-century queer American modernists working in rural locations, see Jonathan Frederick Walz, "'What I Have Done with Where I Have Been': Some Queer American Modernists and the Rural Experience," in *Rural Modern: American Art Beyond the City*, by Amanda Burdan et al. (New York: Skira Rizzoli, 2016), 118–34.

37 Marcel Mauss, "Essai sur le don. Forme et raison de l'échange dans les sociétés archaïques," *Année Sociologique*, 1925.

38 Alfred Stieglitz hung the three poster portraits that Demuth had completed in the vestibule of 291, that is, just outside the gallery proper, "where they functioned as advertisements for the work of Dove and O'Keeffe, all the while underscoring [Stieglitz's] main ambition for the show: to identify a cohesive, definitive group of native talents." Charles Brock, "Charles Demuth: A Sympathetic Order," in *Modern Art and America: Alfred Stieglitz and His New York Galleries*, by Sarah Greenough et al. (Washington, DC: National Gallery of Art, 2000), 366.

39 Singal, "Towards a Definition of American Modernism," 8.

40 Singal, 15.

41 Singal, 12.

42 Erika Doss, "Hopper's Cool: Modernism and Emotional Restraint," *American Art* 29, no. 3 (Fall 2015): 2–27.

43 Charles Demuth, *Study for Poster Portrait: Marsden Hartley*, ca. 1923–24, Yale University Art Gallery (1991.41.1), http://artgallery.yale.edu/collections/objects/31491; Edward Steichen, *Mushton Shlushley, the Lyric Poet and Aestheticurean*, ca. 1922, National Gallery of Art, Washington, DC (2011.85.1), http://www.nga.gov/content/ngaweb/Collection/art-object-page.155087. html; Ben Benn, *Portrait of M. H. (Marsden Hartley)*, 1915, Frederick R. Weisman Art Museum at the University of Minnesota, Minneapolis, see https://www.artsy.net/artwork/ben-benn-portrait-of-mh-marsden-hartley. See also Jonathan Frederick Walz, "Ben Benn/*Portrait of M. H. (Marsden Hartley)*," "Edward Steichen/*Mushton Shlushley, the Lyric Poet and Aestheicurean*," and "Charles Demuth/*Study for Poster Portrait: Marsden Hartley*," in Goodyear, Walz, and Campagnolo, *This Is a Portrait If I Say So*, 130–31, 148–49, 154–56.

44 Wendy Wick Reaves, "Brittle Painted Masks: Portraiture in the Age of Duchamp," in *AKA Marcel Duchamp: Meditations on the Identities of an Artist*, ed. Anne Collins Goodyear and James W. McManus (Washington, DC: Smithsonian Institution Scholarly Press, 2014), 10.

45 Georgia O'Keeffe, *Black and White*, Whitney Museum of American Art, New York (81.9), http://collection.whitney.org/object/1386; Georgia O'Keeffe quoted in *Georgia O'Keeffe* (New York: Penguin, 1977), n.p.

# "CALL IT A LITTLE GAME BETWEEN 'I' AND 'ME'"

## MAR/CEL DUCHAMP IN THE WILSON-LINCOLN SYSTEM

Anne Collins Goodyear

"Call it a little game between 'I' and 'me.'"
—Marcel Duchamp, 1962[1]

Responding late in life to a question about the "cerebral genesis" of *The Bride Stripped Bare by Her Bachelors, Even (The Large Glass)*—or, in the original French, *La mariée mise à nu par ses célibataires, même (Le grand verre)* (fig. 13.1)—Marcel Duchamp emphasized the role of "perspective" in the piece, telling Pierre Cabanne, "*The Large Glass* constitutes a rehabilitation of perspective, which had been completely ignored and disparaged. For me, perspective became absolutely scientific."[2] Numerous historians have pointed to Duchamp's remark as evidence of his copious study of the science of perspective and his familiarity with the contemporary mathematical theories of his own era.[3] But if Duchamp intended to draw attention to his reframing of the very nature of modeling space,

his comment also alludes to a device—itself known as a perspective—that both revealed and concealed. Such perspectives simultaneously captured two (or more) images through a system of slats that made either one image or the other visible depending upon the viewpoint of the spectator.[4] Duchamp's remark, then, hints at the unseen presence in *The Large Glass* of the Wilson-Lincoln system: a "perspective" modeled after a "pleated perspective" that he discovered in a seventeenth-century treatise on optics and reimagined for his own era (fig. 13.2). Capturing the transformative function of a perspective, through his use of the term "system," Duchamp named the Wilson-Lincoln system after an early twentieth-century "perspective," a two-way portrait that combined pictures of Presidents Woodrow Wilson and Abraham Lincoln, enabling the viewer to toggle between one and the other. Although unexecuted, the Wilson-Lincoln system came to occupy a central place conceptually in *The Large Glass*.

In addition to its role as an intermediary between the Bride (la mariée) and the Bachelors (les célibataires), the Wilson-Lincoln system would come to function as a powerful metaphorical device throughout Duchamp's career, providing a symbolic representation of the invisible,

Fig. 13.1
*The Bride Stripped Bare by Her Bachelors, Even (The Large Glass)*
by Marcel Duchamp, 1915–23
Oil, varnish, lead foil, lead wire, and dust on two glass panels
277.5 × 175.9 cm (109¼ × 69¼ in.)
Philadelphia Museum of Art; bequest of Katherine S. Dreier, 1952

or incompletely perceived, reality of the four-dimensional universe that Duchamp understood the most advanced mathematics of his era to describe.[5] Inaccessible to human sensory perception, such a four-dimensional reality could be comprehended, Duchamp believed, through analogy.[6] Modeled after both historic and modern techniques for capturing multiple likenesses within a single matrix, the Wilson-Lincoln system thus came to represent the ever-shifting, unfixed nature of personal identity itself, particularly when viewed through the prism of new geometrical models of spatial reality. Casting himself in this light, the artist reported to his friend Katharine Kuh late in his career: "I was never interested in looking at myself in an aesthetic mirror. My intention was always to get away from myself, although I knew perfectly well that I was using myself. Call it a little game between 'I' and 'me.'"[7]

Duchamp's rejection of traditional aesthetic categories, premised on visuality, in favor of something more cerebral, becomes evident in his approach to constructing his *Large Glass*—complete with its own reflective allusions. As Duchamp wrote to a friend: "the glass in actual fact is not meant to be looked at (with 'aesthetic' eyes). It should be accompanied by a 'literary' text, as amorphous as possible . . . And the two elements, glass for the eyes, text for the ears and understanding, should complement each other and above all prevent one or the other from taking on an aesthetico-plastic or literary form."[8] Consistent with Duchamp's assertion, *The Bride Stripped Bare by Her Bachelors, Even* consists of two parts, each of which is best known by the short title that describes its physical attributes: *The Large Glass*, a visual object, and *The Green Box*, a compilation of unbound notes about the project housed in the eponymous container. First published in 1934, when *The Large Glass* lay in shards in the barn of Katherine Dreier, *The Green Box* enables audiences to understand the fragile and complex object as a conceptual undertaking. In its entirety, *The Green Box* also supplies the narrative for the action animating Duchamp's abstract composition: the

futile attempts of the "Bachelors," represented as "nine malic molds" in the lower register of *The Large Glass*, to project the illuminating gas (whose presence is "given" by Duchamp) upward toward the ethereal Bride in the upper register of the composition, in order to consummate their union with her.[9] Two years after the publication appeared, in 1936, Duchamp would succeed in repairing his damaged masterwork, concluding that the elegant, if unplanned, network of cracks that emerged through the process of the reconstruction improved his opus.[10]

## CRAFTING THE WILSON-LINCOLN SYSTEM

Duchamp's *Green Box* notes, particularly when read in tandem with the related sets of notations published later, reveal a deep interest on the part of the artist in how to represent the fourth dimension by considering how the higher dimension might be experienced by subjects perceptually bound by three.[11] The artist's knowledge of contemporary mathematics built upon a deep familiarity with historical techniques for rendering three-dimensional space. Numerous scholars have addressed Duchamp's interest in perspective, the study of which he seems to have begun in earnest while a librarian at the Bibliothèque Sainte-Geneviève, from 1913 to 1915.[12] The institution had rich holdings in this area, as Duchamp indicated in one of the notes he jotted to himself in the course of working on *The Large Glass*: "See Catalogue of Bibliothèque St. Geneviève/the whole section on perspective."[13] But if Duchamp looked closely at the numerous classic treatises concerning pictorial perspective to which he had access, including the writings of artistic masters such as Albrecht Dürer and Leonardo da

Fig. 13.2
"Wilson-Lincoln System," detail of note from *The Bride Stripped Bare by Her Bachelors, Even (The Green Box)*, by Marcel Duchamp, 1934 Ninety-four facsimiles of manuscript notes, drawings, and photographs, and one original manuscript item, *Broyeuse de Chocolat*, contained in a green flocked cardboard box, 33.2 × 27.9 × 2.5 cm (13$^{1}/_{16}$ × 11 × 1 in.) Philadelphia Museum of Art; The Louise and Walter Arensberg Collection, 1950 (1950-134-986)

semblable aux portraits qui regardés de gauche donnant
Wilson regardés de droite donnant Lincoln →)

[sketch of folded/accordion figure]

vue de droite la figure pourra donner un carré par exemple
vu de face et vue de droite elle pourra donner le même
carré vu en perspective —

   Les gouttes miroiriques pas les gouttes mêmes
mais leur image ~~passent~~ entre ces 2 ~~fig~~ états
                 passent
de la même figure (carré dans cet exemple)

(on[peut] être employer des prismes collés derrière le verre,)
pour obtenir l'effet cherché)

**Fig. 13.3**
Diagram of a pleated perspective, plate 43 from *La perspective curieuse* by Jean-François Nicéron, 1638

Vinci (who may have helped inspire Duchamp to publish his own notes in facsimile),[14] it was not with a mind to replicating traditional three-point perspective. Instead, Duchamp sought to build on this previous work in order to represent the world in light of contemporary science and mathematics, destabilizing inherited assumptions. As Duchamp testified in a late interview, "If I do propose to strain a little bit the laws of physics and chemistry and so forth, it is because I would like you to think them unstable to a degree . . . My landscapes begin where da Vinci's end. The difficulty is to get away from logic."[15]

Given Duchamp's access early in his career to numerous works on perspective, it is notable that the only title to which he made specific reference in his writings was French mathematician, artist, and friar Jean-François Nicéron's *Thaumaturgus opticus*, a seventeenth-century treatise that addressed pictorial anamorphosis, or perspectival distortion of images through geometric means. But while Duchamp specifically referenced the Latin version of Nicéron's famous study, left unfinished due to the mathematician-artist's untimely death, it appears that he was perhaps even more closely acquainted with the French-language version that preceded it, *La perspective curieuse*.[16]

Near the conclusion of Nicéron's French-language volume is an intriguing diagram of an optical device known as a "pleated perspective," an instrument that uses a mirror, installed at an angle above it, to reveal the presence of a previously hidden portrait as a viewer approaches (fig. 13.3).[17] A version of Nicéron's diagram of such a perspective, rotated 90 degrees to the right, appears in Duchamp's *Green Box* (see fig. 13.2) to illustrate the operation of its intellectual offspring: the Wilson-Lincoln system.

Thus appropriated, the "perspective" reconceptualized by Duchamp drives, as described in *The Green Box*, the "illuminating gas" upward from the region of the Bachelors toward the realm of the four-dimensional Bride, by projecting "mirrorical" images of these droplets vertically—an example of what Duchamp referred to as his "playful physics," which actively defied the conventional logic of Newton and Euclid.[18]

The artist described the process as the *renvoi miroirique*, most often translated as the "mirrorical return," in a note from *The Green Box* (see fig. 13.2):

"Mirrorical return—Each drop will pass the 3 planes at the horizon between the perspective and the geometrical drawing of the 2 figures which will be indicated on these three planes by

the Wilson-Lincoln system (i.e. like the portraits which seen from the left show Wilson seen from the right show Lincoln—) / [*Note: As seen in fig. 13.2, the rotated version of Nicéron's diagram is inserted here by Duchamp*] / seen from the right the figure may give a square for example from the front and seen from the [left][19] it could give the same square seen in perspective— / The mirrorical drops not the drops themselves but their image pass between these two states of the same figure (square in this example) / (Perhaps use prisms stuck behind the glass.) to obtain the desired effect)."[20]

While never physically added to the glass, the "perspective" of the Wilson-Lincoln system, which Duchamp envisioned at the "horizon line," as Duchamp labeled the horizontal division of his glass, played a pivotal role, quite literally, in *The Large Glass*.[21]

The ninety-degree rotation by Duchamp of Nicéron's diagram testifies to *The Large Glass*'s three-dimensional interrogation of four-dimensional space. As Duchamp exhorted himself: "Make a painting on glass so that it has neither front, nor back; neither top, nor bottom. To use probably as a three-dimensional physical medium in a four-dimensional perspective."[22] The activity of rotation is further compatible with a strategy described by the artist for evoking a four-dimensional space: "a finite 3-dim'l continuum is generated by a finite 2-dim'l continuum rotating (in the general sense) about a finite 1-dim'l hinge. Thus a 4-dim'l finite continuum is generated by a finite 3-dim'l continuum rotating (here the word loses its physical meaning . . .) about a 2-dim'l hinge."[23]

Duchamp's decision to turn Nicéron's diagram on its side might also help reveal another aspect of its inspiration: a lenticular photograph that was oriented horizontally.[24] Indeed, Duchamp's later association of the object that inspired the Wilson-Lincoln system with the production

of moiré or "dazzle" patterns further indicates that the Wilson-Lincoln system was inspired in part by this new breed of photographic technology that, with its raised, faceted surface, could capture two distinct and alternating images, and at the same time merge them. As Duchamp later explained, "I had seen in a shop somewhere an advertisement of those two faces, the face of Lincoln on one side and the face of Wilson on the other . . . And I call that a system "Lincoln-Wilson" which is the same idea as the moiré. Because, you see, those lines have two facets. And if you look at one facet you see something, if you see the other facet you see the other."[25]

## THE WILSON-LINCOLN SYSTEM BEYOND
### *THE LARGE GLASS*

In this context, Duchamp's 1964 collaboration with the Japanese scholar and artist Shuzo Takiguchi assumes special significance. Intrigued by Takiguchi's undertaking *To and From Rrose Sélavy*, Duchamp authorized the Japanese artist to use Rrose Sélavy's signature.[26] As their conversations unfolded, a new collaborative artwork emerged: *Rrose Sélavy in the Wilson-Lincoln System*, a two-way lenticular photograph featuring a 1930 profile portrait of Duchamp by Man Ray combined with a reproduction of Rrose Sélavy's signature (fig. 13.4). As Takiguchi relates: "Duchamp . . . suggested its title as '[Rrose Sélavy in the] Wilson-Lincoln System,' taken from his note in *The Green Box*. Moreover, he OK'ed and signed it."[27] Duchamp's invocation of the Wilson-Lincoln perspectival device at this late point in his career—a moment at which he continued to produce drawings and prints after *The Large Glass*—demonstrates the persistent metaphorical significance of the pleated perspective that destabilized the illusion of a single "essential" identity, introducing a much more complex four-dimensional identity into the fold. Indeed, the project firmly demonstrates that the pleated perspective, reborn in the twentieth century as a lenticular photograph, provided a compelling illustration of the manifestation of the fourth dimension in

a three-dimensional world—spatially, temporally, and even personally. The perpetually shifting dynamic, alternating Duchamp's likeness with his alter ego's signature, further provided a perfect analogy for the movement of four-dimensional beings as perceived in a three-dimensional space. As Duchamp explained: "The 4-dim'l native when perceiving [a] symmetrical 4-dim body will go from one region to the other by crossing instantaneously the medium [three-dimensional] space. / One can imagine this instantaneous crossing of a [three-dimensional space] by recalling certain effects with 3-sided mirrors in which the images disappear (behind) new images."[28]

The involvement of the two artists—Takiguchi and Duchamp—in appropriating a thirty-year-old photographic likeness by Man Ray also provided an illustration of the complexity of time as experienced four-dimensionally. Indeed, the artists' use of a profile portrait of Duchamp in this vein is revealing, suggesting as it does "a clock seen in profile so that time disappears, but which accepts the idea of time other than linear time," something about which Duchamp had mused in his jottings about *The Large Glass*.[29] In this sense, the project provided a conceptual "echo," of past work—a sign of its persistent "four-dimensional" presence in a three-dimensional world.

Duchamp's decision, late in life and in collaboration with Shuzo Takiguchi, to encode the Wilson-Lincoln system overtly with the double-layering of his masculine and feminine "selves," through the invocation of his female alter ego Rrose Sélavy in combination with a portrait of himself, has intriguing implications. *Rrose Sélavy in the Wilson-Lincoln System* points to an interplay between the male and the female, or a metaphorical instability or changeability of identity, that characterizes Duchamp's self-representation throughout his career. As several scholars have observed, Duchamp, who delighted in the grammatical destabilization of wordplay, located such flexibility in his own name, "Mar/Cel." A note from *The Green Box*, in which the artist labels the two zones of *The Large Glass* "Mariée" and "cel," an

**Fig. 13.4** (opposite)
*Rrose Sélavy in the Wilson-Lincoln System* by Shuzo Takiguchi, in *To and From Rrose Sélavy,* deluxe edition, 1968
35 × 27.5 × 4 cm (13³/₄ × 10¹⁵/₁₆ × 1⁹/₁₆ in.)
Private collection

**Fig. 13.5** (above)
Sketch of *The Large Glass* with "MARiée/CEL," detail of note from *The Bride Stripped Bare by Her Bachelors, Even (The Green Box),* by Marcel Duchamp, 1934
Ninety-four facsimiles of manuscript notes, drawings, and photographs, and one original manuscript item, *Broyeuse de Chocolat*, contained in a green flocked cardboard box, 33.2 × 27.9 × 2.5 cm (13¹/₁₆ × 11 × 1 in.)
Philadelphia Museum of Art; The Louise and Walter Arensberg Collection, 1950 (1950-134-986)

abbreviation for "célibataires," or Bachelors, as well as the last three letters of his name, supports the inference that Duchamp saw the glass, among other things, as a complex form of self-portrayal (fig. 13.5).[30]

This interpretation becomes even more compelling when we focus our attention again on the physical and conceptual structuring of the object and recall that the region of the Wilson-Lincoln system plays out precisely along the work's horizon line, suggesting that the work itself might be read as a sort of lenticular photograph, or perspective, itself fluctuating between the Bride and the Bachelors, or the "MAR"iée and the "CEL"ibataires. Might this indeed have been at least one association Duchamp had in mind when encouraging Shuzo Takiguchi to create *Rrose Sélavy in the Wilson-Lincoln System*?

### THE WILSON-LINCOLN SYSTEM AND OTHER MIRRORICAL REVERSALS

The interpretation of *The Large Glass*, in and of itself, as a symbolic lenticular or two-way image, placing the male and female into perpetual play, gains further support from two related portrayals of Duchamp—each crafted either directly or indirectly by the artist—and clearly intended to function as "mirror reversals" of one another: Duchamp's half-dressed Rrose Sélavy mannequin, created for the 1938 Exposition Internationale du Surréalisme in Paris (fig. 13.6), and Frederick Kielser's 1947 depiction of Duchamp, made in New York (fig. 13.7).[31] Together the works demonstrate that Duchamp understood the Wilson-Lincoln system as an ideal analogy for representing himself and for exploring the implications of personal identity as experienced "four-dimensionally," which is to say, beyond the scope of the bounded three-dimensional universe of sensory experience.

Placed side by side, the formal relationship between the two objects is obvious. Both are full length, with half the body clothed, and the other half unclothed. But, intriguingly, they function as inverses of one another: male versus female, bare legs versus a (nearly) bare chest, two dimensions versus

**Fig. 13.6**
*Duchamp Mannequin* by Raoul
Ubac, Galerie Beaux-Arts, 1938
Gelatin silver print
23.5 × 9.7 cm (9 5/16 × 3 13/16 in.)
Getty Research Institute,
Los Angeles (92.R.76)

**Fig. 13.7**
*Marcel Duchamp* by Frederick
Kiesler, 1947
Pencil with pieces of paper in
wood frame
227.6 × 99.4 × 32.7 cm
(89 5/8 × 39 1/8 × 12 7/8 in.)
The Museum of Modern Art; gift
of the D. S. and R. H. Gottesman
Foundation (106.1963.a-i)

three. In the 1938 work, a female mannequin—part of the first generation of commercial mannequins with heads,[32] enhancing the personification of these female forms—wears a man's jacket, vest, collared shirt, and necktie. A fedora, placed over a curly blond wig, and a pair of men's shoes on the figurine's feet accentuate the deliberately disjunctive gender reversals. This is further amplified by the mannequin's nudity from the waist down and the addition of a signature reading "Rrose Sélavy" immediately above the pubic mound. Its allusion to and inversion of Man Ray's photographs of Duchamp's alter ego is clear (see figs. 13.6 and 13.8A).[33] As Duchamp would later report to Pierre Cabanne, "it was Rrose Sélavy herself."[34] Describing his friend's creation of the work, Man Ray would recall that "Duchamp simply took off his coat and hat, putting it on the figure as if it were a coat rack."[35] But despite this account, Duchamp's work was anything but offhand.

Indeed, Duchamp's purposefulness in crafting his three-dimensional representation of Rrose Sélavy becomes evident in light of his collaboration nine years later with Frederick Kiesler, which led to an unconventional eight-part drawing of the half-clad artist (see fig. 13.7), foreshadowing his later partnership with Takiguchi. As demonstrated by Kiesler's portrait—created in tandem with Duchamp—which records Duchamp stripped to the waist, but with a tie around his neck—a pose that shocked Kiesler's wife—Duchamp clearly envisioned the two works as a pair, toggling back and forth four-dimensionally across time and space.[36]

Given Duchamp's interest in perspective and multidimensionality, and *The Large Glass*'s engagement with these topics, it may be significant that one work—that representing a female body—was realized in three dimensions, and the other—representing a male body—as a two-dimensional drawing on paper. Could such images be understood, in part, as "shadows" representing, respectively, the fourth and third dimensions, referring in turn to the realms of the Bride and the Bachelors in *The Large Glass*? This reading is consistent with Duchamp's

description of his methods for rendering *The Large Glass*, offered in 1966 to Pierre Cabanne:

Since I found that one could make a cast shadow from a three-dimensional thing, any object whatsoever—just as the projecting of the sun on the earth makes two dimensions— I thought that, by simple intellectual analogy, the fourth dimension could project an object of three dimensions, or, to put it another way, any three-dimensional object, which we see dispassionately, is a projection of something four-dimensional, something we're not familiar with.

It was a bit of a sophism, but still it was possible. "The Bride" of the "Large Glass" was based on this, as if it were the projection of a four-dimensional object.[37]

The analogy is particularly pronounced in Kiesler's drawing of the artist, with its hard outline and limited modeling accentuating the flat two-dimensionality of the representation.

Intriguingly, the two works complement one another not only through their distinct dimensional structures, but also through the reversal they manifest, seemingly around a central axis, with respect to their male and female attributes, which, in turn, appear to toggle back and forth. In this regard, it is worth recognizing that Duchamp's description of the *renvoi miroirique* in his notation about the Wilson-Lincoln system, generally translated into English as the "mirrorical return," could be equally well, perhaps even better, translated as the "mirror reversal."[38] Indeed, the up/down dynamic strongly recalls Duchamp's description of the upward movement of the "illuminating gas" facilitated by the Wilson-Lincoln system. The formal relationship between Kiesler's portrait of Duchamp and *The Large Glass* is particularly clear, with the placement of Duchamp's anomalous necktie echoing the Bride, his belt

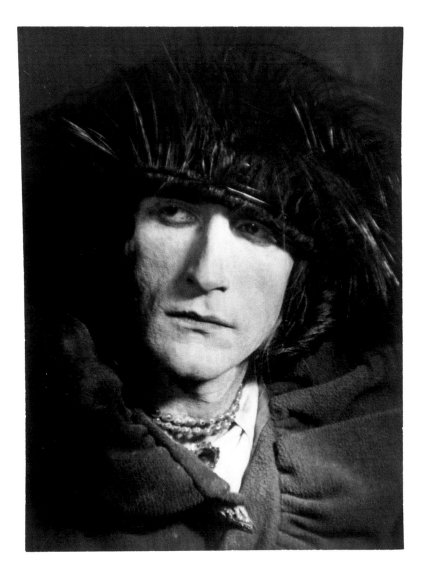

**Figs. 13.8A and B**
*Rrose Sélavy* (recto, left) and
*Duchamp Looking through the
Brawl at Austerlitz* (verso, next
page) by Marcel Duchamp and
Man Ray, 1921 (printed 1966)
Gelatin silver print
25.4 × 20.3 cm (10 × 8 in.)
Philadelphia Museum of Art,
Marcel Duchamp Archive; gift
of Jacqueline, Paul, and Peter
Matisse in memory of their
mother, Alexina Duchamp

the work's horizon line, and his trousers seemingly alluding to the realm of the Bachelors (see figs. 13.1 and 13.7). The large, unconventional frame in which Kiesler placed the work drives home its association with *The Large Glass*.[39]

In both representations of Duchamp, it is the waist, or horizon line, of the figures that serves as a point of reversal, dividing clothing from nudity and suggesting that seemingly incongruous gender identities are always simultaneously present in the person of Marcel Duchamp, though one or the other may be more or less visible depending upon what features, or facets, of his appearance one chooses to focus. Through his very invocation of the alternating presence of

his male and female selves, formulated many years apart on different continents, but nevertheless in tandem with one another, Duchamp thus positions himself within the four-dimensional matrix suggested by the Wilson-Lincoln system.

Such a temporal toggling between Duchamp and Rrose Sélavy similarly plays out in a double-sided photographic self-portrait from 1966 (figs. 13.8A and B), the same year in which the artist described the "Bride" of *The Large Glass* as "the projection of a four-dimensional object." Rrose Sélavy appears—in a print made from a 1921 negative—on the object's recto, while a significantly older Duchamp appears on the verso, tilting his head at the same

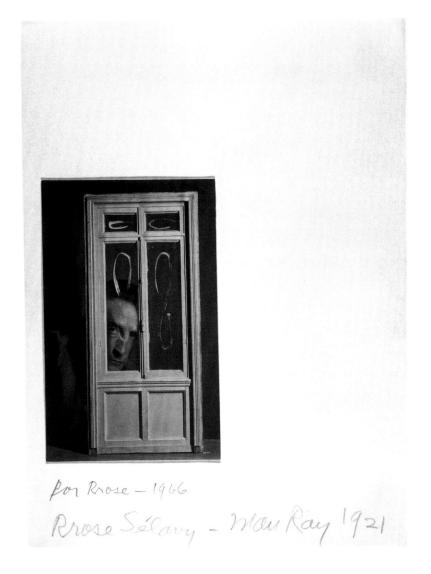

*for Rrose – 1966*
*Rrose Sélavy – Man Ray 1921*

**Fig. 13.8B**

angle as his alter ego. Peering through the lower portion of the glass window of his assisted readymade *The Brawl at Austerlitz* (*La bagarre d'Austerlitz*), co-authored with Rrose Sélavy, Duchamp's pose emphasizes the work's association with *The Large Glass*. The glazier's marks present in *The Brawl at Austerlitz*, in the form of a figure 8 or Möbius strip, also evoke the symbol of eternity, suggesting the ability of the "four-dimensional" artist to defy traditional temporality, not to mention gender roles.[40] As formal constructions, the figure-8-like structures are vertically symmetrical, and the matching pair present on the windows of *The Brawl at Austerlitz* thus seems reminiscent, in this context, of the

relationship between Kiesler's 1947 drawing of a half-nude Duchamp, and Duchamp's 1938 construction of a half-nude Rrose Sélavy, making use of a "readymade" mannequin. Below Duchamp's face in the 1966 double-sided image appears the inscription "For Rrose—1966 / Rrose Sélavy—Man Ray 1921," reiterating the artist's utter disavowal of traditional categories of time, space, and gender in positioning himself as an entity that could slip through such limiting categories at will.

Indeed, Duchamp's relationship with his female alter ego would play out over time—always present, sometimes visible—in a manner analogous to the experience of aspects

of the fourth dimension in our three-dimensional world. As Duchamp would tell an interviewer who inquired after his famous female persona late in his career, "She's still alive; manifests herself little or not at all."[41] In invoking Rrose Sélavy, Duchamp does not entirely allow his male self to disappear. Instead, we are made aware of the temporary concealment, or the layering of identities, that remain in play, precisely as is the case in the Wilson-Lincoln system.[42]

## ON DUCHAMP'S "DOUBLED" SELF

"Drag is an example of what is meant to establish that 'reality' is not as fixed as we generally assume it to be," notes the gender theorist Judith Butler. So cross-dressing enables Duchamp to disrupt familiar rules governing the performance of gender and its rule-bound deployment. His deliberate assumption, in the guise of Rrose Sélavy, of the attributes of femininity, such as make-up, feathers, and jewelry (see fig. 13.8 A), throws into vivid relief the very conventions that shape us, almost imperceptibly, as subjects. Duchamp's oppositional stance toward such traditional social codes is far more significant than mere trickery, however. Instead, his unconventional behavior strains the seemingly "natural laws" of society, just as his "playful physics" upends our perception of the "natural world" itself.

In exploring the significance of Duchamp's actions, the importance of one philosopher in particular becomes manifest: Max Stirner.[43] Most likely introduced to Stirner's *The Ego and Its Own* (1844) by his friend, the French artist Francis Picabia, Duchamp connected deeply with ideas expressed in the work, describing it as a "remarkable book."[44] Indeed, as Herbert Molderings points out, Duchamp actually purchased a new edition of *The Ego and Its Own* in 1960 in order to reacquaint himself with Stirner's arguments.[45]

Critiquing structures of Western European political hierarchy, deeply interlaced with Christianity, Stirner asserts: "The egoist, turning against the demands and concepts of the present, executes most pitilessly the most measureless—

desecration. Nothing is holy to him!"[46] Indeed, it is precisely in rejecting, or seeing through, the claims and implications held "sacred" by civilization and enforced by convention and law, that the individual frees him- or herself from those strictures that, Stirner argues, enslave the individual to the demands of others. The boldness demanded by Stirner seems indeed to animate Duchamp's 1921 self-portrait *Voici Rrose Sélavy*, depicting the artist's recently acquired star tonsure. Defying the conventions of portraiture, the artist's face is not present, only the top of his head, boasting a large star shaved into the artist's hair. With his inscription, Duchamp invokes his female alter ego, while simultaneously allowing his maleness to remain manifest.[47]

But, if an invocation of a feminine identity—through cross-dressing or other means—signals a desecration of social codes, another, even more suggestive passage from Stirner's *The Ego and Its Own* sheds light on still other startling self-portrayals by Duchamp:

*"What am I?" each of you asks himself.* An abyss of lawless and unregulated impulses, desires, wishes, passions, a chaos without light or guiding star! How am I to obtain a correct answer, if, without regard to God's commandments or to the duties which morality prescribes, without regard to the voice of reason, which in the course of history, after bitter experiences, has exalted the best and most reasonable thing into law, I simply appeal to myself? *My passion would advise me to do the most senseless thing possible.—Thus, each deems himself the—devil; for, if, so far as he is unconcerned about religion, he only deemed himself a beast, he would easily find that the beast, which does follow only its impulse (as it were, its advice), does not advise and impel itself to do the "most senseless" things, but takes very correct steps.* But the habit of the religious way of thinking has biased our mind so

grievously that *we are—terrified at ourselves in our nakedness and naturalness; it has degraded us so that we deem ourselves depraved by nature, born devils. . . .*

But what would you think if one answered you by saying: "That one is to listen to God, conscience, duties, laws, and so forth, is flim-flam with which people have stuffed your head and heart and made you crazy"? And if he asked you how it is that you know so surely that the voice of nature is a seducer? And if he even demanded of you to turn the thing about *and actually to deem the voice of God and conscience to be the devil's work?* There are such graceless men; how will you settle them? You cannot appeal to your parsons, parents, and good men, for precisely these are designated by them as your seducers, as the true seducers and corrupters of youth, who busily sow broadcast the tares of self-contempt and reverence to God, who fill young hearts with mud [verschlämmen] and young heads with stupidity [verdummen]."[48]

Stirner's pronouncements signal the philosopher's disgust with codes of propriety, explicitly embracing the inherent morality of those who rebel against the social strictures associated with conventional "morality." In this light, Duchamp's depiction of himself as a transgressive character suggests specific aims. In *Wanted: $2,000 Reward* (1923), Duchamp is a fugitive from justice, answering to—among other pseudonyms—the name of Rrose Sélavy; in *Monte Carlo Bond* (1924), he is the seemingly satanic endorser (together with Rrose Sélavy) of a promissory note based on gambling proceeds. In presenting himself thus—as an outlaw, an outcast, an outright devil of a man—Duchamp signals his disavowal of social regulations.[49] In so doing, Duchamp also creates, once again, a dynamic interchange

between his "proper" self and his assumed alter egos, in the manner of the Wilson-Lincoln system. Duchamp's rejection of social mores represents yet another analogy for his larger repudiations of the trappings of a static, tradition-bound three-dimensional world, in all its manifestations, in favor of the recognition of a far more flexible and complex four-dimensional reality.

As if to further emphasize the connection between the two works, Duchamp included them jointly (together with two other works, *L.H.O.O.Q.* and the *Tzank Check*) on a placard in his autobiographical compendium, the *Boîte-en-valise* (box in suitcase).[50] The *Boîte*, a collection of sixty-eight miniature reproductions of highlights from Duchamp's body of work (in addition to one original work in the deluxe version), first executed between 1935 and 1941, was carried out in multiple editions throughout the remainder of his career.[51] The centerpiece of the compendium, around which all other works both physically and figuratively revolve, is *The Large Glass*, with the invisible Wilson-Lincoln system embedded at its horizon line (see fig. 13.1). The *Boîte* was signed jointly "by and/or of Marcel Duchamp or Rrose Sélavy," as if to create an ongoing toggling between what Duchamp described as his "two identities,"[52] forever casting them into the back-and-forth suggested by the Wilson-Lincoln system itself.

It is perhaps with good reason that when Duchamp's friend and patron Walter Arensberg received his *Boîte* from Duchamp, he not only identified it "as a new form of autobiography," but remarked that Duchamp had become the "puppeteer of his past." Duchamp's tendency to connect thematically works made many years apart demonstrates that this "puppeteer" was indeed interested in conjoining different moments in time; in 1955 he observed, "You should wait for fifty years or a hundred years for your true public. That is the only public that interests me."[53]

Duchamp's recognition of the critical role to be played by posterity in evaluating an artist's achievements and contributions would become a critical feature of a talk

delivered by the artist just two years later: "The Creative Act." In this short lecture, Duchamp acknowledged that no artist could succeed without the essential interplay of a reciprocal partner: one's audience. "All in all, the creative act is not performed by the artist alone," he observed; "the spectator brings the work in contact with the external world by deciphering and interpreting its inner qualifications and thus adds his contribution to the creative act."[54] With this powerful and subversive assertion, Duchamp cast himself into a toggling relationship not only with his own alter ego, but with posterity itself. Duchamp sought to vanquish the corrosive effect of time, conceived in a linear fashion. Rather than allowing his works to recede into the past, Duchamp, through his invocation of an art, and a persona, of many dimensions, conceptualized a relationship with future generations that would regularly refresh his legacy.

Seen through the perspective of the Wilson-Lincoln system, then, many aspects of Duchamp's creative practice come into new focus: in particular, the dynamic exchange between the artist and his alter ego Rrose Sélavy; collaborators such as Takiguchi and Kiesler; and, perhaps most powerfully of all, future audiences. Duchamp's effort to "get away from logic," as he put it, reveals itself as a carefully considered strategic choice. Fashioning an expansive persona flowing across four dimensions, Duchamp revolutionized the nature of self-representation not as something static, but rather as something in constant evolution, sometimes revealing, sometimes concealing aspects of an identity in flux: a "little game between 'I' and 'me,'" as the artist wryly put it. "I have a very great respect for humor, it's a safeguard that allows one to pass through all the mirrors. One can survive, even attain success," remarked this master of a "playful physics" toward the end of his career.[55] Perhaps reflecting upon the journey of the droplets of illuminating gas upward through the Wilson-Lincoln system to meet the Bride—the Mar-iée—this multi-faceted "Bachelor," or "Cél-ibataire" recognized a way to hit the mark, implicating spectators in the very system that shapes the artist, fashioning us as conceptual partners, always already defined by the complex and shifting identity we seek to interpret.

Notes
Acknowledgments: I thank Linda Dalrymple Henderson, Mariko Ikehara, Michael Maizels, James W. McManus, and Wendy Wick Reaves for their invaluable support of this project.

1 Katharine Kuh, interview with Marcel Duchamp, in Katharine Kuh, *The Artist's Voice: Talks with Seventeen Artists*, (New York and Evanston: Harper and Row, 1962), 83.

2 Pierre Cabanne, *Dialogues with Marcel Duchamp* (New York: Da Capo Press, 1987), 38.

3 See, for example, Craig Adcock, "Duchamp's Perspective: The Intersection of Art and Geometry," *Tout-Fait: The Marcel Duchamp Studies Online Journal*, originally published January 4, 2003, revised May 5, 2016, http://toutfait.com/duchamps-perspectivethe-intersection-of-art-and-geometry/, accessed January 29, 2017; Jean Clair "Duchamp and the Classical Perspectivists," *Artforum* 16, no. 7 (March 1978): 40; Stephen Jay Gould and Rhonda Roland Shearer, "Drawing the Maxim from the Minim: The Unrecognized Source of Nicéron's Influence upon Duchamp," *Tout-Fait: The Marcel Duchamp Studies Online Journal*, December 2000, http://toutfait. com/drawing-the-maxim-from-the-minimthe-unrecognized-source-of-nicerons-influence-upon-duchamp/, accessed January 29, 2017; and Linda Dalrymple Henderson, *Duchamp in Context: Science and Technology in "The Large Glass" and Related Works* (Princeton: Princeton University Press, 1998), 80.

4 For a good description of such perspectives, see Allan Shickman, "The 'Perspective Glass' in Shakespeare's Richard II," *Studies in English Literature, 1500–1900* 18, no. 2 (Spring 1978): 225.

5 Duchamp's engagement with the advanced mathematics of his era, including the treatment of N-Dimensional geometry, is addressed at length in Linda D. Henderson, *The Fourth Dimension and Non-Euclidean Geometry in Modern Art*, rev. ed. (Cambridge, MA: MIT Press, 2013), esp. 35–45, 233–88. As Henderson demonstrates, Duchamp was not unique among the avant-garde artists of his era in being interested in four-dimensional geometry. Among his friends to share this interest were Franz Kupka, Albert Gleizes, and Jean Metzinger, all active in the circle of "Puteaux Cubists," which coalesced in the 1910s through meetings at the studio of Marcel Duchamp's elder brother, Jacques Villon.

6 The use of analogies to model or evoke multidimensional realities was common among both popular writers and mathematicians to describe the fourth dimension, as Henderson's *The Fourth Dimension* demonstrates. See also Henderson, *Duchamp in Context*, 80–85.

7 Kuh, interview, 83.

8 Marcel Duchamp, letter to Jean Suquet, December 25, 1949, in *Affectionately, Marcel: The Selected Correspondence of Marcel Duchamp*, ed. Francis M. Naumann and Hector Obalk, trans. Jill Taylor (Ghent: Ludion Press, 2000), 283–84.

9 For a valuable account of the narrative of *The Large Glass*, see Calvin Tomkins, *Duchamp: A Biography* (New York: Henry Holt & Company, 1996), 4–10. Tomkins, however, does not make reference to the role of the Wilson-Lincoln system specifically.

10 Tomkins, *Duchamp*, 308.

11 Duchamp's most extensive notes on multidimensional perspective appear in *À l'infinitif*, in *The Writings of Marcel Duchamp*, ed. Michel Sanouillet and Elmer Peterson (New York: Da Capo Press, 1973), esp. 87–101. Linda Henderson addresses the topic of Duchamp's interest in the fourth dimension at length in *Duchamp in Context* (esp. 80–85).

12 On this point, see Clair, "Duchamp and the Classical Perspectivists," 40–48, esp. 40, and Herbert Molderings, *Duchamp and the Aesthetics of Chance: Art as Experiment*, trans. John Brogden (New York: Columbia University Press, 2010), esp. 15ff. For Duchamp's reading at the Bibliothèque Sainte-Geneviève, see Henderson, *Duchamp in Context*, esp. 58, and Hans Belting, *Looking Through Duchamp's Door: Art and Perspective in the Work of Duchamp, Sugimoto, Jeff Wall*, trans. Steven Lindberg (Cologne: Verlag der Buchhandlung, Walther König, 2009), 18–19.

13 Duchamp, *The Writings of Marcel Duchamp*, 86.

14 See Henderson, *Duchamp in Context*, 72–73.

15 Duchamp, quoted in Francis Roberts, "Interview with Marcel Duchamp: 'I Propose to Strain the Laws of Physics,'" *ArtNews* 67, no. 8 (December 1968): 63.

16 Duchamp specifically cited *Thaumaturgus opticus* in *À l'infinitif* (Duchamp, *The Writings of Marcel Duchamp*, 86), but Stephen Jay Gould and Rhonda Roland Shearer argue (in "Drawing the Maxim from the Minim") for his closer acquaintance with *La perspective curieuse*. The strongest evidence for this is Duchamp's clear reference, in conceptualizing the Wilson-Lincoln system, to the perspectival device illustrated by Nicéron in plate 43 of *La perspective curieuse*, an illustration that does not appear in *Thaumaturgus opticus*, which concludes with plate 42. Up until plate 42, the illustrations in *Thaumaturgus opticus* appear to correspond with those in *La perspective curieuse*; see Jean-François Nicéron, *Thaumaturgus opticus* (1646), Getty Research Library, available online through Internet Archive at http://www.archive.org/details/rpioannisfrancis00nice, accessed November 28, 2011.

17 For a good description of the operation of such "a pleated perspective with a mirror," see Shickman, 226.

18 On Duchamp's "playful physics," see Duchamp, *The Writings of Marcel Duchamp*, 49.

19 In the original Duchamp wrote "right" here, but indicates in a 1959 correction of the notes that he had intended to write "left." See Marcel Duchamp, *Notes and Projects for The Large Glass*, ed. Arturo Schwarz (Thames & Hudson: London 1969), n119.

20 Duchamp, *The Writings of Marcel Duchamp*, 65.

21 See Henderson, *Duchamp in Context*, fig. 77, for an excellent diagram of *The Large Glass*, including the location of the horizon and the Wilson-Lincoln system. Another diagram appears in Duchamp, *The Writings of Marcel Duchamp*, 20–21.

22 Marcel Duchamp, *Notes*, ed. and trans. Paul Matisse (Paris: Centre George Pompidou, 1980), n67.

23 Duchamp, *The Writings of Marcel Duchamp*, 96–97.

24 See Anne Collins Goodyear, "Constructing a 'Made-Up History': Self-Portrayal and the Legacy of Marcel Duchamp," in *Inventing Marcel Duchamp: The Dynamics of Portraiture*, ed. Anne Collins Goodyear and James W. McManus (Washington, DC: National Portrait Gallery, Smithsonian Institution; Cambridge, MA: MIT Press, 2009), 86.

25 Duchamp, quoted in Jeanne Siegel, "Some Late Thoughts of Marcel Duchamp, from an Interview with Jeanne Siegel," *Arts Magazine* 42, no. 3 (December 1968/January 1969): 22.

26 Takiguchi's *To and From Rrose Sélavy*, a metaphorical "shop for objects," featured a Japanese translation of puns by Rrose Sélavy along with prints by Jasper Johns, Shusaku Arakawa, and Jean Tinguely. See Goodyear and McManus, *Inventing Marcel Duchamp*, 266–67.

27 Shuzo Takiguchi, Preface to "Toward Rrose Sélavy: A Marginal Note to *To and From Rrose Sélavy*," *To and From Rrose Sélavy* (Tokyo: Rrose Sélavy, 1968), 1. Takiguchi also recounts this story in Shuzo Takiguchi, "Contribution to 'A Collective Portrait of Marcel Duchamp,'" in *Marcel Duchamp*, ed. Anne d'Harnoncourt and Kynaston McShine (New York: Museum of Modern Art, 1984), 222.

28 Duchamp, *The Writings of Marcel Duchamp*, 94.

29 Duchamp, *The Writings of Marcel Duchamp*, 101. Note that this particular note is signed and dated 1965 by the artist.

30 See Rosalind E. Krauss, "Notes on the Index: Part 1," in *Originality of the Avant-Garde and Other Modernist Myths* (1985; repr. Cambridge, MA: MIT Press, 1993), 202; Amelia Jones, *Postmodernism and the En-Gendering of Marcel Duchamp* (Cambridge: Cambridge University Press, 1994), 143; James W. McManus, "Not Seen and/or Less Seen: Hiding in Front of the Camera," in Goodyear and McManus, *Inventing Marcel Duchamp*, 61; and Henderson, *Duchamp in Context*, 186.

31 In the spring of 2010 another intriguing and unconventional portrait drawing of Duchamp by Kiesler from the same period (ca. 1947–48) came onto the market. The work features a three-quarters view of Duchamp's head, seemingly in anamorphic distortion. The artist is seated. His body, clothed in a suit is rendered sketchily while his head, right arm, pipe, and right shoe receive the most embellishment. The work is now in the collection of the Philadelphia Museum of Art (2010-66-1).

32 As noted by Hans Belting (Belting, *Looking Through Duchamp's Door*, 64–66), *Life* ran a cover story on the adoption of these new forms by upscale

New York City department stores, personifying the "dummy" they showcased with the name "Grace." See *Life*, July 12, 1937, cover and story, 32ff.

33 Lewis Kachur makes this observation in *Displaying the Marvelous: Marcel Duchamp, Salvador Dali, and Surrealist Exhibition Installations* (Cambridge, MA: MIT Press, 2003), 47.

34 Duchamp, quoted in Cabanne, *Dialogues with Marcel Duchamp*, 65.

35 Man Ray, quoted in Kachur, *Displaying the Marvelous*, 47.

36 As a pair, the mannequin and drawing also echo Duchamp's *Self-Portrait at Age 85*, created for the March 1945 issue of *View*. In the publication, Duchamp juxtaposed the new work with one of Stieglitz's 1923 photographic portraits of him. Intriguingly, Duchamp would simultaneously create a three-dimensional life cast of himself at the same time he made his "aged" self-portrait. See Anne Collins Goodyear's entries on *Marcel Duchamp at the Age of Eighty-Five* for *View* and Ettore Salvadore, *Marcel Duchamp*, cast 1963, in Goodyear and McManus, *Inventing Marcel Duchamp*, 196–99.

37 Duchamp, quoted in Cabanne, *Dialogues with Marcel Duchamp*, 40. The passage is quoted in Henderson, *Duchamp in Context*, 81; Henderson's study provides detailed discussions of the four-dimensional nature of the Bride's realm and Duchamp's interest in non-Euclidean geometry more broadly. For related notes by Duchamp, included in *À l'infinitif*, see Duchamp, *The Writings of Marcel Duchamp*, 88–89, 91.

38 For other possible interpretations of the phrase, cf. Thomas Singer in "In the Manner of Duchamp: 1942–47; The Years of the 'Mirrorical Return,'" *Art Bulletin* 86, no. 2 (June 2004): 347.

39 Goodyear and McManus, *Inventing Marcel Duchamp*, 202–5.

40 See Goodyear and McManus, 146–47.

41 Quoted in Dawn Ades, "Duchamp's Masquerades," in *The Portrait in Photography*, ed. Graham Clarke (London: Reaktion Books, 1992), 106. Duchamp was responding to a question posed by Serge Stauffer; see Stauffer, *Marcel Duchamp: Die Schriften* (Zurich: Regenbogen-Verlag, 1981), 178.

42 On Duchamp's invocation of layered male and female identities, particularly as concerns Rrose Sélavy, see David Hopkins, *Dada's Boys* (New Haven, CT: Yale University Press, 2008), esp. 53–63.

43 As Herbert Molderings and James W. McManus have pointed out, interest in the work of the early-nineteenth-century German philosopher Max Stirner enjoyed a renaissance in the opening decades of the twentieth century (Molderings, *Duchamp and the Aesthetics of Chance*, esp. 133–44; see also McManus, "Not Seen and/or Less Seen: Hiding in Front of the Camera," 62.)

44 Duchamp, quoted in Molderings, *Duchamp and the Aesthetics of Chance*, 140.

45 Molderings, 138.

46 Max Stirner, *The Ego and Its Own*, ed. Benjamin R. Tucker, trans. Steven T. Byington, pref. James L. Walker (New York: Benjamin R. Tucker, 1907), http://www.lsr-projekt.de/poly/enee.html, accessed November 27, 2011. All quotations are from this online publication of the book; emphases within quotations are my own.

47 See James W. McManus, "Voici Rrose Sélavy," in Goodyear and McManus, *Inventing Marcel Duchamp*, 158–59.

48 Stirner, *The Ego and Its Own*, emphasis mine.

49 James W. McManus has argued persuasively that Duchamp, in this instance, casts himself in the guise of Mercury, the god of commerce appropriate to such a commercial document, and Duchamp and Rrose Sélavy serve as co-signatories for the enterprise; James W. McManus, "Rrose Sélavy: Machinist/ Erotaton," in *Duchamp and Eroticism*, ed. Marc Décimo (Newcastle, UK: Cambridge Scholars Press, 2007), 66–70. See also a discussion of the work, by McManus and Anne Collins Goodyear, included in Goodyear and McManus, *Inventing Marcel Duchamp*, 170–72. However, it is also worth taking seriously the response of scholars, such as David Joselit (see Joselit, *Infinite Regress* [Cambridge, MA: MIT Press, 2001], 101) as well as Duchamp's contemporaries, that the artist also seems to resemble a satanic figure, thus recalling Stirner's invocation of the devil. A contemporary announcement by Jane Heap for *The Little Review* described Duchamp's image as "devil-like" and noted that "Rrose Sélavy (a name by which Marcel is almost as well known as by his regular name) appears as president of the company." See J[ane] H[eap] "Comment" [advertisement for *Monte Carlo Bond*], *The Little Review* 10, no. 2 (Fall–Winter, 1924–25): 18. Reprinted in Duchamp, *The Writings of Marcel Duchamp*, 185.

50 Ecke Bonk, *Marcel Duchamp: The Portable Museum*, trans. David Britt (London: Thames & Hudson, 1989), 96.

51 The definitive source on the work is Bonk's *Marcel Duchamp: The Portable Museum*. In addition to the deluxe edition—Series A—6 additional series (through Series G) were published. Twelve additional items were added to the Series F and G boxes, bringing the total number of reproduced works to 80 (as one of the 69 items in the deluxe box was an original work of art).

52 Calvin Tomkins, *The Bride and the Bachelors* (1968; repr. New York: Penguin Books, 1976), 47.

53 Marcel Duchamp, in conversation with James Johnson Sweeney, "A Conversation with Marcel Duchamp," televised interview for NBC conducted in 1955 and aired in January 1956, edited version published in Duchamp, *The Writings of Marcel Duchamp*, 133. Quoted in Tomkins, *Duchamp*, 393.

54 Duchamp, "The Creative Act," in *Marcel Duchamp*, ed. Robert Lebel, trans. George Heard Hamilton (1959; repr. New York: Paragraphic Books, 1967), 78.

55 Marcel Duchamp, interview with Otto Hahn, *Paris-Express*, July 23, 1964, 22–23, reprinted in *Étant donnés* 3 (2001): 112–4, quotation appears on p. 114, translation mine. Also referenced by Thomas Singer in "In the Manner of Duchamp." Duchamp's remark concerned his pseudonym, Rrose Sélavy.

# MAKING SENSE OF OUR SELFIE NATION

Richard H. Saunders

"Our bodies are now extensions of data networks, clicking, linking, and taking selfies." —Nicholas Mirzoeff[1]

If the invention of photography in 1839 and its explosive growth in subsequent decades fostered a revolution— granting people of all social strata the opportunity to access images of themselves—it has been dwarfed in recent years by the rise of the internet. By the end of this decade, an estimated five billion people will be on the internet—the first medium of universal communication.[2] One increasingly prominent element in that communication is the dissemination of self-portraits, or selfies: pictures we take of ourselves, most often with a digital camera or a smartphone. Today, selfies are everywhere. While many countries have been quick to embrace the selfie, Americans are among the forefront in the creation and sharing of this form of digital communication. According to one source, every two minutes Americans take more pictures than were created in the entire nineteenth century.[3] The selfie is but one aspect of the new visual culture with which we surround ourselves.

The official arrival of the selfie to mainstream America might be dated to December 10, 2013, the day that President Obama posed, along with British Prime Minister David Cameron, for Danish Prime Minister Helle Thorning-Schmidt's selfie at Nelson Mandela's memorial service (fig. 14.1). That same year, the *Oxford English Dictionary* named *selfie* its International Word of the Year.[4] In April 2016, Snapchat, the image-messaging and mobile media application, announced it had hit ten billion daily video views. That same year, it reported that almost nine thousand images were posted to its site each second, and of these, 5 percent were selfies. According to *Adweek*, "Millions are shared each and every day across all the major social media platforms," while "Samsung reports that selfies make up almost one-third of all photos taken by people aged 18–24."[5] Pew's Internet and American Life project, for example, found that 92 percent of teenagers who use Facebook upload pictures of themselves.[6] The selfie was given enormous visibility at the Academy Award ceremonies in 2014—with a nudge from sponsor Samsung

**Fig. 14.1**
President Barack Obama, Danish Prime Minister Helle Thorning-Schmidt, and British Prime Minister David Cameron at Nelson Mandela's memorial service, December 10, 2013
CHP/FameFlynet Pictures

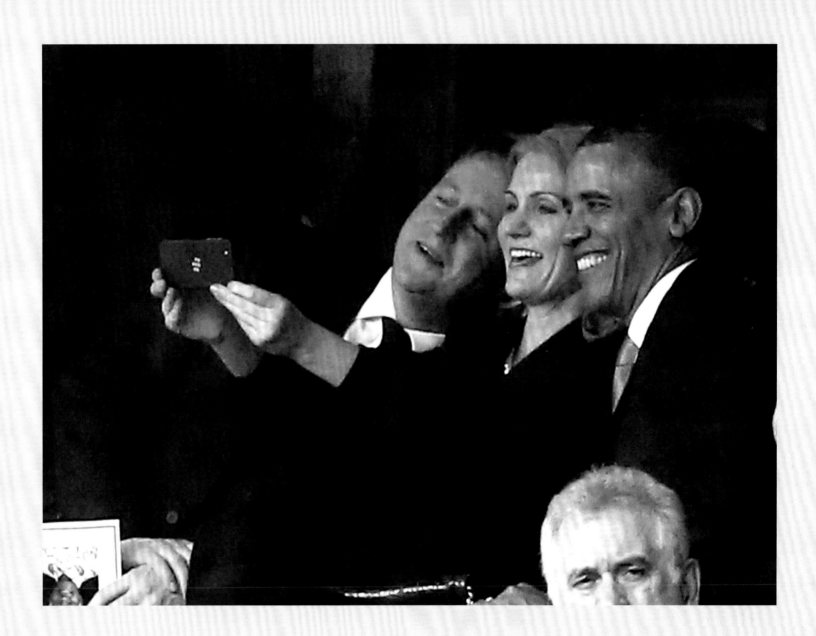

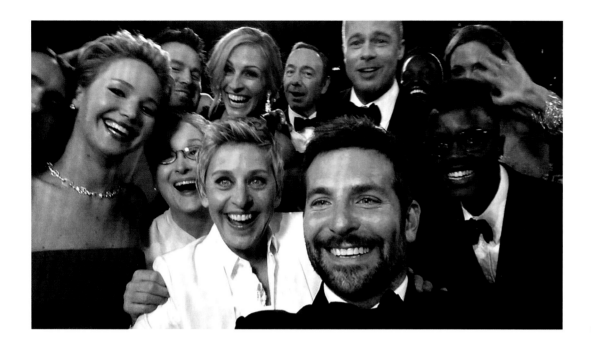

Fig. 14.2
Bradley Cooper taking a group selfie at the 2014 Academy Award ceremonies

Electronics—when Ellen DeGeneres invited Bradley Cooper to take a group selfie of award nominees (fig. 14.2). As a consequence, the image became the most widely shared selfie of all time and was only recently surpassed. Now we even celebrate National Selfie Day: June 21, the longest day of the year.[7] And as of June 2016, if we find ourselves in Sugar Land, Texas, we can take a selfie next to the life-size bronze *Selfie* statue of two teenaged girls photographing themselves with a smartphone.[8]

The word *selfie* itself has been around only for about fifteen years. While its precise origin is unknown, a strong argument has been made for its first recorded use being September 13, 2002, in an online forum in Australia, a country where words are commonly shortened with "-ie" endings, such as *Aussie* (short for *Australian*) and *barbie* (short for *barbeque*).[9] But regardless of the word's origin, there is agreement that it is used to describe pictures we take of ourselves and then share with others via the internet.

The worldwide ubiquity of the selfie is a given today, but prior to the advent of photography in the nineteenth century, creation of self-portraits was limited to professional and amateur artists who painted, drew, or sculpted them,

or incised them on a metal plate for printing. While some of these images, such as pencil drawings, might be rapidly executed and sketchily drawn, others, such as painted portraits and stone or bronze sculptures, were elaborate and time-consuming affairs that represented a concerted effort by the artist to record his or her likeness for posterity. They were not the result of spontaneous decisions but rather a belief in the importance of recording a realistic likeness that reflected an enormous seriousness of purpose. Unlike the selfie, they could not be shared easily with others.

But all that changed, beginning in 1839, when those experimenting with the medium of the daguerreotype realized that, along with images of objects, landscapes, and other people, they could record their own images as well, more quickly and accurately than had previously been possible (fig. 14.3). Within a few short years, as photographic technology rapidly evolved, taking pictures

Fig. 14.3
*Self-Portrait* by Robert Cornelius, believed to be the earliest extant portrait photograph, 1839.
Quarter-plate daguerreotype, 12 × 9.4 cm (4¹¹⁄₁₆ × 3¹¹⁄₁₆ in.)
Library of Congress; Prints and Photographs Division

**Fig. 14.4**
Photo-booth snapshot of John F.
Kennedy and Jacqueline Bouvier
Kennedy, 1953
Courtesy of John F. Kennedy
Presidential Library and Museum

of oneself became ever more possible. The carte de visite, invented in France in 1854 and introduced in the United States at the end of the decade, was a portrait photograph, albeit taken in a photographer's studio, that could be produced as a multiple and given to friends and exchanged.[10] As early as 1862 it was observed: "Cartes de Visite are a curious study. Twelve months ago they were almost unknown; now they fill one or more volumes on every center-table, and overshadow the contents of every card basket. There must be a secret connected with this sudden and astonishing popularity, and the secret, undoubtedly, is self-love."[11]

Among the most significant nineteenth-century developments in photography was George Eastman's

invention of the small, handheld box camera that radically expanded the market for images; for the first time, anyone who could afford to buy a camera could take their own pictures. No longer was it necessary for the average citizen to visit the photographer's studio to have his or her image recorded. As film became less expensive, the entire process of recording a likeness became more accessible. As a consequence, the enormous gravitas with which someone might have approached the experience of having a likeness recorded—in the studio of the painter, sculptor, or photographer—was reduced. Anyone with a camera could take a self-portrait using a mirror.

Over time, other technical improvements made photographic self-portraits by amateurs more prevalent. A key development in the evolution and accessibility of the self-portrait was the invention of the self-timer—a precursor to the selfie stick—which seems to have occurred as early as 1901 but was only popularized around 1918 when Kodak first advertised a compact device.[12] It allowed the photographer, after arranging the composition, to set a time from thirty seconds to three minutes and then "get in the picture." With this invention, every amateur photographer was now in complete control of taking his or her self-portrait.

The rise of the automated photo booth in the 1920s was another important precursor to the selfie. Its concept was simple: in exchange for twenty-five cents, the booth provided passersby with a strip of eight small black-and-white portraits in about two minutes. The booths had enormous appeal: they provided cheap, immediate results, and, in part because of their anonymity, they attracted couples on dates (fig. 14.4).[13] Photo-booth strips became an inexpensive way to share self-portraits with friends.

In the years immediately after the Second World War, increasing numbers of Americans were drawn to the Polaroid instant camera, invented by American scientist Edwin H. Land—the latest device for taking informal portraits with immediate results. Polaroid film first produced

Fig. 14.5
*Mary Jean Mitchell Green* by Andy Warhol, 1976
Polaroid, 10.8 × 8.6 cm (4 1/4 × 3 3/8 in.)
The Art Institute of Chicago; gift of The Andy Warhol Foundation for the Visual Arts

black-and-white prints, but in 1963 color became available. The Polaroid process enabled users to create the first instantaneous portraits.[14] While the deficiencies of Polaroid instant cameras were significant—film colors were unstable and both focal length and print quality were limited—they were enormously popular because of their ease of use and the immediacy of results. Their impact on society portraiture proved enormous: Andy Warhol used the medium to revolutionize the format and character of portraits for wealthy Americans (fig. 14.5).[15]

## THE SMARTPHONE

But all of this is simply a preamble to events of recent years. Martin Cooper invented the modern cellular mobile phone in 1973, but it would be more than a decade before it was commercially available, as the Motorola DynaTAC8000X. In subsequent years, phones became both steadily smaller and capable of an ever-increasing number of applications. During the 1990s several manufacturers experimented with connecting devices wirelessly to the internet, which allowed for instant media sharing. On June 11, 1997, Philippe Kahn shared instantly with more than two thousand people the first pictures of his daughter born in a hospital in Santa Cruz, California—the first documented transmission of a publicly shared picture (although not a selfie) via a cell phone.[16] Six years later, cell phones with a second, front-facing camera were released by Sony Ericsson and Motorola. But large-scale recording and sharing of selfies virtually exploded in 2010 when Apple introduced its enormously popular iPhone 4, accompanied by an increase in the popularity of websites where selfie images could be shared.

## MAKING SENSE OF OUR SELFIES

The selfie is a recent development in Americans' search to define themselves and their place in society, but is selfie America—preoccupied with "vanity, narcissism, and our obsession with beauty and body image"[17]—really that different from pre-selfie America? Perhaps much less so than we would like to think. As Dr. Pamela Rutledge, director of the nonprofit Media Psychology Research Center, has observed, "We are hard-wired to respond to faces. It is unconscious. Our brains process visuals faster, and we are more engaged when we see faces. If you're looking at a whole page of photos, the ones you will notice are the close-ups and selfies."[18]

When selecting selfies for online sharing, one dominant criterion is presenting ourselves in the best possible way to avoid embarrassment.[19] But this is really no different from eighteenth-century America, when the primary means of recording one's portrait was the painted canvas, and only about 1 percent of the population could afford to have their portrait painted.[20] A primary consideration in making a portrait was conforming to one's idealized image. As a consequence, sitters avoided painters whom they felt might paint unflattering likenesses, and painters often made sitters appear younger, thinner, and taller than they actually were.[21] Likewise, portrait painters avoided painting blemishes, just as we can remove them today with such features as Instagram editing filters[22] (fig. 14.6).

For centuries Americans have used portraits of ourselves to define our place in society. For example, those wealthy enough to do so might have had a portrait painted in the setting of their home, which served as a symbol of cohesion and family identity. Similarly, since the advent of photography, we have taken both formal and informal portraits of ourselves as part of various social rituals or gatherings such as family reunions, birthdays, or holiday celebrations. Selfies at these events are really nothing more than the continuation of customs via the most recent technology available.

Not surprisingly, selfies are particularly popular with adolescents and other young users; not only have they grown up entirely in the digital age, but many are at a point in their personal lives where they are beginning to define and reveal their individual identities. For one thing, selfies, as Uschi Klein has pointed out, tend to be relationship focused rather than task focused.[23] In a world where crafting an identity and building a social network are central, selfies are a logical form of expression. Statistics also suggest that more selfies of younger people depict women, while after age forty more men than women are posting selfies. Why this is so remains unclear.[24]

Like other forms of portraiture, selfies are created for specific reasons determined by their creators. As Jerry Saltz has observed, "They are never accidental: Whether

**Fig. 14.6**
Instagram editing filters

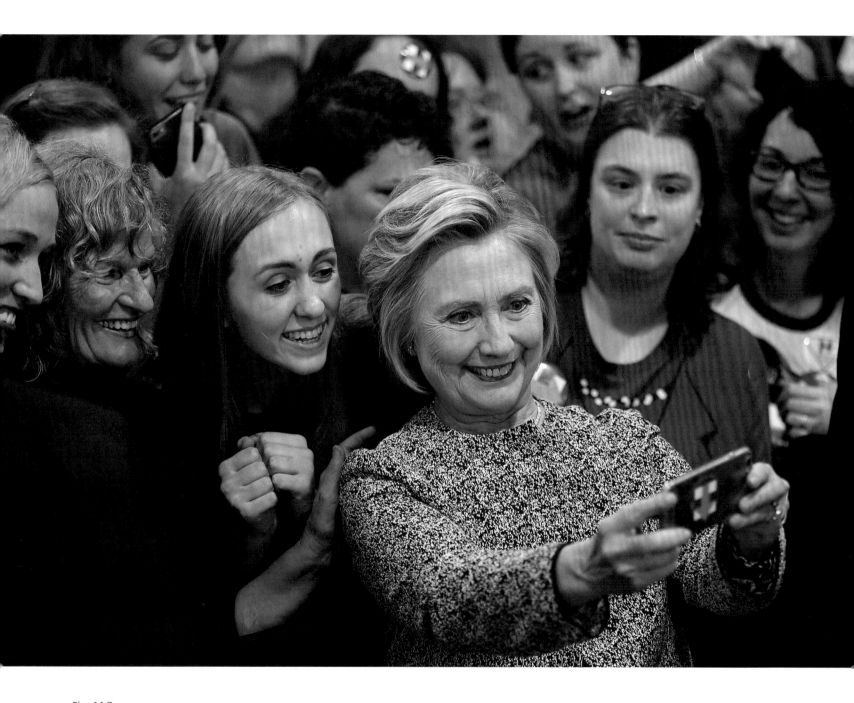

Fig. 14.7
Hillary Clinton takes a selfie with supporters during a
campaign stop on May 1, 2016, in Indianapolis
Joe Raedle/Getty Images

carefully staged or completely casual, any selfie that you see had to be approved by the sender before being embedded into a network."[25] We can divide selfies into various types, including mirror-selfies, ego-shots, PHOBARs (Photoshopped beyond all recognition), and nudes,[26] as well as into subsets that help to reveal their social function.

Selfies reveal a great deal about our social values. For example, we take selfies that shout "Look at our beautiful family!" as procreation and the family continues to be one goal of many Americans, although the idea of the stable, nuclear family is increasingly less common than one might think.[27] We take "I won" selfies, which reinforce our sense of self-esteem and remind us we are victors in our chosen fields. "I made it" selfies record important societal markers, and "I am somebody" selfies show that even though we may not be leaders or celebrities ourselves, we have had contact with such people (fig. 14.7). "I belong" group selfies—in which we are surrounded by friends from school, business, religious, military, political, or social organizations—document relationships beyond the family. And "I exist" selfies share our most banal experiences with friends and family. In one mode of these images, labeled "arties," we photograph ourselves with an acclaimed work of art in a museum to demonstrate that we have seen it.[28] These selfies—like so many photographic portraits from earlier times—enhance our sense of ourselves within a specific community, affirming our individual selves while helping us feel connected to others and part of the modern world. In many ways, these images have taken the place of film snapshots, as well as handwritten letters and diaries, as a way of recording the paths of our personal histories.

One primary difference between the snapshot of past years and the digital selfie is that we do not need to record the images on film, send them off to be developed, and then dispose of images that do not meet our personal standard. We can view, approve, and upload them instantly. This lack of delay, and an enforced pause for reflection, may mean that some selfies (like some emails) might be

better off not having been sent, including intimate selfies intended exclusively for one viewer. An infamous example of this form of selfie—generally shared via personal messages rather than posted to online social platforms, referred to as "sexting"—is a sequence of revealing images sent by former Congressman Anthony Weiner to online acquaintances in 2015 and 2016. When these selfies were shared beyond their intended audience, Weiner resigned from Congress.[29]

In an age in which past standards of decency and decorum are under constant assault, the selfie has been used to test the limits of public tolerance. Because smartphones are always with us, the opportunities to take selfies are limitless. When disasters happen—planes crash, buildings burn, cars collide, and crimes are committed—we are there, often camera and selfie stick in hand, to record the fact that we are part of the current news cycle (fig. 14.8). Similarly, our race to be part of a larger story has led to disturbing subgenres of selfies, where people put themselves in enormous physical danger to photograph themselves demonstrating bravado: driving cars, climbing radio towers, hanging from buildings, approaching wild animals. In worst-case scenarios, some of these stunts have led to injury and death.[30] In addition, some selfies are used to record self-harm.[31] The rise in this type of selfie may reflect "the Internet's relative anonymity [which] has long afforded marginalized communities a refuge to express themselves with little fear of stigmatization."[32]

Jon Wargo has argued that we use selfies as a way to index our identity and curate our digital portrait, and in so doing develop what some have called our digital lifestream, which functions as a diary of our electronic life.[33] One example of this phenomenon is "365" projects, in which people take selfies every day over the course of a year, to record and document change.[34] In one sense, this is a telescoped version of the life-long project of Ivan Albright, the American painter who created a sequence of numerous self-portraits over fifty years.[35]

At this point in the selfie age, there is little agreement as to what benefits this practice affords us. As Noah Berlatsky has pointed out, where some people see selfies as a form of empowerment—for young women in particular—others condemn them as just the most recent phenomenon that encourages women to obsess over their bodies.[36] Indeed, it has been shown that a feeling of discomfort with personal appearance, such as having a receding chin, has in some cases has led to a decision to have cosmetic surgery.[37]

This shift toward an increased emphasis on the self was seen some years ago by the literary critic Lionel Trilling as the twentieth century's displacement of an earlier focus on character and sincerity.[38] One might speculate that, as more Americans abandon such historically important social structures as organized religion, our secularized lives are increasingly dependent on other devices—such as selfies—to provide order and structure to our daily lives. So today's focus on curating our online profile through shared selfies and other electronic means is how we in part fill our secularized void. We craft our identity through fitness regimens, dieting, cosmetic surgery, travel, fashion, and the accumulation of material objects, all of which—like the selfie itself—contribute to our need for self-esteem and relieves any self-doubt about having a meaningful place in society.[39]

These images, when assembled in groups like those found in leather-bound family albums of years past, provide revealing glimpses of our perceived place in American life. They are the visual equivalents to written texts such as diaries and letters. While they can serve as a guide and give structure to memory, these selected images in the past have been called a "matrix of illusions," as they reveal only aspects of our lives that we wish to choose to save.[40]

## CELEBRITIES

One important selfie subgenre is celebrity selfies. There is little agreement about what constitutes a celebrity, but a useful definition is a person who leads a public life, is well known for accomplishments of interest to the public,

actively seeks to maintain that status of being well known, is highly visible in the media, and somehow connects to the public at a subconscious level.[41]

While celebrity portraits have been around at least since the eighteenth century, they have become big business and today occupy an enormous part of American visual culture. One of the primary social media vehicles for celebrity culture is Instagram, which in September 2017 had a user base of 150 million people. This has given rise to what has been called "Instafame," the phenomenon of having a relatively large number of followers on the app.[42] While conventional celebrities, such as pop star Rihanna, for example, might have millions of followers, the Instafamous, or microcelebrities as they have been labeled, have followers numbering only in the hundreds or thousands, but obsessively post well-rehearsed, celebrity-style selfies that document their "outfits, cars, vacations and landscapes."[43]

In a recent article in the journal *Celebrity Studies*, Anne Jerslev and Mette Mortensen argue persuasively for the enormous importance that the celebrity selfie holds for the average person. Such images serve as a vehicle for social bonding with fans, advertise new artistic products and consumer goods, and supply content to celebrity and entertainment news. Selfies serve to sustain celebrity capital and continuously reinforce branding. They appeal to followers through the allure of a desirable career, a fit

**Fig. 14.8**
*So Yup* by Hannah Udren (@han_horan), March 13, 2014
Digital photograph posted on Twitter, https://twitter.com/han_horan/status/444246200451989504
The impetus for this selfie was, not as some might assume, a wish to simply record being at the scene of a disaster. Rather, as explained by the photographer's father, "The first my wife and I heard about the 'plane crash' was this picture from Hannah. She sent it with a comment that let us know right away that she was OK so we would not worry when we later heard the news. I'm sure I don't need to tell you how relieved we were to get the 'good' news first. . . . So, you have more than just a selfie from some kid, you have a selfie from a kid who realized the importance of this kind of news to one's parents."

and styled body, and an enviable level of consumption. By constantly posting different selfies, celebrities also give fans the illusion of a level of intimacy not available elsewhere and a sense of seeing the celebrity's life as it unfolds.[44]

## SELFIECITY AND SELFIES IN THE AGE OF GLOBALIZATION

In February 2014, Dr. Lev Manovich and Software Studies Initiative launched Selfiecity (selfiecity.net), a research project devoted to the collection and analysis of 3,200 selfies, 640 from each of five cities across the globe (Bangkok, Berlin, Moscow, New York, and São Paulo), posted on Instagram.[45] Selfiecity subjected these international selfies to both mechanical and human analyses to determine how selfies on one continent may differ from another, finding, among other things, that people take fewer selfies than often assumed (3–5 percent of uploaded images); the median age for New York selfies is 25.3 years; and women strike more extreme poses than men.[46] Individual selfies, for the most part, may not make much of an impact, but when examined in large numbers they can tell us a great deal about ourselves.

It is not surprising that in an age of globalization, mass production, big business, big government, big media, and standardized public education, we feel a need to reassure ourselves that we are unique and special. Indeed, we are in an age where many of us will go so far as to brand ourselves, and the selfie as self-publicity image is a logical extension of this.[47] In addition to Instagram and Snapchat, which enable us to be the heroes of our daily lives, we now have innumerable devices and apps that collect troves of data about our personal habits in order that we may analyze it and better understand our inner selves and express our individuality.[48] Conveniently, we can share this information with the world. You walked 5,000 steps today? Click here to share on Twitter. You ate at a fancy restaurant? Let Foursquare share it on Facebook. Self-actualization and personal happiness, we are told, is the meaning of life.

It is easy to paint all of this attention on the self as negative. Post–World War II America has seen a steady increase in the concentration of wealth in the hands of an ever-shrinking portion of the population, yet despite this, it has also been a period of unprecedented empowerment, seeing the rise of civil rights movements, Occupy Wall Street, and other protests advocating for social justice. We feel ever more empowered to assert that we are individuals with needs and rights. Although recent world events might make us conclude otherwise, cognitive scientist Steven Pinker has argued that we are generally becoming more and more peaceful.[49] Perhaps all this time we have spent understanding and defining ourselves has, counterintuitively, helped us to realize that those around us are individuals with needs and feelings too.

## WHAT COMES NEXT?

With the past as our guide, we know that current technology, fashion, and social customs will continue to evolve. This is not to suggest that the selfie will vanish—far from it. But the form of the selfie and its use are unlikely to remain static. We know, for example, that there is little agreement on where and when selfies should be taken, as in the ongoing debate over whether selfies should be permitted in voting booths.[50] In addition, we are only beginning to realize the enormous potential that selfies have for practical application. For example, financial-services companies USAA and MasterCard are introducing programs that use the biometric authentication attributes that selfies provide as a security method to replace passwords to log on to their mobile banking apps or withdraw money at ATMs. Several states already allow law-enforcement agencies to use facial recognition as a tool in investigations, while retailers have used it to identify problematic shoppers.[51] In the field of medicine, patients have been encouraged to take selfies to track the progress of medical concerns, and practitioners use them to record how dressings need to be reapplied during in-home treatments.[52] And recently

transport company Uber announced that it will require all drivers to take selfies before signing on to the platform and taking ride requests.[53] The potential of selfies has also not been lost on those wishing to sell us something. For example, to promote the 2016 United States Open Tennis Tournament, organizers offered visitors to New York's Times Square the opportunity to see mega-selfies of themselves on six billboards throughout the area.[54]

Dr. James Canton, longtime CEO and chairman of the Institute for Global Futures and recognized by the *Economist* as "one of the leading global futurists," has given the subject of the future of selfies considerable thought. He believes that selfies are here to stay: "In fact, they're going to morph and change as part of a rich and dynamic media." He predicts that video selfies will, in the next few years, replace the present standard picture selfie and that "augmented reality selfies," which will allow us to project ourselves into other locations around the world, will become part of what he terms the Selfie Economy. In his vision, companies like Apple, Nike, and Philips, as they continue to commodify the self and sell us back our identity, will become creative sponsors for our collective selfie projects. As a result, "Selfies will eventually form part of an energized soup of connectivity of media intelligence. You will be able to say, 'I will be in every place and connected to everyone and everything.'"[55]

Notes

1 Nicholas Mirzoeff, *How to See the World* (New York: Basic Books, 2016), 15.

2 Mirzoeff, 4.

3 Mirzoeff, 4–5. By 2012 we were taking 380 billion images a year.

4 Joseph M. Reagle Jr., *Reading the Comments: Likers, Haters, and Manipulators at the Bottom of the Web* (Cambridge, MA: MIT Press, 2015), 126.

5 Shea Bennett, "The Year of the Selfie – Statistics, Facts & Figures," *Adweek*, March 19, 2014, http://www.adweek.com/socialtimes/selfie-statistics-2014/497309.

6 Cited in Alice E. Marwick, "Instafame: Luxury Selfies in the Attention Economy," *Public Culture* 27, no. 1 (2015): 137–60, http://publicculture.dukejournals.org/content/27/1_75/137.abstract.

7 National Selfie Day website, http://www.nationalselfieday.net, accessed October 2, 2016.

8 Michael Hardy, "Sugar Land Roils Over Selfie Statue," *Texas Monthly*, June 3, 2016, http://www.texasmonthly.com/the-daily-post/sugar-land-roils-selfie-statue/.

9 Karl Kruszelnicki, "A Brief History of the Selfie," *ABC Science*, August 12, 2004, http://www.abc.net.au/science/articles/2014/08/12/4065062.htm.

10 William C. Darrah, *Cartes de Visite in Nineteenth Century Photography* (Gettysburg, PA: W. C. Darrah, 1981), 5.

11 "Cartes-de-Visite," *Humphrey's Journal*, October 1862, quoted in Dan Younger, "Cartes-De Visite: Precedents and Social Influences," *CMP Bulletin* 6, no. 4 (1987): 13.

12 "Recent Patents and Trade Marks," *American Amateur Photographer* 13, no.7 (July 1901): 338. *KODAKS and KODAK SUPPLIES* (Rochester, NY: Eastman Kodak Company, 1918), 58.

13 Richard H. Saunders, *American Faces: A Cultural History of Portraiture and Identity* (Hanover: University Press of New England, 2016), 48.

14 Saunders, 51.

15 Saunders, 22–26.

16 Kevin Maney, "Baby's Arrival Inspires Birth of the Cellphone Camera—And Societal Evolution," *USA Today*, January 23, 2001, http://usatoday30.usatoday.com/tech/columnist/kevinmaney/2007-01-23-kahn-cellphone-camera_x.htm.

17 Jenna Wortham, "My Selfie, Myself," *New York Times*, October 19, 2013, http://www.nytimes.com/2013/10/20/sunday-review/my-selfie-myself.html.

18 Quoted in Wortham.

19 Uschi Klein, "Sharing Selfies," in *Popular Culture as Everyday Life*, ed. Dennis Waskul and Phillip Vannini (London: Routledge, 2015), 89.

20 Saunders, *American Faces*, 4.

21 Saunders, 6, 15.

22 Raymond Wong, "16 Apps That Will Seriously Raise Your Instagram Game," *Mashable*, March 16, 2016, http://mashable.com/2016/03/16/best-instagram-editing-apps/#LLYKxrmlVmqb.

23 Klein, "Sharing Selfies," 92.

24 Kelly Wallace, "Who Takes More Selfies: Women or Men?" *CNN*, October 7, 2014, http://www.cnn.com/2014/02/26/living/parents-selfies-women-over-40-study/.

25 Jerry Saltz, "Art at Arm's Length: A History of the Selfie," *New York Magazine*, February 3, 2014.

26 Katrin Tiidenberg, "Boundaries and Conflicts in a NSFW Community on Tumblr: The Meanings and Uses of Selfies," *New Media & Society* 18, no. 8 (2016): 1564.

27 Debra L. Blackwell, "Family Structure and Children's Health in the United States: Findings from the National Health Interview Survey, 2001–2007," *Vital and Health Statistics*, series 10, no. 246 (December 2010): 1.

28 Tom Jacobs, "And That's Me With the Mona Lisa!" *Pacific Standard*, March 3, 2016, https://psmag.com/social-justice/yeah-honey-this-is-for-sure-a-photo-our-friends-will-care-about.

29 J. J. Gallagher, "A Look Back at Anthony Weiner's Sexting Scandals," *ABC News*, August 30, 2016, http://abcnews.go.com/US/back-anthony-weiners-sexting-scandals/story?id=41735662.

30 Sarah Kaplan, "Washington Man Accidently Kills Himself While Taking a Selfie with his Gun, Police Say," *Washington Post*, March 3, 2016.

31 Yukari Seko and Stephen P. Lewis, "The Self-Harmed, Visualized and Reblogged: Remaking of Self-Injury Narratives on Tumblr," *New Media & Society*, first published online July 28, 2016, https://doi.org/10.1177/1461444816660783.

32 Seko and Lewis.

33 Jon Wargo, "'Every Selfie Tells a Story': LGBTQ Youth Lifestreams and New Media Narratives as Connective Identity Texts," *New Media & Society* 19, no. 4 (2017), first published online October 23, 2015, https://doi.org/10.1177/1461444815612447.

34 John Suler, "From Self-Portraits to Selfies," *International Journal of Applied Psychoanalytic Studies* 12, no. 2 (June 2015), http://dx.doi.org/10.1002/aps.1448.

35 Courtney Graham Donnell, *Ivan Albright* (Chicago: Art Institute of Chicago, 1997).

36 Noah Berlatsky, "Selfies Are Art," *Atlantic*, November 22, 2013, http://www.theatlantic.com/entertainment/archive/2013/11/selfies-are-art/281772/.

37 Reagle, *Reading the Comments*, 127.

38 Reagle, 127.

39 But this is not new, as for years scholars have used such terms as "impression management" to describe the social rituals in self-presentation: see Erving Goffman's use of that term in his 1959 book *The Presentation of Self in Everyday life*, cited in Dannah Boyd, *It's Complicated: The Social Lives of Networked Teens* (New Haven, CT: Yale University Press, 2014), 47.

40 Richard Challfen, "Redundant Imagery: Some Observations on the Use of Snapshots in American Culture," *Journal of American Culture* 4, no. 1 (Spring, 1981): 106–13.

41 Larry Z. Leslie, *Celebrity in the 21st Century* (Santa Barbara, CA: ABC-CLIO, 2011), 17.

42 For statistics, see "Number of Monthly Active Instagram Users from January 2013 to September 2017 (in Millions)," Statista, September 2017, https://www.statista.com/statistics/253577/number-of-monthly-active-instagram-users/. Also see Marwick, "Instafame," 137.

43 Marwick, "Instafame," 137.

44 Anne Jerslev and Mette Mortensen, "What Is the Self in the Celebrity Selfie? Celebrification, Phatic Communication and Performativity," *Celebrity Studies* 7, no. 2 (2016), http://dx.doi.org/10.1080/19392397.2015.1095644,

45 Zach Sokol, "SelfieCity Might Be the Ultimate Data-Driven Exploration of the Selfie," *Creators*, February 19, 2004, https://creators.vice.com/en_us/article/3d5nq9/selfiecity-might-be-the-ultimate-data-driven-exploration-of-the-selfie; Alise Tifentale, "The Selfie: Making Sense of the 'Masturbation of Self-Image' and the 'Virtual Mini-Me,'" February 2014, https://d25rsf93iwlmgu.cloudfront.net/downloads/Tifentale_Alise_Selfiecity.pdf, accessed February 4, 2018.

46 Sokol, "SelfieCity Might Be the Ultimate Data-Driven Exploration of the Selfie."

47 Shama Hyder, "7 Things You Can Do to Build an Awesome Personal Brand," *Forbes*, August 18, 2014, http://www.forbes.com/sites/shamahyder/2014/08/18/7-things-you-can-do-to-build-an-awesome-personal-brand/#309ec66a1274.

48 Laurie Frick, "Will a Data-Selfie Boost Your Immune System?" *Laurie Frick* (blog), March 17, 2015, http://www.lauriefrick.com/blog/will-a-data-selfie-boost-your-immune-system.

49 *The World Is Actually Becoming More Peaceful—Believe It or Not*, produced by Christopher Woolf; broadcast by PRI, September 29, 2014, http://www.pri.org/stories/2014-09-29/world-actually-becoming-more-peaceful-believe-it-or-not. For an opposing argument, see John Gray, "Steven Pinker Is Wrong about Violence and War," *Guardian*, March 13, 2015, https://www.theguardian.com/books/2015/mar/13/john-gray-steven-pinker-wrong-violence-war-declining.

50 Daniel Victor, "Selfies in the Voting Booth? Snapchat Fights for the Right," *New York Times*, April 26, 2016.

51 Jonnelle Marte, "Companies Are Betting on a New Way to Protect Your Identity: The Selfie," *Washington Post,* May 6, 2016, https://www.washingtonpost.com/news/get-there/wp/2016/05/06/companies-are-betting-on-the-selfie-to-protect-your-identity/.

52 Ray Arunava et al., "The Medical Selfie," *British Medical Journal* 351 (2015), https://doi.org/10.1136/bmj.h3145.

53 Andrew J. Hawkins, "Uber Now Requires Drivers to Take Selfies for Added Security," *Verge*, September 23, 2016, https://www.theverge.com/2016/9/23/13030682/uber-driver-selfie-facial-scan-fraud-security.

54 Katie Rogers, "U.S. Open Draws Crowds to Times Square with Promise of Mega-Selfies," *New York Times*, August 25, 2016, http://www.nytimes.com/2016/08/26/business/media/us-open-times-square-billboard-selfie.html.

55 Maseena Ziegler, "The Mind-Blowing Way Selfies Will Change Our Future. Yes, Selfies," *Forbes*, July 14, 2014, http://www.forbes.com/sites/maseenaziegler/2014/07/14/the-mind-blowing-way-selfies-will-change-our-future-yes-selfies-2/.

# HABLA LAMADRE

## MARÍA MAGDALENA CAMPOS-PONS, CARRIE MAE WEEMS, AND BLACK FEMINIST PERFORMANCE

Nikki A. Greene

On April 27, 2014, María Magdalena Campos-Pons, costumed in a startlingly white, hooped dress, processed into the rotunda and up the ramps leading to the second-floor galleries of the Guggenheim Museum in New York, shouting incantations to the hundreds of visitors (fig. 15.1). Eight female attendants sang, accompanied by a band playing Cuban music led by Neil Leonard, Campos-Pons's husband and collaborator. The performance, titled *Habla LAMADRE*, took place during Carrie Mae Weems LIVE: Past Tense/Future Perfect, a weekend of programming featuring artist talks, music, and conversations in celebration of the exhibition *Carrie Mae Weems: Three Decades of Photography and Video*. Campos-Pons invoked the *oricha* Yemayá, a Yoruba-derived goddess, which led to an unprecedented physical and spiritual embodiment of the Guggenheim. On that Sunday morning, Campos-Pons, in that Guggenheim-shaped dress, offered her Afro-Cuban body as a site of the African diaspora and feminism in harmony with Weems—and in dissonance with the museum space—serving to complicate performance art as portraiture within contemporary art.

### YEMAYÁ'S CALLING

María Magdalena (Magda) Campos-Pons was born in 1959 in La Vega, a sugar plantation town in the province of Matanzas, Cuba. She attended the Instituto Superior de Arte (ISA, the Graduate Institute of Art) in Havana between 1980 and 1985, and she taught at ISA from 1986 until 1988, when she left Cuba to spend the spring semester at the Massachusetts College of Art in Boston, in the continuing education master's degree program. That same year, Campos-Pons met Neil Leonard (b. 1959), when she needed sound elements for the video *Rito de iniciación/ Rite of Initiation* (which they later produced in 1991) (fig. 15.2). They were married in Cuba in 1990, returning often since 2001, when it became safe for Campos-Pons to move freely between the United States and Cuba. Campos-Pons taught for many years at the School of the Museum of Fine Arts at Tufts University and now teaches at Vanderbilt University.[1] With Leonard, she founded GASP (Gallery Artists Studio Projects) in Boston, a lab and studio.[2]

**Fig. 15.1**
María Magdalena Campos-Pons and Neil Leonard during the performance of *Habla LAMADRE* at the Solomon R. Guggenheim Museum, New York, April 27, 2014

Fig. 15.2
Still from *Rito de iniciación/Rite of Initiation* by María Magdalena
Campos-Pons and Neil Leonard, 1991
Film (color, sound), 31 min
Commissioned by Western Front, Vancouver; courtesy of the artists

Through his musical and sound compositions, Leonard has complemented and expanded the scope of Campos-Pons's oeuvre. As noted by author Nancy Pick, the two artists have "created a synthesis of art and music, Afro-Cuban and American, ancestral and electronic."[3]

Leonard was a visual artist before turning to electronic music as a passion in the late 1980s, around the time he and Campos-Pons first met. She, too, was an avid musician, having played the oboe. Leonard had already amassed an impressive Cuban album collection before he met his wife, a precursor to a lifelong commitment to acquiring a deep knowledge of music from the island. Leonard intuitively aids Campos-Pons's projects because he understands that "there are things that Magda can't get at through the visual . . . and I find what she can't do and I fill that with music."[4] He frequently plays with Cuban musicians, and often invites some of the best players to perform in concerts and alongside him and Campos-Pons for recordings, installations, and live performances, including *Habla LAMADRE*. Campos-Pons says of Leonard's strengths, "What Neil does so beautifully is to take sound bites of Cuban traditional music and bring them into the twenty-first century. This Yankee, with an ear that is open and sensitive, is able to distill Afro-Cuban music into something different."[5] Campos-Pons's active and consistent collaboration with Leonard enhances her performances, and their sound compositions create a more dynamic environment for all visitors to her installations.

In preparation for her exhibition *Alchemy of the Souls: María Magdalena Campos-Pons* at the Peabody Essex Museum in Salem, Massachusetts, she returned, with Leonard and curator Joshua Beseeches, for the first time to La Vega in September 2015 to observe the ruins of the sugar plantation she grew up on and that she had left nearly thirty years ago.[6] Campos-Pons confesses that "it took [coming] to America and [having] a separation from Cuba to look back and kind of reframe and refocus everything."[7] In La Vega, Campos-Pons's Yoruba

descendants from Nigeria cultivated sugar for generations. She grew up learning about the legacy of slavery firsthand, along with the traditional beliefs held within Santería, a Yoruba-derived religion.[8] As a recognition of the labor of the many black bodies within her family, and within the Americas in general, that endured the Middle Passage in order to harvest crops in places like her native Cuba, Campos-Pons continues to recall and honor the struggle, pain, and survival of her African ancestors through her multimedia presentations in photography, sculpture, and, indeed, performance.

Campos-Pons's performances derive from a direct knowledge of the labor practices and the religious ceremonies, objects, and movements dictated by Santería. Certainly, iterations of these exercises continue to thrive in Santería not only in Cuba, but also throughout North and South America, including the United States. They also vary within different countries and cultures, as in Candomblé in Brazil, and Vodun or Voo Doo in Haiti and Louisiana, respectively. As a trained painter whose work has matured to include multimedia designs and presentations, including sculpture, installations, photography, and video, Campos-Pons articulates her own vision in ways that encompass the worlds of Afro-Cuba and the United States seamlessly. The stunningly complex beauty of the representation of *orichas* as a central component of her own identity has consistently been a successful strategy for combining those respective worlds.[9]

Carrie Mae Weems specifically asked that Campos-Pons and Leonard perform *Habla LAMADRE* on Sunday around the typical time to attend church, marking their performance specifically as a religious ritual, with the Guggenheim standing in for the place of worship. The "service" began at 11 o'clock in the morning for that reason. Starting outside on the lower ramp that extends up to the southwest corner of the Guggenheim, Campos-Pons leads the procession of eight attendants, Cuban batá drummers brought in from Cuba, and brass players,

including Leonard on saxophone. At first only the drummers and their chants sound as they all enter the building from Fifth Avenue. Campos-Pons commands the space of the museum's main rotunda, gripping a bouquet of roses in her right hand and a white and blue tureen, known as a *sopera*, in her left.[10] Her entrance is the invitation to viewers to observe the ritual and to ostensibly participate by virtue of their presence. She begins with an entreaty to the gods:

I ask for your permission to be here
I ask for your blessing to be here
Yemayá, mother of the water, owner of the sea
I ask for your provision to embody for a moment
this sacred institution.
Mother! Are you with me?
Take all of me in this moment.
Father! Are you with me?
Take all of me in this moment.
Obatala, Eshu, Ogun, Ochosi, Shango, Oya
Take all of me and guide me in these few moments.
It took a long time for us to be here.

Dear Mother, owner of the water and the deep sea
Bless Carrie who kicked the door [open] and let us [enter] here.[11]

Yemayá is one of a pantheon of Yoruba *orichas*, or gods, one of the *Siete Potencias* (seven powers), along with Obatala, Eshu, Ogun, Ochosi, Shango, and Oya. Campos-Pons has documented and invoked the Seven Powers prominently in her earlier works, such as the multimedia installation *The Seven Powers Come by Sea* (1992) and the framed series of black-and-white photos with overpainting titled *The Seven Powers* (1994). The *orichas* are honored for important reasons. As Alan West-Durán points out, "despite the depiction of dehumanization and commodification, the orichas' presence reminds one that the kidnapped Africans were human beings, with a culture, beliefs, and profound

relationship to their ancestors."[12] In *Habla LAMADRE*, understanding the full impact of each oricha's presence, but most especially of Yemayá, Campos-Pons engages each attendant as a representative *oricha*. Soon after she enters the rotunda, Campos-Pons's entourage encircles her as she stands on a square, blue piece of fabric. The artist begins a call and response with each one, shouting "Yemayá!" as they bellow back refrains. One of the most powerful requests from Campos-Pons to Yemayá during the ritual in the Guggenheim is that she "show the power of the black body and show the power of the black." Campos-Pons continues, "It took a long time to be here, but we are here. Àshe! We are with our sister Yemayá." Next, she elegantly swooshes the temporary rug of fabric from beneath her into the air as she sways and dances in circles, transforming the cloth into a *paño*, used in Santería ceremonies "during drummings to bless and 'cleanse' participants."[13]

Yemayá is Campos-Pons's specific point of reference. Yemayá is the "owner of the water and the deep sea," represented by the color blue in the head wrap and makeup Campos-Pons wears and in the blue dresses of the seven attendants. In line with the Seven Powers, one attendant embodies Yemayá herself, adorned with a more brilliant blue and gold-flecked dress than the others, holding a cake as an offering. She, as Yemayá, is the lead representative *oricha*, and she/they have metaphysically traveled from Cuba to the United States, and as she traverses the gallery spaces of the Guggenheim Museum in New York, Campos-Pons and her entourage enact not simply a "performance" for a museum audience, but rather an authentic Santería ritual, albeit to a public and perhaps an unknowing audience. As Aisha M. Beliso-De Jesús discusses in *Electric Santería: Racial and Sexual Assemblages of Transnational Religion*, "travelers negotiate the complex environment of travel through religious rituals and ontological navigations that form part of the transnational experience of Santería."[14] The space of "African diaspora" tradition has required modifications of Cuban-based Santería practices

depending on location and access to specific objects (for example, in the San Francisco Bay area, substituting a tropical chickweed vine, *cundiammor*, for basil).[15]

Thus, the many performances by Campos-Pons to date are African diasporic, multisensorial Santería practices specifically designed for museum spaces. From her performance of *Regalos/Gifts* at the Indianapolis Museum of Art in 2007, to *The Flag. Color Code Venice 13* at the 55th Venice Biennale in 2013, and *Identified* at the National Portrait Gallery in 2016, Campos-Pons has invested in claiming an African diaspora through her lens, which includes interrogating her African, Cuban, and American identities within the many spaces she controls and occupies. So much of that inspiration for performance art, and, by extension, "body art," stems from the influence of other Cuban artists who have done the same.

Manuel Mendive (b. 1944), perhaps the most famous and revered artist living in Cuba today, has served as a template for Campos-Pons and nearly three generations of artists, especially for those artists interested in invoking *orichas* in paintings and sculptures, and especially in performance art. At the second Havana Biennial in 1986, Mendive arranged the performance of *La vida*, featuring nearly nude painted bodies dancing in the streets of Havana, which officially established for the contemporary Cuban art scene a genre of so-called body art and "the *performance* as a valid mode of visual arts."[16] Mendive is deeply committed to Afro-Cuban culture and aesthetics, and his paintings, sculptures, and performances characteristically portray anthropomorphic animals, especially birds and fish associated with the *orichas* as recognized in Santería. Yemayá, the goddess of water, also doubles as *Caridad del cobre*, the patron saint of Cuba (fig. 15.3).[17] Mendive's admiration of and devotion to Yemayá and Cuba are a reflection of his overall commitment to Cuba.

As assessed by Coco Fusco in her book *Dangerous Moves: Performance and Politics in Cuba*, Mendive's

**Fig. 15.3**
*Aguas de Rio* by Manuel Mendive, 2009
Mixed media, 137.2 × 91.4 cm (54 × 36 in.)
Studio of Manuel Mendive, Havana

choreographed street processions should be more critically viewed as offering a "spectacle of vitality" that "also serve[s] a political function [for the state] as displays of visual excess that seduce foreign audiences with tropical stereotypes, drawing attention away from the ample evidence of material hardship and repression in the urban landscape."[18] Campos-Pons has also succumbed to the "spectacle of vitality" throughout her career. In *Habla*

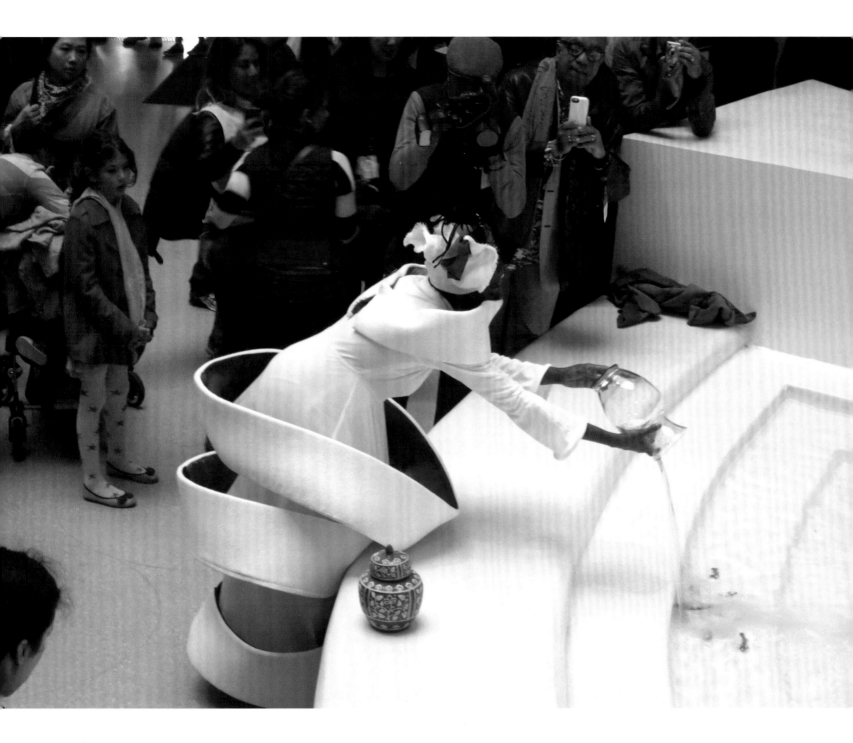

**Fig. 15.4**
María Magdalena Campos-Pons during the performance of *Habla LAMADRE* at the Solomon R. Guggenheim Museum, New York, April 27, 2014

LAMADRE, the artist's procession through the Guggenheim Museum to arrive at Carrie Mae Weems's exhibition on the second floor allows her to be complicit in marking that space, with the museum's permission, as a "spectacle" while simultaneously asserting much more beyond this boundary. What makes her presence there a radical act is the offering of her own black body, which invades the white space of the Guggenheim, a physically white-walled building, but also, bureaucratically, an institution led by a majority of white staff, board members, and donors. She does not portray a "tropical stereotype," but rather the institution itself as she wraps those same white walls around her body through her dress—an original metonymic portrait of the Guggenheim.

The naming of the performance as *Habla LAMADRE* (The mother speaks) refers to Yemayá as the mother of the waters, and also directly references Campos-Pons's own strong relationship with her late mother, Estervina Campos-Leon. The artist named the dress for the Guggenheim performance *Estervina* in her mother's honor, reinforcing the bonds of family, both in memory and in lived experience. Campos-Pons has created multiple photographic projects and installations using her mother and other family members, many of whom she saw infrequently because re-entry into the United States was so uncertain whenever she returned to Cuba, most acutely during the 1990s and early 2000s. In the mixed-media installation *Spoken Softly with Mama* (1998), Campos-Pons aligned seven ironing boards with projections of photographs of family members and her own body, accompanied by stereo tracks composed by Leonard. She represented the domestic work carried out by her mother and other female members of her family, reinforced by the sculpted forms of *pâte de verre* irons and trivets arranged at the forms' bases when installed. The shape of the boards also mimicked the plan of the slave ship made familiar through the nineteenth-century illustrations for Thomas Clarkson's *The History of the Rise, Progress and Accomplishment of the Abolition of the African Slave-Trade*

*by the British Parliament.*[19] Thus, the ironing board became a visual encoding of the transatlantic slave trade, further linking diasporic memory and separation within Campos-Pons's own family history in Matanzas. West-Durán points out Campos-Pons's engagement with the concept of *ori*, the head, as the most important part of the body, which extends to a more general understanding of "consciousness, knowledge, wisdom, thought and emotion."[20]

In *Habla LAMADRE*, by evoking her biological mother, Estervina, in conjunction with Yemayá and water spirits, Campos-Pons suggests the association between memory and water.[21] Just before pouring blue water and seven fish (for the Seven Powers) into the fountain from her *sopera* (fig. 15.4), the artist recites the following:

> She knows when to show her power.
> Brothers, sisters allow me to show you the power of Yemayá.
> Follow me to see the wonderful work of sister Carrie Mae Weems
> As we go out.
> Yemayá! Come with me.
> In the name of the mother
> In the name of my ancestors
> And in the name of this wonderful institution
> Let it be
>
> Come with me as we see the work of the sister Carrie

The female attendants, the traditional Cuban band, the dress, and the fish poured into the fountain, aligned those forces in order to offer the greatest future impact on the museum.

For the 11th Havana Biennial in 2012, Campos-Pons created the stunning installation *Family Abroad* and a performance of *Llegooo! FeFa!* With these works, Campos-Pons encompassed a spirit of memory similar to that evoked in *Habla LAMADRE*, in addition to a longing

for connectedness. In collaboration with Leonard again, Campos-Pons processed along the Malecón, Havana's iconic esplanade and seawall, masked in protective white clay and dressed in a red, floral kimono, giving away bread. Men have traditionally baked bread in Cuba, but more women are entering the profession. Using the *pregón* (street-seller's cry), she called out in concert with other vendors singing throughout the streets to advertise their wares. Through this act, she explored how the female body challenges and reaffirms societal norms and religious practices. Campos-Pons, ten of her American students from the School of the Museum of Fine Arts, and ten female bakers from Havana, worked in partnership to bake bread in a local bakery for the performance and at the Wifredo Lam Center gallery in the Old City section of Havana. In fact, before leaving Boston for Havana, she and her students learned the craft of baking bread and collected and wrapped donated items that were later arranged in the gallery at the Lam Center.[22] The bread; the green, bundled donations; and the video projection of vendors highlighted the fortitude of Havana citizens, their ability to thrive despite limited resources and with a deep sense of cultural pride.[23] Campos-Pons performed *Habla LAMADRE* under the name of FeFa, connecting herself with the 2012 performance of *Llegooo! FeFa!* and once again placing herself between worlds— Cuba and the United States, the art world and family, memory and loss, gratitude and possibly resentment. This kind of resilience by way of community labor and resourcefulness embodies the heart of much of Campos-Pons's art practice.

**ENTERING THE FRAME OF CARRIE MAE WEEMS**
For over thirty years, María Magdalena Campos-Pons and Carrie Mae Weems have continuously combed the diasporic

Fig. 15.5
*In the Halls of Justice* by Carrie Mae Weems, 2002
Gelatin silver print, 71.8 × 71.8 cm (28¼ × 28¼ in.)
Courtesy of the artist and Jack Shainman Gallery, New York

archives of their own history alongside those of other artists who have also been deeply invested in creating a record that includes the circular journey from the western and central coasts of Africa to South and North America. Stuart Hall defines the circular relationship that people of African descent have with the continent they return to physically, intellectually, and spiritually as related to "what Africa has *become* in the New World, what we have made of 'Africa': 'Africa' as we re-tell it through politics, memory and desire."[24] In *Habla LAMADRE*, these factors remain and are embodied in both Campos-Pons and Weems.

The politics of Campos-Pons and Weems within the Guggenheim has much to do with a black feminist intervention. According to conceptual and performance artist and philosopher Adrian Piper, the "triple negation" of black women artists within Eurocentric discourses discriminates against them in terms of their race, gender, and profession.[25] Such negation marginalizes these artists. The perseverance to work within—or despite—these restrictions produces a self-determination for artists. The friendship and collaboration between Campos-Pons and Weems is a premier example of this effort. Art historian Frieda High W. Tesfagiorgis affirms the need for a new discourse that specifically centers black women artists and their works as the critical models that currently operate within the discipline of art history (white, male hegemonic apparatuses) do not appropriately reflect black women artists, forcing them to pursue their own goals in the margins of the discourse.[26] A working discourse can function and validate black women artists like Campos-Pons and Weems as we consider how they utilize black vernacular—Yemayá, in the case of *Habla LAMADRE*—to inform their works successfully without compromising their formal or theoretical qualities. In other words, as Tesfagiorgis argues, "Black feminist art criticism must both utilize aspects of existing paradigms and introduce new ways of thinking about art as it inserts its distinctiveness in subjects and perspectives."[27]

In 1988 Campos-Pons met Carrie Mae Weems, an artist who had already begun to interrogate the multiple meanings and impact of the black female body, first through dance, but primarily through photography and video.[28] According to Campos-Pons, she and Weems "kept a conversation going for many, many years, about life, in general, [about] being women, being artists . . . being everything." This inherent understanding of the "triple negation" of black women artists made Campos-Pons an easy selection for Weems to include in her special weekend, Carrie Mae Weems LIVE: Past Tense/Future Perfect. Ultimately, the sway of Campos-Pons's black body within a Guggenheim-shaped dress along with the invocation of Yemayá provided the foundation for understanding how Habla LAMADRE was most critically about the pioneering efforts made by Carrie Mae Weems and the Guggenheim.

Weems, like Campos-Pons, is a descendant of enslaved Africans; she was born in Portland, Oregon, in 1953 to a family of sharecroppers from Tennessee and Mississippi. In 2014 the Frist Center for the Visual Arts in Nashville opened the traveling retrospective Carrie Mae Weems: Three Decades of Photography and Video, which then moved to the Guggenheim—the first solo exhibition by a woman of African descent to be hosted by that museum.[29] However, the Guggenheim show was half the size it had been at the Frist, a destructive act that New York Times critic Holland Cotter called "appalling," given that the exhibition explored "what it means to be black, female and in charge of your life . . . a ripe, questioning and beautiful show."[30] Weems's historic retrospective at the Guggenheim had difficulty standing out in the museum due to the concurrently running Italian Futurism exhibition, which occupied many of the galleries that might have hosted a larger extension of Weems's photographs and video installations. In spite of the scaled-down version in the most high-profile venue (after Nashville and New York, the exhibition traveled to Portland, Stanford, and Cleveland), Weems took ownership of the location in New York, and she mediated that space similarly

to her many photographic series, which have most often featured her own body as the subject.

Weems interrupted the meaning of her own bodily frame within sites as diverse as Germany, Mali, Philadelphia, and even Campos-Pons's native Cuba (fig. 15.5). Near the end of her residence at the American Academy in Rome in 2005–6, while standing in front of the National Roman Museum, Weems became inspired to consider the impact of the world's museums, especially in the West, in terms of their architecture and also as depositories for works of art that often exclude the art of people of African descent. While her 2006 series Roaming highlights the city of Rome, Weems traveled that same year to other European cities and locations in the United States to contextualize those structures in relation to her own stance before them, in what she later named the Museums series:

> What I'm interested in is leading not only myself, using the sort of physicality to understand something more about the architecture, something about space, something about the power of architecture . . . and how it rules over us. Even through its beauty [the architecture] seduces us, but it also has exacting power over us. I also thought it would be very important to sort of lead my viewer also to those sights.[31]

With this insight, Weems journeyed to northern Spain, for example, to encounter the seduction of the sweeping, undulating, titanium walls of the Guggenheim Museum Bilbao, designed by Frank Gehry and completed in 1997. In the photograph Guggenheim Bilbao (fig. 15.6), Weems stands as a dark silhouette in her black, long-sleeved dress with her back to the viewer, as in photographs in the Roaming series. In Bilbao, Weems stretches her arms outward to rest her hands on a white railing that heightens the chasm between her and the museum as water gently ripples below her. The framing of this photograph plays

on the building's ship-like forms, with stern-like triangular peaks making Weems appear as if she is viewing the museum across a body of water from her own ship. Weems's serenity in the face of the immensity of the museum's presence grounds the viewer, encouraging a pause as the two ships purportedly confront each other. This moment of recognition of each other's position in space acknowledges their unreachability.

The literary scholar Kimberly Juanita Brown notes in *The Repeating Body: Slavery's Visual Resonance in the Contemporary* that in the *Roaming* series, "with Weems's back turned away from the viewer as she faces disparate structures around the Italian capital [of Rome], the viewer must enter the frame through her, or at least with her permission."[32] Entering the frame *through* Weems or "with her permission" means that she is the intermediary, especially in relation to architecture. Coincidentally, Yemayá's symbols, "the key, the ship's wheel, the anchor, the boat, and the crescent moon . . . became integral to Yemayá's metal *herramientas* (tools)."[33] Extending the ship metaphor, Weems, too, conjures Yemayá, (mis)identifying the Guggenheim Museum Bilbao as just another *herramienta* for photographic play. Therefore, in staging the programming of Carrie Mae Weems LIVE: Past Tense/ Future Perfect at the Guggenheim in New York, Weems challenged the power of the institution not just on the walls, but in the presence of so many artists of African descent who could play, sing, read, converse, and *roam* through the Guggenheim that weekend and, by extension, throughout the four months of the exhibition *Carrie Mae Weems: Three Decades of Photography and Video*.

Carrie Mae Weems "kicked the door" open to the Guggenheim, to use Campos-Pons's words during the opening moments of *Habla LAMADRE,* and in her generosity offered an entrance not just for herself, but for other artists. The Carrie Mae Weems LIVE program included a concert by Geri Allen, the late jazz pianist with whom Weems had collaborated for many years; a reading by poet Aja Monet

and others; and "conversations" with other artists, curators, and historians—such as the sculptor Barbara Chase-Riboud; Thelma Golden, the director and chief curator of the Studio Museum in Harlem; and Okwui Enwezor, the director of Haus der Kunst (Munich) and the director of the Visual Arts Section of the 2015 Venice Biennale.

Weems also mediated *Habla LAMADRE*, looking down on the performance in the rotunda from the second floor as Campos-Pons engaged—and interrupted—an "Africa" that thrives in Cuba and the United States through the artist's own metonymic presence both *in* the museum and *as* the museum. Campos-Pons's hooped dress defiantly mimics Wright's upward-sweeping spiral; more notably, the white circles also echo the circularity of "what Africa has become in the New World."[34] In the early video created in Boston, *Rito de iniciación/Rite of Initiation* (1991; see fig. 15.2), Campos-Pons and Leonard walk carefully along a spiral of white clay powder, foreshadowing the circumscription of the Guggenheim's own white circles. For descendants of enslaved Africans in the Americas, this passage marks the trauma of the separation of an indigenous home that transforms, perseveres, and reinvents itself in the "new world" context.

The Solomon R. Guggenheim Museum has been recognized as "an architectural masterpiece of the modern era" since 1959.[35] Frank Lloyd Wright wrote of the museum and its spiral construction in 1958 for the Guggenheim's collection of nonobjective paintings:

> Walls slant gently outward forming a giant spiral for a well-defined purpose: a new unity between beholder, painting and architecture. As planned, in the easy downward drift of the viewer on the giant spiral, pictures are not to be seen bolt-upright as though painted on the wall behind them. Gently inclined, faced slightly upward to the viewer and to the light in accord with the upward sweep of the spiral, the paintings

themselves are emphasized in themselves and not hung "square" but gracefully yield to the movement as set up by these slightly curving massive walls.[36]

Many artists have mounted interventions within the museum's imposing space. Most notably, the French artist Daniel Buren, with *Inside (Center of Guggenheim)* in 1971, and again during his retrospective *The Eye of the Storm: Works In Situ by Daniel Buren* in 2011.[37] In both installations, Buren bisected the space of the rotunda, disrupting its circular movement by blocking views to works across the wide expanse, first with a striped panel measuring nearly 66 by 30 feet and then much later with nearly equally massive sheaths of glass that reflect the building onto itself. Buren boldly challenged the "graceful" flow that Wright most desired. The physical and visual movement up, down, around, and across the Guggenheim Museum via its ramps is integral to the experience of the museum itself; the geometric dynamic movement has become an iconic architectural and experiential component of a visit to Wright's building. Buren's imposition on that space came to be criticized by some and lauded by others, especially because of this knowing engagement with the Guggenheim's dynamism.[38] Buren stated in 1971 that the museum "unfolds an absolute power which irremediably subjugates anything that gets caught/shown in it."[39]

Performances within the rotunda have taken place at the Guggenheim for over thirty years. The presentation of bodies as subject and object has been explored by a number of artists, including Vanessa Beecroft in *VB35* (1998), wherein models wearing bikinis (and some completely nude) stood nearly motionless in a kind of army formation in the rotunda while spectators awkwardly looked on. Tino Sehgal's *The Kiss* (2010) featured two dancers performing daily throughout Sehgal's exhibition, often intimately, while unsuspecting museumgoers entered and exited the building.[40] What does it mean, then, when one sees

Campos-Pons's dress mimicking the Frank Lloyd Wright building? According to Campos-Pons, the success of her performance was due to the way she "centered the Black body in the building . . . Frank Lloyd Wright couldn't do that, but a performative gesture could."[41]

In the *Museums* series images, Weems always stands outside the museum, but as a knowing gesture that she actually belongs inside. Campos-Pons intuited Weems's charge to not only enter the museum, but to fully occupy it during the performance of *Habla LAMADRE* as part of Carrie Mae Weems LIVE. When Campos-Pons enters the Guggenheim Museum in New York, *she* is the work of art and *she* is the nonobjective painting that Wright described in his building: "Gently inclined, faced slightly upward to the viewer and to the light in accord with the upward sweep of the spiral, [Campos-Pons emphasizes *herself* ] and not hung "square" but gracefully yield[ing] to the movement as set up by these slightly curving massive walls [of her dress]." The dress, as envisioned by Campos-Pons and made into a reality by designer Zinda Williams, reinforced these ideals of the building, and ostensibly of the institution overall, as having a presence of its own within the confines of its imposing walls.

Zinda Williams has over thirty years of textile design experience, especially within the dance community. Williams grew up in Spanish Harlem, and she learned to sew from her mother and aunts at age ten. When she began to dance at Hunter College High School, she made costumes for herself and other dance and theater groups. When she attended the College at Brockport, State University of New York, she took classes with choreographer Garth Fagen, who was a professor at the school, and she danced with his company in 1983 in Rochester. She spent much of her time making costumes for Fagen, which she believes

Fig. 15.6
*Guggenheim Bilbao* by Carrie Mae Weems, 2006
Chromogenic print, 182.9 × 152.4 cm (72 × 60 in.)
Courtesy of the artist and Jack Shainman Gallery, New York

was the true reason he hired her, launching a lifetime career in dance and design.[42] In 1995 she began working with first the Alvin Ailey Repertory Ensemble, and then the Alvin Ailey American Dance Theater, including three years as the wardrobe supervisor. Though Williams never received formal training as a designer, she worked with the Merce Cunningham Dance Company and luxury retailer Henri Bendel in New York City. She is now an independent clothing and costume designer, and continues to occasionally contract with Alvin Ailey.

Williams's role as costume designer for *Habla LAMADRE* is yet another example of resistance to the limitation of the "triple negation" of the black, woman artist. Williams's long training in the field of dance and costume design has earned her the label of "unitard queen," as she is meticulous about fit. A primary goal of her designs is that they feel "like a second skin," such that the wearer focuses only on his or her movement within the performance.[43] Williams constructs the "second skin" of the Estervina dress so expertly that Campos-Pons, as a result, transcends her own identity as artist and becomes many other entities: daughter of Estervina, devotee of Yemayá, friend of Carrie Mae Weems, wife of Neil Leonard, and, most poignantly, the Guggenheim itself.

Okwui Enwezor defines "diasporic imagination," as communicated through Campos-Pons's work, as a diasporic archive that operates as a vehicle rather than a narrow context for racial identity.[44] Her projects, including her performances, then function as an archive within the interstices of exile, displacement, and memory and the social crisis produced by these experiences, particularly for black women. What comes across as beautifully composed and brilliantly aligned in many of her self-portraits is the result of painstaking hours, weeks, and months of deep thought and active participation—and collaboration—in conceptualizing and *living* the various precepts of female empowerment, confident sexuality, and resilient cultural survival, especially an African survival.

Additionally, for the weekend of Carrie Mae Weems LIVE, itself an expression of "diasporic imagination," there were restrictions on noise to which performers had to adhere.[45] For the musical performances outside of the Guggenheim's Peter B. Lewis Theater, one major concern was that many of the works in the Futurism show were highly sensitive to vibrations.[46] The musical aspects of Campos-Pons's *Habla LAMADRE* were therefore somewhat constrained, though the performance continued despite the limitations. When Campos-Pons arrived at Weems's exhibition space on the second floor to conclude her procession, she continued her pleas to Yemayá while waving her *paño*. In Santería ceremonies, sounds and offerings sacralize a site and its occupants. Campos-Pons passed out roses to viewers and the attendants gave out posters that marked the event, while the thump of the batá drums and the rattle of the bells that encircle the drum heads continued, along with the brassy sounds of Neil Leonard's band.[47] Due to the constraints on sound, Campos-Pons deliberately measured her speech within Weems's exhibition space. Nevertheless, in keeping with Santería ritual, she smashed pottery—though these were held within in a medium-sized bundle of blue-and-white fabric as a makeshift Afro-Cuban *prenda*, or medicinal packet used to contain "all manner of spiritualizing forces."[48]

Campos-Pons's giveaways were directly inspired by the late Cuban artist Félix González-Torres's participatory practices within his oeuvre, and most acutely during his retrospective at the Guggenheim in 1995. González-Torres's practice consistently included the completion of works of art and performances or "events" by the audience; Campos-Pons recalls the take-home posters *Untitled of 1989–90* provided by the artist for visitors to his exhibition at the Guggenheim. As Mónica Amor notes, "To transgress the notion of control in favor of conditions which promote the participant's freedom in the symbolic construction of the work, is one of the fundamental preoccupations of González-Torres."[49] Occupying the Guggenheim as

González-Torres once had, and with Carrie Mae Weems's exhibition on-site, allowed Campos-Pons to fully engage with the historical moment both as a Cuban artist and as a black woman.

During *Habla LAMADRE* Campos-Pons dances in circles both in the rotunda and in the galleries of the second floor, echoing the shape of the building and of the dress, as well as the transatlantic slave trade and the traditional dance ritual of Yemayá as performed in Cuba and in the United States, a transference through multiple processes of transformation from her familial origins in Nigeria. Campos-Pons—with Carrie Mae Weems's blessing and presence via her exhibition—brings together Yemayá and the ancestors. When asked why she uses herself as the point of exploration for identity, Campos-Pons responded that she sees her autobiography as a touchstone, as a way of speaking—very cautiously—for herself and for others.[50] In *Habla LAMADRE* she cleanses viewers with her *paño*, *sopera*, and *prenda* with authority, using her own body as a vehicle.

Along with the *oricha* Yemayá, Campos-Pons also invokes Eshu—the embodiment of the crossroads and a messenger of the gods. As Santería belief has it, God granted Eshu the power "to make all things happen and multiply (*àshe*)."[51] *Àshe* is a spiritual command, the power to make things happen, and God's enabling light.[52] Only Eshu knows what will happen next. As Yemayá owns the water, Eshu oversees the crossroads. Thus, when Campos-Pons sings "Yemayá es Eshu. Eshu es Yemayá" throughout

the galleries, she is reiterating a claim for the future for the black body within the Guggenheim and within museums more broadly. Carrie Mae Weems's retrospective, *Carrie Mae Weems: Three Decades of Photography and Video*, and the Carrie Mae Weems LIVE: Present Tense/Future Perfect weekend program perfectly encapsulates Eshu at the crossroads, looking back to see what has happened in the past and precariously looking forward to determine the future. In Weems's closing remarks for that weekend, she thanked Campos-Pons, "who brought in for us, *àshe*." When Weems shouted the refrain, "*àshe, àshe, àshe, àshe, àshe*—the power to make things happen," the audience responded in kind: *àshe!* This call-and-response is a natural reply in many African diasporic traditions, as a participatory engagement of a congregation in the pews of an African-American church or within the circle of a Santería ritual. Weems extended her gratitude to the Guggenheim Museum "for its amazing support of *us*." She continued, "We want to thank them for letting us into their house, into their living room, and knocking a few pictures off the wall."[53] Both Weems and Campos-Pons roam—and will continue to haunt—the halls and walls of the modern museum, spaces that were not constructed to contain them per se. With an "invitation" to the Guggenheim, "the mother has spoken;" María Magdalena Campos-Pons and Carrie Mae Weems have both "kicked the door" open and their portraits—vis-à-vis Yemayá—have arrived to stay. *Àshe!*

Notes

I would like to thank Dorothy Moss, associate curator at the National Portrait Gallery, for her invitation to present an earlier version of this paper, "LIVE (at the Guggenheim): Carrie Mae Weems, María Magdalena Campos Pons and Black Feminist Performance," on the panel Performance Art as Portraiture at the 104th College Art Association Conference (February 2016). I would also like to extend my gratitude to Jasmyne Keimig, my research assistant for this project, who proved indispensable in helping me lay the groundwork for this essay.

1 Formerly known as the School of the Museum of Fine Arts (SMFA). Tufts University formally incorporated the SFMA into its School of Arts and Sciences in 2016.

2 Neil Leonard currently serves as the artistic director of the Interdisciplinary Arts Institute at Boston's Berklee College of Music.

3 Lisa Freiman provides a thorough history of the artist's early life and art in "María Magdalena Campos-Pons: Everything Is Separated by Water," in *María Magdalena Campos-Pons: Everything Is Separated by Water*, ed. Lisa D. Freiman (New Haven, CT: Yale University Press in association with Indianapolis Museum of Art, 2007).

4 Leonard quoted in Nancy Pick, "Cuba Distilled: Bringing Sound to Alchemy of the Soul, Elixir for the Spirits," in *Alchemy of the Soul: María Magdalena Campos-Pons*, ed. Joshua Basseches (Salem, MA: Peabody Essex Museum, 2016), 70. Nancy Pick and Neil Leonard, e-mail correspondence, August–November 2015. Interview with Neil Leonard and María Magdalena Campos-Pons, Brookline, Massachusetts, September 5, 2015.

5 Interview with Leonard and Campos-Pons, September 5, 2015.

6 Joshua Basseches, "Transforming Pain Into Beauty," in Basseches, *Alchemy of the Soul*, 14.

7 Interview with María Magdalena Campos-Pons, September 13, 2016.

8 Santería is also known as Lucumí and Regla de Ocha, among other variants. As noted by Kenneth George Schweitzer, *Santería* is the term most recognizable in the United States, and it is not used often within Cuba. *Santería* will be used throughout this text. See Kenneth George Schweitzer, *The Artistry of Afro-Cuban Batá Drumming: Aesthetics, Transmission, Bonding, and Creativity*, Caribbean Studies Series (Jackson: University Press of Mississippi, 2013), n1, and George Brandon, "Santeria," in *Encyclopedia of African Religion*, ed. Molefi Kete Asante and Ama Mazama (Thousand Oaks, CA: Sage Publications, Inc., 2009), 1–7.

9 Okwui Enwezor, "The Diasporic Imagination: The Memory Works of María Magdalena Campos-Pons," in Freiman, *María Magdalena Campos-Pons*, 64–89.

10 *Soperas* generally house the stones associated with corresponding *oricha* being honored and worshipped. See Miguel A. De La Torre, *Santeria: The Beliefs and Rituals of a Growing Religion in America* (Grand Rapids, MI: W. B. Eerdmans, 2004), 135.

11 For an edited video of the performance, see *Habla LAMADRE* in the video playlist "Carrie Mae Weems LIVE: Performances," Guggenheim Museum, https://www.guggenheim.org/video/carrie-mae-weems-live-performances.

12 Alan West-Durán, "What the Water Brings and Takes Away: The Work of María Magdalena Campos Pons," in *Yemoja: Gender, Sexuality, and Creativity in the Latina/o and Afro-Atlantic Diasporas*, ed. Solimar Otero and Toyin Falola (Albany: SUNY Press, 2013), 199.

13 De La Torre, *Santeria*, 238.

14 Aisha M. Beliso-De Jesús, *Electric Santeria: Racial and Sexual Assemblages of Transnational Religion* (New York: Columbia University Press, 2015), 92.

15 Beliso-De Jesús, 94.

16 Adelaida de Juan, "En el monte suena," *La luz y las tinieblas* (Seville, Spain: Escandón Impresores, 2010) 11.

17 This analysis of Manuel Mendive first appeared in Nikki A. Greene, "Artists' Utopia? Cuban Art Defined at the Eleventh Havana Biennal," *Delaware Review of Latin American Studies* 13, no. 2 (December 2012), http://www1.udel.edu/LAS/Vol13-2Greene.html.

18 Coco Fusco, *Dangerous Moves: Performance and Politics in Cuba* (London: Tate Publishing, 2015), 34.

19 Thomas Clarkson, *The History of the Rise, Progress and Accomplishment of the Abolition of the African Slave-Trade by the British Parliament*, 2 vols. (London: Longman, Hurst, Rees, & Orme, 1808).

20 Alan West-Durán, "What the Water Brings and Takes Away," 200.

21 West-Durán, 200.

22 For more on the *Llegooo! FeFa!* performance, see "Exclusive Interview: María Magdalena Campos-Pons & Neil Leonard," *Art Caribéen – Uprising Caribbean Art* (blog), June 7, 2012, http://blog.uprising-art.com/en/interview-exclusive-maria-magdalena-campos-pons-neil-leonard-2/.

23 Greene, "Artists' Utopia?"

24 Stuart Hall, "Cultural Identity and Diaspora," in *Identity: Community, Culture, Difference*, ed. Jonathan Rutherford (London: Lawrence & Wishart, 1990), 232.

25 Adrian Piper, "The Triple Negation of Colored Women Artists," in *Next Generation: Southern Black Aesthetic* (Chapel Hill: University of North Carolina Press, 1990), reprinted in *Out of Order, Out of Sight: Selected Writing in Art Criticism*, by Adrian Piper (Cambridge, MA: MIT Press, 1996), vol. 2: 161–73.

26 Frieda High W. Tesfagiorgis, "In Search of a Discourse and Critique/s that Center the Art of Black Women Artists," in *Black Feminist Cultural Criticism*, ed. Jacqueline Bobo (Malden, MA: Blackwell Publishers, 2001), 146–72. I have also used Tesfagiorgis's framework on black women artists in the multimedia work of Renée Stout; see Nikki A. Greene, "The Feminist Funk Power of Renée Stout and Betty Davis," *American Studies Journal* 52, no. 2 (2013): 64.

27 Tesfagiagorgis, "In Search of a Discourse," 157.

28 Weems joined the Anna Helprin's San Francisco Dancers' Workshop in the early 1970s. Kathryn E. Delmez, ed., *Carrie Mae Weems: Three Decades of Photography and Video* (New Haven, CT: Yale University Press in association with Frist Center for the Visual Arts, 2012), 1.

29 Carrie Mae Weems expressed her excitement about the show a few days before the opening: "Of course, I'm thrilled…I'm the first African-American woman to have a retrospective at the Guggenheim. Not to sound pretentious, but I should be having a show there. By now, it should be a moot point for a black artist—but it's not." Weems as quoted in Andrea K. Scott, "A Place at the Table," *New Yorker*, January 20, 2014, https://www.newyorker.com/magazine/2014/01/27/a-place-at-the-table.

30 Holland Cotter, "Testimony of a Cleareyed Witness: Carrie Mae Weems Charts the Black Experience in Photographs," *New York Times*, January 23, 2014, http://www.nytimes.com/2014/01/24/arts/design/carrie-mae-weems-charts-the-black-experience-in-photographs.html.

31 Carrie Mae Weems, artist tour of *Carrie Mae Weems: I Once Knew a Girl…*, Ethelbert Cooper Gallery of African and African American Art, Hutchins Center for African and African American Research, Harvard University, Cambridge, MA, September 30, 2016.

32 Kimberly Juanita Brown, "Photographic Incantations of the Visual," *The Repeating Body: Slavery's Visual Resonance in the Contemporary* (Durham, NC: Duke University, 2015), 178–79.

33 David H. Brown, *Santería Enthroned: Art, Ritual, and Innovation in an Afro-Cuban Religion* (Chicago: University of Chicago Press, 2003), 218.

34 Hall, "Cultural Identity and Diaspora," 232.

35 Thomas Krens, "Preface," in *The Solomon R. Guggenheim Museum* (New York: Guggenheim Museum Publications, 1995), 1.

36 Frank Lloyd Wright quoted in Bruce Brooks Pfeiffer, "A Temple of Spirit," in *The Solomon R. Guggenheim Museum*, 7.

37 Guggenheim International Exhibition, 1971 (New York: Solomon R. Guggenheim Foundation, 1971); Daniel Buren, *The Eye of the Storm: Works In Situ by Daniel Buren* (New York: Guggenheim Museum, 2005).

38 For more on the reception of Daniel Buren's 1971 installation, see Tom Lubbock, "Inside Out; Daniel Buren's 'Interventions' Respond To, and Challenge, the Sites They Are Created For. Trouble Is, Says Tom Lubbock, They Don't Really Work Confined to Art Galleries," *Independent Extra*, November 20, 2006, 14; Michael Kimmelman, "Tall French Visitor Takes Up Residence in the Guggenheim," *New York Times*, March 25, 2005, sec. Art & Design, https://www.nytimes.com/2005/03/25/arts/design/tall-french-visitor-takes-up-residence-in-the-guggenheim.html; and Linda Yablonsky, "The Guggenheim Outcast Who Laughed Last," *New York Times*, March 20, 2005, sec. Art & Design, https://www.nytimes.com/2005/03/20/arts/design/the-guggenheim-outcast-who-laughed-last.html.

39 Buren, *The Eye of the Storm*, 247.

40 Jeffrey Hogrefe, "The Force Behind Guggenheim's Nudie Show," *Observer*, May 11, 1998; Holland Cotter, "Thinking Encounters in a Naked Guggenheim," *New York Times*, January 31, 2010.

41 Interview with María Magdalena Campos-Pons, September 13, 2016.

42 Interview with Zinda Williams, September 20, 2016.

43 Interview with Williams.

44 Enwezor, "The Diasporic Imagination," 65.

45 Vivien Greene, ed., *Italian Futurism 1909–1944: Reconstructing the Universe* (New York, New York: Guggenheim Museum Publications, 2014).

46 Interview with María Magdalena Campos-Pons, September 13, 2016.

47 For more on the significance of batá drumming, see Schweitzer, *The Artistry of Afro-Cuban Batá Drumming*.

48 Robert Farris Thompson, *Flash of the Spirit: African and Afro-American Art and Philosophy* (New York: Random House, 1983), 123.

49 Mónica Amor, "Félix González-Torres: Towards a Postmodern Sublimity," *Third Text* 9, no. 30 (1995): 69, http://dx.doi.org/10.1080/09528829508576530.

50 Conversation with María Magdalena Campos-Pons, April 23, 2016.

51 Thompson, *Flash of the Spirit*, 18.

52 Thompson, 5.

53 Weems's closing remarks in "Craig Harris Performs" in the video playlist "Carrie Mae Weems LIVE: Performances."

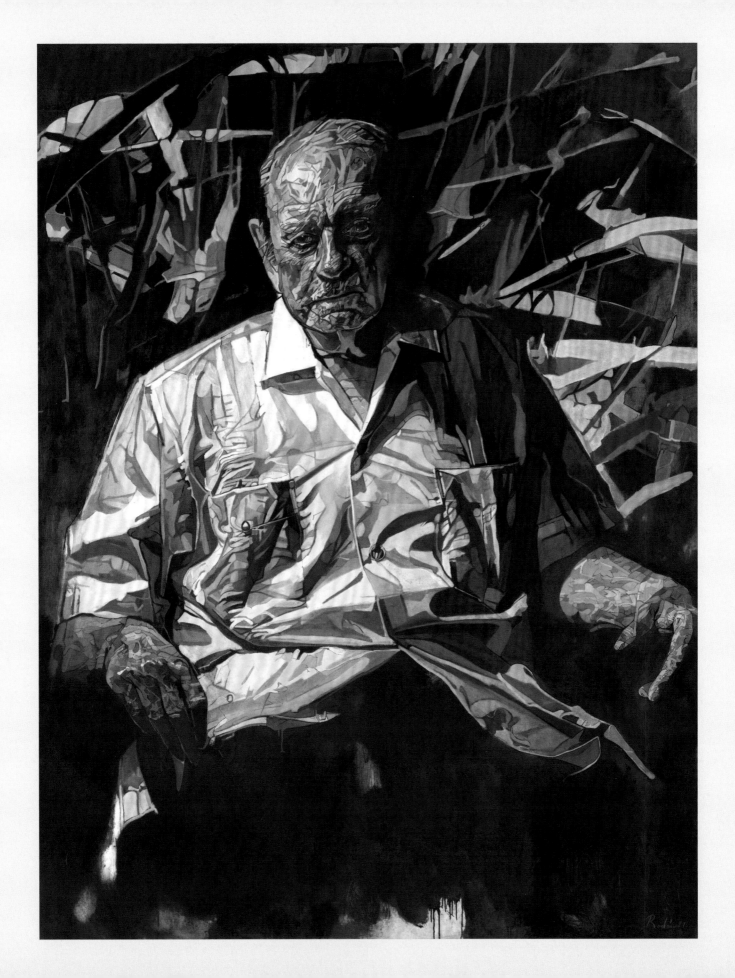

# MEANINGFUL (DIS)PLACEMENTS

## THE PORTRAIT OF LUIS MUÑOZ MARÍN BY FRANCISCO RODÓN AT THE NATIONAL PORTRAIT GALLERY

Taína Caragol

Imagine that a middle-aged couple—perhaps from the Midwest, perhaps from the South—has traveled to Washington, DC, to help their daughter settle in before starting her freshman year in college. Eager to visit the Smithsonian for the first time, they arrive at the National Portrait Gallery, where they expect to see portraits of the founding fathers and renowned American historical figures. After taking in the "America's Presidents" exhibition and seeing George Washington, Abraham Lincoln, and Franklin Delano Roosevelt, they climb a second flight of stairs to "20th Century Americans." Upon entering the gallery that features work made between 1950 and 1990, they are startled by a large, dramatic portrait, standing out among sculptures, prints, and paintings portraying such luminaries as the playwright Arthur Miller, the Nobel Peace Prize–winning chemist Linus Pauling, the "King of Pop" Michael Jackson, and New York Senator Robert F. Kennedy. The visitors wonder, "Who is *that* man whose portrait occupies a full wall? Should we know him?" They read the wall label

and discover that the sitter was once the governor of Puerto Rico. They try to reason: "But Puerto Rico is not part of the United States. At least, it's not a state. What is this portrait doing here?"

Moments later, another visitor who is in town on a business trip for his agricultural-technology startup based in Mayagüez, Puerto Rico, enters the gallery and is stopped in his tracks by the same portrait. He recognizes not only the sitter but also the work of art. Equally disconcerted, he asks why Luis Muñoz Marín, the founder of the Commonwealth of Puerto Rico and a defender of its distinct cultural identity, is represented in an exhibition that focuses on *American* history. He wonders how this important portrait of a Puerto Rican and Latin American came to hang at a museum of American history and portraiture.

The painting in question is Francisco Rodón's *Luis Muñoz Marín* (fig. 16.1), which has been on loan to the Portrait Gallery from the Fundación Luis Muñoz Marín in Puerto Rico since August 2015. While this essay's introductory account is fictional, it is true that the painting has been on view in the museum's "20th Century Americans" galleries, so the story is completely plausible, and the questions from each side are legitimate.

**Fig. 16.1**
*Luis Muñoz Marín* by Francisco Rodón, 1974–77
Oil on canvas, 260.4 × 198.1 cm (102 ½ × 78 in.)
Fundación Luis Muñoz Marín Collection

Puerto Rico and the United States have had intertwined histories since 1898. To be more precise, the island has been a territory of the United States since that year. However, confusion about its relationship to the United States is common among Americans.[1] This confusion stems partly from the island's ambiguous political status as an unincorporated territory, populated by U.S. citizens who can vote in presidential primaries but not in a general election. Since 1952, Puerto Rico has had a measure of local autonomy that is ultimately subject to U.S. federal laws, and Puerto Ricans from the island do have a different culture. A colony of Spain from 1508 until 1898, Puerto Rico's ethnic make-up and culture is largely the result of the miscegenation that occurred during that time, between the native Taínos, the Spaniards, and the enslaved African people. Puerto Ricans from the island—as well as many who live in the United States—rarely talk about themselves as Americans, but rather as Puerto Ricans with American passports. To add to this convoluted picture, Puerto Ricans who live in the continental United States constitute the second-largest group of Latinos in the country after Mexican Americans, and as such are considered a major part of American society.

The current Strategic Plan of the National Portrait Gallery states that one of the organization's primary goals is to "Reflect and portray the diversity of the American people."[2] By the end of 2018, the year of the museum's fiftieth anniversary, the institution aspires to "be widely known as *the* place that sparks thought and conversation and includes the audience as an active participant in defining American identity through portraiture and biography."[3] These goals align with a global trend in museums that emerged with the new millennium, to make these institutions—traditionally bound to grand narratives and stable ideas of the nation-state—reflect and reach out to the diverse communities that surround them.

The Portrait Gallery's loan of *Luis Muñoz Marín* by Francisco Rodón was a step in that direction. But questions

like those of our imaginary gallery visitors persist, and they hint at the difficulties of making room in the master narrative of American history for aspects and episodes that have been overlooked, marginalized, or insufficiently examined. This essay is an analysis of the temporary (dis)placement of *Luis Muñoz Marín* as a practical curatorial measure to achieve the institutional goal of diversity and of expanding the understanding of American history and identity. The guest performance here of this artwork—whose symbolic power in Puerto Rico is in some ways analogous to Gilbert Stuart's *George Washington ("Lansdowne" Portrait)* in the United States (see fig. 3.4, p. 69)—destabilizes more than one historical narrative by tackling difficult political questions that reveal cultural differences and unsolved power asymmetries between Puerto Rico and the United States. At the same time, the unprecedented placement of this iconic portrait in a museum with a growing collection of portraits of distinguished diasporic Puerto Ricans opens up new possible readings for this artwork while giving substance visually to the history of the island's transnational population.

## THE PORTRAIT OF LUIS MUÑOZ MARÍN IN PUERTO RICO

The painting in question depicts an aging Muñoz Marín, seated. Despite his sedentary pose and the fact that only half of his body is visible, he towers over the viewer, occupying most of the 8½-by-6½-foot canvas. Long green streaks of exuberant flora fragment the nocturnal black background, thrusting Muñoz Marín forward. His face—the focal point of the painting—is lit from the left; he wears a tired and sad expression that is accentuated by his garment, a short-sleeved guayabera, an iconic, casually elegant shirt for men in Latin America and the Caribbean, parted to the sides below the lower button, in a sign of apparent carelessness.

The portrait is the work of Francisco Rodón, considered one of the foremost artists of Puerto Rico in

the twentieth century. He was born in 1934 in the island's western town of San Sebastián, and moved to San Juan as a teenager.[4] In the early 1950s he began a decade of extensive travel and study, partly funded with scholarships, through museums and art academies in Latin America and Europe, including, among others, the Académie Julian in Paris, the Real Academia de Bellas Artes de San Fernando in Madrid, and the Art Students League in New York. Toward the middle of the decade, his experience of the monumental public work of the Mexican muralists and his studies under the tutelage of María Izquierdo, painter of enigmatic self-portraits and domestic scenes, at "La Esmeralda," the National School of Painting, Sculpture, and Printmaking in Mexico City, were of particular impact.[5] In 1959 he returned to Puerto Rico and continued his training at the Taller de Artes Gráficas (Graphic Arts Workshop) of Puerto Rico, under Lorenzo Homar, a key figure of the island's "La Generación del '50" (1950s generation), which introduced modern art to Puerto Rico and established through their work what would become the main topics of the island's cultural production through the next half of the century: its lack of political self-determination as a U.S. territory, and its distinct cultural identity.

Rodón's self-directed training and his international search for lessons from old-master paintings and contemporary teachers reveals an idiosyncratic personality and approach to art that rejected academicism and refused to follow international trends.[6] Staying away from the poles of political art and abstraction that were dividing the Puerto Rican art scene, Rodón embraced figuration and color experimentation. In the 1960s, he started winning prizes and earning critical acclaim for his monumental paintings characterized by the use of expressionist distortion and the fragmentation of solid surfaces into colliding, shimmering color tones.

Rodón's subjects initially ranged from still lifes to landscapes, but in the early 1970s, he became well known for his portraits. Between 1971 and 1982 he worked on

the series *Personajes*, which includes *Luis Muñoz Marín*. The series comprises large-scale portraits of major figures of Latin American culture and politics of the time, including Puerto Ricans Marina Arzola, a poet, and Rosario Ferré, a novelist (fig. 16.2); Argentinian art critic Marta Traba and writer Jorge Luis Borges; Mexican writer Juan Rulfo; former Venezuelan president Rómulo Betancourt; and Cuban prima ballerina Alicia Alonso.[7] The portrait of Luis Muñoz Marín is considered the series' pinnacle because of the way that the painting successfully synthesizes scale, composition, and technique to convey the sitter's likeness and reveal his interiority.[8] While other artistic likenesses of Muñoz Marín exist, this one has become iconic. It has often been seen not only as the portrait of Puerto Rico's most prominent politician, but also as a symbolic portrayal of the island's political and cultural dilemma.[9] The painting was a main feature of the exhibition *Campeche, Oller, Rodón: Tres siglos de pintura puertorriqueña* (Campeche Oller, Rodón: Three centuries of Puerto Rican painting), presented at the Puerto Rican National Pavilion of the Universal Exposition of Seville in 1992, and it has been the object of insightful analysis by art historians and cultural critics in printed media, film, and radio. It has been reproduced in at least four catalogues of Rodón's work.

According to art critic Marimar Benítez, with this portrait Rodón "saved us [Puerto Ricans] from the glorification and ridiculous exaggerations of which Bolívar, for example, has been a victim."[10] The artwork is monumental, though not triumphal. It honors the man nicknamed "the father of Puerto Rican modernity" while hinting through his demeanor at the shortcomings of his political project—the ephemeral prosperity yielded by his industrialization plan, the fight to defend a distinct Puerto Rican cultural identity and local autonomy, even as the country was politically subsumed into the United States. The portrait speaks powerfully to the larger issue of the island's historic lack of political self-determination.

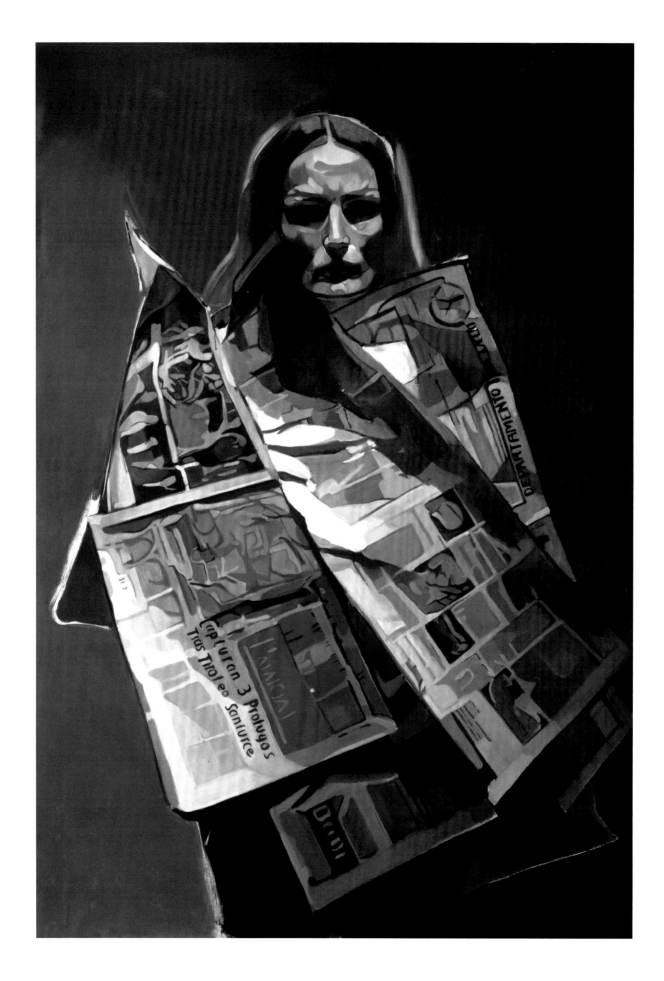

## LUIS MUÑOZ MARÍN: A TERRITORY'S HEAD OF STATE

Understanding the importance of this painting for Puerto Ricans requires examining the pivotal role that its subject played in the island's history. In 1948, Luis Muñoz Marín, became Puerto Rico's first governor to be elected by popular vote, and his important legacy as a politician was cemented with the dramatic political and economic changes that he advanced during his four-term tenure, which lasted until 1964. These efforts included the creation of the Estado Libre Asociado de Puerto Rico (officially translated as the Commonwealth of Puerto Rico) in 1952 and the overall transformation of the poor, agrarian country into an industrial showcase of capitalism in the Caribbean and Latin America—at least for a brief period of time.

In the fifty years leading up to Muñoz Marín's election, the Caribbean island of Puerto Rico had been a country with virtually no agency over its political and economic affairs. In 1898, it had ceased to be a colony of Spain (along with Guam and the Philippines) and had become a possession of the United States after the latter's triumph in the Spanish-American War. That year, under the Treaty of Paris that ended the war, the civil rights and political condition of all the inhabitants of all new possessions were transferred to the determination of the U.S. Congress.[11]

After a brief period of American military rule in 1900, under the Foraker Act signed by President William McKinley, the United States organized a civilian government in Puerto Rico, comprising a governor (appointed by the U.S. president), a supreme court, and an upper legislative body, with a lower house elected by Puerto Ricans.[12] Puerto Ricans were also allowed to elect one local delegate to the U.S. House of Representatives. The Resident Commissioner, as that position was called, could voice his opinions but had no right to vote in the U.S. legislative process.[13] The Foraker Act exempted Puerto Rico from federal income taxes, but it also imposed a temporary tariff of 15 percent on all goods from Puerto Rico entering the United States, and all goods from the United States entering Puerto Rico. A discussion about the constitutionality of this law ensued, and the U.S. Supreme Court ruled that Puerto Rico and the other new overseas territories in the Pacific were "unincorporated territories," foreign possessions with no constitutional rights.[14] In 1917, after sustained pressure from Puerto Rican parties for a more democratic government, President Woodrow Wilson signed the Jones Act of Puerto Rico (also known as the Puerto Rican Federal Relations Act of 1917), which separated the executive, judicial, and legislative branches of the local government. The act expanded Puerto Rican participation in the bicameral legislative system, but it still gave the U.S. president and his appointed governor the power to veto any laws passed by the Puerto Rican legislature.[15] The Jones Act also gave U.S. citizenship to Puerto Ricans, with the requirement of military service for men. That same year, the U.S. entered World War I, and 17,000 Puerto Rican men served on its behalf.[16] The act also demanded that all imported goods brought into Puerto Rico arrive there on American-made ships with American crews, effectively establishing a monopoly of import transportation over the island, designed to protect the U.S. merchant marine.

While a small Creole elite of local planters from Spanish colonial times saw the benefits of modest economic growth under the first decades of American rule, most of the island's population, comprised largely of agricultural workers, remained poor. The island's political status favored U.S. economic interests and gave rise to an economy of foreign dependency for its inhabitants. The two main economic engines were sugar cane and tobacco cultivation and processing. By the 1920s the United States controlled almost all facets of the tobacco industry, and a decade later almost half of Puerto Rico's cane was ground in four

**Fig. 16.2**
*Andrómeda* (portrait of Rosario Ferré) by Francisco Rodón, 1971–73
Oil on canvas, 195 × 136 cm (77⅛ × 53¹⁵⁄₁₆ in.)
Collection of Dr. Thomas Muldon

U.S.-owned sugar mills that held tens of thousands of acres of land, employed underpaid seasonal laborers, and repatriated to the United States most of their earnings.[17] American companies also possessed large parts of the banking sector of Puerto Rico, the rail and tramway system, and much of the electric grid.[18]

Luis Muñoz Marín entered Puerto Rican politics in the early 1930s, a decade when the structural economic problems discussed above, resentment toward the imposition of the English language in schools, and poverty exacerbated by the Great Depression crystallized into strikes and a strong nationalist movement for the island's independence. The son of Luis Muñoz Rivera, the most prominent politician of the later years of the Spanish colony and the first two decades of American rule, Muñoz Marín was a charismatic leader and an exceptional negotiator who inaugurated an unprecedented era of dialogue and collaboration with the United States. After spending most of his youth in the United States, first in Washington, DC, between 1910 and 1916, where his father served as Puerto Rico's Resident Commissioner, and later in New Jersey and New York, where he became a poet, essayist, and publisher, Muñoz Marín returned permanently to the island in 1931 and campaigned for a seat in the Senate that he earned the next year.

As a senator, Muñoz Marín traveled to Washington, DC, requesting measures to extend the New Deal to Puerto Rico in order to stabilize the economy, and as a step toward independence. By the end of the decade, he had founded the Popular Democratic Party, whose support for agrarian reform and the workers' movement led to resounding victory in the legislative elections of 1940. In 1944 he became president of the Senate, from where he devised the industrial program Operation Bootstrap, signed into law in 1947. A year later, he was elected governor in the very first open elections allowed by U.S. Congress on the island. (Beginning in 1898, all appointments had been made by the U.S. president.)

Operation Bootstrap became one of two hallmarks of Muñoz Marín's tenure as governor. The program invited American manufacturing and corporate interests to relocate or establish subsidiaries on the island in exchange for free land, factory buildings, and lucrative tax incentives.[19] As a "safety valve" to alleviate the structural pressures of production, Muñoz Marín worked with the government of the United States to encourage the migration of Puerto Ricans displaced from their jobs in the agrarian sector to enter into manufacturing or service work.[20] Concurrently, in the 1950s, between 40,000 and 50,000 Puerto Ricans a year relocated from the island to the United States in what became the first airborne mass migration in world history. The number of Puerto Rican residents in the United States grew from 69,967 in 1940 to 887,662 in 1960.[21]

The results of Operation Bootstrap were outstanding for more than two decades and were almost immediately measurable. The aggressive promotion of industrialization resulted in the establishment of almost six hundred large American factories in the late 1950s; in the 1940s there were fewer than ten.[22] Between 1954 and 1964, life expectancy rose by ten years, the birth rate declined by 5 percent, per capita annual income doubled from $423 to $820, and school enrollments increased dramatically.[23] According to *Time* magazine in 1964, Puerto Rico's per capita income was second only to oil-rich Venezuela in all of Latin America.[24] This success and prosperity attracted international tourism. Levittowns, suburbs, and shopping malls started to dominate the island's former rural landscape. Puerto Rico became the model of U.S. capitalism for other developing countries, playing a key role in the Cold War as it developed in the American hemisphere.[25] In 1962 President John F. Kennedy named several high-profile implementers of Operation Bootstrap to shape and administer his Alliance for Progress, a program of economic aid designed to counter the appeal of the Cuban Revolution in Latin America after 1959.[26]

The second hallmark of Muñoz Marín's governorship was his founding in 1952 of the Estado Libre Asociado de Puerto Rico (ELA). The name translates into English literally (if slightly oxymoronically) as "Associated Free State," but it was officially translated as "Commonwealth," due to the lack of a legal lexicon in American jurisprudence that would capture the essence of this new state construct.[27] This new political status was the product of negotiations between Muñoz Marín and other leaders of his party, President Harry S. Truman, and members of the U.S. Congress active during mid-1940s, through which Muñoz Marín petitioned the federal government to allow the island to draft and adopt its own constitution. By that time, Muñoz Marín and his party had abandoned the ideal of independence as economically impractical, and were advocating instead for the island's autonomy over local matters. The idea of a new constitution was approved by the United States and ratified by Puerto Rico, and a constitutive assembly was organized to draft it. Muñoz Marín presented this political development—a redefinition of Puerto Rico's relationship to the United States—as "a bilateral agreement." However, although a new local constitution was in place, the ELA left undisturbed the terms giving Congress ultimate power over the territory. Matters of citizenship, military defense, immigration, foreign relations, and maritime commerce remained the exclusive purview of the U.S. Congress, and in case of conflict between the island and the United States, federal law would prevail. Puerto Ricans on the island would also continue to be excluded from voting for the U.S. president. These provisions were heavily criticized by some sectors of society who maintained that the ELA was no more than the legalization of Puerto Rico's colonial status.[28]

Still, the suggestion of a change of status did make the ELA widely popular for some time, and cemented Muñoz Marín's place as a "founding father," the patriarch of Puerto Rico's modern state. His economic and political success story, in alignment with the American capitalist ideology of the Cold War, earned him hemispheric fame.

He made the cover of *Time* magazine in 1949 and again in 1958, and in 1963 was awarded the Presidential Medal of Freedom by President Kennedy.

During his four terms in office, Muñoz Marín also established a vigorous cultural infrastructure, to be led and safeguarded by the Institute of Puerto Rican Culture (Instituto de Cultura Puertorriqueña, ICP) that he founded in 1956. In counterpoint to Operation Bootstrap, Muñoz Marín named his cultural initiative Operation Serenity. In spite of Puerto Rico's continued lack of political sovereignty and its economic reliance on U.S. capital, the ICP promoted a notion of national identity that emphasized the island's Spanish colonial past as constitutive of its unique cultural personality.[29] The University of Puerto Rico also played an important role as the seat of the island's intelligentsia and a fundamental site of intellectual and cultural exchange with important cultural figures of Latin America and Spain.

## NOT A STATE PORTRAIT, BUT A HISTORY PORTRAIT

Francisco Rodón had professed great admiration for Muñoz Marín in his early years as governor, and in 1954 had painted portraits of his daughters with the hope of also being allowed to paint their father, but he was given permission only to sketch him from afar in the governor's palace, La Fortaleza.[30] In 1971, seven years after he had left office, Muñoz Marín contacted Rodón, whom art critics in Latin America already deemed a great portraitist, and asked if Rodón would paint his portrait. Rodón did not hesitate; his greatest dream was still to paint the former governor. The sittings took place over the course of three months in 1973, between six and nine o'clock in the evening, amidst the bucolic setting of Muñoz Marín's house in Trujillo Alto.[31] In 1977, just three years before the governor's death, the portrait was unveiled in a ceremony with Muñoz Marín's family and friends. The most widely reproduced photograph of the unveiling alerts us to the unorthodoxy of this political portrait (fig. 16.3). In it Inés Mendoza (second from the left), wife of Muñoz Marín, reacts with

Fig. 16.3
Photograph of the unveiling of
Rodón's *Luis Muñoz Marín*, by
Héctor Méndez Caratini, 1977
(see fig. 16.1)

dismay at her first sight of the painting, while a friend puts an arm around her shoulder to comfort her. José Trías Monge (left), one of the members of the constitutional assembly that established the ELA and the attorney general under Muñoz Marín, claps, while Muñoz Marín himself (center foreground) examines the painting impassively, his hands calm but perhaps tense, his lips tight.[32]

The painting captures the leader empty of his renowned drive and command, revealing instead his human dimension. His enormous body evokes the patriarchal presence and spirit he embodied for that mid-century generation of Puerto Ricans who believed in his project. His skin, fragmented into a thousand small planes of color, almost like a topographical map, reflects his proximity to the Puerto Rican peasant, the electoral base of his populism, while his shirt reminds us of his Hispanic Creole pedigree and his Latin American and Caribbean identity. But the disheveled garment and the deflated posture of Muñoz Marín—a man whose political acumen was once personified by his impeccable dress and large stature—suggest a personal and a national collapse.[33]

Just a few years before Rodón began this portrait, in the mid- to late 1960s, Operation Bootstrap began to lose steam. The economic contraction left exposed some of the plan's adverse social effects, including a decrease of participation in the workforce; the island's agrarian decay and large dependence on imported foods; and the toll of a displaced community of one million Puerto Ricans in the United States, mainly unskilled rural workers, dislocated by Muñoz Marín's plan, who had migrated to the mainland in search of opportunity only to become part of its urban poor. At the same time, the debate over the island's political status was revitalized with a movement for statehood that rivaled the ELA, and a decimated but persistent independence movement. By that time, Muñoz Marín had also admitted, although in private, that the ELA was no bilateral agreement, as the U.S. government was uninterested in revisiting any terms that would lead to a more autonomous island government.[34] In addition, as recounted in his autobiography, and repeated to Rodón during the intimate sittings for the portrait, Muñoz Marín felt responsible and pained by the addiction to consumerism

and material wealth that had taken root in Puerto Rican society since the 1950s as a consequence of his own economic plan and its emphasis on American markers of progress.[35] The artist has said that the former governor also expressed to him remorse for having persecuted and jailed the nationalists, his radical opposition, who shared the ideal of independence that Muñoz Marín had supported at the beginning of his career.[36]

At the unveiling of the portrait, Muñoz Marín reportedly thanked the artist for "painting his true biography" and for capturing a moment in his life in which "he felt saddened by the weight of not having done more, or not having known how to do more for his country."[37] In creating a portrait that was honest about the culminating dissatisfaction of Muñoz Marín, Rodón broke with the tradition of state portraiture as a propagandistic tool that praises political endeavor in order to cement a leader's position in national history. In spite of his rupture, this political portrait's unusual mixture of monumentality and pathos is what has made it a landmark of Puerto Rican art. Muñoz Marín's droopy eyes and the grim cast of his mouth reveal not just his personal malaise but also the limits of his political rule, marked by the island's status as a possession of the United States. After Rodón's painstaking emphasis on the elements that comprise the portrait—from the vegetation in the background to the skin and garment of Muñoz Marín—the dripping paint and exposed primed canvas at the bottom of the painting become a metaphor of that unfinished national project. This is a history portrait of a man of state, a painting impossible without the distance of a decade from the end of the era in which Muñoz Marín starred.

## READING THE PORTRAIT IN A NEW CONTEXT: MUÑOZ MARÍN AT THE NATIONAL PORTRAIT GALLERY

Political portraiture as a genre aims not only to collectively memorialize leaders, but to create a sense of shared national experience. For this reason, beyond the impulse of political portraiture to put forward a leader's image for "universal" admiration, this genre is one profoundly bound to its context of production. In order to perform its function as a national symbol, to create a sense of community and belonging around the values it embodies, the artwork requires an audience familiar to some degree with the history that the subject helped shape.

This is a given at the National Portrait Gallery, which opened its doors in 1968 with the mission of telling the story of the United States through portraits of people who had shaped the country politically, socially, and culturally. Today the museum has also the additional, more open mission of "expanding the notion of portraiture."[38] However, its permanent collection and most of its exhibitions still comply with a conceptual framework that powerfully binds the museum, the Greek Revival building—a common signifier of timeless ideals—that it occupies, and the artworks it houses to the seemingly stable notions of national history and identity. Built over the course of half a century, the museum's permanent collection tells a national history that is mainly circumscribed to the continental United States, and that anchors national identity in the values of freedom and democracy that are nestled in the U.S. Constitution and the Bill of Rights.

Yet if we understand national identity to be a construct whose meaning changes with time and space, then it operates in tandem with accidental as well as purposeful historical events as varied as migrations, wars, colonization, territorial displacement, secessions, and state policies. Therefore, in a shift from the twentieth century, when the institutional discourse around identity and history at the National Portrait Gallery seemed absolute and conclusive, today the institution recognizes the fluid nature of identity, the richness and diversity of American history, while grappling with the challenge of also representing individuals and stories overlooked or purposefully excluded by the very genre of portraiture.[39] The main goal of this effort is to provide the public with multiple perspectives

and a deeper knowledge of their country's history, without shying away from historical episodes and current social conditions that counter the sacrosanct national values of democracy and freedom.

Bringing Francisco Rodón's *Luis Muñoz Marín* to the Portrait Gallery was a project in that spirit. Before traveling to the museum as a loan in 2015, the portrait had been on view almost without interruption since 2001 at the Museo de Arte de Puerto Rico in San Juan. There, it took its proper place in the island's artistic canon. When viewed alongside other works, such as José Campeche's *Daughters of Governor Ramón de Castro* (1797), Francisco Oller's *Still Life with Avocados and Utensils* (1890–91), and Rafael Tufiño's mural painting *Las Plena* (1952–54), aspects of the island's history, from its Spanish colonial past, to its tropical flora and culinary culture, to its popular music, helped viewers understand the achievements and challenges of the island's governance by Muñoz Marín.

In its new, temporary setting of the "20th Century Americans: 1950–1990" gallery, Muñoz Marín, the statesman, continues to fill the room by virtue of the portrait's scale and the attention it commands. In this gallery, Muñoz Marín is one of many individuals who, by accident of birth or by personal choice, can be called Americans. There he embodies an odd case, owing his nationality to the Jones Act of 1917. Furthermore, throughout his life and in spite of spending most of his youth in the United States, Muñoz Marín identified as Puerto Rican and defended the idea of an unbreakable national identity strongly tied to the island's Spanish colonial past and its indigenous Taíno culture. Although Muñoz Marín was a man of the people, he is in an awkward position in this gallery as the only head of state. Where else might his portrait have been placed in the museum? His professional counterparts are in "America's Presidents," the signature gallery, but there Muñoz Marín—as the governor of a territory possessed by the United States—would be even more awkward.

Within the national and chronological scope of the "20th Century Americans" gallery, he appears as a remarkable politician of his time whose governance ushered in Puerto Rico's first prosperous moment in the twentieth century and helped the United States spread its gospel of capitalism and democracy in the Americas. The chronological scope of the gallery is broad enough to encompass the crumbling of Muñoz Marín's project after the mid-1960s, bringing to mind the island's current economic crisis and begging the question of what dysfunction of local and federal policy allowed it to accrue a debt of $72 billion with Wall Street creditors.[40]

Expanding on the cultural readings of the painting at the National Portrait Gallery, it is noteworthy that here, the portrait loses the company of the artworks at the Museo de Arte de Puerto Rico, which anchor it in Puerto Rican history. During its first year in the Portrait Gallery, *Luis Muñoz Marín* hung with only one portrait in the same gallery that was related to Muñoz Marín and his political, economic, and cultural project in Puerto Rico: a 1959 woodcut by Uruguayan-American master printmaker Antonio Frasconi of Pablo Casals, the foremost cellist of the century, who spent the last sixteen years of his life in Puerto Rico, where he developed the musical component of the ELA's cultural infrastructure.[41] In a way, the proximity to *Luis Muñoz Marín* of the portrait of Casals by Frasconi—another renowned portraitist of Latin America—reinstates the link to Hispanic and Latin American culture that is implicit in Rodón's series *Personajes*.[42]

On the other hand, the presence of Rodón's *Luis Muñoz Marín* here makes it possible to represent visually and in some depth the history of the Puerto Rican diaspora. The painting resonated with the portraits of Supreme Court

**Fig. 16.4**
*Sonia Sotomayor* by Timothy Greenfield-Sanders, from the series
*The Latino List*, 2010
Inkjet print, 101.8 × 76 cm (40 1/16 × 29 15/16 in.)
National Portrait Gallery, Smithsonian Institution

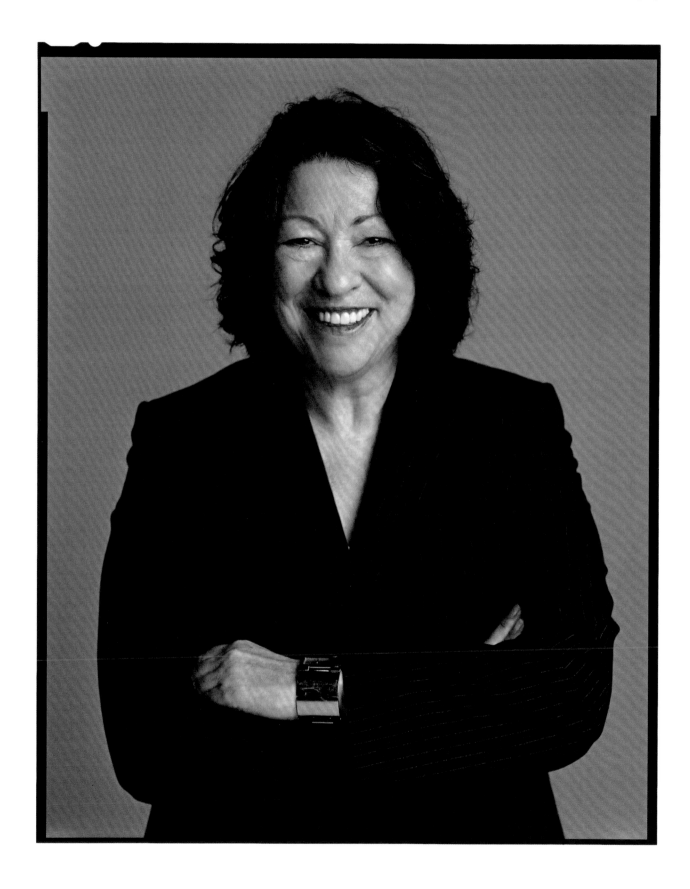

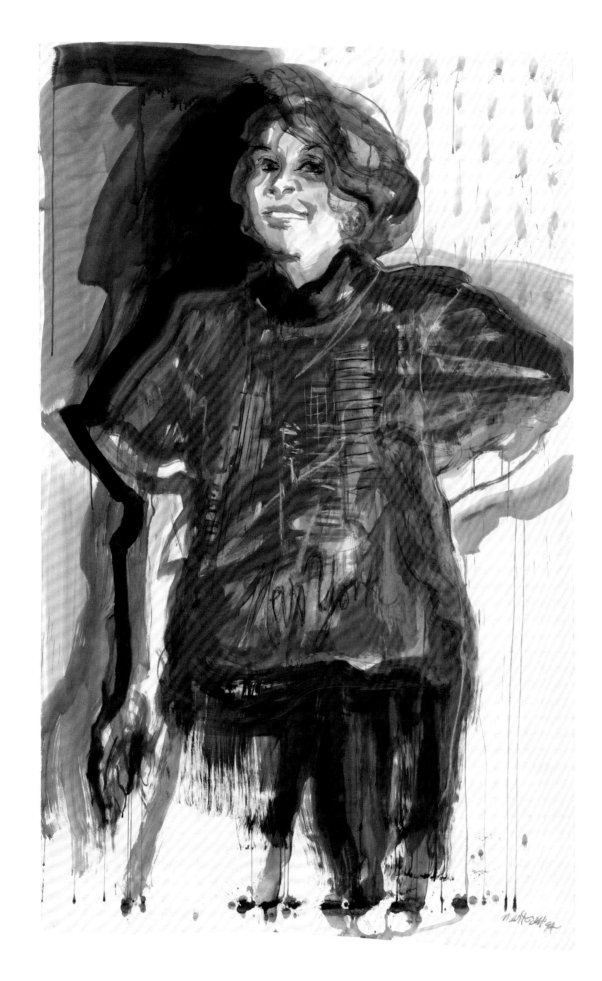

Justice Sonia Sotomayor by Timothy Greenfield-Sanders (fig. 16.4) and singer Marc Anthony by ADÁL in the exhibition *Eye Pop: The Celebrity Gaze* (May 2015–July 2016), and with those of novelist Nicholasa Mohr by Antonio Martorell (fig. 16.5), actress Rita Moreno by ADÁL, and salsa and Latin jazz legend Eddie Palmieri by Máximo Colón in the *Recent Acquisitions* show of 2015 (November 2015–October 2016). These subjects are representative of a vibrant, transnational Puerto Rican community that started growing once the island became a U.S. territory, and became established as a major U.S. Latino demographic as a consequence of Operation Bootstrap. To establish a dialogue between their portraits and that of Luis Muñoz Marín at the National Portrait Gallery is a fitting development, a recognition—at last—of the important cultural, social, economic, and political contributions of transnational Puerto Ricans, who for decades were diminished or made invisible on the island as well as in the United States. Prejudice against Puerto Ricans in the United States developed concurrently with the migration, as diasporic Puerto Ricans were considered incompatible with the Hispanophilic notion of Puerto Rican cultural identity articulated under the ELA. On the other hand, in the United States they were often perceived as an underclass of foreigners whose low level of education and social disenfranchisement made them incapable of assimilating American culture.[43]

While migration from Puerto Rico to the United States decreased in the 1960s, it has seen a historic resurgence since 2010, with Puerto Ricans leaving the island in greater numbers proportionally to its population than during the 1950s Great Migration.[44] Today there are four million Puerto Ricans living in the United States, compared to 3.4 million on the island.[45] These numbers are the most tangible manifestation of the inalienable tie of Puerto Rican and American history since 1898. The portrait of Luis Muñoz Marín by Francisco Rodón invites us to reflect on that relationship, on Rodón's power to capture in his image of Muñoz Marín the statesman's dueling priorities—to ensure prosperity for his people, but at the cost of their independence.

Fig. 16.5
*Nicholasa Mohr* by Antonio Martorell, 1994
Acrylic on paper, 213.4 × 129.9 cm (84 × 51⅛ in.)
National Portrait Gallery, Smithsonian Institution; acquisition made possible through federal support of the Latino Initiatives Pool, administered by the Smithsonian Latino Center

Notes

I am thankful to Francisco Rodón for sharing with me the story of this portrait and his relationship to the sitter; to Julio Quirós Alcalá, director of the Historic Archive of the Fundación Luis Muñoz Marín, for his help identifying specific sources for this essay; and to Fundación Luis Muñoz Marín and its director, Linda Díaz, for the extended loan of this artwork. Finally, my gratitude goes also to Marc Neumann and Dr. Kate Lemay for their keen reading of this essay when it was still a draft, and their comments to strengthen it.

1 For example, a scholar who was recently in residence at the Smithsonian with a fellowship to study Puerto Rican ethnographic collections in museums of the United States was told at the National Archives that she would not be able to find any records on Puerto Rico there, as the Archives only documented the United States. As it turns out, the staff member was wrong. In a widely publicized instance of this confusion, in February 2014 conservative talk show host Laura Ingraham, criticizing Supreme Court Justice Sonia Sotomayor for her preference to use the term *undocumented immigrant* instead of *illegal alien*, said that Sotomayor's allegiance was to her immigrant family, and not to the U.S. Constitution. A small media storm followed, with multiple parties correcting the host on her use of the word *immigrant* to describe someone born a U.S. citizen.

2 *National Portrait Gallery Strategic Plan, 2014–2018*, internal document (Washington, DC: National Portrait Gallery, Smithsonian Institution, March 2014), 13.

3 *National Portrait Gallery Strategic Plan, 2014–2018*, 5.

4 Rodón attributes his initiation into art to his grandmother, who instilled his early passion as a child and youngster for the films of Greta Garbo and María Félix, and introduced him to literary figures such as Jules Vernes, Henry David Thoreau, and Rómulo Gallegos. See Rafael Squirru, "El Gran Rodón," in *Campeche, Oller, Rodón: Tres siglos de pintura puertorriqueña*, by Francisco J. Barrenechea et al., exh. cat. (San Juan: Instituto de Cultura Puertorriqueña, 1992), 78–85. Francisco Rodón and Francisco J. Barrenechea, *Personajes de Rodón, 1971–1983: Museo de la Universidad de Puerto Rico, 2 de diciembre, 1983–31 de enero, 1984* (Río Piedras: Universidad de Puerto Rico, Recinto de Río Piedras, 1983).

5 Marta Traba, "Francisco Rodón" (unpublished book manuscript for *Cuatro Pintores Puertorriqueños*, accessed November 29, 2016), Documents of 20th-Century Latin American and Latino Art, International Center for the Arts of the Americas at Museum of Fine Arts, Houston, ICAA Record ID: 1062265, http://icaadocs.mfah.org/icaadocs/en-us/home.aspx.

6 Traba.

7 Between 1980 and 1987, the series was exhibited partially or in full at the Museum of the University of Puerto Rico, the Ponce Art Museum in Puerto Rico, the Department of State of Puerto Rico, and the Carpenter Center for the Visual Arts at Harvard University in Cambridge, Massachusetts. In 1992 part of the series was featured in the Universal Exposition of Seville, as part of the exhibition *Campeche, Oller, Rodón: Tres siglos de pintura puertorriqueña*, held in the Puerto Rican pavilion. This exhibition also traveled to Sotheby's New York. See Barrenechea et al., *Campeche, Oller, Rodón*.

8 Barrenchea et al., 13.

9 Edgardo Rodríguez Juliá, "La estrategia del retrato," in Rodón and Barrenechea, *Personajes de Rodón*, 33–38.

10 Marimar Benítez, "Viendo pintar a Francisco Rodón," in Barrenechea et al., *Campeche, Oller, Rodón*, 108.

11 Cuba, Puerto Rico, and Guam were ceded to the United States, while the Philippines was sold for $20 million. The United States granted Cuba its independence in 1900, as it had promised the island. The Philippines became independent in 1946. Guam and Puerto Rico have remained U.S. territories.

12 Juan R. Torruella, "A Discussion of Some of the Outstanding Constitutional and International Law Issues that Are Raised by the United States–Puerto Rico Relationship" (paper presented at a conference at the John Jay College of Criminal Justice, City University of New York, April 14, 2016), See the related article published in *Minnesota Law Review* 100 (Summer Part 1, 2016): http://www.minnesotalawreview.org/wp-content/uploads/2016/06/JudgeTorruella_FinalPDF.pdf (accessed 2/6/2018).

13 "Puerto Rico," United States House of Representatives, History, Art and Archives, http://history.house.gov/Exhibitions-and-Publications/HAIC/Historical-Essays/Foreign-Domestic/Puerto-Rico/.

14 As opposed to the territories the United States acquired in the nineteenth century during its westward expansion, which became progressively incorporated into the Union. The constitutionality of the Foraker Law was debated in the United States by people who opposed colonial politics as well as by others who favored it, but the Supreme Court ruled it constitutional in a vote of 5–4 in a series of opinions known as the Insular Cases. See Torruella, "A Discussion of Some of the Outstanding Constitutional and International Law Issues that Are Raised by the United States–Puerto Rico Relationship."

15 César J. Ayala and Rafael Bernabe, *Puerto Rico in the American Century: A History since 1898* (Chapel Hill: University of North Carolina Press, 2009), 58.

16 Félix V. Matos Rodríguez and Pedro Hernández, *Pioneros: Puerto Ricans in New York City, 1896–1948* (Charleston, NC: Arcadia Publishing, 2001), 101.

17 Virginia Sánchez Korrol, *From Colonia to Community: The History of Puerto Ricans in New York City*, 2nd ed. (Berkeley: University of California Press, 1994); Ayala and Bernabe, *Puerto Rico in the American Century*, 25, 39.

18 Ayala and Bernabe, *Puerto Rico in the American Century*, 41.

19 Sánchez Korrol, *From Colonia to Community*, 216.

20 Ayala and Bernabe, *Puerto Rico in the American Century*, 68. Many individuals worked in Puerto Rico's garment, rope, pencil, and biscuit industries, while others served as janitors, porters, and maids.

21 Sánchez Korrol, *From Colonia to Community*, 213–17.

22 Jeffrey Taffet, *Foreign Aid as Foreign Policy: The Alliance for Progress in Latin America* (New York: Routledge, 2012), 37.

23 Sánchez Korrol, *From Colonia to Community*, 216.

24 "Puerto Rico: Solving the Unsolvable," *Time*, February 7, 1964, http://content.time.com/time/magazine/article/0,9171,870672,00.html.

25 Ramón Grosfoguel and Chloé Georas, "Latino Caribbean Diasporas in New York," in *Mambo Montage: The Latinization of New York*, ed. Agustín Laó-Montes and Arlene Dávila (New York: Columbia University Press, 2001), 97–118.

26 Teodoro Moscoso, head of Operation Bootstrap, and Arturo Morales Carrión, advisor to Muñoz Marín on inter-American and international affairs, were chosen by Kennedy to be part of the Task Force for Latin America that developed the Alliance for Progress. Moscoso was then appointed Coordinator of the Alliance; see Taffet, *Foreign Aid as Foreign Policy*, 22.

27 Ramón Soto-Crespo, "An Intractable Foundation: Luis Muñoz Marín and the Borderland State in Contemporary Puerto Rican Literature," *American Literary History* 18, no. 4 (Winter 2006): 712–38.

28 The new status also established that, in case of conflict between the United States and Puerto Rico, American federal law would prevail over Puerto Rican law. To the benefit of the United States, the establishment of the ELA resulted in the removal of Puerto Rico from the United Nations' list of colonies. The establishment of the ELA faced opposition from radical nationalists, who staged armed attacks in Puerto Rico and Washington, DC, to create a crisis that would bring international attention to what they saw as Puerto Rico's continuing political powerlessness. The government of Muñoz Marín responded by legalizing the state's intimidation of supporters of independence and communism through surveillance and unjustified imprisonments. Ayala and Bernabe, *Puerto Rico in the American Century*, 175.

29 Jorge Duany, *The Puerto Rican Nation on the Move: Identities on the Island and in the United States* (Chapel Hill: University of North Carolina Press, 2002), 124.

30 Francisco Rodón, "El Retrato de Luis Muñoz Marín," interview by Angel Collado Schwarz, *La voz del centro*, radio interview no. 72, May 2, 2004, http://www.vozdelcentro.org/2004/05/02/el-retrato-de-luis-munoz-marin/.

31 Francisco Rodón, "Luis Muñoz Marín: Personaje de lo profundo," in *Forjadores de sueños: Rodón*, exh. cat. (San Juan: Departamento de Estado, Puerto Rico, 1987), np.

32 Héctor Méndez Caratini, who took this memorable photograph, describes Muñoz Marín's reaction as "catatonic, while examining the psychological portrait that Rodón made of him." Héctor Méndez Caratini, email message to author, June 5, 2017.

33 For an insightful analysis of Muñoz Marín's visual representation and public perception from official and press photographs of his heyday as governor to his portrait by Francisco Rodón, and to his multitudinous funeral in 1980, see Edgardo Rodríguez Juliá, *Las tribulaciones de Jonás* (Río Piedras, PR: Ediciones Huracán, 1981).

34 Ayala and Bernabe, *Puerto Rico in the American Century*, 175.

35 Francisco Rodón, "El Retrato de Luis Muñoz Marín."

36 Rodón.

37 Luis Muñoz Marín to José M. Caldas Fillat, October 26, 1977, Archivo Histórico de la Fundación Luis Muñoz Marín (my translation).

38 *National Portrait Gallery Strategic Plan, 2014–2018*, 35.

39 According to Shearer West, in the 1990s a brochure from the National Portrait Gallery stated: "This is a history museum. By the time you finish with this, you will have seen all of American history." Shearer West, *Portraiture* (New York: Oxford University Press, 2004), 48.

40 Mary Williams Walsh, "Puerto Rico's Governor Warns of Fiscal 'Death Spiral,'" *New York Times*, October 14, 2016, http://www.nytimes.com/2016/10/15/business/dealbook/puerto-rico-financial-oversight-board.html.

41 The son of a Puerto Rican mother, Casals met the young Puerto Rican cellist Marta Montañez Martínez in 1952, and in 1956 he married her and moved to the island. There he helped establish Festival Casals, a celebration of classical music financed by the Estado Libre Asociado, the Puerto Rican Symphonic Orchestra, and the Conservatory of Music.

42 Interestingly, one of Rodón's early portraits, made in 1956, was of Pablo Casals. The painter destroyed it a year later, unsatisfied with the likeness. Francisco J. Barrenechea, "Rodón: Cronología," in Barrenechea et al., *Campeche, Oller, Rodón*, 138.

43 Edgardo Meléndez Vélez, "The Puerto Rican Journey Revisited: Politics and the Study of Puerto Rican Migration," *Centro: Journal of the Center for Puerto Rican Studies* 17, no. 2 (2005): 193–221. "The Puerto Rican problem" was a phrase coined in early 1947 in the first article of a series on the Puerto Rican migration published by the New York tabloid *PM*, and quickly became the basis for a rabid anti-Puerto Rican campaign in the media, in which *New York World Telegram* and the *New York Times* also took part. The article in *PM* inflated the number of Puerto Ricans who had arrived to New York in the previous six months by more than 50% (from an estimated 17,500 to 50,000) and compared these migrants to the Depression-era "Okies" that roamed the Southwest in the 1930s. *PM* also published the complaints of the city's welfare and service agencies who, it said, were overwhelmed by the sheer number of immigrants. Although the Puerto Rican government was quick in commissioning a survey from Columbia University to get the facts of the migration straight and counteract the sensationalist media, the campaign had profound and long-lasting negative effects on the U.S. perception of Puerto Ricans.

44 Jens Manuel Krogstad, "Historic Population Losses Continue across Puerto Rico," *Fact Tank*, Pew Research Center, March 24, 2016, http://www.pewresearch.org/fact-tank/2016/03/24/historic-population-losses-continue-across-puerto-rico/.

45 Krogstad.

# FURTHER READING

Wendy Wick Reaves

This list, which is not meant to be comprehensive, includes broad, general references valuable for the study of portraiture. Studies of single artists and single pictures have been omitted, as have collection catalogues and some older works. The endnotes for each essay should be consulted for more specific bibliographic sources.

**BOOKS**

Adler, Kathleen, and Marcia Pointon, eds. *The Body Imaged: The Human Form and Visual Culture since the Renaissance*. Cambridge: Cambridge University Press, 1993.

Alarcó, Paloma, and Malcolm Warner. *The Mirror and the Mask: Portraiture in the Age of Picasso*. New Haven, CT: Yale University Press in association with the Kimbell Art Museum, the Museo Thyssen-Bornemisza, and the Fundación Caja Madrid, 2007.

Bond, Anthony, Joanna Woodall, et al. *Self Portrait: Renaissance to Contemporary*. London: National Portrait Gallery, 2005.

Borzello, Frances. *Seeing Ourselves: Women's Self-Portraits*. New York: Harry N. Abrams, 1998.

Brilliant, Richard. *Portraiture*. London: Reaktion Books, 2001.

Clarke, Graham, ed. *The Portrait in Photography*. London: Reaktion Books, 1992.

Colbert, Charles. *A Measure of Perfection: Phrenology and the Fine Arts in America*. Chapel Hill: University of North Carolina Press, 1997.

Craven, Wayne. *Colonial American Portraiture: The Economic, Religious, Social, Cultural, Philosophical, Scientific, and Aesthetic Foundations*. Cambridge: Cambridge University Press, 1986.

Fortune, Brandon Brame, with Deborah J. Warner. *Franklin and His Friends: Portraying the Man of Science in Eighteenth-Century America*. Philadelphia: University of Pennsylvania Press in association with the National Portrait Gallery, Smithsonian Institution, Washington, DC, 1999.

Fortune, Brandon Brame, Wendy Wick Reaves, and David C. Ward. *Face Value: Portraiture in the Age of Abstraction*. London: D Giles Limited in association with the National Portrait Gallery, Smithsonian Institution, Washington, DC, 2014.

Frank, Robin Jaffee. *Love and Loss: American Portrait and Mourning Miniatures*. New Haven, CT: Yale University Press, 2000.

Gallati, Barbara Dayer, ed. *Beauty's Legacy: Gilded Age Portraits in America*. London: D Giles Limited, 2013.

Goodyear, Frank H., III. *Faces of the Frontier: Photographic Portraits from the American West, 1845–1924*. Norman: University of Oklahoma Press, 2009.

Hammer, Martin. *The Naked Portrait, 1900–2007*. Edinburgh: National Galleries of Scotland, 2007.

Jordanova, Ludmilla. *Defining Features; Scientific and Medical Portraits 1660–2000*. London: Reaktion Books in association with the National Portrait Gallery, 2000.

Kozloff, Max. *The Theatre of the Face: Portrait Photography since 1900*. London: Phaidon, 2007.

Lovell, Margaretta M. *Art in a Season of Revolution: Painters, Artisans, and Patrons in Early America*. Philadelphia: University of Pennsylvania Press, 2005.

Lugo-Ortiz, Agnes, and Angela Rosenthal, eds. *Slave Portraiture in the Atlantic World*. Cambridge: Cambridge University Press, 2013.

Meskimmon, Marsha. *The Art of Reflection: Women Artists' Self-Portraiture in the Twentieth Century*. New York: Columbia University Press, 1996.

Miles, Ellen G., ed. *The Portrait in Eighteenth-Century America*. Newark: University of Delaware Press, 1993.

Moorhouse, Paul. *Pop Art Portraits*. London: National Portrait Gallery, 2007.

Piper, David. *The English Face*. Edited by Malcolm Rogers. London: National Portrait Gallery, 1992.

Pointon, Marcia. *Portrayal and the Search for Identity*. London: Reaktion Books, 2013.

Powell, Richard J. *Cutting a Figure: Fashioning Black Portraiture*. Chicago: University of Chicago Press, 2008.

Rideal, Liz, with Whitney Chadwick and Frances Borzello. *Mirror, Mirror: Self-Portraits by Women Artists*. London: National Portrait Gallery, 2002.

Saunders, Richard H. *American Faces: A Cultural History of Portraiture and Identity*. Hanover: University Press of New England, 2016.

Saunders, Richard H., and Ellen G. Miles, *American Colonial Portraits, 1700–1776*. Washington, DC: Smithsonian Institution Press for the National Portrait Gallery, 1987.

Schimmel, Paul, and Judith E. Stein. *The Figurative Fifties: New York Figurative Expressionism*. Newport Beach, CA: Newport Harbor Art Museum, 1988.

Shaw, Gwendolyn DuBois. *Portraits of a People: Picturing African Americans in the Nineteenth Century*. Seattle: University of Washington Press for the Addison Gallery of American Art, Phillips Academy, 2006.

Sidlauskas, Susan. *Body, Place, and Self in Nineteenth-Century Painting*. Cambridge: Cambridge University Press, 2000.

Ward, David C., and Dorothy Moss, with an essay by John Fagg. *The Sweat of Their Face: Portraying American Workers*. Washington, DC: Smithsonian Books with the National Portrait Gallery, 2017.

West, Shearer. *Portraiture*. Oxford: Oxford University Press, 2004.

Woodall, Joanna, ed. *Portraiture: Facing the Subject*. Manchester: Manchester University Press, 1997.

## ARTICLES, CHAPTERS, AND ESSAYS

Buchloh, B. H. D. "Residual Resemblance: Three Notes on the End of Portraiture." In *Face Off: The Portrait in Recent Art*, edited by Melissa E. Feldman, 53–69. Philadelphia: Institute of Contemporary Art, 1994.

Chadwick, Whitney. "An Infinite Play of Empty Mirrors: Women, Surrealism, and Self-Representation." In *Mirror Images: Women, Surrealism, and Self-Representation*, 2–35. Cambridge, MA: MIT Press, 1998.

De Salvo, Donna. "Facing Both Ways: Some Thoughts on Portraiture Today." In *Face Value: American Portraits*, 16–58. Southampton, NY: Parrish Art Museum, 1995.

Ewing, William A., with Jean-Christophe Blaser and Nathalie Herschdorfer. "The Faces in the Mirror." In *About Face: Photography and the Death of the Portrait*, 6–15. London: Hayward Gallery, 2004.

Lukasik, Christopher J. "The Face of the Public." In *Discerning Characters: The Culture of Appearance in Early America*, 121–52. Philadelphia: University of Pennsylvania Press, 2011.

McCandless, Barbara. "The Portrait Studio and the Celebrity." In *Photography in Nineteenth-Century America*, edited by Martha A. Sandweiss, 48–75. New York: Harry N. Abrams, 1991.

Nochlin, Linda. "Impressionist Portraits and the Construction of Modernity." In *Renoir's Portraits*, edited by Colin Bailey, 53–75. New Haven, CT: Yale University Press, 1997.

Nochlin, Linda. "More Beautiful Than a Beautiful Thing: The Body, Old Age, Ruin, and Death." In *Bathers, Bodies, Beauty: The Visceral Eye*, 253–92. Cambridge, MA: Harvard University Press, 2006.

Nochlin, Linda. "Real Beauty: The Body in Realism." In *Bathers, Bodies, Beauty: The Visceral Eye*, 199-249. Cambridge, MA: Harvard University Press, 2006.

Sandweiss, Martha S. "'Momentoes of the Race': Photography and the American Indian." In *Print the Legend: Photography and the American West*, 208-73. New Haven, CT: Yale University Press, 2002.

Sheriff, Mary. "The Portrait Now and Then." In *The Outwin Boochever Portrait Competition 2013*, 9–19. Washington, DC: National Portrait Gallery, 2013.

Smalls, James. "The African-American Self-Portrait: A Crisis in Identity and Modernity." *Art Criticism* 15, no. 1 (1999): 21–45.

Steiner, Wendy. "Postmodern Portraits." *Art Journal* 46 (Fall 1987): 173–77.

# CONTRIBUTORS

**Christopher Allison** is Collegiate Assistant Professor in the Humanities, Affiliate Faculty Member, in the Departments of History and Art History, University of Chicago. He works at the intersection of early American history, material and visual culture, and religious studies. His book manuscript "Protestant Relics: Capturing the Sacred Body in Early America, 1750–1877" is a study of escalating material devotion toward the bodies of vaunted Protestant people in America and beyond.

**Ross Barrett** is Associate Professor of American Art at Boston University. He is the author of *Rendering Violence: Riots, Strikes, and Upheaval in Nineteenth-Century American Art* and co-editor, with Daniel Worden, of *Oil Culture*. His current book project, "Speculative Landscapes: American Art and Real Estate in the Long Nineteenth Century," examines five American artists who painted landscapes and speculated on land.

**Taína Caragol** is Curator of Painting and Sculpture and Latino Art and History at the National Portrait Gallery. Since her appointment in 2013, she has created a more inclusive portrait of the nation by dramatically increasing the representation of Latino sitters and artists in the museum's collection. Caragol curated the exhibitions *Portraiture Now: Staging the Self* and *One Life: Dolores Huerta*, and co-curated *UnSeen: Our Past in a New Light, Ken Gonzales-Day and Titus Kaphar*. Her academic interests include the interplay between portraiture, historical absence, and national myths.

**Anne Collins Goodyear** is Co-Director of the Bowdoin College Museum of Art in Brunswick, Maine, and President Emerita of the College Art Association. She is the co-editor of *This Is a Portrait If I Say So: Identity in American Art, 1912 to Today*, with Kathleen Campagnolo and Jonathan Frederick Walz, and *AKA Marcel Duchamp: Meditations on the Identities of an Artist*, with James W. McManus.

**Nikki A. Greene** is Assistant Professor of Art History at Wellesley College and the Visual Arts Editor of *Transition* magazine. Her book manuscript "Rhythms of Grease, Grime, Glass, and Glitter: The Body in Contemporary Black Art" considers the intersection between the body, black identity, and the musical possibilities of the visual.

**Kate Clarke Lemay** is a Historian at the National Portrait Gallery, where she is currently organizing exhibitions on the American suffragist movement and the Spanish-American War of 1898 and its aftermaths. She recently co-curated the reinstallation of *America's Presidents*, the museum's hallmark exhibition. Lemay's research has been funded by IIE Fulbright, the Georgia O'Keeffe Museum, and the Mémorial de Caen. Her forthcoming book *Triumph of the Dead: American WWII Cemeteries, Monuments and Diplomacy in France* was recently awarded a publication grant from the Terra Foundation for American Art.

**Lauren Lessing** is Mirken Director of Academic and Public Programs at Colby College Museum of Art in Waterville, Maine, where she also serves as a curator. She completed her PhD in Art History at Indiana University under the guidance of Sarah Burns, and she has authored numerous books, articles, essays, and papers on eighteenth- and nineteenth-century American art.

**Amy M. Mooney** is Associate Professor of Art and Art History at Columbia College in Chicago. Her publications include the monograph *Archibald Motley, Jr.* and contributions to *Archibald Motley: Jazz Age Modernist*, *Black Is Black Ain't*, and *Romare Bearden in the Modernist Tradition*. She is a recipient of fellowships from the American Council of Learned Societies, the National Portrait Gallery, the Smithsonian American Art Museum, and the Terra Foundation for American Art.

**Erin Pauwels** is Assistant Professor of Art History at Temple University in Philadelphia. Her current book project, on the American photographer Napoleon Sarony, explores how celebrity and mass media impacted the visual arts in the United States during the Gilded Age.

**Akela Reason** is Associate Professor of History at the University of Georgia. She received her PhD from the University of Maryland in 2005. She is the author of *Thomas Eakins and the Uses of History* and is currently working on a book-length study of Civil War commemoration in New York City.

**Wendy Wick Reaves** is Curator Emerita of Prints, Drawings, and Media Arts, and started the graphic arts department at the National Portrait Gallery in 1974. During her forty-year tenure, she curated numerous exhibitions. Her publications include books and articles on twentieth-century portraiture, celebrity, humor, prints, drawings, posters, cartoons, and caricature. She served as the museum's Interim Director from May 2012 through March 2013.

**Nina Roth-Wells**, a Paintings Conservator, has a BA in Art History and French from Bowdoin College, and a master's degree in Art Conservation with a specialization in Paintings from Queens University. In 2000 she started a private paintings conservation firm that serves both institutions and private collectors.

**Terri Sabatos** is Associate Professor of Art History at Longwood University in Farmville, Virginia. She has published several articles and exhibition catalogue entries on death and mourning culture in nineteenth-century America and Britain. She also co-authored a chapter that focused on liminal spaces in the art of Benjamin West.

**Richard H. Saunders**, Director of Middlebury College Museum of Art in Vermont, and Professor of History of Art and Architecture, has been trying to make sense of American portraiture for more than thirty years. His publications include *American Colonial Portraiture: 1700–1776*, with Ellen G. Miles, which accompanied the exhibition of the same name at the National Portrait Gallery; *John Smibert: Colonial America's First Portrait Painter*; and *American Faces: A Cultural History of Portraiture and Identity*.

**Juanita Solano Roa** is a PhD candidate at the Institute of Fine Arts, New York University. Her work focuses on the history of photography and modern and contemporary Latin American Art. She is currently co-editing the book *Lámparas de mil bujías: Fotografía y arte en América Latina desde 1839* and recently curated the exhibition *Bitter Bites: Tracing the Fruits Market in the Global South* at Cuchifritos Gallery, New York City.

**Allison M. Stagg** is the Terra Foundation Visiting Professor in American Art at the John F. Kennedy Institute for North American Studies, Freie Universität Berlin. Her research focuses on transatlantic visual culture. She received her PhD in art history from University College London and has held postdoctoral fellowships at the Metropolitan Museum of Art, the National Portrait Gallery, and the Technische Universität Berlin. She will soon complete a manuscript on the history of early American caricature.

**Jennifer Van Horn** is Assistant Professor of Art History and History at the University of Delaware. She specializes in American art and material culture. She is the author of *The Power of Objects in Eighteenth-Century British America*, published by the University of North Carolina Press for the Omohundro Institute.

**Jonathan Frederick Walz** is an expert on American modernism and Director of Curatorial Affairs and Curator of American Art at the Columbus Museum, Georgia. His publications include "The Act of Portrayal and the Art of Dying: Charles Demuth 'Faces' Mortality," which appeared in *Ricerche di storia dell'arte*, vol. 118: Mortalità e lutto nell'arte contemporanea and *This Is a Portrait If I Say So: Identity in American Art, 1912 to Today*, which he co-edited with Kathleen Campagnolo and Anne Collins Goodyear.

**ShiPu Wang** is a Professor of Art History and Founding Faculty of the Global Arts Studies Program at the University of California, Merced. He was a 2014 Terra Foundation Senior Fellow at the Smithsonian American Art Museum and is the author of *Becoming American? The Art and Identity Crisis of Yasuo Kuniyoshi*; *The Other American Moderns: Matsura, Ishigaki, Noda, Hayakawa*; and *Chiura Obata: An American Modern* (2018), which accompanied a retrospective he curated.

# IMAGE CREDITS

We would like to thank all those who gave their kind permission to reproduce material. Individual works of art appearing herein may be protected by copyright in the United States of America or elsewhere, and may not be reproduced in any form without the permission of the rights holders. In reproducing the images contained in this publication, the museum obtained the permission of the rights holders whenever possible. In those instances where the museum could not locate the rights holders, notwithstanding good-faith efforts, it requests that any contact information concerning such rights holders be forwarded so that they may be contacted for future editions.

## Artists' Copyrights

© 2017 Artists Rights Society (ARS), New York / ADAGP, Paris: 13.6

© María Magdalena Campos-Pons and Neil Leonard: 15.1, 15.2, 15.4

© 2017 Héctor Méndez Caratini: 16.3

© Association Marcel Duchamp / ADAGP, Paris / Artists Rights Society (ARS), New York 2017: 13.1, 13.2, 13.5, 13.8A–B; and courtesy Estate of Shuzo Takiguchi: 13.4

© Timothy Greenfield-Sanders: 16.4

© 2018 Red Grooms / Artists Rights Society (ARS), New York, p. 22

© Frederick Kiesler Foundation, Vienna: 13.7

© Estate of Yasuo Kuniyoshi / Licensed by VAGA, New York, NY: 12.5

© Man Ray Trust / Artists Rights Society (ARS), NY / ADAGP, Paris 2017: 5.5, 13.8A–B

© Antonio Martorell: p. 10 (detail), 16.5

© Manuel Mendive: 15.3

© Estate of Alice Neel: p. 14, back cover (detail).

© 2018 The Georgia O'Keeffe Foundation / Artists Rights Society (ARS), New York: 12.4

© Francisco Rodón: p. 5 (detail), 16.1, 16.2

© Hank Willis Thomas. Courtesy of the artist and Jack Shainman Gallery: 5.9

© Hannah Udren: cover (detail), 14.8

© 2017 The Andy Warhol Foundation for the Visual Arts, Inc. / Artists Rights Society (ARS), New York: 14.5

© Carrie Mae Weems. Courtesy of the artist and Jack Shainman Gallery: p. 12 (detail), 5.8, 15.5, 15.6

## Photography Credits

American Antiquarian Society, Worcester, MA: 4.1, 4.6, 6.7

Architect of the Capitol: 6.5

Archives of American Art, Smithsonian Institution: 7.8

Archivo fotográfico Martín Chambi: 10.5, 10.6, p. 335 (detail)

The Art Institute of Chicago / Art Resource, NY: 3.6, 14.5

Beinecke Rare Book and Manuscript Library, Yale University (Bonnie and Semoura Clark Black – Vaudeville Photographs and Ephemera. James Weldon Johnson Collection in the American Literature Collection): p. 20, 11.1, 12.1, 12.2

Biblioteca Pública Piloto, Medellín, Colombia: 10.1, 10.2, 10.3, 10.4

Brooklyn Museum: 1.6, 1.7

Courtesy of María Magdalena Campos-Pons and Neil Leonard. Photos by Nikki Greene: 15.1, 15.4

Courtesy of María Magdalena Campos-Pons and Neil Leonard / Western Front, Vancouver: 15.2

Chicago History Museum; Collection of Irene McCoy Gaines: 11.2

Chicago Public Library: 11.3, 11.6

CHP/FameFlynet Pictures: p. 21, 14.1

Colby College Museum of Art: 1.2, 1.3 (courtesy Williamstown Art Conservation Center), 12.4

Facetune app, Lightricks Ltd.: 14.6

Acervo de la Fototeca Romualdo García. Museo Regional de Guanajuato Alhóndiga de Granaditas: 10.7, 10.8

Fundación Luis Muñoz Marín Collection. Photo by Mark Gulezian: 16.1

The J. Paul Getty Museum, Los Angeles: 5.8

Getty Research Institute, Los Angeles: 13.6

Granger: 7.5

Harvard Art Museums. Photo: Imaging Department © President and Fellows of Harvard College: 2.2, 6.4, 12.6

Harvard Theatre Collection, Houghton Library, Harvard University: 7.6

Harvard University Fine Arts Library: 7.3

Hingham Historical Society. Photo: James Vradelis: 2.3, 2.4

Historical Society of Pennsylvania: 4.2

International Center of Photography, New York: 5.6B.

John F. Kennedy Presidential Library and Museum: 14.4

Library of Congress: p. 17, 3.2, 3.8, 4.3, 7.4, 14.3.

Courtesy of Kevin Mac Donnell, Austin, Texas: 7.1.

Studio of Manuel Mendive, Havana. Photo by Nikki Greene: 15.3

The Metropolitan Museum of Art: 2.1, 2.7

Musée Bonnat, Bayonne, France / Art Resource, NY: 5.4

The Museum of Modern Art, New York. Digital Image © The Museum of Modern Art / Licensed by SCALA / Art Resource, NY: 13.7

Museum of the City of New York: p. 7 (detail), 8.4

Photograph © 2018 Museum of Fine Arts, Boston: 8.3, 324 (detail)

Museum Ludwig Cologne / Art Resource, NY: 5.5

Museo de la Real Academia de Bellas Artes de San Fernando, Madrid: 3.3

National Gallery of Art, Washington, DC: 1.8, 3.5, 3.7, 6.1

National Gallery of Canada, Ottawa: 6.3

National Museum of American History, Smithsonian Institution: 8.5

National Portrait Gallery, London: 2.5

National Portrait Gallery, Smithsonian Institution, Washington, D.C. Photos by Mark Gulezian: p. 2 (detail), p. 10 (detail), p. 14, p. 18, 3.4, 4.4, 4.5, 5.1–5.3, 5.6A, 5.7, 6.6, 11.8, 16.4, 16.5, back cover (detail)

New Brunswick Museum—Musée du Nouveau-Brunswick: 1.1

New Mexico Museum of Art. Photo by Blair Clark: 12.8

New-York Historical Society: 8.2

The New York Public Library for the Performing Arts, Astor, Lenox and Tilden Foundations; Billy Rose Theatre Division: 7.7

Okanogan County Historical Society, Washington: 9.3, 9.5

Scripophily: 3.1

Philadelphia Museum of Art: 12.3, 13.1, 13.2, 13.5, 13.8A–B

Philbrook Museum of Art, Tulsa, and the Fred Jones Jr. Museum of Art, University of Oklahoma, Norman, Oklahoma: 12.7

Courtesy of a private collection: 13.4

ProQuest LLC: 11.7

Joe Raedle / Getty Images: 14.7

Santa Barbara Museum of Art: 12.5

The Schomburg Center for Research in Black Culture / The New York Public Library: p. 19, 11.4, 11.5, p. 318 (detail)

Smith College Museum of Art, Northampton, MA: 8.1

Stiftung Preußische Schlösser und Gärten Berlin-Brandenburg/Photographer: Hans Bach: 6.2

Tennessee State Museum: 4.7

Courtesy of Hank Willis Thomas and Jack Shainman Gallery, New York: 5.9

Timken Museum of Art: 2.8

Hannah Udren: cover (detail), 14.8

Washington State University Libraries: p. 8 (detail), 9.1, 9.2, 9.4, 9.6, 9.7, 9.8

Courtesy of Carrie Mae Weems and Jack Shainman Gallery, New York: p. 12 (detail) 15.5, 15.6

Williams College Museum of Art, Williamstown, MA: p. 16, 1.4, 1.5

Yale Center for British Art: 2.6

Yale University Art Gallery: 8.6

# INDEX

Page numbers in *italics* refer to illustrations

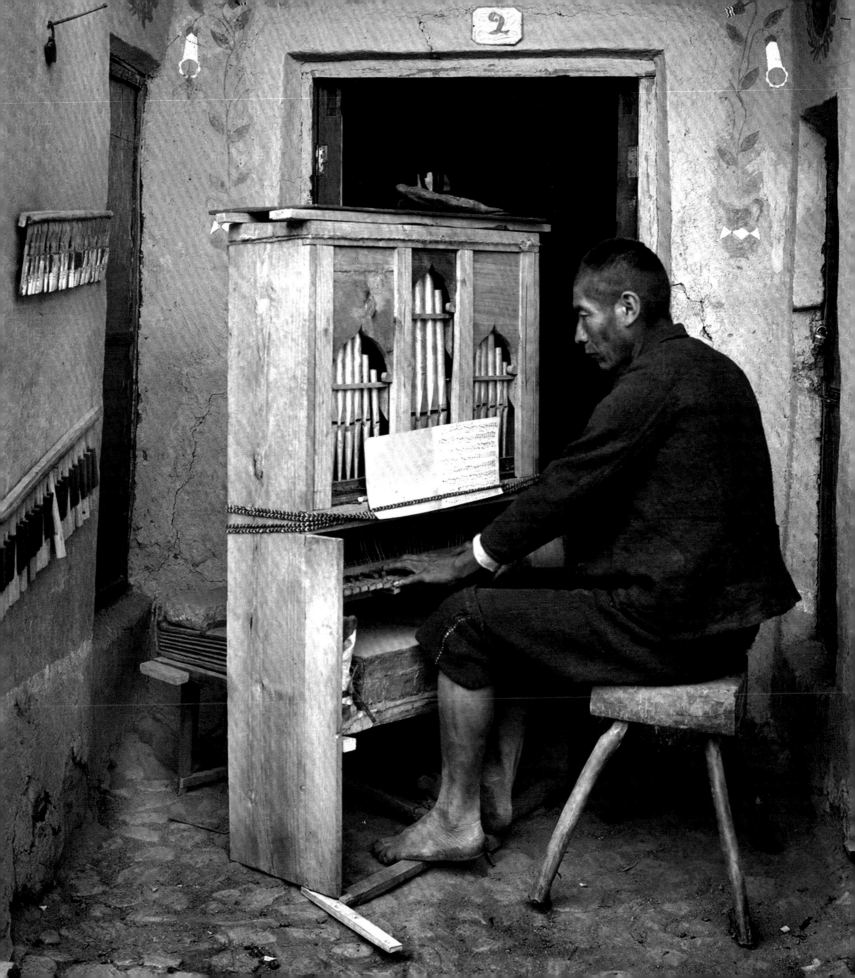

*Beyond the Face: New Perspectives on Portraiture* is published by the National Portrait Gallery, Smithsonian Institution, Washington, DC, in association with D Giles Limited, London.

Library of Congress Control Number:
ISBN: 978-1-911282-20-4 (cloth edition)
All rights reserved

For the National Portrait Gallery, Smithsonian Institution:
Project Editor: Rhys Conlon, Head of Publications

For D Giles Limited:
Copyeditor and proofreader: Jodi Simpson
Designers: Caroline and Roger Hillier, The Old Chapel Graphic Design
Production managers: Pat Barylski and Sarah McLaughlin

Produced by GILES, an imprint of D Giles Limited, London

Printed and bound in Hong Kong

Front cover: *So Yup* (detail) by Hannah Udren, 2014 (see 14.8)
Back cover: *Self-Portrait* (detail) by Alice Neel, 1980 (see p. 14)

p. 3: *Luis Muñoz Marín* (detail) by Francisco Rodón, 1974–77 (see 16.1)
p. 5: *"I Scrubs," Little Katie* (detail) by Jacob A. Riis, ca. 1890 (see 8.4)
p. 6: *Dollie Graves and Pearl Rasilbarth at Matsura's Studio* by Frank Matsura (detail), ca. 1911 (see 9.7)
p. 8: *Nicholasa Mohr* (detail) by Antonio Martorell, 1994 (see 16.5)
p. 10: *Clarence Norris and Haywood Patterson* (detail) by Aaron Douglas, ca. 1935 (see 11.8)
p. 12: *Guggenheim Bilbao* (detail) by Carrie Mae Weems, 2006 (see 15.6)
p. 318: *Portrait of Clarence Muse and Elliot Carpenter* (detail) by Woodard's Studio, ca. 1937 (see 11.4)
p. 324: *The Daughters of Edward Darley Boit* (detail) by John Singer Sargent, 1882 (see 8.3)
p. 335: *Organ Player at the Capilla de Tinta, Sicuani, Cusco* (detail) by Martín Chambi, 1935 (see 10.5)

National
Portrait
Gallery

✺ Smithsonian